THE HISTORY OF PHOTOGRAPHY

THE HISTORY OF PHOTOGRAPHY

from 1839 to the present • *completely revised and enlarged edition*

Beaumont Newhall

The Museum of Modern Art, New York

Distributed by New York Graphic Society Books

Little, Brown and Company, Boston

Copyright © 1982 by The Museum of Modern Art
All rights reserved
Library of Congress Catalog Card Number 82-81430
Clothbound ISBN 0-87070-380-3
Paperbound ISBN 0-87070-381-1

Designed by Steven Schoenfelder
Edited by Susan Weiley
Production by Susan Schoenfeld
Type set by Craftsman Type Inc., Dayton, Ohio
Printed by Rapoport Printing Corp., New York, NY
Bound by Sendor Bindery, Inc., New York, NY

The Museum of Modern Art
11 West 53 Street, New York, NY 10019

Printed in the United States of America
Fifth edition, second printing, 1986

CONTENTS

PREFACE

Ever since 1839 photography has been a vital means of communication and expression. The growth of this contribution to the visual arts is the subject of this book. It is a history of a medium rather than a technique, seen through the eyes of those who over the years have struggled to master it, to understand it, and to mold it to their vision.

Photography is at once a science and an art, and both aspects are inseparably linked throughout its astonishing rise from a substitute for skill of hand to an independent art form. The technology of photography is discussed in this essay in as far as it affects the photographer. No attempt, however, has been made to explain the scientific theory of the photographic process.

This is the fifth revised and expanded edition of the text first published in the illustrated catalog of the exhibition "Photography 1839-1937" that I organized for The Museum of Modern Art in 1937.

I extend thanks to the John Simon Guggenheim Memorial Foundation for the grant of two Fellowships; to the University of New Mexico for its support over the years of research and writing; to The Museum of Modern Art, and to John Szarkowski, Director of the Department of Photography: I hope that this book will show evidence of his wise counsel over many years.

For permission to use copyrighted material I am indebted to the authors and publishers named in the notes.

For permission to reproduce photographs I am grateful to the photographers, collectors, museums, and historical societies named in the captions. I particularly thank the International Museum of Photography at George Eastman House, Rochester, N.Y., for making available the large selection of photographs from its rich collection.

The following historians, photographers, collectors, and curators have generously shared their knowledge with me and to them I am most grateful: H. J. P. Arnold, James Borcoman, Peter C. Bunnell, Van Deren Coke, Amy Conger, Arnold H. Crane, James L. Enyeart, Helmut Gernsheim, Arthur T. Gill, Sarah Greenough, André Jammes, Fritz Kempe, Susan Kismaric, Valerie Lloyd, Bernd Lohse, Harry H. Lunn, Jr., Jerald C. Maddox, Weston J. Naef, Davis Pratt, Joel Snyder, Robert A. Sobieszek, Karl Steinorth, David Travis, Lamberto Vitali, Harold White.

The perceptive editing of the book is by Susan Weiley and the design by Steven Schoenfelder. Production was supervised by Tim McDonough and Susan Schoenfeld. To them and their colleagues in the Department of Publications, my deep thanks.

For her understanding, trust, and encouragement, I dedicate this book to my wife, Christi.

Beaumont Newhall
Santa Fe, N.M.
April 1982

"A Very curious Method of drawing all Perspectives in the most natural manner, without observing the Rules." From *The Practice of Perspective; or, An Easy Method of Representing Natural Objects According to the Rules of Perspective,* written in French by a Jesuit of Paris (London: Tho Boyles and John Boyles, M DCC XXVI).

Jean Dubreuil, the unnamed author, explains that in the engraving (*A*) is a pane of glass that slips into the frame (*BC*). (*E*) is an adjustable sight vane, with a minute peep hole at its top, that fits into the base *BD* of his instrument. The artist (*F*) traces the outlines of what he sees upon window (*G*). "Everybody knows how to take, or copy off, what is thus on the Glass," the Jesuit concludes: "'Tis best to draw the Lines and Figures on the Glass with Pen and Ink; then wetting the Back-side of the Glass a little, and laying a moist Sheet of Paper on the Side that has the Design; rub or press the Paper gently thereon with the Hand, and the whole Draught will be impress'd or transfer'd from the Glass upon the Paper. . . . A little Practice will render the Method exceeding feasible and easy."

1 • THE ELUSIVE IMAGE

Camera pictures have been made ever since the late Renaissance. The principle of the camera had long been known: light entering a minute hole in the wall of a darkened room forms on the opposite wall an inverted image of whatever lies outside. The use of the *camera obscura* (literally "dark room") for the production of pictures, however, was not realized until a century after geometrical linear perspective had been conceived by Leon Battista Alberti and his Florentine colleagues Filippo Brunelleschi and Donato Bramante. The theory on which their classical rules of perspective were based was that light rays emanating from objects are received by the eye at the apex of a cone, or visual pyramid. The picture plane is considered to be a vertical section of this visual pyramid, which Alberti in his book *On Painting* (1435) compared to a window: "Let me tell you what I do when I am painting. First of all, on the surface on which I am going to paint I draw a quadrangle of right angles of whichever size I want, which I regard as an open window through which the subject to be painted is seen."[1]

It was soon discovered that Alberti's theoretical window could become actual, simply by drawing on a pane of glass positioned vertically while looking through a sight or eyepiece opposite the center of the pane. Albrecht Dürer illustrated in 1525 the use of such a device for portraiture, and noted that it was "good for all those who want to make a portrait of somebody, but are not sure about it."[2]

Alberti's window can be duplicated by the image of a camera when the light rays passing through the pinhole are received on a vertical plane. The first description of the camera obscura as an aid to the draftsman was made by Giovanni Battista della Porta in his book *Natural Magic* (1553).[3] Fifteen years later Daniello Barbaro, professor at the University of Padua and author of a treatise on perspective, showed that a more brilliant image could be produced by substituting a lens for the pinhole:

Close all the shutters and doors until no light enters the *camera* except through the lens, and opposite hold a sheet of paper, which you move forward and backward until the scene appears in sharpest detail. There on the paper you will see the whole view as it really is, with its distances, its colors and shadows and motion, the clouds, the water twinkling, the birds flying. By holding the paper steady you can trace the whole perspective with a pen, shade it and delicately color it from nature.[4]

The camera obscura, at first actually a room big enough for an artist to enter, was useless until it became portable. In the seventeenth and eighteenth centuries a lens was fitted into one end of a two-foot box, and the other end was covered with a sheet of frosted or ground glass. The image cast on the ground glass by the lens could be seen outside of the camera. A perfected model, resembling the modern reflex camera, had the ground glass flush with the top of the box, the image being thrown upon it by a mirror placed at an angle of 45°. It had the advantage that the image was not upside down, and the artist could trace it by laying thin paper over the glass.

But there was a problem. Artists demanded that cameras be fitted with lenses that would produce images that conformed to the rules of perspective. The image formed by a simple lens—such as a magnifying glass—is circular and dish-shaped; it is not sharp when received on a plane surface. By combining two lenses ground to segments of arcs of different radii a reasonable flatness of field could be obtained. And by using lenses of different focal lengths, the angle of view could be made narrow for portraiture and wide for landscape work. By the eighteenth century camera obscuras became sufficiently improved so that they were standard equipment for artists. Count Francesco Algarotti devotes a chapter to the camera obscura in his *Essays on Painting* (1764): "The best modern painters among the Italians have availed themselves greatly of this contrivance; nor is it possible they should have otherwise represented things so much to life."[5]

Photography is basically a way of fixing the camera image by the action of light upon substances sensitive to it. The ancients had long observed that light changes the nature of many substances. The chlorophyll of vegetation turns green on exposure to it, colored fabrics fade. Certain salts of silver, especially the halides, are radically altered

Fig. 434.

A camera obscura. The image formed by the lens *(B)* and reflected by the mirror *(M)* on the ground glass *(N)* is traced. From A. Ganot, *Traité élémentaire de physique* (Paris: 1855).

on exposure to light: the combining element is liberated, leaving pure metallic silver that, because unpolished, is dark in tone.

This phenomenon was first scientifically observed by the German natural philosopher Johann Heinrich Schulze in 1727, while he was attempting to repeat an experiment of the alchemist Christoph Adolph Balduin for the production of a luminescent substance. Balduin had found in 1674 that chalk (calcium carbonate) dissolved in aqua regia (nitric acid) formed a compound (calcium nitrate) that was deliquescent, that is, it readily absorbed moisture from the atmosphere. He thought that by distilling the sludge he could trap the *Weltgeist,* or Universal Spirit. By chance he observed that the residue left in the retort when heated glowed in the dark even when cool, and he named it *phosphorous* ("bringer of light").

The aqua regia that Schulze used in his repetition of Balduin's experiment was impure: it contained silver. When he dissolved chalk in it he produced a complex of calcium nitrate and silver carbonate. To his amazement the compound turned deep purple on exposure to the sun's rays. But exposure to the heat of a fire produced no such change, and Schulze deduced that the reaction had been caused by light rather than heat. To prove his deduction he filled a glass bottle with the chalk-silver nitric acid mixture. In his report of his experiment he wrote:

I covered most of the glass with dark material, exposing a little part for the free entry of light. Thus I often wrote names and whole sentences on paper and carefully cut away the inked parts with a sharp knife. I struck the paper thus perforated on the glass with wax. It was not long before the sun's rays, where they hit the glass through the cut-out parts of the paper, wrote each word or sentence on the chalk precipitate so exactly and distinctly that many who were curious about the experiment

but ignorant of its nature took occasion to attribute the thing to some sort of trick.[6]

Schulze named the light-sensitive compound *scotophorous* ("bringer of darkness"), and published his findings in the transactions of the Nuremburg Academy of Natural Philosophers in 1727 under the title "Scotophorous Discovered Instead of Phosphorous; or, A Noteworthy Experiment of the Action of the Sun's Rays." Chemists at once began to repeat Schulze's experiment, which became well-known throughout Europe. By the end of the eighteenth century the means by which to trap the elusive image of the camera obscura existed in a latent form.

The incentive to work out a practical technique was stimulated by the unprecedented demand for pictures from the rising middle class of the late eighteenth century. Reproductions in quantity were required; once lithography was invented and wood engraving revived, pictures could be almost endlessly duplicated. The *Encyclopédie* of Diderot and d'Alembert, that intellectual symbol of the Age of Enlightenment published between 1751 and 1765, was profusely illustrated with pictures showing in exact detail various arts and trades, such as bookbinding, forging an anchor, housebuilding, and so on. Significantly, a picture of a camera obscura was included in the article on optics. The middle class wanted portraits; mechanical devices to eliminate the need for lengthy artistic training were put in its hands, so that

JEAN FOUQUET. *Portrait of Gilles-Louis Chrétien, Inventor of the Physionotrace.* ca. 1792. Physionotrace engraving. George Eastman House, Rochester, N.Y.

Drawing with a camera lucida. From V. Chevalier, *Notice sur l'usage de la chambre claire* (Paris: 1834).

anyone could become something of a draftsman, if not an artist. The *silhouette* required merely the ability to trace a shadow; the *physionotrace,* invented by Gilles-Louis Chrétien in 1786, asked no more of the beginner, with the advantage that a miniature engraved copper plate was produced, from which duplicates could be printed. The sitter's profile was traced through a movable sight connected by levers to a stylus that recorded on a reduced scale its every movement in ink on a copper plate, which was then engraved. The instrument was immensely popular; 600 physionotrace portraits were exhibited at the 1797 Paris Salon alone. Févret de St.-Mémin brought his physionotrace to America and made over 800 portraits with it, including a number of remarkable likenesses of the founding fathers.

Still another mechanical substitute for artistic skill was the *camera lucida,* designed by the English scientist William Hyde Wollaston in 1807. Drawing paper was laid flat. Over it a glass prism was suspended at eye level by a brass rod. Looking through a peephole centered over the edge of the prism, the operator saw at the same time both the subject and the drawing paper; his pencil was guided by the virtual image. The camera lucida, which resembled the camera obscura only in name and function, could easily be carried about and was widely used by travelers. Basil Hall used it to document his American travels; in the preface to *Forty Etchings Made with the Camera Lucida in North America in 1827 and 1828* (Edinburgh, 1829) he praised the instrument that freed the amateur "from the triple misery of Perspective, Proportion and Form," and concluded that although Wollaston, its inventor, had not discovered the "Royal Road to Drawing," he had "at least succeeded in Macadamising the way already known."

But to many amateurs "Macadamising" was not enough. Even the camera lucida demanded a modicum of skill in drawing. Throughout history the experimental amateur has not been the one to accept either his shortcomings or the difficulties that block the professional. The fever for reality was running high. The physical aid of camera obscura and camera lucida had drawn men so near to an exact copying of nature and to satisfying the current craving for reality that they could not abide the intrusion of the pencil of man to close the gap. Only the pencil of nature would do. The same idea burned in many minds, and the race for discovery was on: to make light itself fix the image in the camera without having to draw it by hand.

LOUIS JACQUES MANDE DAGUERRE. *Still Life.* 1837. Daguerreotype. Société Française de Photographie, Paris.

2 • INVENTION

The first person to attempt to record the camera image by means of the action of light was Thomas Wedgwood, son of the famous British potter. He was familiar with the camera obscura, which was used by the pottery to make sketches of country houses for the decoration of plates. And he knew of Schulze's discovery of the light sensitivity of silver salts. Sometime shortly before 1800 he began experiments by sensitizing paper or leather with silver nitrate and then placing flat objects or painted transparencies in contact with it and exposing the whole to light. His friend Sir Humphry Davy described the process in the *Journals of the Royal Institution* for 1802:

White paper, or white leather, moistened with solution of nitrate of silver, undergoes no change when kept in a dark place; but, on being exposed to day light, it speedily changes colour, and, after passing through different shades of grey and brown, becomes at length nearly black . . .

When the shadow of any figure is thrown upon the prepared surface, the part concealed by it remains white, and the other parts speedily become dark.

For copying paintings on glass, the solution should be applied on leather; and, in this case, it is more readily acted upon than when paper is used.[1]

Wedgwood was dismayed that these "sun prints" were not permanent. He found no way to desensitize the unexposed areas of the prepared paper or leather. Only by keeping his results in darkness could they be prevented from becoming total dark blankness: he showed them almost furtively, by the light of a candle. He was also disappointed that his attempts to record the camera's image—"the first object of Mr. Wedgwood in his researches on the subject," wrote Davy—were unsuccessful. Silver nitrate, we now know, is light sensitive only in the presence of organic substances, such as paper or leather, but even so, its sensitivity is weak compared to such other compounds as silver chloride.

Ill health forced Wedgwood to abandon further experiments, and all that remains is the account by Davy, who concluded: "Nothing but a method of preventing the unshaded parts of the delineation from being coloured by exposure to the day is wanting, to render the process as useful as it is elegant."

Joseph Nicéphore Niépce, of Chalon-sur-Saône in central France, was more successful. Although the only example of his camera work that remains today appears to have been made in 1827, his letters leave no doubt that he had succeeded in fixing the camera's image a decade earlier.

Nicéphore Niépce and his brother, Claude, were ardent inventors. They had patented an internal combustion engine powered by the intermittent explosion of lycopodium powder to which they gave the name *Pyréolophore*; with it they drove a boat against the current of the Saône River. When lithography was introduced to France in 1815, Nicéphore proposed replacing the heavy, cumbersome Solenhofen stones used by the inventor, Aloys Senefelder, with coated metal plates. For his experiments he needed drawings, but since he had little artistic skill he conceived the idea of making them by means of light. On April 1, 1816 he wrote his brother in London, where he was attempting to promote the Pyréolophore, of his results using paper sensitized with silver chloride:

The experiments that I have thus far made lead me to believe that my process will succeed as far as the principal effect is concerned, but I must succeed in fixing the colors; this is what occupies me at the moment, and it is most difficult.[2]

A few days later he described his camera as "a kind of artificial eye, simply a little box, each side six inches square; which will be fitted with a tube that can be lengthened and carrying a lenticular glass."[3]

He broke the lens and had to make a new camera, smaller in size—about 1¼ inches on each side—because the only other lens he had was from his solar microscope and consequently of short focal length. He wrote his brother on May 5, 1816:

I placed the apparatus in the room where I work, facing the bird-house and the open window. I made the experiment according to the process which you know, my dear friend, and I saw on the white paper all that part of the bird-house which can be seen from the window and a faint image of the window sashes which were less illuminated than the exterior objects. . . . This is only a very imperfect attempt. . . . The possibility of painting in this

ISAAC BRIOT. *Portrait of Georges d'Amboise, Cardinal and Archbishop of Reims, France.* ca. 1650. Engraving. Collection Van Deren Coke, San Francisco.

NICEPHORE NIEPCE. *Copy of Engraving of Cardinal d'Amboise.* 1826. Heliograph. Science Museum, London.

way seems to me almost demonstrated. . . . That which you have foreseen has happened. The background of the picture is black, and the objects white, that is, lighter than the background.[4]

This is an accurate description of a negative. Had Niépce only been able to make prints from these negatives he could have again inverted the tones so that they would correspond to the order of lights and shades in nature. But he could not find a way to do so, and began to search for a substance that would bleach instead of darken in light. His experiments were fruitless. Then he found that a certain form of asphalt, called bitumen of Judea, was light sensitive. The substance was used by etchers to coat copper plates before drawing upon them; it served as a ground to protect the plate when lines scratched through it by the draftsman were bitten by acid. Normally soluble in oil of lavender, on exposure to light the bitumen hardened, and became insoluble in the oil. Niépce made copies of engravings by oiling them and placing them in contact with the sensitized plate. Isidore, Niépce's son, recollected that his father in 1826

spread on a well-polished pewter plate bitumen of Judea dissolved in Dippel's oil.* On this varnish he placed the engraving to be reproduced, which had been made trans-

lucent, and exposed the whole to the light. After a more or less long time, according to the intensity of the light, he plunged the plate in a solvent which, little by little, made the image—until then invisible—appear.

After these different operations, he placed it in more or less acidified water, for the purpose of etching it.

My father sent this plate to [the engraver Augustin François] Lemaître, requesting him to be good enough to engrave the drawing still deeper. M. Lemaître acceded very courteously to my father's request. He pulled several proofs of the portrait of Cardinal d'Amboise. . . .[5]

The printed lines of the engraving held back the light; the white paper permitted it to pass through. Thus most of the bitumen was rendered insoluble, but that which lay directly beneath the lines remained soluble and could be removed by the lavender oil. The bared metal was then etched to form a printing plate.

The plate, reproducing a seventeenth-century engraving by Isaac Briot of Georges d'Amboise, Cardinal and Archbishop of Rheims, still exists. Excellent proofs were pulled from it as late as 1870.

This invention is epochal. It was the first of those photomechanical techniques that were soon to revolutionize the graphic arts by eliminating the hand of man in the reproduction of pictures of all kinds. It is the most important of Niépce's contributions, for it involved a principle that became basic to future techniques: the differential hardening by light of a ground that would control the

*Johann Konrad Dippel (1673–1734) a German chemist, prepared a curative oil by distilling animal bones.

etching in exact counterpart of the image.

Beside the production of etched plates, Niépce used his bitumen process for making direct positives on metal and also glass plates. After exposure he washed the bitumen-coated plate in his solvent, which laid bare the plate in those parts where little light had fallen. He now put the plate face down on top of an open box containing iodine. This element becomes gaseous at room temperature, and the fumes darkened the plate in the shadowy areas.

Niépce now tried to record the camera image with his bitumen plates. He met with indifferent success, to judge from the only example known to exist: a view taken from an upper window in his estate "Le Gras" in the village of Saint Loup de Varenne, near Chalon-sur-Saône. The plate, now in the Gernsheim Collection of the University of Texas at Austin, shows the open casement and outbuildings in the farmyard.

The exposure was said to have lasted some eight hours; during that time the sun in its travels from east to west lighted both sides of the buildings, destroying the modeling. The image is laterally reversed: left and right are transposed, as in a mirror. The plate, which is of pewter, is not dated, but external evidence points to its production in 1827. A far more successful picture on glass, of a table set for a meal, was presented to the French Society of Photography in 1890 by a member of the Niépce family. The objects—a bottle, a knife, a spoon, a bowl and saucer, a wine glass, and a loaf of bread—are well defined, with middle tones, highlights, and cast shadows. The image alone exists in a coarse halftone reproduction in the Society's *Bulletin*; the original glass plate mysteriously disappeared from the collection not long after its acquisition. A date for the production of this still life has not been determined.

In 1827 Niépce traveled to London to visit his brother, Claude, who was ill; he took with him the farmyard picture and other *heliographs*, as he named the process. On his way he stopped in Paris, where he visited the painter Louis Jacques Mandé Daguerre, who was conducting research toward the same end: capturing the camera image by "the spontaneous action of light."

Daguerre was a scenic artist; he had specialized in painting stage sets for the Opéra and popular theaters. At the time Niépce visited him he and his partner, Charles Marie Bouton, were proprietors of the *Diorama,* a theater built for the display of huge 46 x 72-foot paintings of the most illusionistic kind. Semitransparent theatrical gauze was painted on both sides; on changing the lighting from front to back by adjusting curtains on the skylights and floor-to-ceiling windows behind the stage, one image could be made to dissolve into the other. To produce these paintings Daguerre and Bouton made fre-

NICEPHORE NIEPCE. *View from his Window at Le Gras.* ca. 1827. Heliograph. Gernsheim Collection, Humanities Research Center, University of Texas, Austin.

"Though the image can clearly be seen by holding the plate at an angle against the light, or by reflecting light on it by means of a white cardboard to increase the contrast, the picture presented the greatest difficulty in reproduction, because the plate is as shiny as a mirror, and the image rather faint. . . . Our thanks are due to Mr. P. B. Watt of the Kodak Research Laboratory, who after many trials successfully overcame the difficult problem of reproducing the picture."—Helmut and Alison Gernsheim, *Photographic Journal,* May 1952.

NICEPHORE NIEPCE. *Set Table.* ca. 1827. Heliograph. No longer extant. From A. Davanne and Maurice Bucquet, *Le Musée rétrospectif de la photographie à l'Exposition Universelle de 1900* (Paris: 1903).

LOUIS JACQUES MANDE DAGUERRE. *Two Views of the Boulevard du Temple, Paris, Taken the Same Day.* ca. 1838. Daguerreotypes. Bayerisches Nationalmuseum, Munich.

Samuel F. B. Morse, the American painter and inventor, was in Paris when the news of Daguerre's process was released by the French Academy of Sciences. Morse invited Daguerre to a demonstration of his electric telegraph. Daguerre, in turn, invited Morse to see his daguerreotypes. Greatly impressed, Morse wrote a long letter to his brother, who, as editor of the New York *Observer*, published it in the April 19, 1839 edition, from which the following excerpt is taken:

The day before yesterday, the 7th [of March 1839] I called on M. Daguerre, at his rooms in the Diorama, to see these admirable results.

They are produced on a metallic surface, the principal pieces about 7 inches by 5, and they resemble aquatint engravings; for they are in simple chiaro oscuro, and not in colors. But the exquisite minuteness of the delineation cannot be conceived. No painting or engraving ever approached it. For example: In a view up the street, a distant sign would be perceived, and the eye could just discern that there were lines of letters upon it, but so minute as not to be read with the naked eye. By the assistance of a powerful lens, which magnified fifty times, applied to the delineation, every letter was clearly and distinctly legible, and so also were the minutist breaks and lines in the walls of the buildings; and the pavements of the streets. The effect of the lens upon the picture was in a great degree like that of the telescope in nature.

Objects moving are not impressed. The Boulevard, so constantly filled with a moving throng of pedestrians and carriages was perfectly solitary, except an individual who was having his boots brushed. His feet were compelled, of course, to be stationary for some time, one being on the box of the boot black, and the other on the ground. Consequently his boots and legs were well defined, but he is without body or head, because these were in motion.

quent use of the camera obscura to assure correct perspective, and it was his familiarity with this instrument that led Daguerre toward photographic experimentation. He had learned of Niépce's work through the optician Charles Chevalier, who had supplied him with lenses and told him Niépce was also his customer.

Niépce reported on his visit to his son, Isidore, in a letter dated September 2–4, 1827:

I have had frequent and very long interviews with M. Daguerre. He came to see us yesterday. His meeting lasted for three hours . . . and the conversation on the subject which interests us is really endless. . . . I have seen nothing here that impressed me more, that gave me more pleasure, than the Diorama. We were conducted through it by M. Daguerre, and we were able to contemplate the magnificent tableaux which are exhibited there, quite at our ease. . . . Nothing is superior to the two views painted by M. Daguerre; one of Edinburgh taken by moonlight during a fire; the other of a Swiss village, looking down a wide street, facing a mountain of tremendous height, covered with eternal snow. These representations are so real, even in their smallest detail, that one believes that he actually sees rustic and wild nature, with all the illusion that the charm of colors and the magic of chiaroscuro can give it. The illusion is even so great that one is tempted to leave one's box and wander out into the open and climb to the summit of the mountain. I assure you there is not the least exaggeration on my part, the objects are, or seem to be, of natural size.[6]

In London Niépce met Francis Bauer, a horticulturist and a member of the Royal Society, who urged him to communicate his experiments to that learned body. The Society, however, refused to accept any communication that did not disclose the process, and Niépce would not reveal his technique. He gave Bauer the plates he had brought with him, including the farmyard view, the portrait of Cardinal d'Amboise, and a copy of an aquatint of a stage set painted by Daguerre for the play *Elodie*, which he may well have made expressly for Daguerre as a demonstration. He also gave Bauer the manuscript of an account of his process that he planned to publish.

Discouraged by the lack of interest in England in heliography and by his brother's worsening physical and mental health, Niépce returned to France in 1829, determined to concentrate on what he called "view points" (*points de vue*) with the "sole object to copy nature with the greatest fidelity." He reopened correspondence with Daguerre. The showman advised him to postpone his proposed book: "As regards your intention of publishing your method, there should be found some way of getting a large profit out of it before publication, apart from the honor the invention will do you, but for that is needed a degree of perfection that can only be reached

17

in several years."[7] Lemaître, his Parisian engraver, criticized one of Niépce's "view points" for its contradictory shadows cast by the sun during the excessively long exposure time. Niépce replied:

Unfortunately I am not able to avoid it. . . . It would be necessary to have a camera as perfect as M. Daguerre's; otherwise I shall be condemned to approach the goal without ever reaching it. . . . Therefore I am hastening to reply to his kind offers of help by proposing that he co-operate with me in perfecting my heliographic process.[8]

On December 4, 1829, Niépce and Daguerre signed articles of partnership to last ten years. Only four had run their course when Niépce died in Chalon-sur-Saône.

Daguerre continued alone. Although Isidore Niépce had succeeded to the partnership, he contributed nothing, in spite of Daguerre's constant urging. News of his secret experiments leaked out. Reviewing the Diorama show "The Valley of Goldau" in 1835, the *Journal des Artistes* noted that Daguerre

has found out a method of receiving, on a plate prepared by him, the image produced by the camera obscura, so that a portrait, a landscape or view of any kind, projected upon this plate by the ordinary camera obscura, *leaves its impress* there in light and shade, and thus makes the most perfect of drawings. A preparation applied to this image preserves it for an indefinite period. Physical science has, perhaps, never offered a marvel comparable to this.[9]

The announcement was somewhat premature, to judge from a letter to the editor published in the following year: "I doubt if M. Daguerre has reached the complete results attributed to him. If he had . . . it is very probable that he would have exhibited them . . . he would have had to make a night album, enclosing his results within black envelopes and displaying them only by moonlight."[10]

By 1837 Daguerre had made a highly successful photograph—a still life of plaster casts, a wicker-covered bottle, a framed drawing, and a drapery. This astonishing picture is fully detailed, showing a wide range of tones between highlight and shadow, convincing realism in texture, contour, and volume. It still exists, signed and dated, in the collection of the Société Française de Photographie in Paris. The earliest surviving example of what Daguerre now called the *daguerreotype*, it exhibits the potentials of a new graphic medium that was to revolutionize picture making.

The daguerreotype is on a silver-plated sheet of copper, 6½ x 8½ inches in size. As Daguerre later described his technique, he polished the silver side of the plate mirror bright and chemically clean. He sensitized it by putting it silver side down over a box containing particles of iodine, the fumes of which reacted with the silver to form light-sensitive silver iodide on the surface of the plate. He then exposed it in a camera. The light forming the optical image reduced the silver iodide to silver in proportion to its intensity. Daguerre next placed the exposed plate, which bore no visible image, over a box containing heated mercury; its fumes formed an amalgam with the freshly reduced silver and an image became visible. The plate was then bathed with a strong solution of common salt (sodium chloride), which rendered the unexposed silver iodide relatively insensitive to further light action. Finally, the plate was washed in water and dried.

The result was a record of the lights of the image in frosted, whitish mercury amalgam. The shadows were represented by the relatively bare mirror surface of the plate; when viewed so as to reflect a dark field, the picture appeared positive.

Daguerre now presented a new contract to his partner, Isidore Niépce. He made it clear that he considered the invention to be his own, and agreed to transfer it to the partnership "on *condition* that this new process shall bear the *name of Daguerre* alone; it may, however, only be published simultaneously with the first process, in order that the name of M. Joseph-Nicéphore Niépce may always figure, as it should, in this invention."[11] The contract concluded with details of a plan to sell technical specifications of their separate and different processes by offering 400 subscriptions at 1000 francs each.

Isidore reluctantly signed the contract, although he considered it an insult to his father's memory and unfair, if not dishonest. But in truth Daguerre was correct in claiming the new process as his own. If Nicéphore Niépce knew of the light sensitivity of silver iodide, there is no record that he made use of this property: to him iodine fumes were useful for darkening the bared pewter of his heliographs, and his only existing work involved a quite different photochemical reaction.

Daguerre printed a broadside describing his invention in general terms, and announced the forthcoming sale of technical specifications. But the plan was abandoned at the advice of François Arago, a well-known scientist, director of the Paris Observatory, perpetual secretary of the Academy of Sciences, and a member of the Chamber of Deputies of the French government. He proposed nothing short of the outright purchase of both processes by the state, and told Daguerre that he would call a meeting of the Academy for that purpose.

The newspaper *Gazette de France* wrote in its January 6, 1839 edition:

We announce an important discovery of our famous painter of the Diorama, M. Daguerre. This discovery partakes of the prodigious. It upsets all scientific theories of light and optics, and it will revolutionize the art of drawing.

M. Daguerre has found the way to fix the images which paint themselves within a camera obscura, so that these images are no longer transient reflections of objects, but their fixed and everlasting impress which, like a painting or engraving, can be taken away from the presence of the objects.

Imagine the faithfulness of nature's image reproduced in the camera and add to it the work of the sun's rays which fix this image, with all its range of high lights, shadows and half tones, and you will have an idea of the beautiful drawings which M. Daguerre displayed. . . .

MM. Arago, Biot and Humboldt* have verified the authenticity of this discovery, which excited their admiration, and M. Arago will make it known to the Academy of Sciences in a few days. . . .

Still life, architecture—these are the triumphs of the apparatus that M. Daguerre wants to call after his own name the Daguerotype [sic]. A dead spider, taken through the solar microscope, has such fine detail in the drawing that you could study its anatomy with or without a magnifying glass, as in nature; not a filament, not a duct, as tenuous as it might be, cannot be followed and examined. Travelers, you will soon be able, perhaps at the cost of some hundreds of francs, to acquire the apparatus invented by M. Daguerre, and be able to bring back to France the most beautiful monuments and scenes of the whole world. You will see how far from the truth of the Daguerotype [sic] are your pencils and brushes. Let not the draftsman and painter despair; M. Daguerre's results are something else from their work and in many cases cannot replace it.

If I wanted to find something resembling the effects rendered by the new process, I would say that they take after copperplate engravings or mezzotints—much more the latter. As to truth, they are above all. . . .[12]

The meeting took place on the following day, and was reported by the Academy in its official publication, the *Cômpte-rendu des Séances de l'Académie des Sciences.* An English translation of the report appeared in the *Literary Gazette* for January 19.

The news of Daguerre's invention astonished William Henry Fox Talbot, English scientist, mathematician, botanist, linguist, and classical scholar, for quite independently he had invented a technique that seemed to him to be identical to Daguerre's. He later wrote that he was "placed in a very unusual dilemma (scarcely to be paralleled in the annals of science)"[13] and rushed to publish his work and thus to claim priority of invention.

Talbot was born in Melbury, Dorset, England in 1800. He had inherited Lacock Abbey, a beautiful country estate not far from Bath. Like so many of the landed gentry, he was educated at Harrow and Cambridge University, where he received the degree of Master of Arts in 1826. Already he had contributed learned papers on

WILLIAM HENRY FOX TALBOT. *Botanical Specimen.* 1839. Photogenic drawing. Printroom, University of Leiden, The Netherlands.

Sent by Talbot to Jean Baptiste Biot, a member of the French Academy of Sciences.

mathematics and physics to scientific journals, and in 1832 he was elected a Fellow of the Royal Society, England's top scientific body, the equivalent of the French Academy of Sciences.

His discovery of a photographic system came about almost accidentally.

One of the first days of the month of October, 1833 [he later recollected], I was amusing myself on the lovely shores of the Lake of Como in Italy, taking sketches with Wollaston's *camera lucida,* or rather, I should say, attempting to take them: but with the smallest possible amount of success. . . . After various fruitless attempts I laid aside the instrument and came to the conclusion that its use required a previous knowledge of drawing which unfortunately I did not possess. I then thought of trying again a method which I had tried many years before. This method was, to take a *camera obscura* and to throw the image of the objects on a piece of paper in its focus —fairy pictures, creations of a moment, and destined as rapidly to fade away. It was during these thoughts that the idea occurred to me—how charming it would be if it were possible to cause these natural images to imprint themselves durably, and remain fixed upon the paper.[14]

That fall, as soon as he returned to England, Talbot began to experiment.

He bathed paper with a weak solution of common salt (sodium chloride) and then, after it had dried, with a

*Jean Baptiste Biot and Alexander von Humboldt, noted scientists and fellow members of the Academy of Sciences, to whom Arago appealed for support.

strong solution of silver nitrate. These chemicals reacted to form silver chloride, a light-sensitive salt insoluble in water, within the paper structure. He placed a leaf, a feather, a piece of lace in contact with this prepared paper and exposed it to sunlight. Gradually the paper darkened wherever it was not protected from light by the opacity of the object in contact with its surface. The result was a white silhouete against the dark ground of the blackened paper, or shadowgraph.. Today we should call this a negative image. As early as February 28, 1835 Talbot described how a positive image could be made from the negative. He entered in his notebook:

In the Photogenic or Sciagraphic (Greek: *skia*—a shadow) process, if the paper is transparent, the first drawing may serve as an object, to produce a second drawing, in which the light and shadows would be reversed.[15]

Before this could be done, the negative had to be "fixed," that is rendered insensitive to the further action of light. This Talbot did by washing the paper with a strong solution of salt or with potassium iodide, a treatment that made the unaltered silver salts relatively, but not completely, insensitive to light. This change in property is due to the fact that silver salts differ greatly in their sensitivity to light according to the way they are produced. If a strong solution of salt is added to a weak solution of silver nitrate, the silver chloride that is precipitated is much less sensitive to light than one produced by a weak solution of salt, even though it is identical in chemical structure. Talbot's "preserving" technique was impermanent, and many of the early experiments fixed with strong salt solution have faded—some, indeed, so completely that only Talbot's signature in ink gives evidence that the blank sheet once carried a picture. But at least his process stabilized these "photogenic drawings" to the extent that they could be viewed in daylight, and printed as positives.

Talbot now began to use his invention to record the images made by the camera. The first one he used, he recollected, was made "out of a large box, the image being thrown upon one end of it by a good object glass fixed in the opposite end."[16] An hour's exposure on a summer afternoon left only the impress of the highlights on the paper. But with small cameras, fitted with lenses of relatively large diameter, he had better success, obtaining "very perfect, but extremely small, pictures; such . . . as might be supposed to be the work of some Lilliputian artist."[17] One of these is now preserved in the Science Museum, London. It is a negative, hardly an inch square, of a lattice window in Lacock Abbey. He mounted it neatly on a card and wrote beside it: "Latticed Window (with the Camera Obscura) August 1835.—When first made,

the squares of glass about 200 in number could be counted, with the help of a lens." He had a collection of box cameras—"little mouse traps," his wife called them —which, upon a summer day, he would train upon the Abbey. "After the lapse of half an hour," he wrote, "I gathered them all up, and brought them within doors to open them. When opened, there was in each a miniature picture of the objects before which it had been placed."[18]

Talbot laid aside these experiments, which he realized were incomplete, and began work on the book, *Hermes, or Classical and Antiquarian Research.* He thought then that perhaps at some later time he would perfect his photogenic drawing process and present it to the Royal Society. There seemed no hurry. But now there was no time to lose. He rushed samples of his work to the Royal Institution in London, where they were shown to the members at the regular Friday evening meeting on January, 25, 1839. They comprised:

flowers and leaves; a pattern of lace; figures taken from painted glass; a view of Venice copied from an engraving; some images formed by the Solar Microscope, viz. a slice of wood highly magnified, exhibiting the pores of two kinds, one set much smaller than the other and more numerous. Another Microscopic sketch, exhibiting the reticulations on the wing of an insect.
Finally: various pictures, representing the architecture of my house in the country; all these made in the summer of 1835.
And this I believe to be the first instance on record, of a house having painted its own portrait.[19]

On January 29, Talbot wrote identical letters to the academicians Arago, Biot, and Humboldt, stating that he would file claim of priority over Daguerre in "fixing the images of the camera obscura and the subsequent preservation of the image so they would bear full sunlight."[20]

On January 31, Talbot's paper, "Some Account of the Art of Photogenic Drawing, or, the Process by which Natural Objects May Be Made to Delineate Themselves without the Aid of the Artist's Pencil," was read at the Royal Society. It was a general description of the results he obtained. Technical details, specific enough to enable anyone to repeat his results, were given in a second paper, read on February 20.

While both Talbot's and Daguerre's processes were still secret, the astronomer and scientist Sir John F. W. Herschel, with characteristic intellectual curiosity and vigor, set about solving the problem independently. In his notebook, now preserved in the Science Museum, London, he wrote: "Jan. 29 [1839]. Experiments tried within the last few days since hearing of Daguerre's *secret* and that Fox Talbot has also got something of the same kind . . . Three requisites: (1) Very susceptible paper; (2) Very perfect camera; (3) Means of arresting the

further action."[21] Like Talbot, he sensitized paper with silver salts. Of his camera we know nothing. His method of "arresting the further action" of light was an epochal contribution. He had noted in 1819 that the hyposulphite of soda dissolved silver salts; now, in 1839, he recorded his successful attempt to use this chemical to fix his photographs.

Tried hyposulphite of soda to arrest action of light by washing away all the chloride of silver or other silvering salt. Succeeds perfectly. Papers ½ acted on ½ guarded from light by covering with pasteboard, were when withdrawn from sunshine, sponged over with hyposulphite soda, then well washed in pure water—dried, and again exposed. The darkened half remained dark, the white half white, after any exposure, as if they had been painted in sepia. . . . Thus Daguerre's problem is so far solved."

This chemical is known today as sodium thiosulfate, but photographers still persist in calling it "hypo."[22]

Talbot visited Herschel on February 1 and learned of this fixing technique. He described it, with Herschel's consent, in a letter published in the *Cômpte-rendu* of the French Academy of Sciences.[23] Daguerre at once adopted it. Almost all subsequent photographic processes rely upon Herschel's discovery. Herschel, who was something of a linguist, also proposed "photography" to replace Talbot's somewhat awkward phrase "photogenic drawing" as well as "positive" and "negative" for "reversed copy" and "re-reversed copy." These words were quickly adopted universally.

Materials and apparatus for working Talbot's process soon came on the market. Ackerman & Co., London's leading printseller and purveyor of "Colours & Requisites for Drawing," advertised in April a Photogenic Drawing Box—not a camera, but a packaged kit with chemicals for sensitizing paper and an instruction booklet for making contact prints. In the same month the *Magazine of Science* published facsimiles of three photogenic drawings made, not on paper, but on boxwood blocks sensitized by Talbot's process and subsequently engraved by hand.[24] They were shadowgraphs of a Fool's Parsley seedling, a sprig of Grass of Parnassus, and a piece of lace. This novel use of photography, which eliminated the need for a draftsman to make a drawing upon the block for the engraver to follow, lay fallow until the 1860s, when it revolutionized the craft of wood engraving.

Variations of Talbot's technique were introduced. Of these the most original was devised by the Scotsman Mungo Ponton: instead of sensitizing with a silver salt he used the far less expensive chemical potassium bichromate. The bright orange crystals of this chemical (now also known as potassium dichromate) are normally

Artist unknown. *An Engraving of Christ's Head Superimposed on an Oak Leaf.* 1839. Photogenic drawing. Fox Talbot Collection, The Royal Photographic Society, Bath, England.

WILLIAM HENRY FOX TALBOT. *Lacock Abbey.* 1839. Photogenic drawing. The Metropolitan Museum of Art, New York. Sent by Talbot to the Italian botanist Antonio Bertolini on August 21, 1839.

soluble in water. On exposure to light they turn brownish gray and become insoluble. Ponton simply brushed a saturated solution of potassium bichromate on paper, let it dry, and then used it to make shadowgraphs. The silhouette of whatever had lain upon the paper during exposure appeared in orange on a brown ground. To fix the image, Ponton simply washed away the still-soluble orange bichromate. Ponton's demonstration of the differential solubility of potassium bichromate according to strength of light action proved to be of the greatest importance in the production of photochemical plates for the printing industry. This use Ponton predicted in his presentation of his technique to the Society of Arts of Scotland on May 25, when he expressed the hope that his process "might be found of considerable practical utility in aiding the operation of lithography."[25]

In May Arago invited Herschel and other British scientists to inspect Daguerre's results in Paris. Herschel was so impressed he said to Arago: "I must tell you that compared to these masterpieces of Daguerre, Monsieur Talbot produces nothing but vague, foggy things. There is as much difference between these two products as there is between the moon and the sun."[26] He wrote Talbot:

It is hardly too much to call them miraculous. Certainly they surpass anything I could have conceived as within the bounds of reasonable expectation. The most elaborate engraving falls far short of the riches and delicateness of execution, every gradation of light and shade is given with a softness and fidelity which sets all painting at an immeasurable distance. His *times* are also very short. In a bright day three minutes suffice. In short, if you have a few days at your disposition, I cannot commend you better than to *come and see*. Excuse this ebullition![27]

Arago now redoubled his efforts to secure a government subsidy for Daguerre and Niépce. He wrote the Minister of the Interior on May 2, with the result that a proposal was made to Daguerre and Isidore Niépce: as recompense for granting the state the right to publish the inventions, they would be awarded generous annuities for life. The partners agreed, and a bill was drawn up for presentation to both houses of the government.

Six of Daguerre's daguerreotypes were put on display at the Chamber of Deputies on July 7. *The Literary Gazette* reported in its July 13 edition:

There were views of three of the streets of Paris, of the interior of M. Daguerre's studio, and a group of busts from the Musée des Antiques. The extraordinary minuteness of such multiplied details as was shown in the street views, particularly in that of the Pont Marie, was much admired. The slightest accidental effects of the sun, or boats, the merchandise on the banks of the river, the most delicate objects, the small pebbles under the water, and the different degrees of transparency which they imparted to it,—everything was reproduced with incred-

ible exactness. The astonishment was, however, greatly increased when, on applying the microscope, an immense quantity of details, of such extreme fineness that the best sight could not seize them with the naked eye, were discovered, and principally among the foliage of the trees. In the view of the studio, all the folds in the draping, and the effects of light and shade produced by them, were rendered with wonderful truth.[28]

After hearing a report by Arago, the Chamber of Deputies passed the bill on July 9 by a vote of 237 to 3. Daguerre demonstrated his process to the Chamber of Peers on August 2; their vote (92 to 4) was also affirmative. The bill became law when it was signed by King Louis Philippe on August 7.[29] Arago was directed to make public technical details at a joint meeting of the Academy of Sciences and the Academy of Fine Arts in the Palace of the Institute.

An eye witness, Marc Antoine Gaudin, relates that

the Palace of the Institute was stormed by a swarm of the curious at the memorable sitting on August 19, 1839, where the process was at long last divulged. Although I came two hours beforehand, like many others I was barred from the hall. I was on the watch with the crowd for everything that happened outside. At one moment an excited man comes out; he is surrounded, he is questioned, and he answers with a know-it-all air, that bitumen of Judea and lavender oil is the secret. Questions are multiplied, but as he knows nothing more, we are reduced to talking about bitumen of Judea and lavender oil. Soon the crowd surrounds a newcomer, more startled than the last. He tells us with no further comment that it is iodine and mercury. . . . Finally the sitting is over, the secret is divulged . . .

A few days later, opticians' shops were crowded with amateurs panting for daguerreotype apparatus, and everywhere cameras were trained on buildings. Everyone wanted to record the view from his window, and he was lucky who at first trial got a silhouette of roof tops against the sky. He went into ecstasies over chimneys, counted over and over roof tiles and chimney bricks, was astonished to see the very mortar between the bricks— in a word, the technique was so new that even the poorest plate gave him indescribable joy.[30]

Daguerre wrote a seventy-nine page booklet, *Historique et description du procédé du Daguérreotype et du Diorama*, which appeared in more than thirty editions, translations, and summaries:[31] to list their places of publication is to plot the spread of the daguerreotype throughout the world: Amsterdam, Barcelona, Berlin, Boston, Copenhagen, Dublin, Edinburgh, Genoa, Graz, Halle, Hamburg, Karlsruhe, Leipzig, London, Madrid, Naples, New York, Paris, Philadelphia, Posnen, Quedlinburg, Rome, Saint Gall, Saint Petersburg, Stockholm, Stuttgart, Tokyo, Vienna, Warsaw. The book contained Arago's report to the Chamber of Deputies, a record of political action taken by the government, a description of Niépce's heliography, and exact technical details of

HIPPOLYTE BAYARD. *Plaster Casts*. ca. 1839. Direct paper positive. Société Française de Photographie, Paris.

HIPPOLYTE BAYARD. *Self-Portrait as a Drowned Man.* 1840. Direct paper positive. Société Française de Photographie. Paris.

the daguerreotype process. It was illustrated with scale drawings of the camera and processing equipment. The instructions were so complete that anyone could have the apparatus built by an instrument maker and could obtain some sort of success by following Daguerre's directions carefully.

Daguerre had arranged with his brother-in-law, Alphonse Giroux, for the construction of a supply of cameras and accessories. The cameras were beautifully made of wood and fitted with lenses ground by Chevalier, the Parisian optician who had supplied lenses to both Niépce and Daguerre for their early experiments. These were achromatic telescope objectives of 16-inch focal length, working at an aperture we would today designate as $f/16$.* Each camera bore an ornate label on its side, reading (in translation): "The Daguerreotype. No apparatus is guaranteed unless it bears the signature of M. Daguerre and the seal of M. Giroux." The equipment was put on sale in Paris immediately following publication day and soon was exported to other countries.

Talbot was in Birmingham, attending a meeting of the British Association for the Advancement of Science, just after Daguerre's process was disclosed. He had brought a collection of his photogenic drawings, which he put on display. On August 26 he addressed the mem-

*A number obtained by dividing the focal length of a lens by its maximum diameter. All lenses with the same f-number form images of equal brilliance of the same subject. This system of lens marking, which originated in the nineteenth century, was adopted as an international standard at the International Congress of Photography held in Paris in 1900.

bers on the daguerreotype. He stated that he had long since studied the light sensitivity of silver iodide but found it too weak to be of practical use; Daguerre's contribution, he noted, was that a feeble image "can be increased, brought out, and strengthened at a subsequent time, by exposing the plate to the vapours of mercury."[32]

The publication of the photographic processes of Talbot and Daguerre brought forth a host of claimants for priority. Of these, the most convincing came from Brazil and Norway.

Hercules Florence, a Frenchman living in Brazil, claimed that as early as 1832 he made photographs with a camera and by contact printing. His notebooks, written between 1833 and 1837, contain clear descriptions of his technique—and what is even more remarkable—he used the word "photographie" at least two years before Herschel suggested "photography" to Talbot. Contact prints of a diploma and labels for pharmaceutical bottles made by Florence before 1837 exist, though none of his camera work appears to have survived.

Hans Thøger Winther, a Norwegian lawyer, proprietor of a lithographic printing shop and a book publisher, claimed that in 1826 he had the idea of fixing the camera image by the use of light-sensitive materials, and that he succeeded in making direct positives before the disclosure of Daguerre's process. His experiments, however, have not yet been located.

The most luckless pioneer was Hippolyte Bayard, a clerk in the French Ministry of Finance, who exhibited thirty photographs in Paris on July 14, 1839. His method was original: silver chloride paper was held to the light until it turned dark. It was then plunged into potassium iodide solution and exposed in the camera. The light bleached the paper in proportion to its strength, and he thus obtained direct positives, each unique.

In the spectacular publication of the daguerreotype the work of Bayard was completely overlooked. He commented on his misfortune in a photograph dated 1840. He showed himself half naked, propped up against a wall as if dead. On the back of the print he wrote:

The body you see is that of Monsieur Bayard. . . . The Academy, the King, and all who have seen his pictures admired them, just as you do. Admiration brought him prestige, but not a sou. The Government, which gave M. Daguerre so much, said it could do nothing for M. Bayard at all, and the wretch drowned himself.[33]

Happily, Bayard lived on, to make handsome photographs using both Daguerre's and Talbot's techniques. Both methods became fully practical and reigned supreme throughout the world for almost two decades.

ISAAC AUGUSTUS WETHERBY. *Self-Portrait with a Daguerreotype Camera.* ca. 1855. Gelatin-silver print from the original negative. The Library of Congress, Washington, D.C.

3 · THE DAGUERREOTYPE: THE MIRROR WITH A MEMORY

The daguerreotype process at first seemed excessively complicated, and the French government ordered Daguerre to give public demonstrations. What bothered Parisians was the expense: the camera and processing equipment cost 400 francs, the better part of a month's living when compared to Daguerre's annuity of 6000 francs. And they complained that the apparatus was bulky. Soon smaller, less expensive cameras appeared. The plates for these were at first manufactured by silversmiths in sizes that became internationally standard:

Whole plate	6½ x 8½ inches	165 x 216 mm
Half plate	4½ x 5½ inches	114 x 140 mm
Quarter plate	3¼ x 4¼ inches	83 x 108 mm
Sixth plate	2¾ x 3¼ inches	70 x 83 mm
Ninth plate	2 x 2½ inches	51 x 64 mm

Occasionally "mammoth" or "double whole" plates were used; these were seldom of a standard size.

The first daguerreotypes were mainly of architecture, since the exposure times of Daguerre's technique were of such length that people could not be recorded. Within a few days after the August 19 disclosure of the process, the magazine *Le Lithographe* published a lithograph drawn from a daguerreotype of the Cathedral of Notre Dame, Paris. Crude as it is, the print indicates an important use of the new invention—as a substitute for drawing from nature. Copies of daguerreotypes, printed by conventional graphic arts techniques, soon became popular. Between 1840 and 1844, 114 travel views were issued in Paris as the series *Excursions daguerriennes*.[1] Daguerreotypes taken in Europe, the Middle East and America for the publisher N. M. P. Lerebours were painstakingly traced and transferred to copper plates by the aquatint process. Figures and traffic, imaginatively drawn in the romantic style, were added in an attempt to please the public, who deplored the depopulated aspect of the first daguerreotypes.

Among the first to take these daguerreotypes for Lerebours was a Canadian, Pierre Gustave Joly de Lotbinière. As early as October 1839 he was in Greece, where he made several views of the Acropolis in Athens. The aquatint in the *Excursions daguerriennes* made from his daguerreotype of the Propylae is an astounding image,

bathed in light, rich in detail, surprisingly modern in feeling. He went on to Syria and Egypt, where he met another cameraman on assignment by Lerebours: Frédéric Goupil-Fesquet, a Frenchman traveling in the Middle East with the painter Horace Vernet, who wrote the French consul from Cairo, "We are daguerreotyping like lions."[2] Joly de Lotbinière joined them and they sailed together in a dahabeah up the Nile to produce the first photographic documentation of Egypt. Lerebours credited H. L. Pattinson of Newcastle-upon-Tyne with a view of Niagara Falls, perhaps the earliest photograph of that much-photographed landmark; we know nothing of him beyond the meager note accompanying the plate: "This distinguished amateur daguerreotypist is one of the first who busied himself with this art in America." Another cameraman, name unknown, made a beautiful plate of the Kremlin in Moscow under snow. Many of the original daguerreotypes, like the names of their makers, are now lost; they were undoubtedly destroyed by the engravers in tracing them. The aquatints in the *Excursions daguerriennes*, however, retain to a remarkable degree the peculiar clarity and chiaroscuro of photographs. The *Edinburgh Review,* praising the publication in 1843, wrote that the pictures "actually give us the real impression of the different scenes and monuments at a particular instant of time, and under existing lights of the sun and atmosphere."[3]

There were other travelers who recorded what they saw by daguerreotype. The French diplomat Baron Jean Baptiste Louis Gros made photographs in Bogotá, Colombia in 1842 while he was chargé d'affaires there; when sent to Greece as French ambassador he continued to take daguerreotypes. Joseph Philibert Girault de Prangey, an archaeologist, took over a thousand plates of Arabic architecture in the Middle East from 1842 to 1844. On his second trip to explore pre-Columbian ruins in Central America in 1841, John Lloyd Stephens took along a daguerreotype outfit, hoping to use it to supplement the pictorial records that Frederick Catherwood was drawing with the help of the camera lucida; unfortunately he met with little success.

Although daguerreotypes of architecture and faraway

PIERRE GUSTAVE JOLY DE LOTBINIERE. *The Propylaea at Athens.* Aquatint engraving from a daguerreotype taken in 1839, from N. M. P. Lerebours, *Excursions daguerriennes* (Paris: 1841-42).

landmarks were popular, the public was disappointed that the invention did not fulfill the promises implied in the first announcement. "It has excited some surprise," we read in the London *Athenaeum* of October 26, 1839, "that, after the eager and natural curiosity of the public concerning the discovery of M. Daguerre while it yet remained a secret, so little interest should now be taken in the subject." One reason was that, in spite of the apparently generous action of the French government in offering the daguerreotype process "free to everybody (*à tout le monde*)," the inventor applied for and received a patent in England. Another, more important reason, was that the process did not at first satisfy the public's demand for portraits.

Daguerre himself despaired of ever securing portraits by his invention, because of the length of exposure required, which led the satirical journal *Le Charivari* to propose, in its August 30, 1839, edition:

You want to make a portrait of your wife. You fix her head in a temporary iron collar to get the indispensable immobility . . . You point the lens of the camera at her face, and when you take the portrait it doesn't represent your wife; it is her parrot, or watering pot, or worse.

In October Alfred Donné showed the Academy of Sciences a portrait of a woman with her face powdered white. It could hardly have been successful, for in April 1840, Jean Baptiste François Soleil wrote in his instruction manual that "hopes that had been held for obtaining portraits have not yet been realized . . . I know that up to now no portrait has been produced with the eyes open and the attitude and face natural."[4]

Samuel F. B. Morse, the American painter and inventor and one of the earliest to use the daguerreotype process in America, tried to take portraits in New York in the fall of 1839. His wife and daughter sat "from ten to twenty minutes," he recollected, "out of doors, on the roof of a building, in the full sunlight, with the eyes closed."[5] He stated that his associate, John William Draper, was taking portraits "at about the same time." Alexander S. Wolcott and John Johnson claimed to have taken "profile miniatures" in New York in October using a patented camera of their own invention in which a concave mirror was substituted for the lens. The results were at first indeed miniatures, for the plates were but three-eighths of an inch square. A few months later they were taking them 2 x 2½ inches, and opened a studio

28

that the New York *Sun*, in its issue of March 4, 1840 called "the first daguerreotype gallery for portraits." Robert Cornelius, a metal worker, opened a studio in Philadelphia early in 1840. He had become interested in the daguerreotype process upon its introduction to America. He told an interviewer in 1893 that his first portrait was of himself. "You will notice the figure is not in the centre of the plate. The reason for it is, I was alone, and ran in front of the camera . . . and could not know until the picture was taken that I was not in the centre."[6] And in London, Richard Beard imported the Wolcott camera from America and opened a public studio—the first in Europe—in March 1841. It quickly became popular.

To increase the illumination, sunbeams were reflected into these first portrait studios by mirrors. Sitting was an ordeal, for the light, in spite of being intercepted by a rack of bottles filled with blue vitriol, was of blinding brilliance. One victim recollected that he sat

for eight minutes, with the strong sunlight shining on his face and tears trickling down his cheeks while . . . the operator promenaded the room with watch in hand, calling out the time every five seconds, till the fountains of his eyes were dry.[7]

As long as such heroics were demanded, portraitists could not hope for popular support. Radical improvements in technique were needed. Daguerre himself did little to perfect his invention. He again took up the scene painter's brush and painted an illusionary apse for the church at Bry-sur-Marne. He died in that village in 1851.

By the end of 1840 three substantial technical advances had been made. First, an improved lens, which formed an image twenty-two times more brilliant than Daguerre's, was put on the market in 1840 by Peter Friedrich Voigtländer of Vienna.[8] By today's nomenclature it would be rated as $f/3.6$. It was designed by Josef Max Petzval at the suggestion of Andreas von Ettingshausen, professor of mathematics and physics at the University of Vienna, who was in Paris at the announcement of the daguerreotype, learned the process from Daguerre, and introduced it to Austria. The lens at once became popular in Europe and America; in the first ten years of manufacture over eight thousand were sold, and countless imitations were marketed as "German lenses."

Second, the light sensitivity of the plates was increased by recoating the iodized surface with halogens other than iodine. The thought had occurred to many and had been tried by many, but it is clear that the first to publish a practical method was John Frederick Goddard, lecturer on optics and natural philosophy at the Adelaide Gallery, London:[9] after the silvered plate had been fumed with iodine, the operation was repeated with bromine, either alone or in combination with chlorine. The use of such an

BARON JEAN BAPTISTE LOUIS GROS. *Rue de l'Observatoire, Bogotá, Colombia.* 1842. Daguerreotype. Private collection.

Gros noted on the back of the mount: "11 o'clock in the morning. Reversed with parallel mirror. Chlorobromide of iodine. 47 seconds."

ROBERT CORNELIUS. *Self-Portrait.*
1839. Daguerreotype. Private collection, Philadelphia.

accelerator, or in the vernacular of the daguerreotypists *quickstuff,* in combination with the Petzval lens, made it entirely possible to take portraits regularly in less than a minute. George W. Prosch, an American instrument maker and daguerreotypist, noted in 1841 that by using quickstuff he had been able to reduce exposures from four minutes to twenty-five seconds.[10]

Third, the tones of the daguerreotype were enriched by *gilding* the plate, the invention of the Frenchman Hippolyte Louis Fizeau. After the plate had been bathed in hypo it was heated by placing it horizontally over a gentle flame, and a solution of gold chloride was flowed over it, "giving to the light parts of the image more intensity," Fizeau wrote, explaining:

Silver has been dissolved and gold has been precipitated upon the silver, and also upon the mercury, but with very different results. The silver, which by its polish forms the dark parts of the picture, is in some degree browned by the thin coating of gold which covers it, whence results an increased intensity in the black parts; the mercury, on the contrary, which under the form of infinitely small globules, forms the whites, increases in strength and brilliancy, by its amalgamation with the gold, whence results a greater degree of fixity, and a

remarkable augmentation of the image.[11]

This operation had the added advantage that the delicate surface of the daguerreotype—compared by Arago to a butterfly's wing—was rendered less fragile.

As soon as these technical improvements had been made, portrait studios were opened almost everywhere in the western world. Their number can hardly be estimated. Their proprietors came from a wide variety of trades and professions: in two weeks almost anyone could gain sufficient technical proficiency to set up business. And their production was enormous. Statistics are rare, but in America it was officially recorded by the state of Massachusetts that 403,626 daguerreotypes had been taken in the year ending June 1, 1855.[12] A New York gallery boasted of a daily production of three hundred to one thousand portraits.

All kinds of people sat before the camera; thanks to the relative cheapness of production, financial distinctions mattered little. Celebrated men and women as well as less renowned citizens who otherwise would be forgotten have left their features on the silvered plate, which Oliver Wendell Holmes, American physician, man of

Photographer unknown. *Académie.* ca. 1845. Daguerreotype. George Eastman House, Rochester, N.Y.

JEAN BAPTISTE SABATIER-BLOT. *Maria Sabatier-Blot and Her Grandchild.* 1843. Daguerreotype. George Eastman House, Rochester, N.Y.

Photographer unknown. *Mrs. Joseph Elisha Whitman and Her Son.* ca. 1854. Daguerreotype. Society for the Preservation of New England Antiquities, Boston.

letters and amateur photographer, called "the mirror with a memory."[13]

Most sitters were posed against a plain background, usually dark but occasionally light. Painted backgrounds were infrequent. The lighting was diffused, coming from a skylight and sometimes from side windows as well. The three-quarter length portrait was the most popular.

The best daguerreotype portraits are straightforward and penetrating, due partly to the complete absence of retouching which, except for delicate tinting, the fragile surface did not allow. But perhaps of more importance was the apparent handicap of the long exposure time. It was hard work to be daguerreotyped; you had to co-operate with the operator, forcing yourself not only to sit still for about half a minute, but also to assume a natural expression. If you moved the picture was ruined; if you could not put yourself at ease in spite of the discomfort the result was so forced that it was a failure.

The enormous demand for family pictures was due in large part to the sensitivity to mortality so prominent in the nineteenth century, when the death rate, particularly among children, was high. The couplet "Secure the shadow 'ere the substance fade/Let Nature imitate what Nature made" was used as an advertising slogan, and almost every daguerreotypist announced his readiness to take posthumous portraits.

The finished daguerreotypes were protected under glass in velvet-lined cases, at first similar to the leather cases supplied for miniature paintings. The earliest were of plain design, with geometrical or floral decorative motifs on their covers. Less expensive cases were made of papier-mâché, with stamped decoration. In the mid-1850s plastic cases, made of sawdust, shellac, and a brown or black pigment pressed into steel dies, were introduced in America. These "Union Cases" were often highly elaborate bas-reliefs based on such popular paintings as Emmanuel Leutze's *Washington Crossing the Delaware* and lithographs by Currier and Ives. In Europe daguerreotypes were also framed in passe-partout mats of painted glass. Sometimes the signature of the artist was inscribed directly on the plate, or the name of the studio appears inside the case cover, but by far the majority of portraits bear no indication of producer. For the most part daguerreotypes reflect the style of a period, rather than of an individual, and personal attribution becomes impossible in the absence of documentation. Hundreds of daguerreotypists are known by name, and thousands of daguerreotypes exist, but it is only rarely that the documented oeuvre of an individual artist can be studied.

Many of the finest French portraits were made by Jean Baptiste Sabatier-Blot, a miniature painter who became Daguerre's pupil and friend. His portrait of the inventor is one of the best, and his daguerreotypes of his family are beautifully composed, sensitive portraits that show, in pose and detail, his painting experience. "Académies"—nude models—posed and daguerreotyped for

artists were popular, and often of intrinsic beauty. In Germany there was great activity, particularly in Hamburg; the leading portraitists in that city were Carl Ferdinand Stelzner, who opened a studio in 1842, and Hermann Biow, who specialized in large-size daguerreotypes and in portraits of such famous contemporaries as Alexander von Humboldt. There was activity also in Italy. In November 1839 Alessandro Duroni, an optician, took several daguerreotypes of Milan with equipment and materials imported from France; in 1840 Lorenzo Suscipi and John Alexander Ellis took views of Rome. The painter Stefano Stampa, stepson of Alessandro Manzoni, made an unusual portrait of the novelist's wife, seated by a window. In England the leading portraitists were Antoine François Claudet, who learned the process from Daguerre and held a license for using the patent, and Richard Beard. They were followed by John Jabez Edwin Mayall, who came to London from Philadelphia.

Of all countries, America adopted the daguerreotype with the most enthusiasm, and excelled in its practice. In the fall of 1839, François Gouraud, a Frenchman, came to America with daguerreotypes taken by Daguerre and himself that far excelled in quality the work of Morse and Draper and the other American pioneers.

Gouraud exhibited these pictures in New York, Boston, and Providence, gave demonstrations to packed audiences, offered private instruction, and sold apparatus imported from Paris.

Soon Yankee ingenuity brought mechanical improvements. The tedious task of buffing plates to a high polish was done by machinery. John Adams Whipple of Boston installed a steam engine in his gallery to run the buffers, heat the mercury, fan the clients waiting their turn, and revolve a gilded sunburst over the street entrance. More silver was added to the plates by electroplating—a technique introduced to France as "the American process." International recognition quickly came to American daguerreotypists. When Edward Anthony and his partner sent Daguerre some portraits they had made in their New York gallery the inventor replied:

It is with great satisfaction that I express all the pleasure that your daguerreotype portraits have given me. I certify that these pictures, in execution, are among the most perfect I have ever seen.

I am very flattered to see my invention thus propagated by such artists in a foreign country; it brings me much honor.[14]

In 1848 Charles R. Meade visited Daguerre and made seven portraits of the inventor. And at the Great Exhibi-

HERMANN BIOW. *Alexander von Humboldt.* 1847. Daguerreotype. Museum für Kunst und Gewerbe, Hamburg.

JOHN WERGE. *John Frederick Goddard, British Photographer.* ca. 1850. Albumen print by Werge from a copy negative of his own daguerreotype. Collection Beaumont Newhall, Santa Fe.

STEFANO STAMPA. *Teresa Borri, The Second Wife of Alessandro Manzoni, Italian Novelist.* 1852. Daguerreotype. Centro Nazionale di Studi Manzoniani, Milan.

tion of the Works of Industry, held in the Crystal Palace in London in 1851, Americans won three of the five medals awarded for daguerreotypes. Horace Greeley, editor of the New York *Tribune*, wrote from London: "In Daguerreotypes it seems to be conceded that we beat the world, where excellence and cheapness is both considered—at all events, England is no where in comparison—and our Daguerreotypists have a great show here."[15] John Edwin Mayall produced a series of mammoth plates (10½ x 13½ inches) of the Crystal Palace and the exhibition, thirty-one of which were published in Tallis's *History and Description of the Crystal Palace and the Exhibition of the World's Industry*, together with forty-two plates from daguerreotypes by Beard and forty unsigned. The publisher, John Tallis & Co., noted: "In order that the engravings should be faithful transcripts from the actual objects they profess to delineate, the proprietors have been at the expense of having all these objects taken on the spot by the Daguerreotype. . . ."

By 1853 there were eighty-six galleries in New York City alone; of these the largest were those of Mathew B. Brady, Martin M. Lawrence, and Jeremiah Gurney. Brady, a manufacturer of leather cases for jewelry, instruments, and miniatures opened a gallery on Broadway in 1844. He began to collect a *Gallery of Illustrious Americans;* twelve of the portraits were published as lithographs by François d'Avignon in 1850.[16] It must not be assumed that all of the portraits in the collection were by Brady himself. For years he had three galleries— two in New York and one in Washington—and employed many "operators," as cameramen were called. He also constantly acquired by purchase or exchange portraits made in other galleries. The credit "From a Daguerreotype by Brady," which appeared time and again beneath wood engravings in the illustrated magazines of the fifties and as frontispieces of biographies, was the trademark of a firm, not the signature of an artist.

In Boston Albert Sands Southworth[17] and Josiah Johnson Hawes, both pupils of Gouraud, produced portraits far removed from the conventional stiff poses so favored by the majority of their colleagues. When Chief Justice Lemuel Shaw of the Massachusetts Supreme Court came to their gallery he happened to stand in a beam of sunlight that brought out his rugged features with uncompromising force; the daguerreotypists took him as he stood. Southworth and Hawes posed Lola Montez lolling against a pedestal, a cigarette in her gloved hand. They took their camera to the operating room of the Massachusetts General Hospital in Boston to record a reenactment of the first use of ether as an anesthetic. They even took a schoolroom full of girls. In an 1852 advertisement they boasted:

ANTOINE CLAUDET. *Family Group*. ca. 1852. One-half of a stereoscopic daguerreotype. George Eastman House, Rochester, N.Y.

"Mr. Claudet's portraits recommend themselves by the instaneity of the process, by which only faithful and pleasing likenesses can be produced, by his method of durably fixing the image, which also prevents fading or changing of color, and by the introduction of beautiful backgrounds, producing the most picturesque effect."—*Journal of Commerce* (London), March 25, 1842.

CHARLES RICHARD MEADE. *Louis Jacques Mandé Daguerre*. 1848. Daguerreo-
type. Museum of American History, Smithsonian Institution, Washing-
ton, D.C.

ALBERT SANDS SOUTHWORTH & JOSIAH JOHNSON HAWES. *Lemuel Shaw, Chief Justice of the Massachusetts Supreme Court.* 1851. Daguerreotype. The Metropolitan Museum of Art, New York.

JOHN EDWIN MAYALL. *The Crystal Palace, London, During the Great Exhibition of the Works of Industry of All Nations.*
1851. Daguerreotype. Collection Arnold H. Crane, Chicago.

CHARLES FONTAYNE & WILLIAM SOUTHGATE PORTER. *Cincinnati.* 1848. Daguerreotype. Public Library of Cincinnati and Hamilton County, Cincinnati.

One of the partners is a practical Artist, and as we never employ *Operators,* customers receive our personal attention. . . . We will reserve and claim by right the name of our establishment, "The Artists' Daguerreotype Rooms." As no cheap work is done, we shall spend no time in bantering about prices; and we wish to have all understand that ours is a one price concern. . . .[18]

Their prices varied according to size: in 1850 they billed a customer $33.00 for a "large" daguerreotype, $8.00 for a "¼ size" and $2.50 each for three "small" daguerreotypes.[19] Most galleries charged $2.00 for a sixth plate. Soon competition forced prices lower and lower: the public was offered daguerreotypes at 50 cents, at 25 cents, and even at 12½ cents—made "two at a pop" with a double-lens camera. In picture factories division of labor was said to have speeded up the work to a production of 300, 500 and even 1,000 daily. The sitter bought a ticket and was posed by an operator who never left the camera. A plate, already prepared by the polisher and the coater, was brought to him and he passed it on after exposure in its protective shield to the mercurializer who developed it, to the gilder who enriched it, and to the artist who tinted it: fifteen minutes later the customer exchanged his ticket for the finished likeness. Such hastily made portraits were seldom satisfactory; many were left behind by disappointed customers; but prospects streamed up the stairs to the skylight and the cash rolled in.

Although by far the majority of daguerreotypes are portraits, views of architecture, panoramas of cities, and even news events were taken on the silver plate. Charles Fontayne and William Southgate Porter photographed three miles of the Cincinnati riverfront on eight whole plates in 1848. The daguerreotypes were framed end to end to form a richly detailed panorama over five feet long. San Francisco was a favorite subject; of the several panoramas made of the city the most spectacular was taken on five plates by William Shew, who went to California from Boston in 1850. He sent around Cape Horn a studio-on-wheels that he called his Daguerreotype Saloon; he photographed it in Portsmouth Square in San Francisco just after the great fire of 1851. Among the earliest news photographs in existence are a series of daguerreotypes of burning mills in Oswego, New York by George N. Barnard in 1853.

Despite its popularity, the daguerreotype was doomed. It did not lend itself to ready duplication. It was fragile and had to be kept under glass in a bulky case, or framed. And it was expensive. At the 1856 annual exhibition of the Photographic Society of London, 606 images were on display. Of these only three were daguerreotypes.[20] In America the process survived longer, but by 1864 the profession "daguerreotypist" no longer appeared in the business directories of San Francisco.

FREDERICK COOMBS. *Montgomery Street, San Francisco,* 1850. Daguerreotype. George Eastman House, Rochester, N.Y.

GEORGE N. BARNARD. *Burning Mills, Oswego, N.Y.* 1853. Daguerreotype. George Eastman House, Rochester, N.Y.

The following advertisement appeared in the *Oswego Daily Times* from July 12 to August 1, 1853:

"Daguerreotype Pictures of the late fire taken while burning may be obtained at Barnard's Daguerrean Rooms. These pictures are copied from large pictures, and are faithful representations of the different stages of the fire as it appeared on the 5th. Also views of the Ruins as they now appear."—Geo. N. Barnard

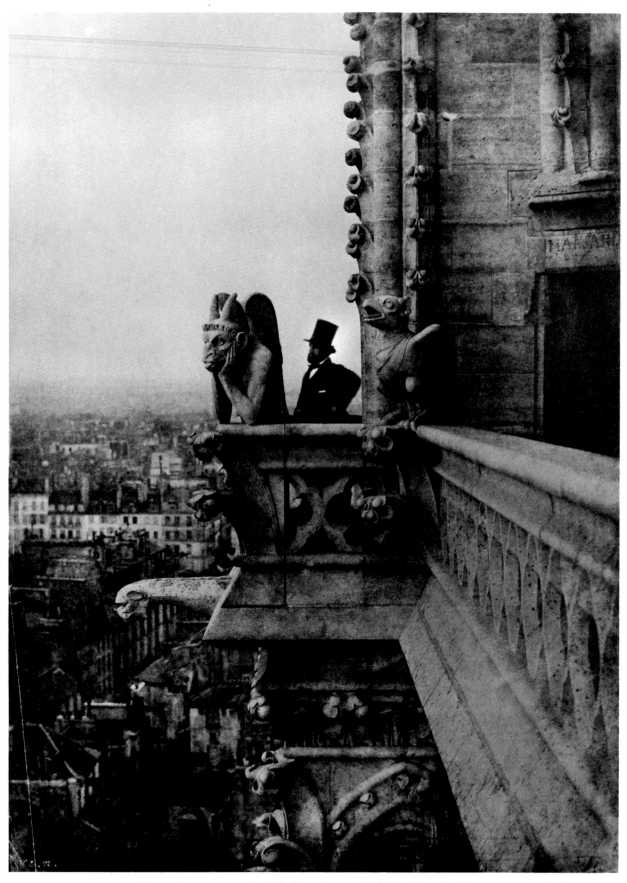

CHARLES NEGRE. *Henri Le Secq at Notre Dame Cathedral, Paris.* 1851. Gelatin-silver print from the original calotype negative. Collection André Jammes, Paris.

4 • THE CALOTYPE: THE PENCIL OF NATURE

In 1841 William Henry Fox Talbot announced an improvement of his photogenic drawing process, which he named *calotype* (from the Greek, meaning "beautiful picture").[1] Previously he had allowed his sensitized paper to remain exposed to light until an image became visible. He now made a remarkable discovery: a much shorter exposure so changed the characteristics of the silver salts that they could be reduced to silver by chemical after-treatment. This principle of the *development* of the *latent image* is basic to most subsequent photographic processes. A relatively weak light signal is amplified enormously by development. Only a few atoms are reduced to silver by direct light action, but tens of thousands are reduced by development.

To make a calotype negative, Talbot bathed a sheet of paper in two solutions, one of silver nitrate, the other of potassium iodide. The relatively stable silver iodide thus formed became, he found, highly light sensitive when he washed the paper with a mixture of gallic acid and silver nitrate, a solution he named "gallo-nitrate of silver." After exposure the paper was bathed again in this solution, which acted as a physical developer and gradually brought out the image. To fix these negatives Talbot at first used potassium bromide and later a hot solution of hypo. He printed them with his original silver chloride paper.

Talbot secured Her Majesty's Royal Letters Patent No. 8842, dated February 8, 1841, for this invention. This action, so out of keeping with the open and unrestricted publication of his original process, was perhaps suggested to Talbot by the example of Daguerre in taking out a patent for his process in England. Talbot had received no recompense and but little recognition for his work; Daguerre, on the other hand, was receiving an annuity and also income from the sale of licenses in England, and had won international fame. Talbot saw others making a commercial success with photography and felt entitled to extract royalties from those using his improved technique.

On his frequent travels in Europe and in Britain Talbot photographed extensively, sometimes producing as many as twenty views a day. He sent the negatives back to Lacock Abbey, where they were printed by his wife, Constance, and by Nicolaas Henneman, a member of the domestic staff trained by Talbot as his assistant in his photographic work. To judge from the letters of Talbot, his wife, and his mother, the production was voluminous. In the fall of 1843 Talbot set up a photofinishing laboratory in Reading, The Talbotype Establishment, and put Henneman in charge. Each negative was locked in a frame with the sensitized silver chloride printing-out paper in contact with it and exposed to sunlight for periods ranging from a few minutes to an hour or more, until an image appeared. The print was then fixed, washed, and dried. The rate of production increased to such a degree that it became possible to make original prints by the thousand to illustrate Talbot's *The Pencil of Nature*, a book published in six installments by Longman, Brown, Green, & Longmans of London between June 1844 and April 1846. It was a collection of twenty-four calotypes with a historical introduction putting on record, Talbot wrote, "some of the early beginnings of a new art, before the period, which we trust is approaching, of its being brought to maturity by the aid of British talent." The plates were mostly of architecture, still-life arrangements, or works of art. Accompanying each was a page or two of text explaining the significance of the picture and occasionally offering predictions not realized for decades.

The most interesting of the calotypes are casual views of Lacock Abbey: the barn, with a ladder against it; a haystack; or *The Open Door*, revealing a dark interior, with a broom leaning against the jamb—perhaps the picture that Talbot's mother referred to as "the soliloquy of the broom."[2] Talbot wrote opposite this plate:

We have sufficient authority in the Dutch school of art for taking as subjects of representation scenes of daily and familiar occurrence. A painter's eye will often be arrested where ordinary people see nothing remarkable. A casual gleam of sunshine, or a shadow thrown across his path, a time-withered oak, or a moss-covered stone may awaken a train of thoughts and feelings, and picturesque imaginings.

Above: WILLIAM HENRY FOX TALBOT. *The Nelson Column, Trafalgar Square, London, under Construction.* ca. 1843. Salted paper print from a calotype negative. The Museum of Modern Art, New York.

Opposite top: WILLIAM HENRY FOX TALBOT. *The Open Door.* 1843. Salted paper print from a calotype negative. Plate VI of *The Pencil of Nature* (London: 1844-46). The Fox Talbot Museum, Lacock, England.

Opposite bottom: WILLIAM HENRY FOX TALBOT. *The Haystack.* 1843. Salted paper print from a calotype negative. Plate X of *The Pencil of Nature* (London: 1844-46). The Fox Talbot Museum, Lacock, England.

Eleven years after his unsuccessful attempts to sketch Lake Como, Talbot could write:

There is, assuredly, a royal road to *Drawing,* and one of these days, when more known and better explored, it will probably be much frequented. Already sundry *amateurs* have laid down the pencil and armed themselves with chemical solutions and with *camera obscurae.* These amateurs especially, and they are not a few, who find the rules of *perspective* difficult to learn and to apply—and who moreover, have the misfortune to be lazy—prefer to use a method which dispenses with all trouble.[3]

Talbot explained the simplicity of his process to Sir Charles Fellows, the English archaeologist who discovered the ruins of Xanthus, the ancient capital of Lycia: "The paper may be prepared in the evening by candlelight for use the following day.... Suppose that in travelling, you arrive at some ruins unexpectedly, which you wish to have drawn. You set up the Camera, open the portfolio, and take out a sheet of paper ready prepared, slip it into the instrument, and take it out again when you think that a sufficient time has elapsed, and in ten minutes all is packed up again and you are proceeding on your

45

WILLIAM HENRY FOX TALBOT. *Portrait of Antoine Claudet.* ca. 1845. Gelatin-silver print from a calotype negative. Collection Harold White, Filby, England.

DAVID OCTAVIUS HILL & ROBERT ADAMSON. *Colonel James Glencairn Burns.* ca. 1845. Gelatin-silver print from the original calotype negative. Collection Beaumont Newhall, Santa Fe.

journey."[4] Processing, Talbot continued, could be deferred until evening.

The first artistic success with the calotype process was that of David Octavius Hill and Robert Adamson. Hill was a well-known painter in Edinburgh, and Secretary of the Scottish Academy of Painting. In 1843 he set himself a colossal task: to paint a group portrait of 457 men and women present at the convention in Edinburgh when the Free Church of Scotland was founded. At the suggestion of his friend Sir David Brewster, who had learned the process from Talbot, he turned to photography as an aid in securing likenesses of the many delegates and obtained the services of Robert Adamson, who had recently opened a professional studio in Edinburgh. They collaborated until 1848, when Adamson died at the age of twenty-seven. The partners did not limit their work to making memoranda for Hill's painting. All kinds of sitters found their way to the outdoor studio on Calton Hill, or were photographed among the baroque monuments of the Greyfriars' Cemetery. Some of their finest calotypes are informal portraits of the fisherfolk of nearby Newhaven. It is estimated that they took more than fifteen hundred negatives during their short partnership. Calotypes from them were widely ex-

DAVID OCTAVIUS HILL & ROBERT ADAMSON. *Lady Ruthven.* ca. 1845. Salted paper print from a calotype negative. The Museum of Modern Art, New York.

DAVID OCTAVIUS HILL & ROBERT ADAMSON. *The McCandlish Children.* ca. 1845. Salted paper print from a calotype nega-
tive. The Museum of Modern Art, New York.

DAVID OCTAVIUS HILL & ROBERT ADAMSON. *Fishwives, Newhaven.* 1845. Salted paper print from a calotype negative. The Museum of Modern Art, New York.

hibited and sold by art dealers as single prints and mounted in albums.

Hill and Adamson posed their sitters outdoors, usually singly. The strong shadows cast by the direct sunlight were softened by reflecting light into them with a concave mirror; the exposures were often minutes long. They saw their subjects broadly, and composed in simple masses of light and shade, for they had an intuitive respect for the medium. In 1848 Hill wrote:

The rough surface, and unequal texture throughout of the paper is the main cause of the Calotype failing in details, before the process of Daguerreotypy—and this is the very life of it. They look like the imperfect work of a man—and not the much diminished perfect work of God.[5]

It is not surprising that the influence of painting is strong in the photographs of these Scottish pioneers. Hugh Miller, the geologist, had compared their portraits with Raeburn's, and some of their genre studies of ladies clothed in glistening gowns of rich silk remind one of seventeenth-century Dutch paintings. But we remember the calotypes of Hill and Adamson for their dignity, their depth of perception, and the expression of the in-

dividual character of the sitter. The part played by Adamson appears to have been far more than technician, for after his death Hill ceased to make photographs until he again found a collaborator, and these later pictures do not compare with the work he did with Adamson. Hill's paintings have long been forgotten; he did not complete the great canvas that had led him into photography until 1866, four years before his death.

The chief use of the calotype, however, was not for portraiture, but for recording architecture and landscapes. There was much activity in this field by British amateurs: Thomas Keith, famous as a surgeon, made a number of excellent calotypes of Edinburgh; C. S. S. Dickins recorded country estates; John Shaw Smith of Dublin, traveling in the Mediterranean area from 1850 to 1852, came back with several hundred paper negatives.

Although Talbot had taken out a French patent, he does not appear to have enforced it, and the calotype was widely used in France, especially for the documentation of architecture under the auspices of the government.

Frenchmen made two important technical improvements on Talbot's basic calotype process. The first was

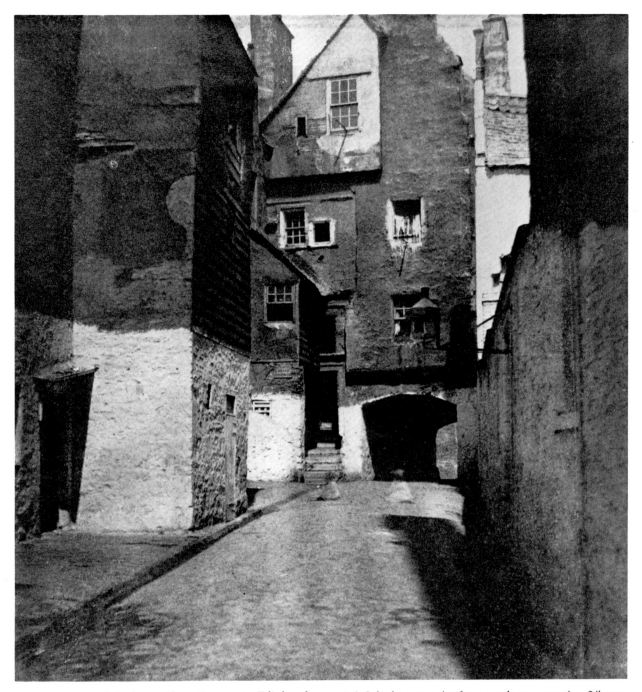

THOMAS KEITH. *Bakerhouse Close, Canongate, Edinburgh.* ca. 1854. Salted paper print from a calotype negative. Library of the City of Edinburgh.

waxing the paper for negatives *before* applying to it the sensitizing solutions. The technique was described by Gustave Le Gray, a painter turned photographer, in a note published in the *Cômpte-rendu* of the French Academy of Sciences for 1851.[6] A metal plate somewhat larger than the paper was held level by a support over a spirit lamp. A lump of wax was passed over the heated plate until it was evenly coated and then the paper was firmly pressed against the plate. It was dried between two sheets of blotting paper and sensitized by dipping it into successive baths of potassium iodide and silver nitrate. After exposure the image was brought out by development in gallic acid. Le Gray noted that errors in exposure could be compensated for in development: a twenty-second exposure required "a stay of a day and a night in the gallic acid," while a fifteen-minute exposure of the same view "was completely out in an hour."[7]

The second improvement to the calotype process made possible the mass-production of prints for publication in books and albums in quantity exceeding the output of the Talbotype Establishment in Reading. Louis Désiré Blanquart-Evrard of Lille devised a developing-out paper that reduced the printing times to six seconds in sunlight and thirty to forty seconds in the shade. This meant that over four thousand prints could be made in one day. Unlike the "rich, velvety, 'mulberry tints' " that Talbot sought, Blanquart-Evrard's prints were slate-gray when removed from the strong solution of sodium thiosulfate he used for a fixing bath.

In the summer of 1851 his "Photographic Printing House" published the first number of the *Album photographique*; a portfolio of single prints of architectural and landscape subjects in the style of romantic lithographs, handsomely mounted on fine paper with engraved captions in gold ink. Thomas Sutton, editor of *Photographic Notes*, wrote in 1857:

. . . the proofs are permanent, they have not faded. They are also beautifully artistic: vigorous, without being glazed, and superb in color, particularly in the lights. A vast number of copies of this *Album* were sold, and it became necessary for him in 1852 to enlarge his printing establishment. A huge building, resembling a manufactory, was then erected in the grounds of a chateau, belonging to a friend, situated three miles from Lille. Blanquart-Evrard being a man of fortune, handed over the concern to his friend, who had been connected with chemical and dyeing operations, and who speedily mastered the details of Photographic Printing. A staff of thirty or forty assistants, mostly girls, were then instructed, each in a particular branch of the process, and operations commenced on a large scale.[8]

The chef-d'oeuvre of Blanquart-Evrard's publications was *Egypte, Nubie, Palestine et Syrie* (Paris: Gide et J. Baudry, 1852), a volume containing 122 prints from negatives taken by Maxime Du Camp, a man of letters, on a voyage to the Middle East with the novelist Gustave Flaubert from 1849 to 1852. Strictly an amateur, Du Camp took up photography because, he noted in his *Recollections of a Literary Life,* "I had realized upon my previous travels that I wasted much valuable time trying to draw buildings and scenery I did not care to forget. I drew slowly and not very correctly. . . . I felt that I needed an instrument of precision to record my impressions if I was to reproduce them accurately. . . ."[9] So he turned to Gustave Le Gray for instruction, who prepared for him a supply of waxed paper, ready for sensitizing. But when Du Camp arrived in Egypt he found to his dismay that the negatives were hopelessly bad, due, he thought, to the high temperature of the land. By chance he met in Cairo another expeditionary photographer, by the name of Lagrange, who was on his way to India. He advised Du Camp to bathe the prepared paper in a second bath of albumen and potassium iodide and use it while still moistened with the sensitizing solution. The technique was successful but, Du Camp complained, "tedious and lengthy, needing great manual dexterity and more than forty minutes spent upon a negative to obtain a complete picture. The sitter or object had to be posed for at least two minutes, whatever the strength of the chemicals, and however powerful the camera, and given the most favorable conditions of life." Among the finest of the plates are the first photographs ever taken of the rockcut temple of Ramses II at Abu Simbel. The colossal statues were then so buried that Du Camp ordered the sailors of the dahabeha that had carried them 500 miles up the Nile to dig away the sands of the desert so he could photograph them.

In 1854 John B. Greene, an American archaeologist and photographer whose career was cut short by his death in 1856 at the age of twenty-four, made a series of calotypes of the ancient Egyptian monuments amid the landscape of the banks of the Nile, remarkable for their sense of the desert environment. A selection of his photographs were published in 1854 by Blanquart-Evrard in the album *Le Nil: Monuments, Paysages, Explorations photographiques* (1854). The firm also published an album of views of ancient buildings of Jerusalem, taken by Auguste Salzmann to support the French archaeologist F. de Saulcy's theory of dating monuments by their physical fabric. Consequently the calotypes of Salzmann emphasized the very texture of mortar and stone.

Blanquart-Evrard also published single plates by Henri Le Secq who, like most French calotypists, was a former painter. He was now official photographer to the Historical Monuments Commission of the French Ministry of the interior. Of his photographs of the sculptured portal

MAXIME DU CAMP. *The Colossus of Abu-Simbel, Nubia.* 1850. Salted paper print by L. D. Blanquart-Evrard from a calotype negative. Plate 107 of the album *Egypte, Nubie, Palestine et Syrie* (Paris: 1852). George Eastman House, Rochester, N.Y.

CHARLES MARVILLE. *Le Porte Rouge, Notre Dame de Paris.* Salted paper print by L.-D. Blanquart-Evrard from a calotype negative. Plate 46 of the album *Mélanges photographiques* (Paris: 1851). George Eastman House, Rochester, N.Y.

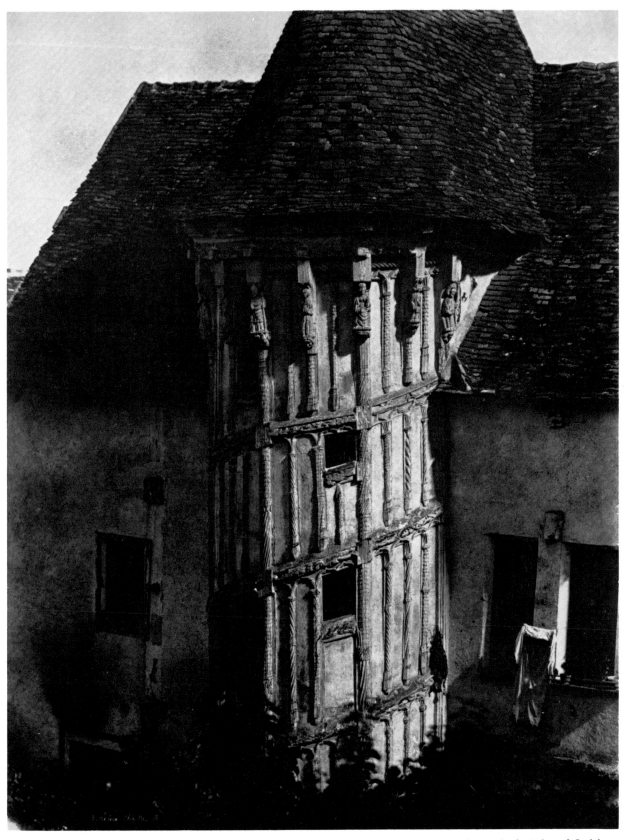

HENRI LE SECQ. *Stair Tower, Rue de la Petite Boucherie, Chartres, France.* 1852. Gelatin-silver print by Edward Steichen from a calotype negative formerly in the collection of Victor Barthélemy, Paris. The Museum of Modern Art, New York.

JOHN BULKLEY GREENE. *Thebes, Egypt.* 1854. Salted paper print from a calotype negative. Gilman Paper Company Collection, New York.

of Rheims Cathedral, one critic went so far as to write that the tympanum could be studied better in the print than on the spot, where the eye is overwhelmed by the great scale and wealth of detail.

Charles Marville, who was a book illustrator before taking up photography, gave a romantic touch to his photograph of the Porte Rouge of Notre Dame de Paris by introducing a figure, not only to give scale, but to add the sense of nostalgia.

Charles Nègre photographed his friend Le Secq standing on one of the towers of the same cathedral beside the gargoyle added by Viollet-le-Duc in the restoration of the building. Nègre used unusually large negatives: some of his views of the Cathedral of Chartres measure 29 x 21 inches. He also made fine landscapes in the south of France, near his birthplace at Grasse. Hippolyte Bayard, following his disappointing attempt at promoting his direct positive system in Paris, adopted the calotype process with marked success.

The calotype was never popular in the United States. The best work done with paper negatives was by a Frenchman, Victor Prevost, who came to New York as a colorist for Jeremiah Gurney. Prevost's calotypes of New York, made in 1854, are among the earliest surviving photographs of the city.

An attempt was made to market licenses for the use of Talbot's American patent by Frederick and William Langenheim, pioneer daguerreotypists of Philadelphia. William visited Talbot at Lacock Abbey in 1849 and paid him £1000 for the exclusive American rights. He and his brother pointed out in a broadside addressed to daguerreotypists that paper portraits and views were "devoid of all metallic glare," and could be multiplied "to an unlimited extent with very little expense and labor." Their appeal met with little response. They failed, partly because their results could not be compared with the brilliant and precisely defined daguerreotypes that delighted the American public, and partly because American photographers rebelled at paying a license fee to anybody.

In England, Talbot's insistence on controlling his patent became an almost unsupportable burden to photographers. He vigilantly protected his rights and aggressively prosecuted any person making calotypes who had

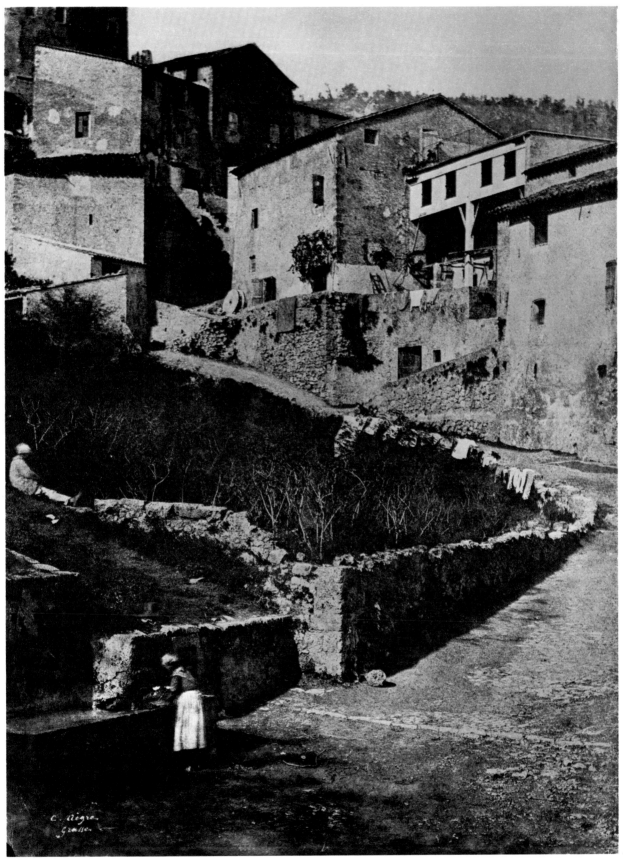

CHARLES NEGRE. *Oil Presses at Grasse, France.* 1852. Gelatin-silver print from a calotype negative. Collection André Jammes, Paris.

CHARLES NEGRE. *Self-Portrait*. ca. 1850. Gelatin-silver print from a calotype negative in the collection of Charles Nègre, Aîné, Grasse, France.

considered identical to his "gallo-nitrate of silver" solution. He sued William Henry Sylvester, who operated a London studio under the name "Martin Laroche," for working the new collodion process without a calotype license, and took him to court in 1854.[10]

Colleagues sprang to Laroche's support. The defense attempted to show that Talbot was not entitled to the patent he held and, secondly, even if he was, the collodion process was so dissimilar to and distinct from the calotype that no infringement could be claimed. To support the first argument, evidence was submitted that Talbot had been preceded in the invention of a photographic process involving the use of gallic acid by The Reverend Joseph Bancroft Reade—a claim that only recently has been proved false. The intricacies of photochemistry perplexed the judge, who said to the jury, "It is already sufficiently difficult to understand the subject, particularly as I know nothing about it . . . I am sorry to say the case kept me awake all last night." He was able, however, to reduce the second charge to a technicality which he summed up for the jury:

Is pyrogallic acid, though it may differ in its shape, in its action with reagents, in its composition, is it or is it not a chemical equivalent with gallo-nitrate of silver? If it is, the defendant is guilty; if it is not, he is not guilty.[11]

After an hour's deliberation the jury brought in a double verdict. They found the defendant not guilty. They also found that Talbot was the first and true inventor of the calotype process "within the meaning of the Patent Laws: that is the first person who disclosed it to the public."

Talbot wrote his wife: "The jury understood little of the subject, but trusted to the judge, and the judge fell into awful mistakes. . . . It is impossible we can rest content. . . ."[12] But Talbot did not press the matter further. He turned his attention to perfecting a process for the photomechanical reproduction of pictures that he had patented in 1852 (see Chapter 14). When he died in 1877 he was translating from the Assyrian, and the best obituary of the inventor of the negative-positive system of photography appeared not in a photography journal, but in the *Transactions* of the Society for Biblical Archaeology.

not paid him a fee, which cost from £100 to £150 a year. Photographers, both amateur and professional alike, felt hampered, and the presidents of the Royal Academy and of the Royal Society jointly appealed to Talbot to relax his grip. In a letter published in the London *Times*, August 13, 1852, he relinquished all control of his invention except its use for taking portraits for profit.

By then a new process had been made public for producing negatives on glass coated with light-sensitive collodion. It was not patented, and professional portraitists thought that they were at last freed from having to pay for the right to photograph. But Talbot felt that the new collodion process itself was an infringement for, like the calotype, it was a negative-positive system, and although the negative support was glass instead of paper, the image was developed in pyrogallic acid, which he

HIPPOLYTE BAYARD. *The Madeleine, Paris.* ca. 1845. Gelatin-silver print from a calotype negative in the Société Française de Photographie, Paris.

Photographer unknown. *Fredericks' Photographic Temple of Art.* ca. 1857. Salted paper print. Collection André Jammes, Paris.

Charles DeForest Fredericks opened his Photographic Temple of Art at 585 Broadway, New York, in 1856. This photograph was probably taken by an assistant.

Polishing the plate.

Coating the plate.

Sensitizing the plate.

Developing the plate.

Albumen paper, so-called because it was prepared with egg white, became the most commonly used printing material. It was the invention of Blanquart-Evrard, proprietor of the calotype printing works in Lille, in 1850. He coated paper with egg white in which was dissolved potassium bromide and acetic acid. When dry, the coated paper was floated on the surface of a solution of silver nitrate in a tray, then again dried. The sensitized paper was put in contact with the negative in a glazed frame and exposed to sunlight for several minutes, sometimes even hours, until an image appeared. The print was then toned to a rich brown in gold chloride, fixed in hypo, thoroughly washed, and dried. To give the surface a brilliant gloss, the print was commonly squeezed between a metal plate and a heated cylinder in a burnisher.

Coated paper, ready for sensitizing by the photographer, was sold by manufacturers. The number of eggs used was enormous; girls in factories did nothing all day but separate the whites from the yolks, which were used in the preparation of patent leather. It was stated that the Dresden Albumenizing Company, the largest in the world, used 60,000 eggs a day.

A serious disadvantage of salted paper and albumen prints was their instability. Improper fixing, inadequate washing out of residual chemicals, contamination by acids and sulfur compounds in mounting boards and the adhesives used to attach silver prints to them all too frequently caused the images to fade. In the 1850s the potential evanescence of photographs caused alarm and concern. Surely, it was argued, some way could be discovered to assure permanence to the camera record. In 1856 Honoré d'Albert, Duc de Luynes, a French archaeologist and wealthy patron of the arts, put up 10,000 francs, to be awarded by the Société Française de Photographie, in the form of two prizes—one of 2000 francs for a permanent photographic printing process, and one of 8000 francs for a photomechanical technique that would enable photographs to be reproduced by printers' ink. After a long delay, when the entries of a score or more of experimenters were studied, both prizes were awarded to Adolphe Louis Poitevin. His *carbon prints* directly fulfilled the conditions of the Duc de Luynes contest, for the announcement in the Society's *Bulletin* of the "petit prix" stated that

of all the elements . . . carbon is the most permanent. . . . If we could therefore make it possible to reproduce photographic images in carbon, we should have a basis for their permanency, as we now have in our books, and that is as much as we may hope for and wish.[4]

Poitevin's second process, which won him the "grand prix" was the photolithographic technique known today as *collotype*, which will be described later (Chapter 14).

5 · PORTRAITS FOR THE MILLION

A new era opened in the technology of photography in 1851, with the invention by Frederick Scott Archer, an English sculptor, of a method of sensitizing glass plates with silver salts by the use of *collodion*. Within a decade it completely replaced both the daguerreotype and calotype processes, and reigned supreme in the photographic world until 1880.[1]

The imperfection of the calotype negative because of the fibrous texture of paper had early suggested the use of glass as an alternative support for the light-sensitive material. To attach the silver salts to glass various substances had been tried, even the gluey slime exuded by snails, until partial success came with the use of egg white. These albumen plates—invented in 1847 by Claude Félix Abel Niepce de St. Victor, a cousin of Niépce—gave excellent negatives, of a brilliance and fineness of detail approaching that of the daguerreotype. They could be prepared in advance; Felice Beato, a naturalized Englishman, photographed the Indian Mutiny in 1857 with plates coated in Athens and exposed months later. The chief drawback of albumen plates was their low sensitivity. Beato at first gave exposures of three hours for well-lighted subjects with a 36-inch lens stopped to the equivalent of $f/72$. He was able to reduce that time to four seconds by developing the plates in a saturated solution of gallic acid for several hours, a technique he did not disclose until 1886, long after the process was obsolete. Although albumen plates never became universally popular, remarkable architectural photographs were made with them, such as the series of fine views of Paris taken on glass plates by Henri Plaut and Renard in 1852 and printed by H. Fontenoy at his Paris "Imprimerie Photographique."

Collodion is a viscous solution of nitrocellulose in alcohol and ether. It quickly dries to form a tough, waterproof film; it was first used medically, for protecting minor lesions of the skin. Archer added potassium iodide to collodion and coated a glass plate with it. Then, in subdued light, he dipped the plate in a solution of silver nitrate. The silver ions combined with the iodine ions to form light-sensitive silver iodide within the collodion. He exposed the plate, while wet, in the camera. It was then developed in pyrogallic acid, fixed in hypo, washed, and dried. All these operations had to be done rapidly, before the collodion dried and became impervious to the processing solutions.[2] Thus the photographer could not be too far from a darkroom. In the field he had to bring along some kind of darkroom—usually a wagon or a tent, chemicals and processing equipment—the camera, plate holders, as well as the essential tripod, for the exposure times were too long to permit the camera to be hand-held. In his *Photographic Manual* of 1863, N. G. Burgess writes:

The time of exposure in the camera is entirely a matter of judgment and experience. No definite rules can be laid down, but usually in a strong light from fifteen seconds to one minute will answer.[3]

Coincidental with the collodion plate—or *wet plate* as it came to be called—came other technical innovations in lens design and printmaking processes.

The first lens designed specifically for photographic purposes was Petzval's 1840 portrait lens. The images formed by this lens showed great loss of definition at the corners of the plate—a fault more theoretical than practical in portraiture, where edges mattered little. For outside work, however, particularly in photographing architecture, a lens with a flat field was desirable; and one free of spherical aberration, which caused straight lines to be imaged as slightly curved, was essential. In 1866 two opticians, Hugo Adolph Steinheil of Munich and John Henry Dallmeyer of London, independently and simultaneously designed almost identical lenses composed of two symmetrical cemented elements mounted facing one another with a central stop: spherical aberration was corrected to a marked degree and astigmatism somewhat. Both had a field of view of about 25°, and a working aperture of $f/6$ to $f/8$. Steinheil named his lens the Aplanat, and Dallmeyer chose Rapid Rectilinear, a name that became generic when the design was almost at once universally adopted and became the most widely used photographic lens until it was replaced by the anastigmat in 1893.

HENRI PLAUT. *View of the Apse of the Cathedral of Notre-Dame de Paris.* 1852. Salted paper print by H. de Fonteny from an albumen negative; Plate 9 of *Paris Photographié* (Paris: 1853). The Museum of Modern Art, New York.

Both processes relied upon the property of potassium bichromate to alter the solubility in water of such colloids as gum arabic, albumen, and gelatin upon exposure to light, a phenomenon that had long been known.

In the carbon process, particles of carbon were mixed with gelatin and potassium bichromate. Paper was coated with this emulsion and dried. On exposure beneath a negative the bichromated gelatin was rendered insoluble in proportion to the light received. The unexposed emulsion was then washed away, leaving only the pigment suspended in gelatin. All chemicals were washed out, and thus the prints were permanent. The rendering of the half tones, however, was not satisfactory, and, since exposure had to be made through the *back* of the paper, the images were not critically sharp. These deficiencies were corrected by Sir Joseph Wilson Swan of Newcastle-upon-Tyne, England, who patented a carbon transfer process in 1864 that immediately became popular. The photographer now could purchase *carbon tissue*. This was

a sheet of thin paper coated with gelatin containing carbon particles or some other pigment. It was sensitized before use by immersion in a solution of potassium bichromate. When dry, the tissue was exposed in contact with a negative, and then immersed in water together with a blank sheet of paper. When both were limp they were removed and squeegeed together, and again immersed in hot water. The unexposed gelatin dissolved, allowing the photographer to strip away the tissue support, leaving the exposed surface on top. Because the image was laterally reversed, a second transfer was commonly made when a mirror image would be objectionable.

Carbon prints were not only permanent, but rendered a rich tonal scale. The term "carbon print" became a misnomer, for soon a wide variety of pigmented tissue of various colors became available. Swan's London licensee, The Autotype Company, offered tissues of over fifty different colors; most photographers preferred the

Photographer unknown. *The Solar Camera "Jupiter" on the Roof of the Nashville, Tennessee, Studio of Van Stavoren.* ca. 1866. Gelatin-silver print, probably a copy. The Astronomical Society of the Pacific, San Francisco.

rich purple-browns that matched the popular albumen prints in tone.

Although almost all photographs of the nineteenth century were printed by contact, and were thus the exact size of the negatives, enlarging was not infrequent. *Solar cameras,* as daylight enlargers were called, came into use in the late 1850s. The optical system was analogous to that of a slide projector. A condenser lens, the size of the negative, was illuminated by direct sunlight; the image was thrown by a second lens on an easel to which albumen paper was fastened. The most popular type of solar camera was self-contained in a lighttight box; it could be set up outdoors, usually on the studio roof. Exposures were hours, sometimes even days long, and it was the job of apprentices to keep the apparatus pointed directly toward the sun.

The production of "life-size" portraits as big as 6 x 10 feet is recorded, but these enlargements were of such poor quality that they were heavily retouched. Marcus

Aurelius Root, a prominent Philadelphia photographer, wrote in 1864:

Since the introduction of the Solar Camera, life-size and other enlarged photographs have begun to excite popular attention. These pictures, from causes both inherent and incidental, require, more than any other photographs, some aid from the artist's touch.[5]

Simultaneously from Belgium came the prediction that "the future of photography resides in the practical solution of the amplification of small photographic images."[6] But enlarging did not come into general use until the introduction of more highly sensitive printing papers two decades later.

A weak negative, in which the silver deposit is somewhat light in tone and the shadows are transparent, will appear as a positive when viewed against a black background. This phenomenon was observed by Sir John F. W. Herschel in 1839. No practical use was made of the method, however, until shortly after Archer published

details for working his collodion process, when articles began to appear in the British press on this adaptation of his process. Archer himself clearly described "The Whitening of Collodion Pictures as Positives" in the second edition of his manual (1854).[7]

These direct collodion positives bore a striking resemblance to daguerreotypes, especially when they were mounted in the same type of case. They became extremely popular in America. Technical details for producing them were clearly given by J. H. Croucher in his book *Plain Directions for Obtaining Photographic Pictures* (1853),[8] examples were publicly shown in Philadelphia in 1854, and a year later the word *ambrotype* was coined by M. A. Root to describe them. James A. Cutting of Boston secured three patents for improvements: for the addition of camphor and of potassium bromide to the collodion, and for the use of fir balsam to cement a cover glass to the plate. Cutting vigorously prosecuted professionals who were using his technique without securing licenses, which cost upwards of $1000 for a city of 5000 inhabitants.

In general, ambrotypes lack the brilliancy of daguerreotypes, but they were easier to produce, and to professionals the fact that they could be finished and delivered at the time of the sitting was their most attractive feature. The process was short-lived. We read in the *American Journal of Photography* for 1863: "At the present time glass is less used for ambrotypes than iron plates. The name 'Ambrotype' may soon become obsolete."[9]

The writer was referring to yet another adaptation of the wet-plate process: the familiar *tintype*. Instead of glass, thin sheets of iron, japanned black, were coated with the light-sensitive emulsion. The inventor of the process for making the japanned plates, Hamilton L. Smith, assigned his 1856 patent to William Neff and his son Peter. The manufacture of prepared plates was begun in 1856 by the Neffs, who named them *melainotype* plates, and by Victor M. Griswold, who chose the name *ferrotype*. The more popular word tintype was introduced later.

Because the surfaces of tintypes were not fragile they could be sent through the mail, carried in the pocket, and mounted in albums. They were processed while the customer waited. They were cheap, not only because the materials were cheap, but also because by using a multilens camera several images could be secured with one operation. After processing, the plate was cut into single pictures with shears.

Tintyping was usually casual; when the results have charm it is due to the lack of sophistication and to the naive directness characteristic of folk art. Records of outings, mementos of friendships, stiffly posed portraits of

Photographer unknown. *The Horn Player*. ca. 1855. Ambrotype. Collection Eleanor Coke, Albuquerque.

Photographer unknown. *Civil War Soldier*. ca. 1862. Tintype. Chicago Historical Society, Chicago, Ill.

Photographer unknown. *The Carriage Party, Lynn, Massachusetts.* ca. 1885. Tintype. Collection Beaumont Newhall, Santa Fe.

HER MAJESTY THE QUEEN

JOHN EDWIN MAYALL. *Queen Victoria.* 1861. Carte-de-visite. Collection Beaumont Newhall, Santa Fe.

country folk against painted backgrounds are common; views are few. The process lingered in the backwaters of photography as the direct descendant of the daguerreotype. Tintypes were enormously popular: "It is impossible to compute the number of quantities which have been made and sold since 1860," wrote Edward M. Estabrooke in his standard handbook, *The Ferrotype and How to Make It*, and concluded, "I suppose it would exceed that of all other pictures put together."[10]

Despite the competition of direct imitation, neither the tintype nor the ambrotype dealt the death blow to the daguerreotype. That was left to a third application of the collodion technique, the *carte-de-visite* photograph, patented in France by André Adolphe-Eugène Disdéri in 1854. The name refers to its similarity to a common visiting card in size, for it was a paper print pasted on a mount measuring 4 x 2½ inches. To take these small portraits, Disdéri first made a wet-plate negative with a special camera that had four lenses and a plateholder that could be slid from side to side. Four exposures were made on each half of the plate; thus eight poses could be taken on one negative. A single print from this negative could then be cut up into eight separate portraits. Unskilled labor was used for this work; the production of the cameraman and printer was thus increased eightfold.

Disdéri, a brilliant showman, made this system of mass production portraiture world famous. His studio was, in the eyes of a German visitor, "really the Temple of Photography—a place unique in its luxury and elegance. Daily he sells three to four thousand francs' worth of portraits."[11]

Disdéri, whose fortune had once been the talk of Paris, was blind, penniless, and deaf when he died in a public hospital in Paris in 1890. He was a victim of his own invention. The system that he popularized was so easy to imitate that all over the world cartes-de-visite were being made in a mechanical, routine way by photographers who were hardly more than technicians.

The "cardomania"[12] jumped to England (70,000 portraits of the Prince Consort were sold during the week following his death) and to America (1000 prints a day were sold of Major Robert Anderson, the popular hero of Fort Sumter).

At first sitters were invariably taken at full length. To Americans, the first cartes-de-visite imported from France seemed comical. Abraham Bogardus, a veteran New York daguerreotypist, recollected that "it was a little thing; a man standing by a fluted column, full length, the head about twice the size of the head of a pin. I laughed at that, little thinking I should at a day not far distant be making them at the rate of a thousand a day."[13]

As portraits, most cartes-de-visite are of little aesthetic

ANDRE ADOLPH-EUGENE DISDERI. *Portrait of a Ballerina.* ca. 1860. Uncut albumen print from a carte-de-visite negative. George Eastman House, Rochester, N.Y.

"There is a perfect mania now in Paris for photographic visiting cards, and the *ateliers* of Disderi, Pierson, Mayer, and others, are thronged with visitors. The process employed is thus described by M. Lacan (Editor of "La Lumière").

" 'I went to Disderi's rooms yesterday. I found the crowd in them as numerous as it always is, and it was not without difficulty that I gained access to his operating-room. In my presence he took four portraits in the space of twenty minutes, giving to each model two different attitudes. The objective that he makes use of is a four-inch Voigtlander. He places it at about eight metres from his model. Each glass moves in a grooved frame, and serves him for eight cliches. The exposure yesterday—at five o'clock in the afternoon, and with cloudy weather—lasted from ten to twelve seconds. Such is, in substance, the process employed by this talented operator. Of course, the artistic skill with which he places his model in good attitude and in good light, counts for much in the beauty of the results obtained; but that skill is to be taught by good taste and experience, rather than by rule.' "—*Photographic Notes,* August 1, 1860, pp. 207-08.

Photographer unknown. *A Hand of Cartes-de-Visite.* ca. 1865. Collage. Christie's South Kensington Ltd., London.

value. No effort was made to bring out the character of the sitter by subtleties of lighting, or by choice of attitude and expression. The images were so small that the faces could hardly be studied, and the posing was done too quickly to permit individual attention. To accommodate card photographs of relatives, friends, and celebrities, elaborately bound albums were introduced around 1860. The cards, of uniform size the world over, could readily be slipped into cutout openings. The family album became a fixture in the Victorian home, and as a consequence, quantities of cartes-de-visite have survived. As documents of an era, they are often of great charm and interest.

It is to the more serious photographers, who worked with a larger format, that we must turn for the finest portraits of the midcentury. Especially in France a school of photographers developed a bold and vigorous style well suited to interpreting those highly individualistic personalities who made Paris a center of the literary and artistic world.

The most prominent of these photographers had for the most part been Young Romantics of the Latin Quarter, living *la vie de bohème* as second-rate painters, caricaturists, and writers. Nadar, whose real name was

Gaspard Félix Tournachon, contributed sketches and articles to comic magazines and founded a new one, *La Revue comique.* He planned in 1851 to publish four large lithographs of mildly ridiculous caricatures of a thousand or so prominent Parisians. He began to collect hundreds of portraits for this vast *Panthéon-Nadar.* Some were his own sketches, others were drawings by a staff of draftsmen he had assembled for the purpose. A few were contributed by the subjects themselves. The first sheet, which measured 28 x 37 inches and contained 249 satirical portraits, appeared in 1854. It was received with enthusiasm by the press and the public. The stone was reworked in 1858; a few subjects were replaced by more topical figures such as the painter Eugène Delacroix, the illustrator Gustave Doré, and the composer Gioacchino Rossini. They are direct copies of photographs taken by Nadar himself. He had quickly mastered the collodion process and in 1853 began to record the famous people who flocked to his studio, which became a favorite meeting place for those of liberal politics and thought.[14] His portrait style was simple and straightforward; he posed his sitters against plain backgrounds beneath a high skylight, usually standing and seen in three-quarter length. The faces are photographed with a directness and penetration due partly to the fact that he knew most of his sitters, but more to the power of his vision. He wrote, in 1856:

Photography is a marvellous discovery, a science that has attracted the greatest intellects, an art that excites the most astute minds—and one that can be practiced by any imbecile. . . . Photographic theory can be taught in an hour, the basic technique in a day. But what cannot be taught is the feeling for light. . . . It is how light lies on the face that you as artist must capture. Nor can one be taught how to grasp the personality of the sitter. To produce an intimate likeness rather than a banal portrait, the result of mere chance, you must put yourself at once in communion with the sitter, size up his thoughts and his very character.[15]

Nadar was a ceaseless, energetic worker. While still taking portraits he continued to illustrate books and to write novels. He constantly experimented. He was among the first to photograph by electric light, and produced a documentation of underground Paris, its catacombs and its sewers. He was the first to photograph from a balloon, in 1858.

Aeronautics became his obsession. He built one of the largest balloons in the world, *Le Géant* ("The Giant"), so big it had a two-story nacelle. He almost lost his life in it when the balloon went out of control on a flight over Hanover, Germany, and he and his companions were dragged some twenty-five miles over open country. He saw that the future of aeronautics lay in powered aircraft,

NADAR. *Théophile Gautier.* 1857. Salted paper print. Formerly Collection Georges Sirot, Paris.

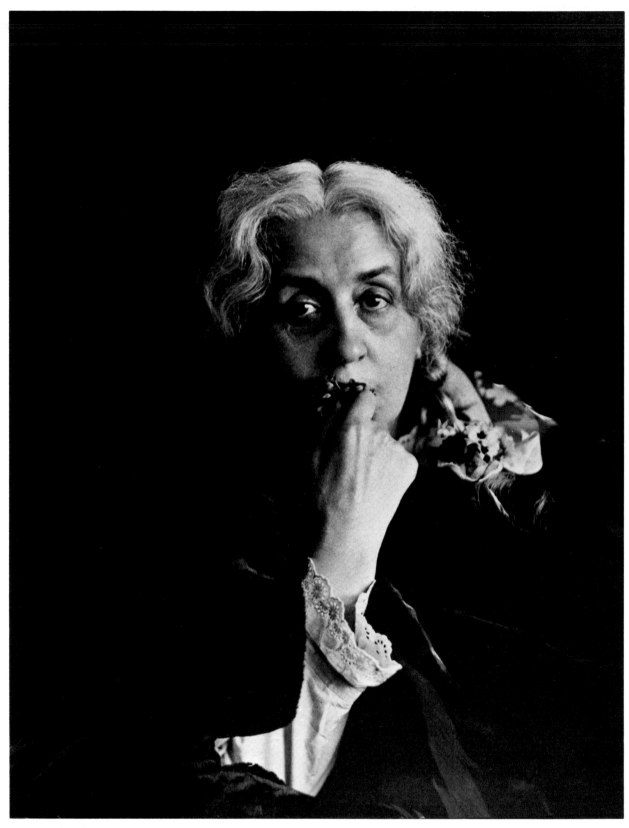

NADAR. *The Photographer's Wife.* 1853. Gelatin-silver print from a collodion negative in the Caisse de Monuments Historiques, Paris. Menil Foundation Collection, Houston.

and formed a society for the encouragement of experimentation. One of the members demonstrated a small steam-driven helicopter in his vast new studio that he opened on the fashionable Boulevard des Capucines in 1860. Across the front of the building a sign, illuminated by gas at night, bore the single word: NADAR. Inside and outside the studio was painted red; Nadar even affected red clothing to proclaim his sympathy with the liberal republican left. His staff numbered twenty-six:

The persons employed may be thus described: Nadar, who has taken for aid, in the direction of his ateliers, one of the most esteemed Belgian photographers, Mr. Walter Damry, of Liege; Paul Nadar, who, though only eighteen years of age, is already a skilful operator, and actively assists his father; two aids and a boy complete the service in the making of the negatives; four printers and toners; six retouchers of negatives; and three artists for retouching the positive prints; three women for the mounting, and two ladies for the reception of customers and the keeping of the books; and finally, four male and female servants. Such is the ensemble of the working force at the command of the celebrated artist, to defy competition and overcome the difficulties of the art.[16]

Nadar's studio was typical of photographic establishments in the major cities of the world. Demand and competition made division of labor economically indispensable. The photographer who signed the finished product seldom did more than pose the sitters, and not always that. He was the chief executive and artistic director of a highly trained staff. We are so accustomed to thinking of paintings, sculpture, and drawings as the work of gifted individuals that it is difficult to appreciate the team work lying behind photographs attributed to many famous photographers. Often the name of the studio sold the product: it became a trademark. For instance, in faraway Peru the photographer E. Maunroy boasted that he was "agent of the House of Nadar of Paris" and stamped on the face of cartes-de-visite of Indians the bold initial "N" in scarlet.

There is a curious parallel between the careers of Nadar and his contemporary Étienne Carjat, who produced many of the finest portraits of the period. Like Nadar, he was a caricaturist and magazine editor. Like Nadar, he was a friend of artists and writers, who met in the studio he opened in 1860. Perhaps the success that both photographers had with portraiture was partly due to their skill in caricature, which necessitates recognizing the essential features of the face that reveal the character of the subject. Less flamboyant and less the showman than Nadar, Carjat nevertheless was highly popular: in one year, 1866, he made a thousand portraits. He is seen at his best in his portraits of Daumier, Courbet, and Baudelaire.

A more self-conscious approach is seen in the portraits of the French sculptor Antony Samuel Adam-Salomon.

E. MAUNOURY. *Peruvian Indian.* ca. 1860. Carte-de-visite. George Eastman House, Rochester, N.Y.

On the verso of the card Maunoury states that he is "Agent of the House of Nadar of Paris."

He posed his models under the high side light which has ever since been called "Rembrandt lighting." He swathed them with velvet drapery to make the effect more painterly. And he mounted his prints on blue cards printed with the legend "composed and photographed by the sculptor Adam-Salomon." Alphonse de Lamartine, who once called photography "a plagiarism of nature," confessed that

After admiring the portraits caught in a burst of sunlight by Adam-Salomon, the sensitive sculptor who has given up painting, we no longer claim that photography is a trade—it is an art, it is more than an art, it is a solar phenomenon, where the artist collaborates with the sun.[17]

When some prints of Adam-Salomon's were shown at the Edinburgh Photographic Society, an argument broke out: was the effect due to retouching? It was settled only by a microscopic examination of the prints: Adam-Salomon had indeed retouched them.

Retouching had become controversial ever since Franz Hanfstaengl, the leading portrait photographer of Germany, showed at the 1855 Exposition Universelle in Paris a retouched negative with a print made from it before and after retouching. It was, Nadar recollected, the begin-

ETIENNE CARJAT. *Charles Baude-laire.* ca. 1863. Salted paper print. Collection Harry H. Lunn, Jr., Washington, D.C.

ning of a new era in photography. So difficult was it to believe that modifications had been made to the negative rather than to the print that one of Hanfstaengl's prints was even tested by the somewhat extreme method of bleaching out the silver image entirely with potassium cyanide; no trace of India ink was found.

Although most photographers found the practice "detestable and costly," to quote Nadar, retouching became routine, because sitters now demanded that the often harsh, direct camera records of their features be softened, facial blemishes removed, and the wrinkles of age smoothed away. Besides the retouching of the negative, the prints were often tinted or painted over with opaque pigments; each major studio usually employed several artists as "colorists."

In America, the best portraits came from the studios of former daguerreotypists. Brady continued to collect portraits of celebrities; best known are the many photo-

graphs of Abraham Lincoln, who is reputed to have once said that his Cooper Union speech and Brady's photographs put him in the White House. On February 9, 1864, Lincoln sat for the portrait now used on the five-dollar bank note of American currency. The pose is one of several taken for the painter Francis B. Carpenter, who stated in his diary that the cameraman was Brady's operator Anthony Berger.

Around 1860 portrait photographers began to substitute elaborate painted backgrounds for the simple plain screens against which most sitters since the days of the daguerreotype were posed. Props of papier-mâché were introduced; fluted columns, rustic fences, boulders, and stumps to be placed on artificial grass. Posing chairs were ingeniously designed for the eye of the camera, sometimes with different ornamentation on each side, usually with attached head rests. The small carte-de-visite format gave way in popularity to larger sizes, especially the *cabi-*

NAPOLEON SARONY. *Sarah Bernhardt.* ca. 1880. Albumen print. George Eastman House, Rochester, N.Y.

net photograph, a burnished print 5½ x 4 inches on a mount 6½ x 4½ inches, introduced first in England in 1866. The demand for publicity photographs by actors and actresses led to specialization in this work. Most theatrical photographs owed their effect to the actor. The stage settings were imitated in the studio, and the actor played out his role before the camera; the success of the photograph was largely due to the sitter's power to project his personality.

One of the most colorful theatrical photographers was Napoleon Sarony, born in Canada in 1821, the year his famous namesake died. In 1846 he joined Henry B. Major to found the lithographic firm of Sarony & Major in New York City. In 1856 he visited his brother, Oliver Francis Xavier Sarony, who was a photographer in England, with the result that he, too, became a photographer and opened his own studio in Birmingham. He returned to New York in 1864; his studio portraits, marked by his flowing signature, became famous. He posed and directed his sitters, using flattery, threat, mimicry, to bring out their histrionic powers. Unlike most of the photographers who had large studios, he gave full credit to his cameraman, Benjamin Richardson. "If I make a position," he told an interviewer, "and his camera is right, my long-time assistant here, Richardson, is able to catch my ideas as

deftly and quickly as necessary."[18] The cameraman recollected:

Sometimes when things were quiet under the skylight suddenly his step would be heard on the stairs followed by half a dozen sitters. "Put in a plate my boy;" answer would go back, "Hi, hi, your honor!" and then things were quite lively for a time. When he photographed Jim Mace, the pugilist, on his first visit to this country, he danced around him, slapping him on his chest and in the ribs in a way which fairly astonished the champion, who enjoyed it hugely.[19]

Sarony complained at the rush of business: "Think what I must suffer . . . fancy my despair. All day long I must pose and arrange for those eternal photographs. They *will* have me. Nobody but me will do; while I burn, I ache, I die, for something that is truly art. All my art in the photograph I value as nothing. I want to make pictures out of myself, to group a thousand shapes that crowd my imagination. This relieves me, the other oppresses me."[20] And so he spent his few odd moments in what he called his "den," drawing in charcoal such subjects as *Venus in the Bath* and *The Vestal Virgin*.

There were other photographers who felt that the camera offered them the opportunity to rival the painter, and they set about emulating the older art, largely by imitation.

GUSTAVE LE GRAY. *The Great Wave—Cette.* 1856. Combination albumen print. Collection Paul F. Walter, New York; on extended loan to The Museum of Modern Art, New York.

6 · ART PHOTOGRAPHY

In 1861 an English critic, in an article "On Art-Photography," wrote: "Hitherto photography has been principally content with representing Truth. Can its sphere not be enlarged? And may it not aspire to delineate Beauty, too?" He encouraged photographers to produce pictures "whose aim is not merely to amuse, but to instruct, purify and ennoble."[1]

Allegories had been attempted. In 1843 John Edwin Mayall of Philadelphia made ten daguerreotypes to illustrate the Lord's Prayer; they were acclaimed by the British art press when he showed them a few years later in London. In 1848 he produced six plates based on Thomas Campbell's poem "The Soldier's Dream." At the Great Exhibition of 1851 in the London Crystal Palace other American daguerreotypists exhibited allegorical pictures: Martin M. Lawrence, for example, showed a 13 x 17-inch plate of three models facing left, front, and right, which he titled *Past, Present and Future*; it was, he said, inspired by Edward Green Malbone's miniature painting *The Hours*. This daguerreotype was one of several that won for Lawrence a prize medal; but they were made by Gabriel Harrison, then his cameraman, who later protested: "Why not," he asked in a letter published in the New York *Tribune* "give the name of the operator by whom they were taken?"[2]

In the work of Hill and Adamson are many calotypes of friends dressed up in armor and monk's garb, acting out passages from the novels of Sir Walter Scott. These pictures, and the allegorical daguerreotypes, relied for their effect upon the choice, costuming, and posing of models; they were records of *tableaux vivants*, or amateur theatricals. In lighting and in technique they were routine, and foreshadowed theatrical photography.

With the perfection of the collodion process an increasing number of amateurs were attracted to photography, and they brought with them a broader view of artistic matters than the average professional possessed. In 1853 the Photographic Society of London (since 1894 the Royal Photographic Society of Great Britain) was founded. Its first president, Sir Charles Eastlake, was himself an amateur, and although the membership was divided between those who practiced photography as an avocation and as a profession, the amateurs were more often heard. At the first meeting Sir William Newton, miniature painter to the court, addressed the members "Upon Photography in an Artistic View."[3] He denied photography's position as an independent art, and urged photographers who were taking studies to be used by painters to put the image slightly out of focus.

The concept was not new. In 1843 daguerreotypists were instructed to use a relatively large lens opening when taking a portrait of a person with wrinkled features to "obtain one of those soft and rather vague likenesses which painters call 'flous'."[4] But Sir William's recommendation led to such a heated controversy that, at a later meeting, he reminded the members that he was referring to photographs taken *for the use of artists*: when making record photographs, the sharper the focus the better, he said.

The silver iodide emulsions of the time were sensitive only to the blue rays of the spectrum and those that lay beyond. It was impossible to photograph objects that reflected *only* red or green: a very bright red flag with a green cross upon it appeared totally black in a print. But pure, monochromatic colors are seldom found in nature except in the rainbow. Blue is present in most hues in varying amounts. In the sky it is predominant, and thus skies were overexposed and cloudless when a sufficient time had been given to record the features of a landscape. At gross overexposure a negative will reverse to a positive. Direct exposure to the sun will often produce a transparent disc in the negative, which will appear in the print as menacingly black. Hence this reversal of tones is known as *solarization*. Because of this phenomenon the skies in wet-plate landscape negatives were not uniformly black, but had patches of low density that gave a mottled appearance to the print. Consequently they were generally retouched around the contours with opaque paint and the remaining sky area was protected with a paper mask.

An alternative was for the photographer to take two negatives of a landscape; one was exposed for the earth-

73

DAVID OCTAVIUS HILL & ROBERT ADAMSON. *John Henning and the Daughter of Lord Cockburn in a Scene from Sir Walter Scott's Novel "The Antiquary."* ca. 1845. Salted paper print from a calotype negative. Courtesy of Arthur T. Gill, Eastbourne, England.

bound features and the other exposed for a much shorter time in order to record the sky and clouds. The two negatives were masked; part of the print was made from one, and part from the other.

This technique, which came to be called *combination printing*, appears to have been used by Gustave Le Gray of Paris to produce his dramatic seascapes, which were widely praised when they were shown in London in 1856. Making multiple prints from several negatives was carried to an extreme by Oscar G. Rejlander, a Swede working in Wolverhampton, England in his allegorical picture of 1857, *The Two Ways of Life*.[5] He conceived a vast stage on which was acted out an allegory

representing a venerable sage introducing two young men into life—the one, calm and placid, turns towards Religion, Charity and Industry, and the other virtues, while the other rushes madly from his guide into the pleasures of the world, typified by various figures, representing Gambling, Wine, Licentiousness and other vices; ending in Suicide, Insanity and Death. The center of the picture, in front, between the two parties, is a splendid figure symbolizing Repentance, with the emblem of Hope.[6]

He would have needed a huge studio and many models

to take this picture with a single negative. Instead, he enlisted the services of a troupe of strolling players and photographed them in groups at scales appropriate to the distance at which they were to appear from the spectator. On other negatives he photographed models of the stage. He made thirty negatives in all, which he masked so they would fit together like a picture puzzle. Then, painstakingly masking a sheet of sensitized paper to match each negative in turn, he printed them one after the other in the appropriate positions. It took him six weeks to produce the final print, which measured 31 x 16 inches. He made it expressly for display at the Art Treasures Exhibition held in Manchester in 1857. This ambitious undertaking was one of the most important art exhibitions of the nineteenth century. A special building, rivaling the Crystal Palace of London, was erected, and in it was installed a loan exhibition of a 1000 Old Master paintings, hung chronologically, an equal number of contemporary paintings, as well as drawings, engravings, art objects from Persia, India, and China, and ivory sculptures. That 600 photographs were included in this mammoth exhibition is a tribute to the growing position of the new medium in the artistic world. Yet more influential was the purchase of Rejlander's *Two Ways of Life* by Queen Victoria. It was hailed as "a magnificent picture, decidedly the finest photograph of its class ever produced."[7] Rejlander considered it an example of the camera's usefulness to artists, in making a first sketch for an elaborate composition, and said that he could think of no other subject which would enable him better to portray "various draped figures as well as exhibit the beautiful lines of the human form."[8] The nudity was not universally accepted; only the righteous half of the photograph was shown at the annual exhibition of the Edinburgh Photographic Society.

Rejlander produced a large number of character studies, of street urchins, genre groups, and self-portraits in theatrical gestures. For he was, at heart, an actor. He delighted in such make-believe as photographing himself as Garibaldi, the then-popular Italian hero. He liked to register such emotions as fear and disgust before the camera. Charles Darwin used some of these to illustrate his book *The Expression of the Emotions* (1872). He also used some of Rejlander's photographs of infants; one of them, a child weeping in a somewhat comic fashion, became so popular it was said that over a quarter of a million copies were sold. Rejlander also produced what may well be one of the first deliberately double-exposed photographs, *Hard Times*.

Henry Peach Robinson, a painter and etcher who took up photography as a profession in 1852 in Leamington, England, first became famous with *Fading Away*, a com-

OSCAR G. REJLANDER. *The Two Ways of Life.* 1857. Combination albumen print. The Royal Photographic Society, Bath, England.

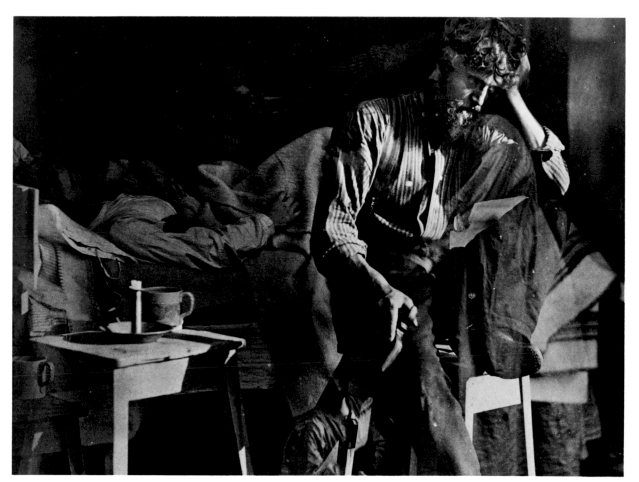

OSCAR G. REJLANDER. *Hard Times.* 1860. Combination albumen print. George Eastman House, Rochester, N.Y.

On the mount Rejlander has written: "A Spiritistical Photo."

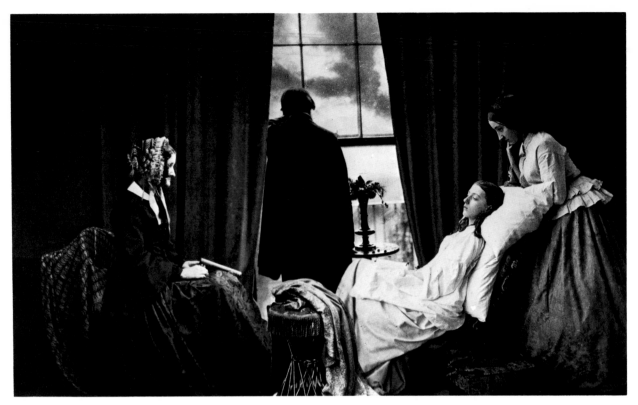

HENRY PEACH ROBINSON. *Fading Away.* 1858. Combination albumen print. George Eastman House, Rochester, N.Y.

bination print showing a dying girl attended by grief-stricken parents. On the mat he wrote:

Must, then, that peerless form
Which love and admiration cannot view
Without a beating heart; those azure veins,
Which steal like streams along a field of snow,
That lovely outline, which is fair
As breathing marble, perish?

—Shelley

The print was made from five negatives. Robinson stated that the principal model "was a fine healthy girl of about fourteen, and the picture was done to see how near death she could be made to look."[9] The public was shocked by the subject; it was felt to be poor taste to represent so painful a scene. Though such criticism no longer seems valid, we should not ignore it as Victorian sentimentality. Far more painful subjects were painted in those days. But the very fact it was a *photograph* implied that it was a truthful representation, and so the scene was viewed literally. Its artificiality did not escape criticism. "Look steadily at it a minute," the *Literary Gazette* told its readers, "and all reality will 'fade away' as the make-up forces itself more and more on the attention."[10] Such criticism, which was widespread, was discouraging. Rejlander wrote Robinson in 1859:

I am tired of Photography for the public, particularly composite photos, for there *can be no gain* and there is no honor but cavil and misrepresentation. The next Exhibition must, then, only contain Ivied Ruins and landscapes forever besides portraits—and then stop.[11]

But Robinson produced quantities of art-photographs: he published one every year. His influence was even more strongly felt through his prolific writing. His *Pictorial Effect in Photography*, 1869,[12] went through edition after edition, and was translated into French and German. The book, a handy manual for the production of art-photographs, was based on academic rules of composition. Robinson illustrated his text with his own photographs and etchings, and with reproductions of paintings by Benjamin West, J. M. W. Turner, William Mulready, David Wilkie, and other Victorian artists, including the illustrator Myles Birket Foster. His stated aim was

to set forth the laws which govern—as far as laws can be applied to a subject which depends in some measure on taste and feeling—the arrangement of a picture, so that it shall have the greatest amount of pictorial effect, and to illustrate by examples those broad principles without regard to which imitation, however minute or however faithful, is not picturesque, and does not rise to the dignity of art.[13]

To force the camera image to conform to these academic formal concepts required ingenuity and manipulative skill. Robinson habitually began by drawing a sketch of the final composition. If it was to be a combination print he posed the models separately. Not all his

HENRY PEACH ROBINSON. *Carrolling.* 1887. Combination albumen print and the artist's sketch for its production. The Royal Photographic Society, Bath, England.

JULIA MARGARET CAMERON. *Thomas Carlyle.* 1867. Albumen print. The National Portrait Gallery, London.

Carlyle, on receiving this portrait, wrote Mrs. Cameron: "It is as if it suddenly began to speak, terrifically ugly and woe-begone."

pictures were printed from several negatives, however; many group photographs were acted out by models in his studio. At the very time when painters were moving their easels outdoors, Robinson was building nature under the skylight: shrubbery was mounted on a rolling platform; a brook was improvised from the darkroom drain; clouds were painted on backdrops. He told the beginning photographer that

Any "dodge, trick, and conjuration," of any kind is open to the photographer's use *so that it belongs to his art, and is not false to nature....* It is his imperative duty to avoid the mean, the bare and the ugly, and to aim to elevate his subject, to avoid awkward forms, and to correct the unpicturesque.[14]

There was a curious duality apparent in the writings and work of these artist-photographers. Robinson on one page wrote that beautiful photographs could be made "by the mixture of the real and the artificial,"[15] and on another page praised "this perfect truth, this absolute rendering of light and shade and form . . . beyond the reach of the painter and sculptor."[16] The nineteenth-century critic Jabez Hughes, while praising Rejlander's and Robinson's work, strongly rebelled against combination printing.

When an artist conceives a brilliant thought, and hastens to put it on canvas, how he sighs that he is obliged to work piecemeal—that he cannot, with one sweep of his brush, realize the thought in his mind. It is the proud boast of photography that it can do this.[17]

This ambivalence is characteristic of the photographs of Julia Margaret Cameron. Her dynamic portraits are among the most noble and impressive yet produced by means of the camera; her costume pieces, on the other hand, lie within the stylistic idiom of the Pre-Raphaelite painters.

At Freshwater Bay, in the Isle of Wight, Mrs. Cameron, whose husband was a British civil servant, entertained illustrious friends: Tennyson, Herschel, Carlyle, Darwin, Browning, Longfellow. She took up photography in middle age: a portrait titled *Annie, My First Success* is dated 1864. She trained her camera on her friends; by the sheer force of her personality she seems to have intimidated them into cooperation. In her autobiographical *Annals of My Glass House* she describes the intensity she brought to portraiture:

When I have had such men before my camera my whole soul has endeavored to do its duty towards them in recording faithfully the greatness of the inner as well as the features of the outer man. The photograph thus taken has been almost the embodiment of a prayer.[18]

She blundered her way through technique, resorting to any means to get desired effects. The blurred, out-of-focus images that many critics deplored were deliberate. She wrote to her friend Sir John Herschel that she hoped to elevate her art beyond

mere conventional topographic Photography—map making & skeleton rendering of feature & form without that roundness & fulness of force & feature that modelling of flesh & limb which the focus I use only can give tho' called & condemned as *"out of focus."* What is focus—& who has a right to say what focus is the legitimate focus—My aspirations are to ennoble Photography and to secure for it the character and uses of High Art by combining the real & ideal & sacrificing nothing of Truth by all possible devotion to Poetry & Beauty—.[19]

Mrs. Cameron gave her photographs that breadth and simplicity that was characteristic of early calotypes. Her compositions, inspired by her friendship with the painter George Frederick Watts, are for the most part costume pieces, *tableaux vivants,* with her family and friends acting out scenes from literature before the camera. She admired the work of Rejlander and invited him to Freshwater Bay "to help her with his great knowledge." But her greatest debt, she said, was to the painter and photographer David Wilkie Wynfield, who photographed his friends dressed in Renaissance costume: "To my feeling about his beautiful Photography I owed *all* my attempts and indeed consequently all my success," she wrote William Michael Rossetti in 1864.[20] Her illustrations to

JULIA MARGARET CAMERON. *Mrs. Herbert Duckworth (later Mrs. Leslie Stephen), Mother of Virginia Woolf.* 1867. Albumen print. Collection Beaumont Newhall, Santa Fe.

JULIA MARGARET CAMERON. *Whisper of the Muse.* ca. 1865. Gum platinum print by Alvin Langdon Coburn from the original negative. Collection Beaumont Newhall, Sante Fe.

LADY CLEMENTINA HAWARDEN. *Photographic Study.* ca. 1863. Albumen print. The Victoria and Albert Museum, London.

Tennyson's *The Idylls of the King,* her religious groups, her studies of children posed as angels or as *Venus Chiding Cupid and Removing His Wings* stand in contrast to her powerful portraits. Without the challenge of interpreting great personalities, her work tended to become lost in sentiment and to echo paintings. This was deliberate on the part of Mrs. Cameron: she wrote on the mount of one of her prints, "decidedly Pre-Raphaelite."

More and more people found photography a stimulating avocation. Lady Clementina Hawarden made many photographs of her family in the 1860s, and some of her full-length portraits of young women in resplendent Victorian costume, bathed in light, have a charm and soft sentiment that is in direct contrast to the force of Mrs. Cameron's portraits. Her work was admired by Lewis Carroll, author of *Alice's Adventures in Wonder-*

land. An ardent amateur, he made many photographs of the children who were his friends and of celebrated contemporaries.

An extraordinary series of photographs of Victor Hugo living in exile on the island of Jersey were taken in 1853–54 by his son Charles and his friend the poet Auguste Vacquerie. An eerie romanticism pervades these pictures; details seem selected for their symbolism: Hugo's favorite rocks or his resting place under the flowering vines of the conservatory. A series of just hands—Hugo's and his wife's—was made; a novel idea in photography, it was a portent of the close-up. Hugo was greatly interested in these photographs, and even made a drawing based on the *negative* of a gnarled and twisted barnacle-clad breakwater—an astonishingly early recognition of the beauty of the tone reversal of a negative image.

LEWIS CARROLL. *Alice Grace Weld as "Little Red Riding Hood."* 1857. Albumen print. Gernsheim Collection, Humanities Research Center, University of Texas, Austin.

If photographers found inspiration in paintings, painters found photography a useful ally. We do not know who took the series of photographs for the Pre-Raphaelite painter Dante Gabriel Rossetti now in the Victoria and Albert Museum in London, but we know they were posed by the painter in July 1865 and were used in his painting *La Reverie.* Many other famous painters of the nineteenth century were grateful to photography: Eugène Delacroix posed nude models, and from the photographs that his friend Eugène Durieu took of them he made frequent sketches. He wrote his friend Constant Dutilleux of his enthusiasm for photography in a letter dated March 7, 1854:

How I regret that such a wonderful invention arrived so late—I mean as far as I am concerned! The possibility of studying such results would have had an influence on me that I can only guess at by their usefulness to me now, even with the little time I can put aside studying them in depth: it is the tangible demonstration of drawing from nature, of which we have had more than quite imperfect ideas.[21]

Gustave Courbet based the nude model in his 1849 *The Artist's Studio* on a photograph. Jean François Millet told

his pupil Edward Wheelwright that photographs are valuable as studies for drapery and other details.

Other artists used photography in a more slavish manner, basing whole compositions on the camera image. This was particularly true of portraiture. William Etty's *Self Portrait* (London, National Portrait Gallery) is hardly more than an enlarged copy of a calotype by Hill and Adamson, made in 1844, on the occasion of the artist's visit to Edinburgh. Many American painters relied upon daguerreotypes in the pose and delineation of the features of celebrities. Charles Loring Eliot, a popular American portraitist, for example, based his painting of the novelist James Fenimore Cooper on a daguerreotype ascribed to Mathew B. Brady. Such use of his daguerreotypes was intended by Brady; he wrote Samuel F. B. Morse in 1855 asking his opinion "in reference to the aid which . . . Daguerreotyping has afforded the kindred arts of painting, drawing and engraving. . . . During my experience, I have endeavored to render it as far as possible an auxiliary to the artist."[22] Morse's reply is not known.

To the British realist genre painters of the Victorian period, photography was an especial boon, though they would seldom admit it. For example, William Powell Frith, the popular genre painter of Victorian England, stated in 1893: "In my opinion photography has not benefitted art at all,"[23] yet in 1863 the London periodical *Photographic Notes* reported:

Photographer unknown. *Jane Morris.* 1865. Albumen print. The Victoria and Albert Museum, London.

Posed by Dante Gabriel Rossetti, as a study for a painting.

On a Derby Day, Mr. Frith employed his kind friend, Mr. [Robert] Howlett, to photograph for him from the roof of a cab as many queer groups of figures as he could, and in this way the painter of that celebrated picture, the "Derby Day" got many useful studies, not to introduce literally into his picture, as Robinson and Rejlander would have done, but to work up in his own mind and then reproduce with the true mark of genius stamped upon them.[24]

The same magazine reported that Frith commissioned Samuel Fry to make a series of 25 x 18-inch negatives for help in painting his equally popular *Life at a Railway Station.*

The technology of photography also presented to etchers and printmakers a new medium: the *cliché-verre,* a term for which there is no English equivalent. A glass negative is prepared by hand, from which prints can be made on photographic paper. The artist simply draws with a stylus upon a coated plate, scratching through the emulsion with each stroke. The process was especially popular among the members of the Barbizon School in the 1850s, to whom it was introduced by Adelbert Cuvelier. The most prolific of the artists who used the cliché-verre process was Jean Baptiste Corot, who produced sixty-six plates.

Art critics did not accept photography as readily as artists. They often used the word in a negative way, to condemn painting and sculpture that, to their eyes, did not go beyond verisimilitude, but merely recorded the outward appearance of the world. Charles Baudelaire was exceptionally harsh. In 1859 the French Society of Photography at last succeeded in getting the Ministry of Fine Arts to allow them to hold an exhibition in the Palace of the Champs Élysées at the time of the annual painting Salon. Baudelaire reviewed the show:

If photography is allowed to supplement art in some of its functions, it will soon have supplanted or corrupted it altogether . . . It is time, then, for it to return to its true duty, which is to be the servant of the sciences and arts—but the very humble servant, like printing or shorthand, which have neither created nor supplemented literature. Let it hasten to enrich the tourist's album and restore to his eye the precision which his memory may lack; let it adorn the naturalist's library, and enlarge microscopic animals; let it even provide information to corroborate the astronomer's hypotheses; in short let it be the secretary and clerk of whoever needs an absolute factual exactitude in his profession—up to that point nothing could be better. Let it rescue from oblivion those tumbling ruins, those books, prints and manuscripts which time is devouring, precious things whose form is dissolving and which demand a place in the archives of our memory—it will be thanked and applauded. But if it be allowed to encroach upon the domain of the impalpable and the imaginary, upon anything whose value depends solely upon the addition of something of a man's soul, then it will be so much the worse for us![25]

J.-B.-C. COROT. *Self-Portrait.* 1858. Cliché-verre. Detroit Institute of Arts, Detroit.

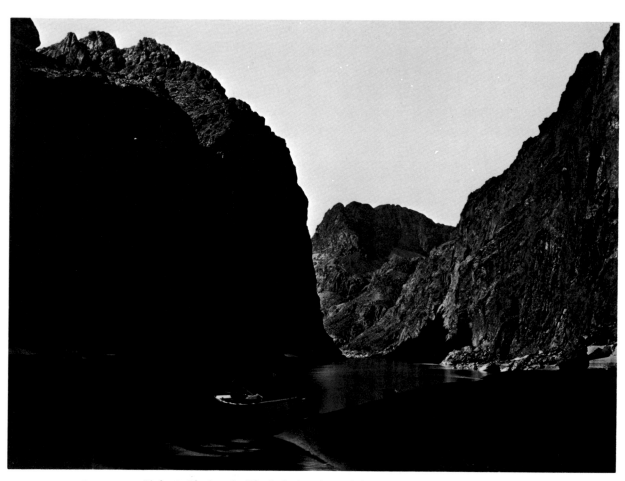

TIMOTHY H. O'SULLIVAN. *Light & Shadow in Black Cañon from Mirror Bar.* 1871. Albumen print. The National Archives, Washington, D.C.

7 • "A NEW FORM OF COMMUNICATION"

In contrast to those who sought to rival the painter with camera and lens, there were hundreds who used photography quite simply and directly as a means of recording the world about them. The ability of the medium to render seemingly infinite detail, to record more than the photographer saw at the time of exposure, and to multiply these images in almost limitless number, made available to the public a wealth of pictorial records exceeding everything known before. Photographers the world over were recording history in the making, the look of faraway and often hitherto unexplored places and the people living there, the familiar "sights" worth seeing and remembering by travelers, and man's most recent architectural and engineering accomplishments.

This contribution of photography, which had won the support of Baudelaire, was also praised by Lady Elizabeth Eastlake in her essay "Photography" in the *London Quarterly Review* for 1857. Her aesthetic could not embrace photography as one of the Fine Arts. She wrote:

"For everything for which Art, so-called, has hitherto been the means but not the end, photography is the allotted agent. . . . She is the sworn witness of everything presented to her view. What are her unerring records in the service of mechanics, engineering, geology, and natural history, but facts of the most sterling and stubborn kind? . . . Facts which are neither the province of art nor of description, but that of a new form of communication between man and man—neither letter, message, nor picture—which now happily fills up the space between them?"[1]

The first extensive photographic coverage of war was undertaken by Roger Fenton, an Englishman who came to photography from the legal profession, first as an amateur and then as a professional. His first work was a series of calotypes taken during a visit to Russia with his friend Charles Vignoles, a civil engineer who was building a bridge in that country. Fenton became the principal founder of the Photographic Society of London, and well known for his finely detailed yet massive architectural views and carefully composed still life studies, taken on collodion plates sensitized with his own modification of Archer's formula. Queen Victoria requested him to photograph the royal family and estates. He then became official photographer to the British Museum and produced hundreds of prints of artifacts and works of art in that collection. The excellence of his work led the printseller Thomas Agnew and Son to commission him to photograph the theater of war in the Crimea.

He took with him a wagon, fitted out as a darkroom, for he was using the wet-collodion process. Five cameras, 700 glass plates, chemicals, rations, harnesses, and tools made up his equipment. At Gibraltar he bought four horses. The "Photographic Van" was unloaded at Balaklava in March 1855. In a month he was at the front with his assistant, Marcus Sparling.

The battlefields of the Crimea were vast, level plains; they appear flat and dull in Fenton's photographs of them, and it is difficult to realize that many of the views were taken at great personal risk, under direct shellfire. At the ravine known as "The Valley of the Shadow of Death," Fenton wrote his family on April 24:

I took the van down nearly as far as I intended to go and then went forward to find out the chosen spot. I had scarcely started when a dash of dust behind the battery before us showed that something was on its way to us. We could not see it, but another flood of earth nearer showed us that it was coming straight, and in a moment we saw it bounding toward us. It was plain that the line of fire was upon the very spot I had chosen, so very reluctantly I put up with another view of the valley 100 yards short of the best point.[2]

Fenton's view of Balaklava, its harbor choked with ships, its quais with matériel of all sorts, shows the confusion that marked this disorganized war. Most of the 300 negatives he made are portraits of the officers in full dress, and of the men. He was constantly bothered by demands for portraits. "If I refuse to take them," he wrote, "I get no facilities for conveying my van from one locality to another."[3] The heat was excessive. "When my van door is closed before the plate is prepared, perspiration is running down my face, and dropping like tears. . . . The developing water is so hot I can hardly bear my hands in it."[4]

He returned to England in July, a sick man suffering from cholera. Exhibitions were held of the photographs in London and Paris; wood engravings of some of them

Above: ROGER FENTON. *Roslyn Chapel, Scotland.* ca. 1856. Albumen print. The Museum of Modern Art, New York.

Opposite top: ROGER FENTON. *The 57th Regiment.* 1855. Salted paper print. Gernsheim Collection, Humanities Research Center, University of Texas, Austin.

Opposite bottom: ROGER FENTON. *"The Valley of the Shadow of Death."* 1855. Salted paper print. Gernsheim Collection, Humanities Research Center, University of Texas, Austin.

Roger Fenton's Crimean War photographs were exhibited at the Gallery of the Water Colour Society in London in 1855. The editor of *The Photographic Journal* wrote that it was "The most remarkable and in certain respects the most interesting exhibition of photographs ever opened." He was particularly impressed by *The Valley of the Shadow of Death,* "with its terrible suggestions, not merely those awakened in the memory, but actually brought materially before the eyes, by the photographic reproduction of the cannon-balls lying strewd like the moraines of a melted glacier through the bottom of the valley."—*The Photographic Journal,* vol. 2 (1855), p. 221.

FELICE BEATO. *Headquarters Staff, Pehtang Fort.* 1860. Albumen print. The Museum of Modern Art, New York.

were printed in the *Illustrated London News;* prints pasted on paper mounts with engraved titles, were sold by Agnew. The London *Times* wrote: "The photographer who follows in the wake of modern armies must be content with conditions of repose and with the still life which remains when the fighting is over."[5] To a public used to the conventional fantasies of romantic battle painters, these photographs seemed dull, yet they recognized in them the virtue of the camera as a faithful witness. "Whatever he represents from the field must be real," the London *Times* admitted, "and the private soldier has just as good a likeness as the general."

The fall of Sebastopol was photographed by James Robertson, then chief engraver to the Imperial Mint in Constantinople; in 1857 he was official photographer to the British military force sent to India to quell the Bengal-Sepoy Mutiny. He worked there with Felice Beato; their photographs of the aftermath of the siege of Lucknow in 1858 are records of the shattered ruins of architectural splendor; amidst them are sun-bleached skeletons of the fallen defenders. Beato went on to Japan

and China. His photographs of the capture of Tientsin by British and French troops in August 1860, at the end of the Opium Wars, are even more terrifying, for Beato shows corpses strewn about just hours after they fell in the bitter fighting.

When the Civil War broke out in America in 1861, the photographic fraternity took the news lightly. "A battle scene is a fine subject for an artist,—painter, historian or photographer," declared the editor of the *American Journal of Photography.* "We hope to see a photograph of the next battle. . . . There will be little danger in the active duties for the photographer must be beyond the smell of gunpowder or his chemicals will not work."[6]

How greatly the dangers and difficulties of combat photography had been underestimated was soon found out by Brady, the former daguerreotypist. He already had shown his interest in history in the publication of *The Gallery of Illustrious Americans.* This sense of photographic documentation impelled him to undertake the recording of the Civil War; his close friendship with influential government leaders enabled him to secure the

ALEXANDER GARDNER. *Scouts and Guides to the Army of the Potomac.* 1862. Albumen print. Plate 28 of *Gardner's Photographic Sketch Book of the War* (Washington, D.C.: 1866). The Museum of Modern Art, New York.

necessary authorization to enter combat zones; and he had skilled cameramen in his employ.

With his cameramen he hurried to the front, where his photographic buggy became a familiar sight to the soldiers, who called it the "What-is-it?" wagon, and spoke of Brady as "that grand picture maker." It required no little zeal and intrepidity to remain crouched for minutes on end in the darkness of that fragile darkroom, going through the delicate manipulations of preparing and processing the glass plates while the din of battle shook the ground. Unarmed, knowing that the wagon itself was a suspicious-looking target, the photographers were exposed to the hazards of war. They risked their lives to save their plates. Brady was almost killed at Bull Run. Lost for three days, he finally turned up in Washington, haggard and hungry, still in his long linen duster, from which protruded a sword given him by a Zouave. He purchased new equipment, rounded up his cameramen, and rushed back to the battlefields. The New York *World* wrote:

Mr. Brady's "Scenes and Incidents" . . . are inestimable chroniclers of this tempestuous epoch, exquisite in beauty, truthful as the records of heaven. . . . Their projector has gone to his work with a conscientious largeness becoming the acknowledged leader of his profession in America. . . . "Brady's Photographic Corps," heartily welcomed in each of our armies, has been a feature as distinct and omnipresent as the corps of balloon, telegraph, and signal operators. They have threaded the weary stadia of every march; have hung on the skirts of every battle-scene; have caught the compassion of the hospital, the romance of the bivouac, the pomp and panoply of the field review—aye, even the cloud of conflict, the flash of the battery, the afterwreck and anguish of the hard-won field.[7]

Brady's men photographed every phase of the war that their technique could encompass: battlefields, ruins, officers, men, artillery, corpses, ships, railroads. There were over seven thousand negatives when peace was declared; the majority of them are now preserved in the National Archives of the United States and in the Library of Congress.

Brady appears to have been the first to undertake the photographic documentation of the Civil War, for the

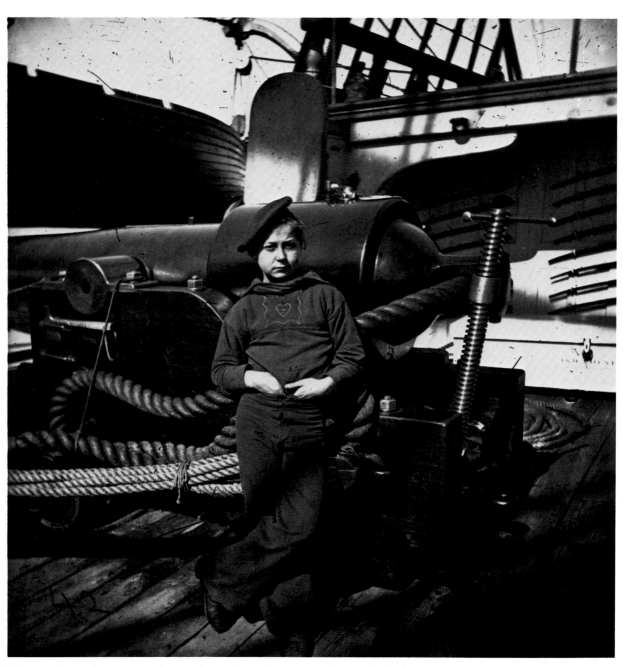

Photographer unknown. *Powder Monkey, "U.S.S. New Hampshire," off Charlestown, S.C.* ca. 1865. Gelatin-silver print from the original negative in The Library of Congress, Washington, D.C.

editor of *Humphrey's Journal of Photography* remarked in the issue of September 15, 1861, that Brady was planning to return to the front and was amazed that others had not followed his example. Soon cameramen by the score went to the battlefields. The Army of the Potomac alone issued passes to over three hundred of them.[8] Chief among Brady's cameramen were Alexander Gardner, in charge of the Washington Gallery since 1858, Timothy H. O'Sullivan, and George N. Barnard.

Gardner broke with Brady in 1863, and founded his own photographic corps, taking with him O'Sullivan and other photographers. The split was caused by Brady's unwillingness to credit his cameramen and his refusal to allow them to keep negatives taken on their own time. In 1865–66 Gardner published the two-volume *Photographic Sketch Book of the War,* containing 100 original prints, each accompanied by a page of text.[9] They contain some of the finest photographs of the Civil War. The names of the makers of the negatives and prints are meticulously recorded.[10]

George N. Barnard, who worked for a while in Brady's Washington Gallery and photographed for him the landmarks of the Battle of Bull Run after the Union armies recaptured that area of hostilities, was the official photographer for General W. T. Sherman in his campaign from Tennessee through Georgia and South Carolina. He published a collection of these photographs in 1866; they show battlegrounds, hastily thrown up fortifications, immense railroad bridges built by the Engineer Corps, and destruction in Atlanta.[11] There is a strange mixture in Barnard's photographs of the immediacy of the scenes of devastation and the romanticism of the landscapes, most of which were taken long after the cessation of hostilities.

Among the powerful pictures of the Civil War are the stiff and gruesome corpses strewn upon the battlefield, awaiting hasty burial during the short truces that followed each battle. An editorial in The New York *Times* for October 20, 1862, brings home to us the impact of these tragic documents:

BRADY'S PHOTOGRAPHS
PICTURES OF THE DEAD AT ANTIETAM

. . . Mr. Brady has done something to bring home to us the terrible reality and earnestness of war. If he has not brought bodies and laid them in our door-yards and along the streets, he has done something very like it. At the door of his gallery hangs a little placard, "The Dead

Photographer unknown. *Ruins of the Gallego Flour Mills, Richmond, Virginia.* 1865. Albumen print. The Museum of Modern Art, New York.

GEORGE N. BARNARD. *"Sherman's Hairpins."* 1864. Albumen print. The Museum of Modern Art, New York.

Brady wrote: "On the March to the Sea Sherman's Army burned the bridges and destroyed the rail road as they went . . . The rails are first torn up, then, the wooden ties are pried out and piled in heaps and burned; the iron rails are laid across the burning ties and soon get hot enough in the middle so that the weight of the ends bend the rails. Of course when they get cold they are simply good as 'old Iron.' "—Brady's *Lecture Book,* lantern slide No. 109, quoted in Roy Meredith, *Mr. Lincoln's Camera Man* (New York: 1946).

Photographer unknown. *Dead Confederate Soldier in Trench Beyond Cheveaux-de-frise, Petersburg, Virginia.* 1865. Gelatin-silver print from the original negative in The Library of Congress, Washington, D.C.

at Antietam." Crowds of people are constantly going up the stairs, follow them, and you find them bending over photographic views of that fearful battlefield, taken immediately after the action. . . .

These pictures have a terrible distinctness. By the aid of the magnifying-glass, the very features of the slain may be distinguished. We would scarce choose to be in the gallery, when one of the women bending over them should recognize a husband, son, or a brother in the still, lifeless lines of bodies, that lie ready for the gaping trenches. . . .

Corpses abound in battle paintings since the Renaissance. For the most part these dead are civilian figures; they are accessories, stage settings. But O'Sullivan's rifleman, lying in death, is a portrait. This man lived; this is the spot where he fell; this is how he looked at the very moment when he expired. Therein lies the great psychological difference between photography and the other arts; this is the quality that photography can transmit more strongly than can any other picture making. As Oliver Wendell Holmes put it:

The very things which an artist would leave out, or render imperfectly, the photograph takes infinite care with, and so renders its illusions perfect. What is the picture of a drum without the marks on its head where the beating of the sticks has darkened the parchment?[12]

The camera records what is focused upon the ground glass. If we had been there, we would have seen it so. We could have touched it, counted the pebbles, noted the wrinkles, no more, no less. However, we have been shown again and again that this is pure illusion. Subjects can be misrepresented, distorted, faked. We now know it, and even delight in it occasionally, but the knowledge still cannot shake our implicit faith in the truth of a photographic record.

The fundamental belief in the authenticity of photographs explains why photographs of people no longer living and of vanished architecture are so melancholy. Neither words nor the most detailed painting can evoke a moment of vanished time as powerfully and as completely as a good photograph.

In the unsettled days that followed the cessation of hostilities in America, many Civil War photographers followed the building of the transcontinental railroad and joined the semi-military survey parties of the army engineers. Combat photography had not only toughened them for the rigors of frontier travel, but it had also trained them to handle the troublesome wet-collodion technique under unfavorable conditions.

Alexander Gardner photographed the construction of the Eastern Division of the Union Pacific Railroad across Kansas from the Missouri River to its junction with the main line at Hays City. He then proceeded, apparently with a surveying party, on a southwestern course across Colorado, New Mexico, and Arizona to the Sierra Nevada—"1700 miles west of the Missouri," as he noted in the caption of a photograph of Tejon Pass in California. An album of albumen prints titled *Across the Continent on the Kansas Pacific Railroad* was published in 1868, the year when the railroad changed its name. The photographs not only document the construction of the railroad, but vividly present cross-country travel by wagon train.

Captain Andrew Joseph Russell was present at the historic moment on May 10, 1869, when the tracks of the Union Pacific Railroad met those of the Central Pacific at Promontory, Utah, and the last spike was driven. The Mormon photographer Charles R. Savage and Alfred A. Hart of Sacramento, were also on hand. Their photographs of "The Meeting of the Rails" were widely reproduced in such picture magazines as *Harper's Weekly* and *The Police Gazette*.

Photographers accompanied the government expeditions sent out to explore the territories. In *A Canyon Voyage*, Frederick S. Dellenbaugh described the photographic outfit as the terror of Major John Wesley Powell's exploration of the Grand Canyon in 1871:

The camera in its strong box was a heavy load to carry up the rocks, but it was nothing to the chemical and plate-holder box, which in turn was featherweight compared to the imitation hand organ which served for a darkroom. This dark box was the special sorrow of the expedition, as it had to be dragged up the heights from 500 to 3000 feet.[13]

Men would travel miles over back-breaking terrain and come back empty handed. Two of the photographers who had made a side trip to the Kanab Canyon did not get a single negative. "The silver bath had got out of order, and the horse bearing the camera fell off a cliff and landed on top of the camera, which had been tied on the outside of the pack, with a result that need not be described."[14]

The photographers were, successively, E. O. Beaman of New York City, who quit after eleven months in a dispute; James Fennemore of Salt Lake City, who became ill; and John K. Hillers, the party's oarsman, who had been trained in the field by both professionals. Hillers served as Powell's cameraman on the expeditions of 1873–79, and then was appointed Chief Photographer of the newly-formed United States Geological Survey.

Timothy H. O'Sullivan, one of the most daring of the war photographers, joined Clarence King's Geological Exploration of the Fortieth Parallel in 1867.[15] Seventeen civilians and twenty cavalry troops left San Francisco for the Great Salt Lake via the Sierra Nevada. Two mules and a packer were assigned to O'Sullivan. At Virginia City,

ALEXANDER GARDNER. *View Near Fort Harker, Kansas, 216 Miles West of Missouri River,* 1867. Albumen print. Collection Arnold H. Crane, Chicago.

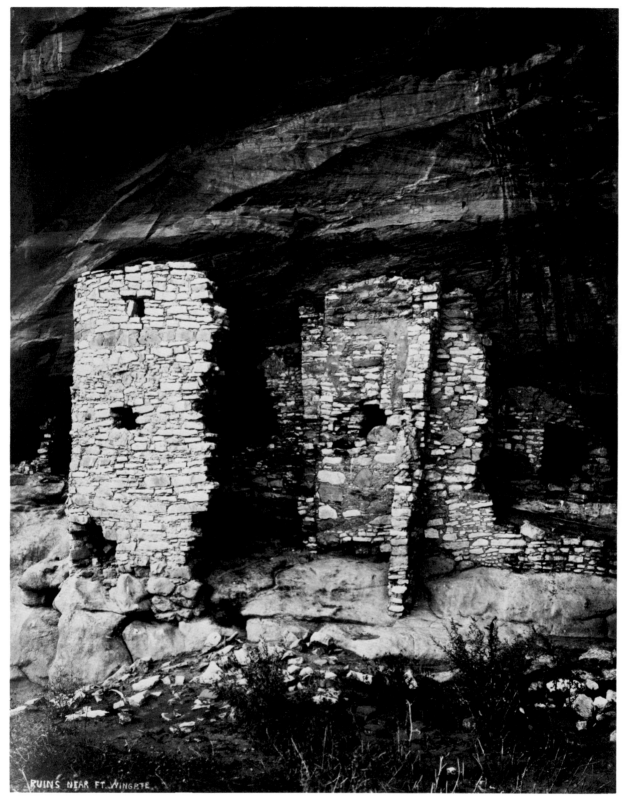

Above: JOHN K. HILLERS. *Ruins Near Fort Wingate, N.M.* 1879. Albumen print. The Museum of Modern Art, New York.

Opposite top: ANDREW J. RUSSELL. *Union Pacific Railroad West of Cheyenne, Wyoming.* 1867. Albumen print. The Museum of Modern Art, New York.

Opposite bottom: ANDREW J. RUSSELL. *Meeting of the Rails, Promontory Point, Utah,* 1869. Albumen Print. Union Pacific Historical Museum, Omaha, Nebraska.

E. O. BEAMAN. *The Heart of Lodore, Green River. Dinosaur National Monument, Colorado.* 1871. Gelatin-silver print from the original negative in archives of the U.S. Geological Survey, Denver.

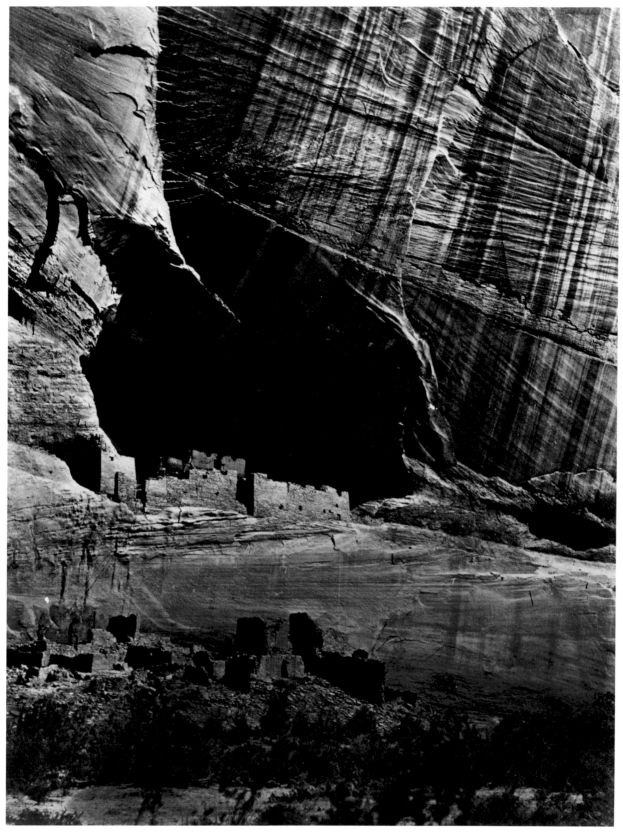

TIMOTHY H. O'SULLIVAN. *Ancient Ruins in the Cañon de Chelle, N.M. In a Niche 50 feet above Present Cañon Bed.* [Now the Canyon de Chelly National Monument, Arizona.] 1873. Albumen print, in *U.S. Geological Surveys West of the 100th Meridian, Photographs . . . of the Western Territory of the United States* (Washington, D.C.: 1874). The Museum of Modern Art, New York.

Nevada, he photographed hundreds of feet underground in the Comstock Lode mines by magnesium flare—dangerous and unpredictable anywhere, almost suicidal in mines where inflammable gas might be lurking. A later side trip took him into the desert sixty miles south of Carson Sink where, with the luxury of a darkroom in an ambulance drawn by four mules, he photographed the five-hundred-foot-high shifting sand dunes.

In 1870 O'Sullivan was in Panama, photographing for Commander Thomas Oliver Selfridge's Darien Expedition. The following year, when he joined 1st Lt. George Montague Wheeler in the Engineer Corps' Geological & Geographical Surveys & Explorations West of the 100th Meridian, O'Sullivan was probably the most experienced expeditionary photographer in the country. He was to find high adventure and magnificent material for his camera in the Southwest. The expedition's first sortie was an ascent of the Colorado River. In camp thirty-five miles below the present site of Boulder Dam, O'Sullivan made one of his finest views. In the foreground his boat, *Picture,* is drawn up to the bank, with the omnipresent black dark tent inside it. The waters of the Colorado appear deceptively smooth, due to the length of exposure; behind rise the dark and menacing profiles of Black Canyon. As the party passed through the area now submerged by Lake Mead the going became increasingly tough: ". . . . The boat party entered the jaws of the Grand Canyon, not knowing what was before them," Wheeler wrote. "Up to this time the rapids, though often very swift, had not been accompanied by heavy falls, and the estimate for the time to reach the mouth of the Diamond Creek [the rendezvous with the ground party] was based on our experience up to that time, which supposed due allowance for increasing difficulties."[16] Wheeler's papers were lost in an upset; at Camp 28, Starvation Camp, rations were so low that Wheeler guarded them personally, complaining to his diary that there was not enough to make even a decent pillow. After a month's trip the exhausted travelers reached Diamond Creek.

Some of O'Sullivan's finest photographs were made on the Survey's 1873 exploration of the area now known as the Canyon de Chelly National Monument in Arizona. The awe-inspiring scale of the Canyon is wonderfully sensed. One view was taken by brilliant, raking sunlight, which picks out every stratum of the Canyon wall. Two tiny figures pose on the famous White House ruins "in a niche 50 feet from the present Cañon bed," as the caption reads. Two other explorers stand among the lower ruins; one holds the rope by which the cliff was scaled.

William Henry Jackson joined the geologist Francis Vandiveer Hayden's Geological and Geographic Survey of the Territories in 1870. As a boy in Vermont he had been employed as "colorist" in photographic galleries. Restless for the West, he bullwhacked from Missouri across the Continent and then, in 1867, settled in Omaha, Nebraska, where he opened a studio with his brother. Omaha was a bustling railroad town, and portrait business was brisk, but Jackson found indoor work irksome, and left routine portrait sittings to his brother while he went out into the country, photographing Indians and the landscape. In 1869 he went out with his camera along the line of the newly completed transcontinental railroad, beginning at Promontory, where the lines met, and worked his way southeast to the vicinity of Salt Lake City. He took with him 300 glass plates, cameras, processing equipment, and two tents—one for his darkroom and one to sleep in. He covered some 120 miles in three months. These landscapes so impressed Hayden when he saw them that he invited Jackson to join the survey party. On the 1871 survey Jackson made many photographs of the Rocky Mountains, particularly the Yellowstone area, which, with its geysers and hot springs and grand scenery hardly seemed believable to those who had not made the arduous trip into the wilderness. At the end of his career Jackson recollected in his autobiography, *Time Exposure,* that his photographs "helped to do a fine piece of work: without a dissenting vote, Congress established the Yellowstone as a national park, to be forever set aside for the people. And on March 1, 1872, with the signature of President Grant, the bill became a law.[17]

Like most photographers, Jackson took several cameras into the field, partly as insurance against accidents and partly to make a variety of negative sizes. Although enlarging was possible, contact printing was much preferred, particularly when quantities of prints were needed for distribution. The very expanse of western scenery demanded photographs large in size. In 1875 Jackson astounded the photographic world by packing a camera for 20 x 24-inch plates up the Rocky Mountains. He recorded twelve of these huge negatives in the official government catalog: "These are the largest plates ever used in field photography in this country. They convey an impression of the real grandeur and the magnitude of mountain scenery that the smaller views cannot possibly impart."

The editor of *The Philadelphia Photographer* praised these mammoth views:

An examination of these pictures fills us with admiration and amazement. Admiration for this magnificent scenery of our own country, which is scarcely excelled by that of any other, and for the wonderfully successful work of this mammoth size, each picture of which is a study in its composition, its lighting and general grandeur of effect produced by its breadth and perspective. Amaze-

THE BEE HIVE GROUP OF GEYSERS
YELLOWSTONE PARK

WILLIAM HENRY JACKSON. *The Beehive Group of Geysers, Yellowstone Park,* 1872. Albumen print. Denver Public Library, Western History Department, Denver.

THE ILLUSTRATED CHRISTIAN WEEKLY.

VOL. II. NO. 48. NEW YORK, SATURDAY, NOVEMBER 30, 1872. PRICE SIX CENTS.

ENTERED, ACCORDING TO ACT OF CONGRESS, IN THE YEAR 1872, BY THE AMERICAN TRACT SOCIETY, IN THE OFFICE OF THE LIBRARIAN OF CONGRESS, AT WASHINGTON.

GEYSERS ON THE YELLOWSTONE RESERVATION. DRAWN BY H. BISBING. SEE PAGE 573.

Geysers on the Yellowstone Reservation. Drawn from photographs by William Henry Jackson. From the *Illustrated Christian Weekly*, November 30, 1872.

WILLIAM HENRY JACKSON. *The Photographer's Assistants.*
1891. Albumen print. University Art Museum, University
of New Mexico, Albuquerque.

ment that such work could be executed in the wild
regions of the Rocky Mountains, from almost inaccessi-
ble positions, whence everything had to be carried on
pack-mules, and much of the work done under circum-
stances of the greatest disadvantage. Most photographers
consider the manipulation of 20 x 24 plates formidable
enough under the most favorable conditions . . . but Mr.
Jackson has proved himself a master, not only of the
principles of art which govern such work, but of every
circumstance or condition which may in any way affect
his success in producing the grandest results photogra-
phy is capable of.[18]

Jackson, despite his proud boast, was not alone in the
use of large plates. The spectacular landscape of Yosemite
Valley in Northern California had already been exten-
sively photographed by Carleton E. Watkins and Ead-
weard Muybridge with cameras of almost equal size.

Photographic expeditions were undertaken all over
the world. Désiré Charnay, a French archaeologist, pho-
tographed the pre-Columbian ruins of Mexico and Yuca-
tán in 1857, and native life on the island of Madagascar
six years later. Samuel Bourne climbed the Himalayas
with a train of thirty coolies bearing the baggage and
photographic equipment to an altitude of 15,000 feet in
1863. The brothers Louis Auguste and Auguste Rosalie
Bisson went from Paris to Switzerland with Napoleon III
and the Empress Eugénie and produced a dazzling series
of photographs of the Alps in 1860. Francis Frith[19] went
from London to Egypt and the Holy Land year after year;
in 1858 he made a series of 16 x 20-inch plates in the
desert under the most trying conditions. Francis Bedford
was selected by Queen Victoria to accompany the Prince
of Wales in his tour of the Middle East in 1862. William
Stillman photographed the Acropolis in Athens in detail.
Thousands of negatives of the goldfields of Australia
were made by Henry Beaufoy Merlin and his successor
Charles Bayliss.

Nor was the Far East overlooked by cameramen. The

English traveler John Thomson, Fellow of the Royal
Geographical Society, spent several years photographing
in Cambodia, Malaya, and China. He was concerned not
only with the scenery and the monuments of ancient
civilizations, but with the manners and customs of the
inhabitants: his four-volume *Illustrations of China and
Its People* (London, 1873) is a remarkable ethnographic
survey—a pioneering photographic documentation.[20]

On his return to England Thomson photographed in a
similar spirit the London poor. Thirty-six of his photo-
graphs were published in *Street Life in London* (1877),
with a detailed sociological text by Adolphe Smith. The
reproductions were by the woodburytype process (Chap-
ter 14), which gave them a fidelity matching that of the
original photographs: they are charged with a sense of
authenticity that gives them great impact.

In their preface Thomson and Smith state that they
brought to bear "the precision of photography in illus-
tration of our subject. The unquestionable accuracy of
this testimony will enable us to present true types of
the London Poor and shield us from the accusation of
either underrating or exaggerating individual peculiari-
ties of appearance."[21]

As the major cities of Europe grew in size in the second
half of the nineteenth century, extensive urban renewal
plans were put into effect, which necessitated the ex-
tensive demolition of structures long standing and often
of historical significance. In Paris, London, and Glasgow
photographic surveys were organized to record the archi-
tectural heritage that was doomed for destruction. Of
these surveys, the most complete was the systematic street-
by-street documentation of vast areas in the very heart
of old Paris that Baron George Eugéne Haussmann, pre-
fect of the Seine, had ordered razed to the ground to
allow the construction of public buildings, parks, and the
"grands boulevards" that so distinguish modern Paris.
Charles Marville, who had used the calotype when record-
ing medieval buildings for the Committee of Historical
Monuments a decade earlier, now, in 1864–65, used collo-
dion plates. His photographs are meticulously detailed;
he captured the very texture of cobblestoned streets, and
weathered walls, signboards of shops and their wares.

Thomas Annan of Glasgow was commissioned in 1868
by the Trustees of the Glasgow City Improvements Act
to photograph the picturesque but unsavory and un-
healthy narrow passageways between multistoried build-
ings called "closes" in Old Glasgow that had become
slums. The Society for Photographing Old London was
formed for a similar purpose; between 1874 and 1886
it issued to its members 120 photographs printed by
Henry Dixon from his own negatives and those of Alfred
and John Boole.

CARLETON E. WATKINS. *El Capitan (3600 feet) from the Foot of the Mariposa Trail, Yosemite, California.* ca. 1865. Albumen print. The Museum of Modern Art, New York.

LOUIS BISSON & AUGUSTE BISSON. *The Alps: View of "The Garden" from Mont Blanc.* 1860. Albumen print, in the album *Le Mont Blanc et ses glaciers* (Paris: 1860). George Eastman House, Rochester, N.Y.

FRANCIS FRITH. *The Pyramids of Dahshur, Egypt.* 1858. Albumen print. George Eastman House, Rochester, N.Y.

Millions of photographs were taken of familiar landscapes, cities, towns, villages, historical landmarks, ancient churches, and new public buildings with no other purpose than their sale to tourists. In the days before the snapshot camera and the printed postcard, travelers collected albumen prints of all the "sights" they wished to remember, and pasted them in albums.

The photographers who specialized in making these views often found the demand so great that they established publishing companies, with camera teams in the field and a large staff manning the printing works at home. In England Francis Frith opened the largest of these picture factories in 1860, on his return from Egypt. At his Reigate factory he had a stock of more than a million prints. Similar publishing companies were established in Scotland by George Washington Wilson and James Valentine. Contact prints on gold-toned albumen paper were made in vast quantities: over a thousand 18 x 24-inch sheets of paper were sensitized in every working day. As many as 1300 printing frames, each with a glass negative and a sheet of sensitized paper of the same size pressed against it, were put on racks and wheeled out on tracks into the sunlight. If it suddenly rained, they could be quickly housed. At Wilson's Printing Works in Aberdeen the racks covered half an acre. The exposures varied with the intensity of the sunlight

and the density of the negative; Wilson's son recollected that the time varied from 15 to 20 minutes to two *days,* and he estimated the average daily production at 3000 prints. Toning, fixing, washing, and drying were done by separate departments. Thus the production could reach a million a year.[22]

The concern of Frith, Wilson, Valentine, and a host of other photographers the world over with the literal, straightforward representation of the most characteristic aspects of places and things has been called "topographic." In the 1860s the term "mechanical-photography" was used by Jabez Hughes to differentiate this approach from that of those photographers whose aim was aesthetic and who found photography a means of personal expression, beyond record making for commercial purposes. He explained:

Let it be understood that I do not mean the term *mechanical* to be understood depreciatingly. On the contrary, I mean that everything that is to be depicted exactly as it is, and where all the parts are to be equally sharp and perfect, is to be included under this head. I might have used the term *literal* photography, but think the former better. This branch, for obvious reasons, will always be the most practised; and where the literal unchallenged truth is required, is the only one allowable.[23]

Typical topographical photographs are almost always technically excellent, with brittle-sharp detail, full tonal

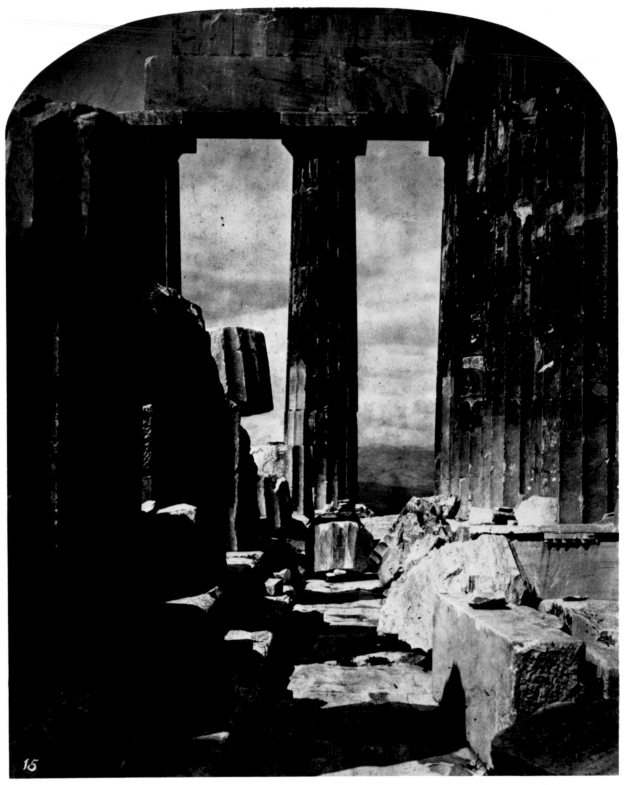

WILLIAM JAMES STILLMAN. *The Parthenon, Athens.* 1869. Carbon print in the album *The Acropolis of Athens* (London: 1870). The Museum of Modern Art, New York.

JOHN THOMSON. *Physic Street, Canton*. ca. 1868. Carbon print in *Illustrations of China and Its People* (London: 1873). Peabody Museum, Salem, Mass.

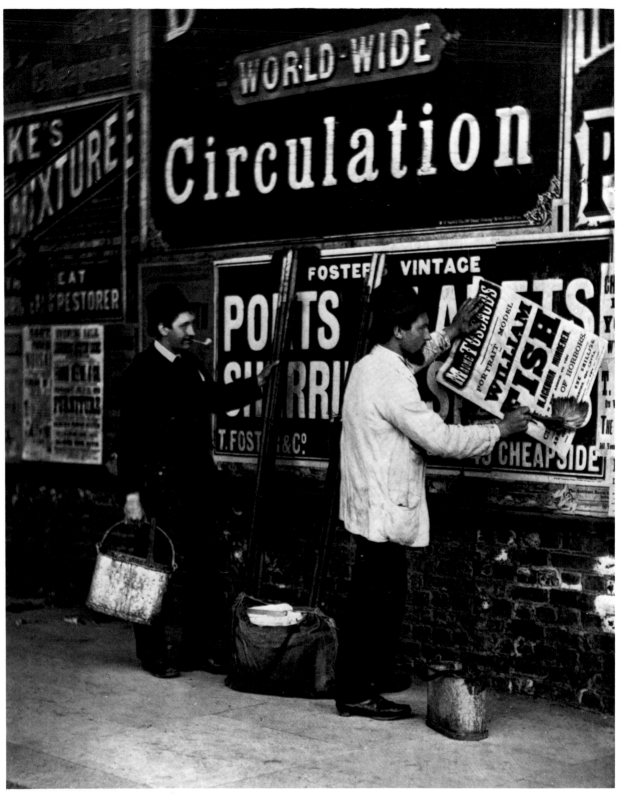

JOHN THOMSON. *Street Advertising.* ca. 1877. Woodburytype in *Street Life in London* (London: 1877). The Museum of Modern Art, New York.

CHARLES MARVILLE. *Rue Glatigny, Paris.* 1865. Albumen print. Formerly Collection V. Barthélemy, Paris.

NADAR. *The Arc de Triomphe and the Grand Boulevards, Paris, from a Balloon.* 1868. Gelatin-silver print from the original negative in the Caisse Nationale des Monuments Historiques, Paris.

rendition, and often with skillfully printed-in clouds from separate negatives. The title of each view was printed on each negative so that white lettering inpinged on the bottom of the image.

For the most part the photographs of these publishing houses are dull, commonplace records, indistinguishable in style regardless of the photographer who took them, (whose name was seldom credited). But now and then appear remarkable street scenes, lyric views of the countryside, and well-seen architectural interiors. When picture postcards came into vogue, Frith and Valentine published them by the thousand. Indeed, only recently have the firms these photographers founded gone out of business.

A similar commercial production was followed in America by William Henry Jackson. After leaving the United States government surveys he founded the W. H. Jackson Photograph and Publishing Company in Denver in 1883, which was merged with the Detroit Publishing Company in 1897, when Jackson joined the firm and transferred to it his entire stock of negatives. Which of

the thousands of photographs marked W. H. Jackson and Company were taken by Jackson himself is not a matter of record.

Photographs of the engineering accomplishments of the industrial age are frequent, especially in Britain, where Philip Henry Delamotte recorded the reconstruction of the Crystal Palace in Sydenham in 1853–54, Robert Howlett photographed the launching of the *Great Eastern* steamship in 1857, and James Mudd produced a photographic inventory of locomotives built by the Manchester firm of Beyer-Peacock in the same period.

Photographers took the camera into the air to record the earth from above as early as 1858, when Nadar made his first photograph from a balloon over the village of Petit Bicêtre, just outside Paris. It was a collodion positive, made with great difficulty, as the fumes of gas escaping from the balloon contaminated the sensitizing bath. Unfortunately, it no longer exists. James Wallace Black of Boston had better success: he made several views of that city and of Providence, Rhode Island, in 1860; a few years later Nadar took a multilens camera up in a balloon over Paris to make the first successful photographs of that city.

Almost all of the photographers discussed in this chapter took stereographs as well as the larger single negatives. The paired images made with a twin-lens camera produce a startling three-dimensional illusion when viewed through a stereoscope, and reveal that wealth of information that is essential to a record photograph.

The stereograph creates its dramatic effect because it reproduces binocular vision. Normally we see the world with both of our eyes. The image formed on the retina of each eye is very slightly different, due to its position in space: the fusion of the two in our mind is an important part of our perception of the relative distance of objects from us. Sir Charles Wheatstone, in a classic study published by the Royal Society in London in 1838, clearly described this phenomenon, and he illustrated his report in the Society's *Philosophical Transactions* with outline drawings of solid geometrical forms in the perspective in which they would be seen by each eye. He placed these drawings in an instrument he designed that he called the *stereoscope.*

Looking into the mirrors Wheatstone saw "instead of a representation on a plane surface . . . a figure of three dimensions, the exact counterpart of the object from which the drawings were made.[24] For purposes of demonstration, he used outline drawings,

for had either shading or colouring been introduced it might be supposed that the effect was wholly or in part due to these circumstances, whereas by leaving them out of consideration no room is left to doubt that the entire effect of relief is owing to the simultaneous perception

PHILIP HENRY DELAMOTTE. *The Upper Gallery of the Crystal Palace, Sydenham, England.* ca. 1853. Salted paper print. Gernsheim Collection, Humanities Research Center, University of Texas, Austin.

JAMES MUDD. *Industrial Shunting Engine Built by Beyer-Peacock, Manchester, England.* 1858. Gelatin-silver print from original negative in the North Western Museum of Science and Industry, Manchester, England.

ROBERT HOWLETT. *Isambard Kingdom Brunel, Builder of the Steamship "Great Eastern," Standing Against the Launching Chains.* 1857. Albumen print. George Eastman House, Rochester, N.Y.

CHARLES CLIFFORD. *Armor.* ca. 1857. Albumen print. The Museum of Modern Art, New York.

The Wheatstone Stereoscope. From *Transactions of the Royal Society of London*, vol. 129 (1838), Plate, XI.

A'A: Mirrors, set at right angles to each other. *E'E:* Drawings of a truncated pyramid. When the viewer looks at mirror *A* with the right eye, drawing *E* is seen; with the left eye, drawing *E'*.

The Brewster Stereoscope. From D. Brewster, *The Stereoscope* (London: 1856).

AB, stereo slide. *S*, slot in which to insert mounted photographs. *RL*, lenses for the right and left eyes. *CD*, door, opened to allow light to fall on photographs.

The Holmes Stereoscope. From *Photographer's Friend* (Philadelphia), April 1872.

of the two monocular projections, one on each retina. But if it be required to obtain the most faithful resemblances of real objects, shadowing and colouring may properly be employed to heighten the effects. Careful attention would enable an artist to draw and paint the two component pictures, so as to present to the mind of the observer, in the resultant perception, perfect identity with the object represented. [25]

But such exact draftsmanship, however theoretical, was difficult to attain. With timing so precise that it is difficult to dismiss it as coincidental, photography provided the means of fulfilling this prediction. Wheatstone later wrote: "It was at the beginning of 1839, about six months after the appearance of my memoir in the *Philosophical Transactions,* that the photographic art became known. Soon after, at my request, Mr. Talbot, the inventor, and Mr. [Henry] Collen (one of the first cultivators of the art) obligingly prepared for me stereoscopic Talbotypes of full-sized statues, buildings, and even portraits of living persons.[26] These first photographic stereographs have not yet been found, but some were exhibited at the Royal Academy of Science in Brussels in 1841.

Stereoscopic photography did not become practical until Sir David Brewster invented in 1849 a less cumbersome device for viewing them. Basically his stereoscope was a box in the form of a truncated pyramid.

At the small end he put two lenses, each of about 6 inches focal length. At the other end was a frame, to hold two photographs, each approximately 3 x 3 inches in size and mounted side by side. The bottom of the box was of frosted glass so that transparencies could be viewed by refracted light. Daguerreotypes and paper prints were viewed by light admitted by opening a small door, its inner surface silvered.

The lenses were wedge-shaped, forming prisms that so diverged the line of vision that each picture was seen in full frame, even though they were separated by more than the distance between the eye pieces.

Brewster's stereoscope was mass produced by the Parisian optical and scientific instrument firm of Duboscq & Soleil. They placed one on display at the London Crystal Palace exhibition in 1851, with a set of daguerreotypes taken by Jules Duboscq. The public marveled: Queen Victoria was personally so enthusiastic that Brewster presented to her a specially built viewer; at once stereo photography became immensely popular. Brewster boasted:

It has been estimated that upwards of half a million of these instruments have been sold. . . . Photographers are now employed in every part of the globe in taking binocular pictures for the instrument—among the ruins of Pompeii and Herculaneum—on the glaciers and in the valleys of Switzerland—among the public monuments in the Old and the New World—amid the shipping of our commercial harbours—in the museums of ancient and

NO. 49.—PONT NEUF, À PARIS.—VUE INSTANTANÉE.—(NO. 2.)

Photographer unknown. *The Pont Neuf in Paris.* ca. 1860. Albumen prints from a stereographic negative. Collection Beaumont Newhall, Santa Fe.

modern life—in the sacred precincts of the domestic circle. . . .[27]

Firms began to specialize in the mass production and world distribution of stereographs. The first of these publishers appears to be The London Stereoscopic Company, founded in 1854 by George Swan Nottage; in the single year 1862 they sold a million views. The collecting of stereographs became a craze, and—until the advent of photographically illustrated magazines at the end of the century—there was, it seemed, a stereoscope in every home. Oliver Wendell Holmes, the American writer and physician, was an ardent collector. He wrote eloquently about the process in *The Atlantic Monthly,*[28] and around 1860 he designed a new type of stereoscope. Although based on Brewster's lenticular optics, it was more convenient; it was mass produced by Joseph L. Bates of Boston.

It is remarkable that throughout its history stereography has not appealed to photographers as an artistic medium. Its very virtue, that of creating an astonishing illusion of depth, is felt to be too close to reality. J. Craig Annan, a leader in the pictorial movement, remarked in 1892:

The stereoscopic effect is an endeavor to imitate nature, while the object of an ordinary photograph, or drawing is only to reproduce an impression of nature. The failure of the stereoscope in its greater aim is more marked than the less ambitious but more practical endeavour to reproduce on a flat surface an impression of what we see.[29]

But if the stereograph did not appeal to those to whom the aesthetic of the conventional graphic arts was the goal, it was the ideal technique for recording visual information, and its finest practitioners were to be found in the army of amateur and professional photographers who delighted in the very look of the world. It is an image, not a picture.

A unique property of the stereoscopic image is its apparent size. When properly fused, the paired photographs no longer seem three-inch-square prints, but a single image as large as life.

Because of the small negative size, the lenses of stereo cameras could be of relatively short focal length. This made it possible to take stereographs of moving objects.

The focal length of a lens is a fixed characteristic that determines the point at which a sharp image will be formed of an extremely distant object. Imagine the light ray from a distant point as a lever, which is pivoted where it passes through the lens, and which continues until it forms an image. When the point at one end of the lever moves, its image at the other end moves; the shorter the arm of the lever behind the lens (a distance determined by the focal length), the less the image moves. Consequently, by using a short focal length lens the motion of the image of a moving object can be reduced on the plate to a degree so negligible that during the brief time the lens is open no appreciable blur will be produced.

Stereographs of the late 1850s first showed us, in what were called "instantaneous views," phases of action in the stride of animals and humans never before seen. Photographers were learning how to record even the most fleeting motion.

115

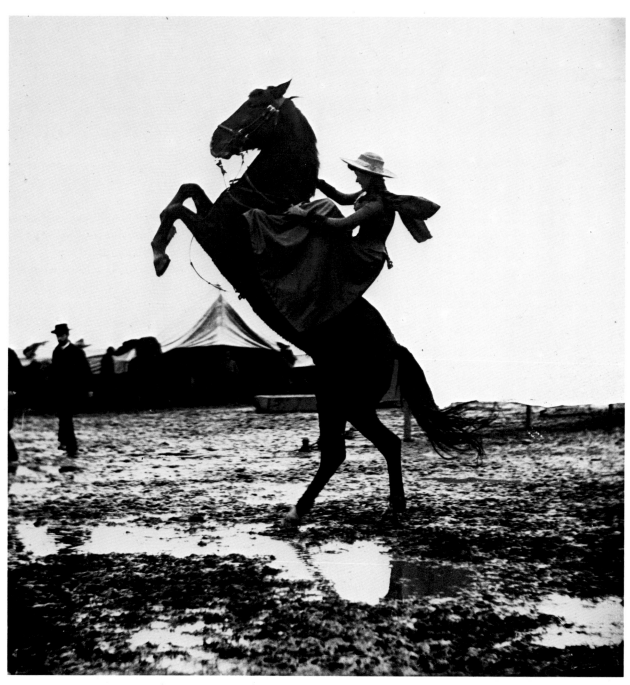

COUNT GIUSEPPE PRIMOLI. *Annie Oakley, Buffalo Bill's Wild West Show, on Tour in Rome.* 1890. Gelatin-silver print. Fondazione Primoli, Rome.

8 · THE CONQUEST OF ACTION

In the earliest photographs action was not recorded. The almost universal praise of Daguerre's first work was tempered with the criticism that in depicting motion he was far less successful than in recording architecture. Indeed one critic went so far as to state in 1839 that moving objects "can never be delineated without the aid of memory."[1]

Outdoors, in brilliant sunlight, "instantaneous" photographs were occasionally taken, but they were the exception. In *A Manual of Photographic Manipulation* (1858) Lake Price said:

If there is one direction more than another in which we may look for greater artistic excellence and interest to be imparted to the photographic picture it will be by the process being so much accelerated by optical and chemical improvements, that any dimension and class of picture may be taken *instantaneously:* nor need we despair of witnessing this result, when we see what progress a few past years have brought with them to this art Views in distant and picturesque cities will not seem plague-stricken, by the deserted aspect of their streets and squares, but will appear live with the busy throng of their motley population.[2]

The first photographs in which action was stopped with more or less regular assurance were stereoscopic views of city streets, peopled with minute figures of pedestrians. In 1859 George Washington Wilson photographed people walking on Princes Street, Edinburgh, and in the same year Edward Anthony made a remarkable series of instantaneous stereographs of traffic in New York, some of which were even taken on a rainy day. He sent samples to Thomas Sutton, the editor of the British magazine *Photographic Notes,* with a letter dated August 29, 1859, asking: "If you have any specimens of similar results obtained in Europe, we should be pleased to hear how they compare."[3] Sutton answered in his magazine: ". . . we can only say we know of no pictures, save two or three of Mr. Wilson's best, which could be put in comparison with those he has sent,"[4] and Wilson himself wrote: "Anthony's pictures are much quicker than mine, and I must get some sort of shutters to open and shut quickly."[5] Extremely detailed glass stereoscopic transparencies were made in 1860 in Paris by Claude-Marie

Ferrier, A. Ferrier, and Charles Soulier. When they were exhibited in Paris they were hailed by the *Photographic News* as,

the most perfect things of the kind ever produced Not one of a thousand figures of all kinds, foot passengers and vehicles passing in all directions, shows the slightest sign of movement or imperfect definition. Figures standing in the shadows of porticos are all perfectly rendered, although the exposure was but the imperceptible fraction of a second.[6]

To Oliver Wendell Holmes photographs such as these proved invaluable in the study he was making of how man walks. As a physician he was deeply concerned with the problem of designing artificial limbs for those Civil War soldiers who had been maimed upon the battlefield. He tells, in *The Atlantic Monthly* of May 1863, of basing his theory on

a new source, accessible only within the last few years and never, so far as we know, employed for its elucidation, namely the instantaneous *photograph.* . . . We have selected a number of instantaneous stereoscopic views of the streets and public places of Paris and New York, each of them showing numerous walking figures, among which some may be found in every stage of the complex act we are studying.[7]

The article was illustrated with wood engravings drawn by Felix O. C. Darley directly from photographs. Holmes found the attitudes in these pictures startlingly different from the conventions that had been used for centuries: he called attention to the length of stride and to the almost vertical position of the sole of the foot in one of the figures. Of another, showing a leg suspended in midair, he remarked: "No artist would have dared to draw a walking figure in attitudes like some of these."[8]

Perhaps it was not so much dare as do, for the eye alone cannot detect attitudes that exist for mere fractions of a second. This inadequacy of human vision was even more convincingly demonstrated a decade later, when Eadweard Muybridge, through his photographs, showed the world how a horse gallops.

Former governor of California Leland Stanford owned a string of race horses and was especially proud of his trotter "Occident." According to the San Francisco *Alta*

EDWARD ANTHONY. *A Rainy Day on Broadway, New York.* 1859. Albumen print (one half of a stereo-graph). George Eastman House, Rochester, N.Y.

of April 7, 1873,

he wanted his friends abroad to participate with him in the contemplation of the trotter "in action," but did not exactly see how he was to accomplish it until a friend suggested that Mr. E. J. Muybridge be employed to photograph the animal while trotting. No sooner said than done. Mr. Muybridge was sent for and commissioned to execute the task, though the artist said he believed it impossible. . . .

Muybridge, whose large photographs of Yosemite Valley were world famous, was born in Kingston-on-Thames, England, in 1830. He had taken the strange name Eadweard Muybridge in the belief that it was the Anglo-Saxon original of his real name, Edward James Muggeridge. In California he photographed the Pacific Coast for the government, accompanied the official expedition to Alaska when that territory was acquired from Russia in 1867, and became a specialist in industrial photography. In 1869 he invented one of the first shutters for a camera. His experience was to serve him in good stead. The *Alta* reporter continued:

All the sheets in the neighborhood of the stable were procured to make a white ground to reflect the object, and "Occident" was after a while trained to go over the white cloth without flinching; then came the question how could an impression be transfixed of a body moving at the rate of thirty-eight feet to the second. The first experiment of opening and closing the camera on the first day left no result; the second day, with increased velocity in opening and closing, a shadow was caught. On the third day, Mr. Muybridge, having studied the matter thoroughly, contrived to have two boards slip past each other by touching a spring, and in so doing to leave an eighth of an inch opening for the five-hundredth part of a second, as the horse passed, and by an arrangement of double lenses, crossed, secured a negative that shows "Occident" in full motion—a perfect likeness of the celebrated horse.

The experiments were interrupted when Muybridge was tried in 1874 for murdering his wife's lover; although he was acquitted, he left the country and the work for Stanford was dropped.

In 1877 Muybridge was able to resume work, with success enough to encourage him to send a photograph to the editor of the *Alta* with a letter explaining that it "was made while 'Occident' was trotting past me at the rate of 2.27, accurately timed . . . the exposure . . . being less than 1/1000 part of a second. . . .The picture has been retouched, as is customary at this time with all first-class photographic work, for the purpose of giving a better effect to the details. In every other respect the photograph is exactly as it was made in the camera."[9] The retouching was unfortunate, for the authenticity of the photograph was immediately questioned. So he began all over again, using a battery of cameras rather than a single one.

Beside the race track Muybridge ranged twelve cameras, each fitted with a shutter working at a speed he claimed to be "less than the two-thousandth part of a second."[10] Strings attached to electric switches were stretched across the track; the horse, rushing past, breasted the strings and broke them, one after the other; the shutters were released by an electromagnetic control, and a series of negatives made. Though the photographs were hardly more than silhouettes, they clearly showed that the feet of the horse were all off the ground at one phase of the gallop—but, to the surprise of the world, only when the feet were bunched together under the belly. None of the horses photographed showed the "hobbyhorse attitude"—front legs stretched forward and hind legs backward—so traditional in painting. The photographs looked absurd.

They were widely published in America and Europe. The *Scientific American* printed eighteen drawings from

Drawings from instantaneous photographs to illustrate an article on human locomotion by Oliver Wendell Holmes in *The Atlantic Monthly Magazine,* May 1863.

EADWEARD MUYBRIDGE. *Galloping Horse.* 1878. Albumen print. George Eastman House, Rochester, N.Y.

ETIENNE JULES MAREY. *Measuring the Speed of a Swordthrust by Means of Photochronography.* ca. 1890. From *La Nature,* October 11, 1890.

Muybridge's photographs on the first page of its October 19, 1878 issue. Six of them showed "Abe Edgerton" walking: the remaining twelve were of the same horse trotting. Readers were invited to paste the pictures on strips and to view them in the popular toy known as the *zoetrope,* a precursor of motion pictures. It was an open drum with slits in its side, mounted horizontally on a spindle so it could be twirled. Drawings showing successive phases of action placed inside the drum and viewed through the slits were seen one after the other, so quickly that the images merged in the mind to produce the illusion of motion. The editor wrote: "By such means it would be possible to see not only the successive motions of a trotting or running horse, but also the actual motions of the body and legs in passing through the different phases of the stride."

In 1880, using a similar technique with a device he named the *zoogyroscope,* or *zoopraxiscope,* Muybridge projected his pictures on a screen at the California School of Fine Arts, San Francisco.[11] Motion pictures were born.

Etienne Jules Marey, a French physiologist who had been specializing in the problem of locomotion, was inspired by Muybridge's work to invent in 1883 a single camera that would take a series of exposures on a single plate. He clothed men in black, painted white lines along their arms and legs, and had them run or walk against a black background while many exposures were made on the same plate. The result was a linear graph of the motion of arms and legs. He later devised a camera with a moving plate, so that each exposure was a separate picture.

The American realist painter Thomas Eakins was greatly impressed by Muybridge's horse photographs. He owned a set of the published prints, from which he made lantern slides for teaching purposes at the Pennsylvania Academy of the Arts. In 1879 he painted *A May Morning in the Park,* showing the four-in-hand of his friend and patron Fairman Rogers; the attitudes of the sixteen legs of the four horses pulling the coach he calculated from the Muybridge photographs. Rogers, who was equally impressed by them, invited Muybridge to give some lecture-demonstrations in Philadelphia. They were so enthusiastically received that the provost of the University of Pennsylvania offered Muybridge—for an advance of $5000—a contract to continue his work under the University's auspices in Philadelphia. The offer was accepted, a commission was formed, and Eakins was named as the supervisor of the project. With the help of Muybridge, Eakins devised a camera similar to Marey's, with a single lens and a movable plate: thus he could secure sequential images of athletes in action.

Between the spring of 1884 and 1885 Muybridge took

EADWEARD MUYBRIDGE. *Pole Vaulter.* 1885. Gelatin-silver print from the original negative in The Museum of Modern Art, New York.

some 30,000 negatives with perfected equipment. The shutters were now controlled by clockwork, so that exposures could be made at any desired interval; three cameras, each with thirteen lenses (one for viewing, twelve for taking) were used to photograph from side, front, and rear; and, most importantly, the newly perfected gelatin dry plate made it possible for him to secure well-detailed images at short exposure times.

The results of Muybridge's labors were published in 1887 in the form of 781 collotype plates; they were sold separately, or bound in eleven volumes with the title *Ani-*

EADWEARD MUYBRIDGE. *Head-spring, a Flying Pigeon Interfering.* 1885. Plate 365, *Animal Locomotion* (Philadelphia: 1887). Albumen print from original master negative in George Eastman House, Rochester, N.Y.

mal Locomotion. In addition to horses, animals of all kinds were borrowed from the Philadelphia zoo for photographing. But the most significant work was the human figure. Male and female models, nude and draped, were photographed in all manner of activity—walking, running, laying bricks, climbing stairs, fencing, jumping. Muybridge even photographed one girl throwing a bucket of water over another girl's shoulders, and a mother spanking a child. His specific intention was to create an atlas for the use of artists, a visual dictionary of human and animal forms in action.

Similar action photographs were being made at the same time in the city of Lissa (now Leszno, Poland) by Ottomar Anschütz. His earliest instantaneous photographs, of military maneuvers and animals, were taken with a camera of his own design, fitted with a focal plane shutter that permitted extremely short exposures. His pictures of storks in flight astounded the photographic world in 1884. He devised a sequence camera and made series photographs of men and animals that he exhibited in motion in a viewing device he called a *Tachyscope.* Transparencies of the photographs were mounted on the periphery of a large disk that revolved continuously behind the lens of a projector. As each picture moved into position opposite the lens, an electric flash from a Geissler tube threw its image on a small viewing screen.

The evidence of the photographs taken by Muybridge and the other pioneers whom he inspired shook the artis-

tic world. The attitudes of the horse in gallop were disbelieved. To show the wheels of a moving vehicle with each spoke distinct seemed absurd. Joseph Pennell, the American etcher, lithographer, and illustrator, told the members of the London Camera Club that,

if you photograph an object in motion, all feeling of motion is lost, and the object at once stands still. A most curious example of this occurred to a painter just after the first appearance in America of Mr. Muybridge's photographs of horses in action. This painter wished to show a drag coming along the road at a rapid trot. He drew and redrew, and photographed and rephotographed the horses until he had gotten their action apparently approximately right. Their legs had been studied and painted in the most marvellous manner. He then put on the drag. He drew every spoke in the wheels, and the whole affair looked as if it had been instantaneously petrified or arrested. There was no action in it. He then blurred the spokes, giving the drag the appearance of motion. The result was that it seemed to be on the point of running right over the horses, which were standing still.[12]

There is little doubt that Pennell was referring to Eakins's *A May Morning in the Park,* for the painting corresponds exactly to the description. The case of the "frozen" wheel continued to bother photographers themselves. The photographic scientist W. de W. Abney preferred the "fuzzy mass of wool-like matter radiating from the center,"[13] as drawn by John Leech, the *Punch* artist. He concluded that instantaneous photographs were untrue and artistically incorrect; the strange positions often as-

sumed in them by men and animals could, he said, be seen by the eye only if the scene were illuminated by a flash of lightning, and he counseled photographers to represent only those phases of action that approach those of rest. P. H. Emerson, artist-photographer, found "nothing more inartistic than some positions of a galloping horse, such as are never seen by the eye, but yet exist in reality, and have been recorded by Mr. Muybridge."[14]

The gelatin plates that Muybridge used in his later experiments evolved from the increasing demand for dry plates that would eliminate the need for processing immediately after exposure. The first thought was to add a hygroscopic substance, such as honey, sugar, raspberry syrup, glycerine, or even beer to the collodion in an effort to delay its drying and thus to postpone the need for on-the-spot development. Then in 1864 B. J. Sayce and W. B. Bolton showed how the silver bath could be eliminated by coating the glass plate with an emulsion of collodion mixed first with ammonium and cadmium bromide and then with silver nitrate. Such plates could be used while dry; they could be manufactured, and the photographer need no longer be his own plate maker.

The Liverpool Dry Plate and Photographic Printing Company began to put these *collodio-bromide* dry plates on the market in 1867. But the convenience of being able to dispense with the wet-plate paraphernalia was gained at the expense of a pronounced loss of sensitivity. Sayce and Bolton noted that their first plates required an exposure of 30 seconds at a lens setting equivalent to $f/24$. The manufacturers stated that exposures with these dry plates averaged three times that of wet plates.

In 1871 the *British Journal of Photography* published a letter from a physician, Richard Leach Maddox, describing an emulsion made of gelatin, which the editor pronounced to be "the driest of the dry processes."[15] Maddox soaked gelatin in water, added cadmium bromide in solution and then silver nitrate; these chemicals reacted to form silver bromide crystals suspended in the gelatin. This emulsion was flowed on glass and allowed to dry. Maddox stated that he had been unable, because of the pressure of his medical practice, to perfect his experiment, and urged others to continue where he had been forced to stop. He later stated that he had been led to the use of gelatin not because he found the wet collodion

THOMAS EAKINS. *Double Jump.* 1884. Gelatin-silver print. The Franklin Institute, Philadelphia.

process troublesome to manipulate, but because he could not stand the smell of ether in the hot glass house where he was doing photomicrographic work.

Seven years went by before Dr. Maddox's odorless process was refined to a workable technique. The first improvement was to wash the prepared emulsion to remove excess soluble salts that had not reacted with the silver ions. The first practical technique was devised by Richard Kennett in England in 1873: he forced the emulsion while in a jelly state through a canvas of coarse weave, breaking it into coarse threads or "noodles" that he soaked in water for an hour, then filtered. Then in 1878 Charles Harper Bennett allowed the emulsion to ripen by holding it at 90° F for several days before washing. He found this emulsion to be remarkably light sensitive: exposures could regularly be made in sunlight in the fraction of a second. Photographs of people jumping and of flowers after watering, with the falling drops visible, amazed the photographic world when they were shown at the South London Photographic Society. A new era opened.

The editor of the *British Journal of Photography* wrote in 1879 that the year would "be looked back to in the future as one of the most noteworthy epochs in the history of photography." His prediction was exact. In every camera club there was talk of gelatin:

Onward still, and onward still it runs its sticky way,
And Gelatine you're bound to use if you mean to
 make things pay.
Collodion—slow old fogey!—your palmy days have been,
You must give place in the future to the plates of
 Gelatine.[16]

Manufacturers in Great Britain, Europe, and America now began to supply gelatin plates packaged and ready for use. Problems that had long plagued the photographer were abruptly solved. No longer was there need of a portable darkroom in the field, for the plates held their light sensitivity for months and could be developed successfully long after exposure.

Edward L. Wilson, editor of *The Philadelphia Photographer*, told the members of the National Photographic Association that the photographs of the Middle East he took in 1882 were all made on gelatin plates prepared in Philadelphia, "exposed on the journey, carried for twenty-two thousand miles on steamer, on donkey-back, on camel-back, and across the Atlantic and the Mediterranean, through the hills of Arabia, in Egypt and other hot countries of the East, and developed eight months afterwards, again in Philadelphia, and the results you see! Why it would be impossible to get *any* results with the wet plate. Blessed then be the dry plate!"[17]

The perfection of gelatin emulsion not only led to the conquest, analysis, and synthesis of action, but it brought about standardization of materials, the scientific investigation of the photographic process, and an extension of sensitivity into the green, yellow, orange, and red bands of the spectrum.

In 1876 Vero Charles Driffield, a British scientist and amateur photographer, persuaded his friend and colleague, Ferdinand Hurter, to join him in his hobby. "But to a mind accustomed like his to methods of scientific precision," Driffield wrote, "it became intolerable to practice an art which—at that time—was so entirely governed by rule-of-thumb, and of which the principles were so little understood."[18] They began a series of investigations on the relationship between exposure, or the amount of light falling on the photographic plate, and density, or the amount of silver reduced by the combined action of light and development. With an apparatus made from an old sewing machine, and a candle for standard illumination, they exposed plates to successively increasing amounts of light. The silver deposit, or *density*, produced upon subsequent development they measured optically with a homemade photometer. From this data they were able to calculate the "speed" of an emulsion (that is, its sensitivity to light).

In May 1890, Hurter and Driffeld announced their researches in the *Journal* of the Society of Chemical Industry. They opened their report with a statement that has become classic:

The production of a perfect picture by means of photography is an art; the production of a technically perfect negative is a science.[19]

The greatest value of their work to the practicing photographer was a simplification of the developing process. They showed that for every plate or film there is an optimum developing time, depending on the brightness ratio of the subject, the composition of the developer, and the temperature at which it is used. Negatives could be developed in total darkness by immersing them in the developing solution for a predetermined time, which varied according to the temperature of the solution and characteristics of the emulsion. It was no longer needful to watch the gradual appearance of the image by red light. Thus plates sensitive to light of all colors, and which would be fogged by the red safelight of the darkroom, could readily be processed.

Wet-collodion plates, as we have noted, and the first gelatin plates were overly sensitive to blue light and insensitive to the green, yellow, orange, and red rays of the spectrum.

In 1873 Hermann Wilhelm Vogel, professor of photography at the Berlin Technical University—then called the Technische Hochschule—discovered that adding dyes

OTTOMAR ANSCHUTZ. *Storks*. 1884. Agfa-Gevaert Foto-Historama, Leverkusen, West Germany.

to a photographic emulsion rendered it sensitive to the colors absorbed by the dye. Plates dyed blue became sensitive to yellow; those dyed green recorded red rays, as well as all the other visible rays of the spectrum. Vogel described this epochal discovery, which he named *optical sensitizing*, in a letter dated December 1, 1873, that was published in *The Philadelphia Photographer*:

After all these experiments, I believe that I am entitled to the conclusion that we are able to make bromide of silver *sensitive to any color*; it is only necessary to add to the bromide of silver a substance which absorbs the color in question, and which at the same time promotes the chemical decomposition of bromide of silver by light. . . .[20]

Although Vogel was working with collodion plates, optical sensitizing was applied to the manufacture of gelatin dry plates in the 1880s. At first the sensitivity of the plates extended only to the orange rays; they were called *orthochromatic*. Later red-sensitive plates were available: they were named *panchromatic*.

By the turn of the century, photographers were given not only negative material that could record all colors, they were also given a new creative tool. By using colored filters placed over the lens they could accentuate or eliminate colors. Now they could not only photograph clouds in the sky but they could make the sky any desired tone of gray. At first "overcorrected" skies were not acceptable. As late as 1905 a landscape taken with "the deepest ray filter" showing massive white clouds against "a sky as seemingly black as that of midnight" was criticized as false, and the amateur who sent it to *Camera Craft* magazine was advised to try to correct the distortion in printing the negative. When commercial large-scale production of panchromatic film was made possible in the 1920s, through the use of newly discovered dyes, the new emulsion soon came to be universally used.

Almost simultaneously with the introduction of these gelatin dry plates for negative use came the large-scale manufacture of new types of ready-sensitized printing papers. These were of two types: *printing-out paper* (P.O.P.) which, like albumen paper, gave a visible image on exposure, and *developing-out paper* (D.O.P.), which required development to bring forth the image but had the advantage of greater sensitivity, so that prints could be made by artificial light.

The first printing-out paper was coated with a collodio-chloride emulsion. Manufacture was begun by Emil Obernetter in his Munich factory in 1867. His son, Johann Baptist Obernetter, began to produce a similar paper with a gelatin emulsion in 1885. A year later Raphael Eduard Liesgang of Düsseldorf called his ver-

sion of this type of paper "aristotype," a name that was, confusingly, at once adopted for collodio-chloride printing-out paper as well.

These aristo papers were exposed to sunlight for minutes, even hours, beneath the negative until a strong image appeared that was then toned with gold chloride to a rich chocolate brown, fixed, washed, and dried. Commonly the surface was brought to a high gloss by passing it through the heated rollers of a burnisher. These papers almost completely replaced albumen papers by the turn of the century, and themselves became obsolete—except for making proof prints—by 1920. The most commonly used photographic paper today is the developing-out variety.

In 1879 the platemaking firm of Mawson and Swan of Newcastle, England, began to coat paper with gelatin emulsion of such sensitivity that it could be exposed briefly to an electric light bulb or gas mantle, and then processed exactly like a plate. This combination of photographic and electrical technology—for the partner Sir Joseph William Swan was at that very time, independently of Edison, working out his invention of an incandescent light bulb—made enlarging practical, and it also made possible bulk printing in quantities never before realized. The Automatic Photograph Company in New York boasted in 1895 that they could produce 157,000 finished photographic prints in a ten-hour working day. A 3000-foot roll of bromide paper 36 inches wide was "fed under two or more negatives, then automatically pressed upward by a platen against the face of the negative, at the same instant also automatically exposed by the flashing of incandescent electric lamps above the negatives, then moved along the proper distance for a fresh section to be exposed and finally wound up on another roller."[21] In a second machine the exposed paper was fed by rollers through the processing solutions.

Coinciding with the universal adoption of these new sensitized materials came other technical improvements in lenses, shutters, and camera design. The rapid rectilinear lenses, universally popular since 1866, worked well when stopped down, but were of relatively narrow angle of view of about 25°. Used at large apertures they lacked definition because designers had not been able with existing optical glass to eliminate all aberrations, especially that of astigmatism. The problem was solved with the introduction in 1886 of barium crown glass by the Schott Glass Works in Jena, Germany. This glass had a higher refractive index for a given dispersion than any previously available, and with its use many of the aberrations that produced lack of sharpness could be minimized, especially that of astigmatism. The most successful of these *anastigmat* objectives were the Double Anastigmat or

FREDERICK FARGO CHURCH. *George Eastman with a Kodak Camera on Board the "S.S. Gallia."* 1890. Albumen print from a Kodak film negative. George Eastman House, Rochester, N.Y.

Photographer unknown. *Swimming Party.* ca. 1890. Albumen print from a Kodak film negative. George Eastman House, Rochester, N.Y.

PAUL MARTIN. *The Magazine Seller, Ludgate Circus, London.* ca. 1895. Gelatin-silver print. The Museum of Modern Art, New York.

Dagor of C. P. Goerz in Berlin (1893), which covered a 70° angle of view at ƒ/7.7, and the ƒ/4.5 Tessar of Zeiss in Jena (1902), with the smaller angle of view of 50°.

In the days of the daguerreotype, the calotype and the collodion plate, photographers made exposures simply by removing the lens cap and replacing it seconds, or even minutes later. Now the increased sensitivity of negative material made it necessary to slice time into precise fractions of a second. Shutters of the most ingenious kind were designed in great variety. These were commonly fitted between the lens elements of the photographic objective and were thus called *between-the-lens* shutters. Others were in the form of a curtain within the camera, directly in front of the plate, attached to spring-loaded rollers. At the touch of a button a narrow slit in the curtain traveled swiftly across the plate, thus exposing it to the image. Because of its placement, this type was known as the *focal-plane shutter.* By the end of the century accurate exposures of 1/5000 of a second could be made.

Cameras were now so reduced in bulk they could be held in the hand. The photographer was freed from the need to carry a tripod wherever he went. A bewildering array of hand cameras appeared on the market. Some held several plates in a magazine, so that photographers could take a dozen or more exposures in rapid succession. Because these cameras allowed exposures to be made surreptitiously, they were often called "detective cameras." They were given fanciful names. Here are a few of the more popular mass-produced hand cameras of the late nineteenth century:

Academy, As de Carreaux (Ace of Diamonds), Brownie, Buckeye, Bulls Eye, Comfort, Compact, Cosmopolite, Cyclone, Delta, Demon, Eclipse, Escopette (Pistol), Fallowfield Facíle, Filmax, Frena, Hawk-Eye, Harvard, Hit-or-Missit, Instantograph, Kamaret, Kinegraphe, Kodak, Kombi, Kozy, Lilliput, Luzo, Nodark, Omnigraphe, L'Operateur, P.D.Q. (Photography Done Quickly), Photoret, Photosphere, Photake, Poco, Simplex, Takiv, Tom Thumb, Velographe, Verascope, Vive, Weno, Wizard, Wonder.[22]

To choose which hand camera to purchase was a problem that H. P. Robinson solved by lot. "I put the names

Most of these periodicals were lavishly illustrated with photographs by famous as well as unknown photographers. For thousands the photographic magazines were both education and inspiration.

Many of these periodicals were the official organs of amateur camera clubs, which grew in number at a remarkable rate. In 1893 the *American Annual of Photography* published an international list of these societies, which numbered 500—more than half of them in Great Britain and its colonies. They ranged from small groups of enthusiasts meeting at homes or public buildings to large societies with permanent headquarters complete with studios, darkrooms, and the latest equipment; a program of exhibitions and lectures; and often publications and even libraries. The Club der Amateur-Photographen in Vienna (later named the Wiener Kamera Klub), the Gessellschaft zur Förderung der Amateur Photographie (Society for Promoting Amateur Photography) in Hamburg, the Photo-Club de Paris, the Camera Club of London, the Society of Amateur Photographers

of New York, and the New York Camera Club were in-institutions of an importance far beyond the usual meaning of the word "club." Their members were overwhelmingly those amateurs who were referred to in the press as "serious" or "advanced."

Journalists, writers, artists, and others who had no desire to take up photography as a profession now began to find the camera a useful adjunct to their work. Usually self-taught, they often produced photographs of lasting value, transcending mere records.

When Jacob A. Riis, a police reporter in New York, began his personal campaign to expose the misery of the underprivileged living in the crime-infested slums of the lower East side, he soon found that the printed word was not sufficiently convincing, and so he turned to photography by flashlight.

In 1888 the New York *Sun* published twelve drawings from his photographs with an article headlined "Flashes from the Slums" and told how

a mysterious party has lately been startling the town

JACOB A. RIIS. *Home of an Italian Ragpicker, New York.* 1888. Gelatin-silver print from the original negative. The Museum of the City of New York, New York.

JACOB A. RIIS. *Bandits' Roost, New York.* 1888. Gelatin-silver print from the original negative. The Museum of the City of New York, New York.

ularly of subjects close to the camera, were slightly different. This discrepancy was corrected by the introduction of the *single-lens reflex camera.* The mirror was now put inside the camera body. By an ingenious spring-loaded mechanism it flipped from its 45° position to the horizontal on pressing the shutter release. The American Graflex (introduced in 1903) and the British Soho Reflex of three years later became the standard hand cameras of pictorial photographers for the first two decades of the century.

From stopping the action of life with the hand camera to recreating action by motion pictures was a logical progression. Sir John F. W. Herschel clearly foresaw the technique in 1860:

I take for granted nothing more than the possibility of taking a photograph, as it were, by a snap-shot—of securing a picture in a tenth of a second of time; and . . . that a mechanism is possible . . . by which a prepared plate may be presented, focussed, impressed, displaced, numbered, secured in the dark, and replaced by another within two or three tenths of a second.[29]

He suggested that these plates be shown in a *phenakistoscope*—a well-known device for showing animated drawings, similar to the zoetrope used by Muybridge for demonstrating his sequence photographs of animals in motion. Herschel foresaw

the representation of scenes in action—the vivid and lifelike reproduction and handing down to the latest posterity of any transaction in real life—a battle, a debate, a public solemnity, a pugilistic conflict, a harvest home, a launch—anything, in short, where any matter of interest is enacted within a reasonably short time, which may be seen from a single point of view.[30]

In the 1890s inventors throughout the western world were simultaneously and independently working on just such mechanisms as Herschel envisaged. The solution came with roll film, which could be driven inside the camera intermittently from a supply reel to a takeup reel, so that fresh film could be quickly put in place for successive exposures, at the rate of sixteen or more per second. The first system to meet with public favor as a form of entertainment was Thomas Alva Edison's Kinetoscope.

It was a peepshow, a cabinet with an eyepiece through which a loop of 35mm positive film—driven by an electric motor between a light bulb and a whirling slotted disk—could be glimpsed picture by picture at the rate of about forty-eight per second. The images thus seen merged in the mind to produce the illusion of motion. The design and production of these machines Edison assigned to his gifted employee, William Kennedy Laurie Dickson.

A Kinetoscope Parlor, with ten machines, was opened in New York in April 1894. In May machines were shipped to Chicago, in June to San Francisco, in September to Paris and London.

Popular as they were, the Kinetoscopes did not satisfy fully the public's demand. The pictures were too small, and could be viewed by only one person at a time. Inventors in Europe and America began independently of one another to devise projectors in which Edison's films, or ones like them, could be thrown on a screen, like a magic lantern show. The first projector to meet with instant success was the Cinématographe of the brothers Louis and Auguste Lumière. On December 28, 1895, they put on a program of short films at the Grand Café, Paris. The subjects were similar to those taken by amateurs with hand cameras: a railroad train entering a station, workers leaving the Lumière factory at lunch time, a fishing boat entering a harbor. *Le Jardinier* ("The Gardener," alternatively titled *L'Arroseur arrosé*) showed how a story could be told by motion pictures. A gardener is seen sprinkling the lawn. A small boy jumps on the hose. The gardener looks in the nozzle, puzzled that the stream of water suddenly stopped. The boy jumps off the hose, the gardener's face is doused with water, he throws down the hose, chases the boy, catches him, and spanks him.

By the end of 1896 films were being screened regularly in the principal cities of Europe and America with the Vitascope, the American Biograph, the Theatrograph, the Phototachyscope, the Bioscop, the Kinetoscop, and a host of other ingeniously designed projectors. The technology of bulk printing, described above, was at once applied to producing the vast number of release prints needed at home and abroad. The great twentieth-century medium of the motion picture was born, full fledged. So great has been its swift, astounding growth and its international importance that its history forms a field in itself; to report further upon it in these pages is hardly feasible.

The greatest technological contribution to picture making in the fecund last two decades of the nineteenth century was the perfection of the halftone printing plate, which made it possible to print facsimiles of pictures of all kinds together with type. (The development of this photomechanical technique, which revolutionized book, magazine and newspaper illustration, will be discussed in Chapter 14.) Photojournalism was born, and its effect upon photographers was immediate, for illustrated magazines and yearbooks addressed to the amateur began to appear in every country. By 1900 twelve were regularly published in America, ten in England, nine in France, seven in Germany and Austria, and one or more in other European countries. They carried how-to-do-it articles, reviews of exhibitions, announcements of new products, and, in lively correspondence columns, answers to questions of technique. Some offered artistic criticism by mail.

on separate pieces of paper, of what appeared to me to be about 500 species of hand-cameras, into a hat, and got a child to draw one out and bought that one. This was a great saving. I am saved the trouble and worse of looking over a thousand more or less different ways of doing the same thing."[23]

The best remembered of these cameras is the Kodak, invented and manufactured by George Eastman, a dry-plate maker in Rochester, New York. Introduced in 1888, its strange name was a word coined by Eastman. He explained,

It was a purely arbitrary combination of letters, not derived in whole or part from any existing word, arrived at after considerable search for a word that would answer all requirements for a trademark name. The principal of these were that it must be short; incapable of being misspelled so as to destroy its identity; must have a vigorous and distinctive personality; and must meet the requirements of the various foreign trademark laws. . . .[24]

The original Kodak was a box camera, 3¼ x 3¾ x 6½ inches with a fixed-focus lens of 27mm focal length and aperture $f/9$, fitted with an ingenious cylindrical, or barrel, shutter. It differed from most of its competitors because it used film in a roll long enough for 100 negatives, each with a circular image 2½ inches in diameter. At first this "American Film" was paper, coated with a substratum of plain gelatin and then with light-sensitive gelatin emulsion; after processing, the hardened gelatin bearing the image was stripped from the paper base. This delicate operation became obsolete with the introduction of "transparent film" on a clear plastic base of nitrocellulose in 1891.

Eastman's most important contribution, however, was not the design of the camera, but providing a photofinishing service for his customers. The camera was loaded when sold; its $25 cost included processing. A contact print from each good negative was made and neatly mounted on a gilt-edged chocolate-brown card. All the Kodak owner had to do was point the camera at the subject, release the shutter by pressing a button, wind on film for the next exposure, and recock the shutter by pulling a string that wound up its clockwork mechanism. Eastman's slogan "You Press the Button, We Do the Rest" was exact, and it caught on with the public. *Harper's Magazine* noted in 1891:

It is heard on the street, in the cars, at the theatre, in the clubs, and, in fact, wherever men and women congregate. The comic papers have burlesqued it, statesmen have paraphrased it, and it is repeatedly used to point a moral or adorn a tale.[25]

Convenient, ready-sensitized dry plates and film of unprecedented speed, ease of processing and printing, fast lenses, quick-working shutters, hand cameras—all these technical advances led to a casual use of photography by untrained amateurs.[26] Freed from the labor demanded by the wet-plate process, with its bulky equipment and exacting technique, people began to take all kinds of subjects: stiffly posed family groups, informal records of picnics and outings, street scenes, things near and dear, things distant and seen only on travels. Eastman called the Kodak

a photographic notebook. Photography is thus brought within reach of every human being who desires to preserve a record of what he sees. Such a photographic notebook is an enduring record of many things seen only once in a lifetime and enables the fortunate possessor to go back by the light of his own fireside to scenes which would otherwise fade from memory and be lost.[27]

These pictures came to be called "snapshots," a word used by hunters to describe shooting a firearm from the hip, without taking careful aim. The first Kodak, like many other detective cameras, had no finder: the camera was simply pointed at the subject. The "brilliant finders" later built into the bodies of box cameras gave images only the size of a postage stamp. Careful composition was hardly possible with them, nor was it of concern, for most snapshooters had little artistic ambition.

To photographers who were accustomed to studying the full-size image on the ground glass of their tripod cameras before exposing the plate, the typical hand camera finder was inadequate and lacked the precision they found essential to artistic success. Furthermore these photographers were not satisfied with focusing by merely estimating the lens-subject distance or by relying on depth-of-field tables. They wanted to see the image the way the camera saw it before making the exposure.

To fill their needs, manufacturers began to introduce in the 1890s a new kind of finder: a second camera mounted on top of the camera with which the exposure was made. It was fitted with a lens of exactly the same focal length of the taking lens; both were focused together. On the top of the finder-camera was a ground glass the size of the negative. Within was a mirror, fixed at 45° to the lens axis, which reflected the image upwards, like the eighteenth-century camera obscura. A collapsible hood shaded the ground glass so that the image could be seen clearly. The Cosmopolite, manufactured by E. Français in Paris in 1889, was sold in England as the *Twin Lens Artist Hand Camera* by the Stereoscopic Company, which stated its advantages succinctly: "Can be focussed and shows a duplicate of the Picture simultaneously."[28]

But in fact the picture was not a duplicate, for the viewing lens was at another point in space than the taking lens: by the phenomenon of *parallax* the images, partic-

o' nights. Somnolent policemen on the street, denizens of the dives in their dens, tramps and bummers in their so-called lodgings, and all the people of the wild and wonderful variety of New York night life have in their turn marvelled at and been frightened by the phenomenon. What they saw was three or four figures in the gloom, a ghostly tripod, some weird and uncanny movements, the blinding flash, and then they heard the patter of retreating footsteps and the mysterious visitors were gone before they could collect their scattered thoughts and try to find out what it was all about.[31]

The intruders were Riis, two amateur photographers, Henry G. Piffard and Richard Hoe Lawrence (members, be it noted, of the Society of Amateur Photographers of New York), and Dr. John T. Nagle of the Health Board. Their purpose, Riis stated, was to make a collection of views for lantern slides to show "as no mere description could, the misery and vice that he had noticed in his ten years of experience . . . and suggest the direction in which good might be done."[32]

In the 1880s facsimile reproduction techniques had not reached the point at which photographs could be printed in newspapers, and the column-wide drawings accompanying the article were not convincing. When Riis's famous book *How the Other Half Lives* was published in 1890,[33] seventeen of the illustrations were halftones, but of poor quality, lacking detail and sharpness. The remaining nineteen photographs were shown in drawings made from them: some of them are signed "Kenyon Cox, 1889, after photograph."

The result was that the photographic work of Jacob Riis was overlooked until 1947, when Alexander Alland, himself a photographer, made excellent enlargements from the original glass negatives that the Museum of the City of New York, through his efforts, had acquired. The exhibition held by the Museum, and the subsequent publication of some of the best of the prints in *U.S. Camera 1948*, revealed Riis as a photographer of importance.

The photographs are direct and penetrating, as raw as the sordid scenes that they so often represent. Riis unerringly chose the camera stance that would most effectively tell the story. There are glimpses in his second book, *Children of the Poor*, of his experiences:

Yet even from Hell's Kitchen had I not long before been driven forth with my camera by a band of angry women, who pelted me with brickbats and stones on my retreat, shouting at me never to come back. . . . The children know generally what they want and they go for it by the shortest cut. I found that out, whether I had flowers to give or pictures to take. . . Their determination to be "took" the moment the camera hove into sight, in the most striking pose they could hastily devise, was always the most formidable bar to success I met.[34]

Riis and his companions were among the first in

EMILE ZOLA. *Denise and Jacques Zola*. ca. 1900. Gelatin-silver print. Collection Dr. François Emile Zola, Gif-sur-Yvette, France.

America to use *Blitzlichtpulver*—flashlight powder—invented in Germany in 1887 by Adolf Miethe and Johannes Gaedicke. Piffard had modified the German formula, which he had found extremely dangerous; he sprinkled guncotton with twice its weight of magnesium powder on a metal tray and ignited the mixture.

Because it burned instantaneously—in a flash—it was an improvement over the magnesium flare, with its several seconds duration, which O'Sullivan had used in the Comstock Lode mines. Riis succeeded in its use; the blinding flash reveals with pitiless detail the sordid interiors, but deals almost tenderly with the faces of those whose lot it was to live within them.

He was always sympathetic to people, whether he was photographing street Arabs stealing in the street from a handcart, or the inhabitants of the alley known as Bandits' Roost peering unselfconsciously at the camera from doorways and stoops and windows. The importance of these photographs lies in their power not only to inform, but to move us. They are at once interpretations and records; although they are no longer topical, they contain qualities that will last as long as man is concerned with his brother.

Emile Zola, the novelist, took up photography in 1887. He made charming portraits of his family, views of Paris, and a large series of pictures of the 1900 World's Fair and the Eiffel Tower. It is tempting to see in these documen-

EDGAR DEGAS. *Portrait of his Brother*. ca. 1895. Gelatin-silver print. Bibliothèque Nationale, Paris.

EDOUARD VUILLARD. *The Artist's Sisters-in-law*. ca. 1898. Gelatin-silver print. Collection Antoine Salomon, Paris.

EMILE ZOLA. *The Eiffel Tower, Paris.* 1900. Gelatin-silver print. Collection Dr. François Emile Zola, Gif-sur-Yvette, France.

tary material for his powerful realist novels, but they were made at the end of his career, after his greatest literary triumphs; their excellence stems from his keen power of observation transferred to the medium of photography. In 1864 he had already compared his work to photography: "a reproduction that is exact, frank, and naive."[35] He told a reporter in 1900:

Pray excuse me for keeping you waiting. This is the time of day which I usually devote to a new hobby of mine: photography. When you arrived I was developing some snapshots I had taken this afternoon at the Exhibition. Every man should have a hobby, and I confess to a wondrous love of mine. In my opinion, you cannot say you have thoroughly seen anything until you have got a photograph of it, revealing a lot of points which otherwise would be unnoticed, and which in most cases could not be distinguished.[36]

Giovanni Verga, the Italian realist writer, also photographed; his pictures of the Sicilian towns and people he wrote about carry the same conviction and sympathy as his strong, earthy novels and short stories.

The painter Edgar Degas was much interested in photography. He made drawings from Muybridge's photographs of horses and became an ardent photographer; in 1895 he ordered plates by the dozen, which he processed himself. Unfortunately only a few of his photographs are known. They are mostly interiors, taken by artificial light. In pose and composition they are reminiscent of his paintings, though there is no evidence that he made direct use of them as studies. Edouard Vuillard, too, was an amateur photographer as well as a painter: a folding Kodak camera was a fixture in his house, and during social gatherings he liked to put it casually on a piece of furniture, point it at his guests, and ask them to hold still while he made short time exposures.

There was a growing interest in recording custom and manners, particularly those that were becoming obsolete. Sir Benjamin Stone, a member of the British Parliament, devoted his fortune to producing an extensive photographic survey of the folk festivals in his country and the life of the English peasantry. He appealed to amateurs to conduct photographic surveys of their home areas—historic buildings, landscapes, ceremonies, the life of the people. In 1897 he founded the National Photographic Record Association with the goal of depositing prints in the British Museum and local libraries.

Adam Clark Vroman, a bookseller in Los Angeles, between 1895 and 1904 made a moving, sympathetic documentation of the Indians of the American Southwest. His greatest difficulty was caused by casual snapshooters, who not only got in his way, but had made the Indians so camera conscious that only by befriending them and winning their confidence could he take serious portraits of them.

The most ambitious photographic record of Indians was undertaken by Edward S. Curtis, a professional portrait photographer in Seattle who, with the financial support of John Pierpont Morgan, dedicated his life to documenting the Indian. Between 1907 and 1930, under the title *The North American Indian,* twenty volumes of richly illustrated text and twenty volumes of photogravures were published, with a foreword by President Theodore Roosevelt.[37] If his work lacks the direct objectivity of Vroman it is due, in part, to a different attitude. To Vroman the Indians of the Southwest were a living people whose way of life he admired and was privileged to share; to Curtis the Indian, as a nation, was "the vanishing race," whose ancient manners, customs, and traditions should be recorded before they disappeared, and this often led him to pose his subjects so that at times his pictures seem reenactments; indeed, he is known to have had his subjects wear the long-obsolete dress of their forefathers for his camera. But the work as a whole is most impressive, and is often poignant and well seen, especially in his informal portraits.

There were other photographers whose concern for the medium went beyond recording. They passionately believed that photography was a fine art and deserving recognition as such. With vigor and dedication they not only explored the aesthetic potentials of the camera, but also crusaded for their cause. As amateurs they were not burdened with financial responsibilities and could ignore limits self-imposed by professionals. They were free to experiment, and they had the imagination and will to break accepted rules. Their style became universal. For a quarter of a century, under the name "pictorial photographers," they dominated the photographic scene.

ADAM CLARK VROMAN. *Nawquistewa, Hopi Indian, Oraibi.* 1901. Gelatin-silver print from the original negative in the Los Angeles County Museum, Los Angeles.

ADAM CLARK VROMAN. *Mission, Santa Clara Pueblo, New Mexico*. 1899. Gelatin-silver print from the original negative. Los Angeles County Museum, Los Angeles.

EDWARD S. CURTIS. *Watching the Dancers—Hopi.* 1906. Photogravure in *The North American Indian* (New York: 1907).
The Museum of Modern Art, New York.

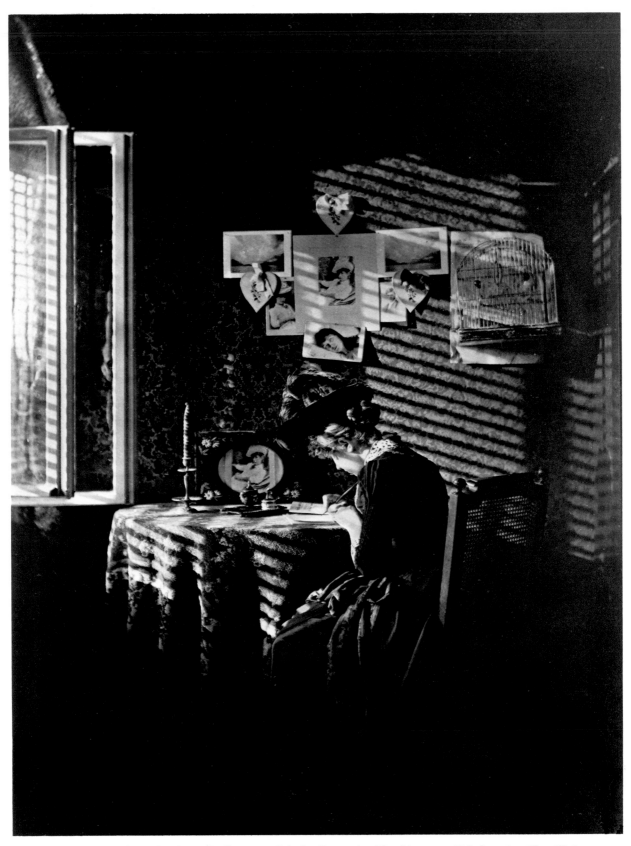

ALFRED STIEGLITZ. *Paula, or Sun Rays, Berlin.* 1889. Gelatin-silver print. The Museum of Modern Art, New York.

9 · PICTORIAL PHOTOGRAPHY

Art-photography, as championed by Rejlander and Robinson in the late 1850s, was languishing in England when the dry-plate revolution took place. Robinson himself was still the leader—subscribers still looked forward to his annual photographs—but the walls of most exhibition galleries were crowded from floor to ceiling with the same kind of anecdotal genre scenes, sentimental landscapes, and weak portraits that characterized academic painting of the most unimaginative sort.

Against the artificiality of these stiffly posed studio scenes and patchwork prints made up of pieces of different negatives, Peter Henry Emerson protested with a vehemence that shook the photographic world. His weapons were his own photographs, lectures, articles, and books. In March 1886 he spoke to the Camera Club in London on "Photography, a Pictorial Art."[1] Sweeping aside John Ruskin as a "spasmodic elegant of art literature" because he denied any connection between science and art, and dismissing Robinson's books as "the quintessence of literary fallacies and art anachronisms," Emerson laid before his audience a theory of art based on scientific principles. He held that the artist's task was the imitation of the effects of nature on the eye, and pointed to Greek sculpture, Leonardo da Vinci's *Last Supper,* and the paintings of Constable, Corot, and the Barbizon group as the peaks of artistic production of all times. Trained as a physician, he was greatly impressed by Hermann von Helmholtz's *Handbook of Physiological Optics,* which he quoted as the ultimate authority on visual perception.

Emerson came to the conclusion that photography was "superior to etching, woodcutting and charcoal drawing" in the accuracy of its perspective rendition, and that it was second to painting only because it lacked color and, he believed, the ability to reproduce exact tonal relationships.

In the same year he published in a limited edition *Life and Landscape on the Norfolk Broads,* a collection of forty platinum prints mounted to form a handsome folio volume.[2] These photographs had all been made in East Anglia, and presented a record of·the strange amphibious life of the marsh dwellers. The publication was followed by similar volumes that included a text describing the manners and customs of the peasants and photogravures directly from his negatives. These books were folkloristic studies, of which the photographs were an integral part. Each picture had been made on the spot, often with great difficulty, always with direct honesty. Free from sentimentality and artificiality, they were diametrically opposed to the art-photographs of Robinson and his followers.

Having established himself as a photographer, Emerson proceeded to explain his aesthetic and technical approach in a textbook, *Naturalistic Photography for Students of the Art* (1889).[3] It was not illustrated: students were referred to the plates of *Pictures of East Anglian Life* (1888).[4] To camera clubs all over Britain Emerson gave copies of a special edition containing a variant plate and, pasted to the inside of the front cover, a page of notes on the photographs. *Naturalistic Photography,* called "a bombshell dropped in a tea party,"[5] is a curious mixture of truth and fallacy. In it Emerson expanded his warped history of art and again propounded the Helmholtzian theory of vision. His practical advice was often sound, however, and the book can still be read with profit; he had a respect for the medium and understood both the limitations and the capabilities of photography.

The equipment Emerson recommended was the simplest: a view camera, preferably of whole-plate size (6½ x 8½ inches), a sturdy tripod, and a lens of relatively long focal length—at least twice the plate's longest side. He had no use for hand cameras. He condemned enlarging. He saw no relation between size and artistic quality: "An artistic quarter plate [3¼ x 4¼ inches] is worth a hundred commonplace pictures forty by thirty inches in size." The student was advised to develop his negatives on the very day they were taken "whilst yet the mental impression of what you are trying for is fresh." He rejected retouching as "the process by which a good, bad, or indifferent photograph is converted into a bad drawing or painting. . . . The technique of photography is perfect, no such botchy aids are necessary." For printing he ad-

vised two processes, the platinotype and photogravure, or photo-etching.

The platinotype relies upon the property of iron salts to change from the ferric to the ferrous state on exposure to light. In the presence of the nascent ferrous salt, platinum salts when developed in potassium oxalate are reduced to metallic platinum, which is a more stable metal than silver, and hence prints made by this process are of great permanence. The technique was invented in England by William Willis in 1873. When his Platinotype Company put ready-sensitized paper on the market in 1880 the new printing process soon became extremely popular. To Emerson the permanence of this method of printing, although important, was secondary to its aesthetic quality. He liked the delicacy and soft grays it could yield. "For low-toned effects, and for the grey-day landscapes, the platinotype process is unequalled," he wrote. And he criticized the Platinotype Company for insisting upon making brilliant prints: ". . . It is to be hoped they will soon . . . cease to encourage the false notion that good, ergo plucky, sparkling, snappy negatives are those required for the use of the paper." He further stated:

Every photographer who has the good and advancement of photography at heart, should feel indebted to Mr. Willis for placing within his power a process by which he is able to produce work comparable, on artistic grounds, with any other black and white process. . . . No artist could rest content to practise photography alone as an art, so long as such inartistic printing processes as the pre-platinotype processes were in vogue. If the photo-etching process and the platinotype process were to become lost arts, we, for our part, would never take another photograph.[6]

Photogravure is a means of reproducing the photographic image in printer's ink. It is based on Fox Talbot's invention of 1852 (Chapter 14). As practiced by Emerson, a glass positive transparency is made from the negative. "Carbon tissue"—paper coated with gelatin and reddish pigment—was sensitized in a solution of potassium bichromate, squeezed on a ferrotype plate, and allowed to dry. The tissue was then put in a printing frame with the transparency and exposed to light. The gelatin became insoluble in proportion to the light it received through the gradations of the transparency.

A copper plate was now prepared by dusting one side with powdered bitumen, and gently heating it, so the particles became fixed to its surface. The tissue was squeezed onto the bitumen-coated plate, and in a tray of warm water, its paper base was pulled away, leaving the hardened gelatin with raised highlights and shallow shadows. Next, the copper plate was etched with ferric chloride, which bit into the metal through the gelatin in

proportion to the thickness. The surface of the plate was smoothed and could then be inked and printed in an etching press.

Emerson considered this type of gravure a direct printing process, akin to the traditional etching medium as used by artists since the days of Rembrandt. At first he left the platemaking and the printing to technicians working under his direct supervision; later he did all the work himself.

His advocacy of these printing processes was widely accepted, but his theory of focusing raised debate. He reasoned that our field of vision is not entirely uniform. The central area is clearly defined, while the marginal areas are more or less blurred. To reproduce human vision with the camera, he advised the photographer to put the camera's lens slightly out of focus. But, he warned,

it must be distinctly understood that so-called "fuzziness" must not be carried to the length of *destroying the structure* of any object, otherwise it becomes noticeable, and by attracting the eye detracts from the harmony, and is then just as harmful as excessive sharpness would be. . . .

Nothing in nature has a hard outline, but everything is seen against something else, and its outlines fade gently into that something else, often so subtly that you cannot quite distinguish where one ends and the other begins. In this mingled decision and indecision, this lost and found, lies all the charm and mystery of nature.[7]

British photographic magazines were full of stormy letters pro and con this theory. "Naturalistic focus, then, according to Emerson, means no focus at all, a blur, a smudge, a fog, a daub, a thing for the gods to weep over and photographers to shun," wrote "Justice."[8] "It is not in man, even in f.64 man," George Davison replied, choosing the technical designation of one of the smallest lens apertures to imply concern with overall sharpness in the negative, "to overlook the unnaturalness of joinings in photographic pictures, and the too visible drawing-room drapery air about attractive ladies playing at haymaking and fishwives."[9] Robinson thundered: "Healthy human eyes never saw any part of a scene out of focus,"[10] and hinted that the Naturalists were indebted to him for their knowledge of composition. Emerson retorted, "I have yet to learn that any one statement or photograph of Mr. H. P. Robinson has ever had the slightest effect upon me except as a warning of what not to do."[11] Many of Emerson's followers ignored his qualifying advice, and "soft focus" photographs—derisively called "fuzzygraphs" by some—began to appear in quantity.

In January 1891 Emerson courageously and dramatically renounced what he had so passionately advocated. He declared that "a great painter"—whom he did not identify but appears to have been James McNeil Whistler—had shown him the fallacy of confusing art and nature,

PETER HENRY EMERSON. *Gathering Water Lilies.* 1886. Platinum print. Plate 10 of *Life and Landscape of the Norfolk Broads* (London: 1886). The Museum of Modern Art, New York.

"The first case in which Dr. Emerson invited public attention and criticism was the issue in May, 1886, of the autogravure 'Gathering Water Lilies,' the first of its class from a negative from nature ever published separately as a work of art . . . in breadth and technique it is magnificent."—*International Annual of Anthony's Photographic Bulletin,* 1888.

PETER HENRY EMERSON. *Marsh Weeds.* ca. 1895. Photogravure in *Marsh Leaves* (London: 1895). Lunn Gallery, Inc., Washington, D.C.

GEORGE DAVISON. *The Onion Field.* 1889. Photogravure in *Camera Work,* no. 18 (1907).

and that the recently published scientific investigations of the photographic process by Ferdinand Hurter and Vero C. Driffield had convinced him that the control of tonal relations by development was far more rigid than he had realized.

Emerson, in despair, concluded that photography was not art. In a black-bordered pamphlet, *The Death of Naturalistic Photography,* he explained that

the limitations of photography are so great that, though the results may and sometimes do give a certain aesthetic pleasure, the medium must always rank the lowest of all arts . . . for the individuality of the artist is cramped, in short, it can scarcely show itself. Control of the picture is possible to a *slight* degree, by varied focussing, by varying the exposure (but this is working in the dark), by development, I doubt (I agree with Hurter and Driffield, after three-and-half months careful study of the subject), and lastly, by a certain choice in printing methods.

But the all-vital powers of selection and rejection are *fatally* limited, bound in by fixed and narrow barriers. No differential analysis can be made, no subduing of parts, save by dodging—no emphasis—save by dodging, and that is not pure photography, impure photography is merely a confession of limitations. . . . I thought once (Hurter and Driffield have taught me differently) that . . . true values could be *altered at will* by *development.* They cannot; therefore, to talk of getting values in any subject whatever as you wish and of getting them true to nature, is to talk nonsense. . . .

In short, I throw my lot in with those who say that photography is a very limited art. I deeply regret that I have come to this conclusion.[12]

Although Emerson could not recall the fresh spirit he had brought to photography in a period when it was verging on academicism, he did not give up photography. Whether or not the delicate photogravures in his *Marsh Leaves* of 1895 are "art" seems of little importance; they are his finest photographs.[13] His bold renunciation was more a matter of semantics than of aesthetics, for to Emerson "art" and "painting" appear to have been synonymous. In 1898 he published a third and revised edition of *Naturalistic Photography*; it was substantially the same as the first two editions, except for the final chapter, which instead of "Photography, a Pictorial Art," became "Photography—Not Art."

But Emerson's infatuation with the landscape and the rural and seaside scene attracted many followers. Among them was George Davison, a founding director of George Eastman's British operation, the Eastman Photographic Materials Company (later styled Kodak, Ltd.). In his zeal to produce soft-focus images he stepped beyond Emerson's theories, substituting a pinhole for the lens of his camera. His *Onion Field* of 1889 was highly controversial. And in Germany a remarkable series of photographs, taken by A. Vianna de Lima on a thirty-square-mile island

A. VIANNA DE LIMA. *Fisherboy.* ca. 1890. Collotype in *Nach der Natur* (Berlin: 1890).

145

in the North Sea, was published under the title *Nach der Natur* ("After Nature") in 1890.

These photographers and many others continued in their belief in the aesthetic potentials of the medium, and the desire to achieve recognition for photography as an art became a burning issue. With evangelical passion passive defense gave way to offensive action; the battle was on throughout Europe and, somewhat later, in America.

The first skirmish was in Vienna. At one of the first meetings of the Club der Amateur-Photographen in 1887, Baron Alfred Von Liebig, a founder, showed the members ten photogravures by P. H. Emerson, and stated that, to his knowledge, it was "the first time that art lovers had been offered a series of original photographs of interest not in the objects they represent, but in the interpretation and handling."[14] In 1891 the Club took a bold, unprecedented step: they organized an exhibition of 600 photographs selected from more than 4000 by a jury of six painters and sculptors. The photographic world was stunned. Hermann Wilhelm Vogel, professor of photography at the Berlin Technische Hochschule, wrote: "I believe that a general cry of indignation would be raised if the jury for an exhibition of oil paintings consisted of professional photographers only. Is it therefore to be wondered at if similar feelings are expressed by the photographers?"[15]

The precedent established in Austria of exhibiting photographs judged exclusively on their aesthetic excellence was followed in 1893 in London by the first in a series of exhibitions called The Photographic Salon. These exhibitions, which were international in scope, were held in the Dudley Gallery, well-known art dealers, by the Linked Ring, a group of photographers who had broken away from the Photographic Society because they were displeased with the lack of attention given to art-photography—or pictorial photography as it came to be known—by that august body. The founders were twelve: Bernard Alfieri, Tom Bright, Arthur Burchett, H. H. Hay Cameron (son of Julia Margaret Cameron), Lyonel Clark, George Davison, A. Horsley Hinton, Alfred Maskell, H. P. Robinson and his son Ralph W., H. Van der Weyde, and William Willis. This elite group called for the complete emancipation of pictorial photography, properly so called, from the retarding and nanizing bondage of that which was purely scientific or technical, with which its identity had been confused too long; its development as an independent art; and its advancement along such lines as to them seemed the proper track of progress into what, as the perspective of logical possibilities opened itself to their mental visions, appeared to be its promised land.[16]

Three hundred prints were shown, hung asymmetric-ally on discreetly decorated walls, in marked contrast to the Photographic Society's annual exhibitions, where photographs of all sorts—scientific, technical, artistic—were jammed frame to frame from floor to ceiling. Critics singled out the work of the veteran H. P. Robinson, the pictures of seaport life in Whitby by Frank Sutcliffe, impressionist landscapes of George Davison, portraits by Frederick Hollyer and J. Craig Annan. Art critics were divided in their opinion. The progressive magazine *The Studio* declared: "Photography as a medium for artistic expression is now established for ever."[17] To *The Star's* critic, however, the Photographic Salon was a folly: "Photography may advance and advance and develop and progress; it may have in store for us surprises and inventions innumerable, but it can never be ranked with the graphic arts."[18]

The character of camera clubs elsewhere began to change. The Photo-Club de Paris announced in July 1893 the "First Exhibition of Photographic Art." The rules of entry emphasized, in boldface type, that "only work which, beyond excellent technique, presents real artistic character . . . will be accepted." The jury was made up of four painters, a sculptor, an engraver, an art critic, and the National Inspector of Fine Arts, as well as two amateur photographers. The exhibition was held in the art gallery of Durand-Ruel during January 10-30, 1894; the Photo-Club announced that it was "the standard bearer of photographic art . . . through propaganda by exhibition."[19] A handsome folio album of fifty photogravures was published as a record of the show, and the publication was continued through 1896.

In Germany artistic photography was launched by Alfred Lichtwark, an art historian and the dynamic director of the Kunsthalle in Hamburg. In 1893, with admirable tact, he enlisted the support of both professionals and amateurs in organizing a "First International Exhibition of Amateur Photographs" in the museum. The public was astounded to find 6000 photographs on display in the painting galleries of an art museum. "To them it seemed like holding a natural history congress in a church," Lichtwark recollected.[20] As if in justification, he said that the purpose of the exhibition was to revive the dying art of portraiture. The stilted studio portraits of professional photographs, with their painted backgrounds, fake columns, and imitation furniture, were not shown. Lichtwark felt that the only good portraiture in any medium was being done by amateur photographers, who had economic freedom and time to experiment, and he persuaded the professionals, for their own good, to study and emulate their work. For the first time Germans saw the new art photography movement; they learned how to frame photographs and how to use the new printing

papers that were replacing albumen. From the Hamburg museum's exhibition came a great stimulus: "With fiery ardour amateurs and very soon professionals rushed out on the newly opened road," Lichtwark wrote.[21]

These international salons became annual events and were highly influential in propagandizing the pictorial movement; they provided an incentive for the production of new work and an opportunity for recognition far beyond geographical limits, for many of the exhibits were widely reproduced, not only in the evergrowing photographic press but in popular magazines as well. The English publication *Photograms of the Year** reproduced installation photographs showing every picture hung in the annual exhibitions in London, and correspondents the world over sent accounts and illustrations of pictorial activity in their countries. The salons were tastemakers; they also launched new techniques.

At the 1894 Photographic Salon Robert Demachy, a founder of the Photo-Club de Paris, and his English friend, Alfred Maskell, showed prints by the *gum-bichromate* process. Although not new—it was a simplification of carbon printing techniques of the 1850s—the process had not been used for pictorial purposes. The control that it gave the photographer in the formation of the image was so great that the process was enthusiastically adopted almost at once.

The technique is based on the property of gum arabic when mixed with potassium bichromate to change its solubility in water upon exposure to light. The more strongly light acts upon the bichromated gum, the less easily it can be dissolved. A watercolor pigment of the type used by painters is mixed with the prepared gum and washed over the surface of a sheet of drawing paper. When dry it is exposed to sunlight beneath a negative. The image appears when the paper is washed with warm water. The "developing" is done with a brush or less commonly by pouring a "soup" of sawdust and hot water over the print again and again, a technique devised by Victor Artigue in 1892. If very hot water is applied to the print, all of the pigment can be removed. Weak areas can be strengthened simply by recoating the paper, carefully replacing the negative in exact register, and repeating the process. In this way different colors can be applied on the same sheet of paper. Media can be mixed: a platinotype can be coated with gum and printed again to give it greater depth. When rough paper is coated with sepia

or sanguine pigment and developed by vigorously washing away unwanted details, and leaving brush marks, gum prints often resemble to a startling degree watercolors or wash drawings. Indeed, the innovator of the process, A. Rouillé-Ladévèze, titled his 1894 instruction manual *Photosepia, Photo-sanguine.*[22]

Demachy learned about gum printing from him and at once began to promote it as an artistic medium of great potential. A prolific worker, he widely exhibited his prints. He wrote voluminous articles, both explaining and defending the process. Its simplicity appealed to him: "Fancy what a saving of time—two or three little squirts of coloured paste in a small saucer, a liqueur glass of gum, a little bichromate, a vigorous churning with a hard brush and all is ready for coating."[23] To the criticism that gum printing was not purely photographic, but relied on skill of hand, he answered that his work was the exact opposite of the painter, that he *removed* the pigment, rather than laying it on. He claimed that he did not paint over or add to the photographic image but merely revealed the image by brush development, altering only values and tones.

Despite his arguments, critics over and again pointed out the resemblance of his prints to paintings and drawings. The editor of the magazine *Photography* noted that a series of ballet girls backstage bore "a curious resemblance to the work of the French painter Degas" and regretted that the photographer did not "go further to emulate the great painter in exercises of movement."[24]

Heinrich Kühn of Innsbruck and his Austrian friends Hugo Henneberg and Hans Watzek excelled in gum printing. Under the name of Kleeblat (cloverleaf) they exhibited as a group. Their style was distinctive: large prints (Kühn's standard size was 20 x 40 inches), posterlike composition, and rich pigments, usually brown or blue, on rough drawing paper.

In contrast to these highly painterly gum prints are the platinotypes of Frederick H. Evans, who specialized in photographing the cathedrals of France and England. He first became prominent in 1900, when the Royal Photographic Society held an exhibition of his work, and he was elected a member of the Linked Ring. He was by profession a bookseller, but not the usual merchant: his shop in London was a meeting place of writers and artists. Through Evans the youthful Aubrey Beardsley got his first commission, to illustrate with drawings an edition of *Le Morte d'Arthur.* Evans had taken up photography, he said, because of his love of beauty. His teacher, George Smith, was a specialist in photography through the microscope, and almost fanatic in his insistence on pure photography. He wrote:

"I am of the opinion that to *dodge* a negative in any way

*The editor proposed the word *photogram* in the belief that it was a more correct derivation from the Greek than *photography* and insisted on its use editorially. He had no idea that the word would come to be used to designate a photograph made without a camera.

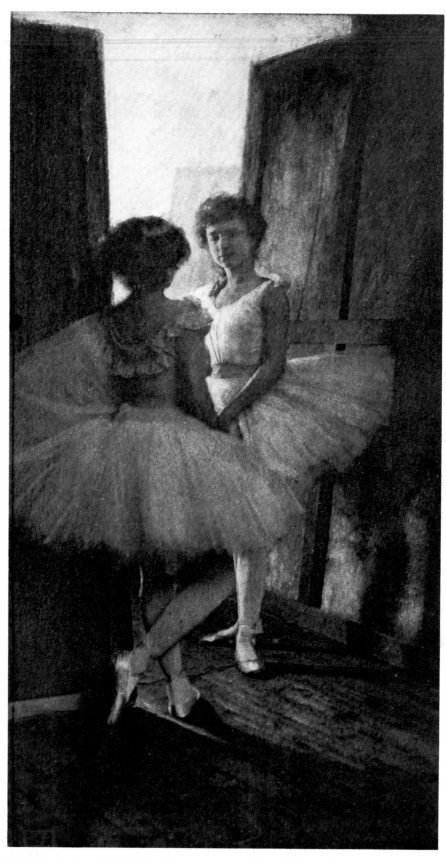

ROBERT DEMACHY. *Behind the Scenes.* ca. 1897. Gum-bichromate print. The Metropolitan Museum of Art, New York.

HEINRICH KUHN. *A Study in Sunlight.* ca. 1905. Photogravure in *Camera Work*, no. 13 (1906).

FREDERICK H. EVANS. *Aubrey Beardsley.* 1893. Platinum print. Collection Beaumont Newhall, Santa Fe.

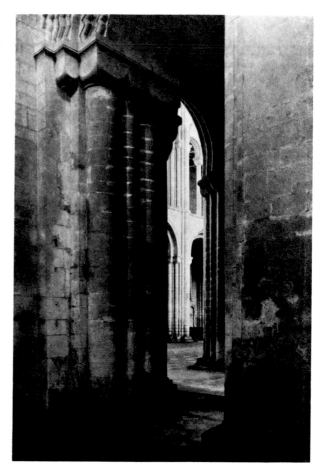

FREDERICK H. EVANS. *A Memory of the Normans—Ely Cathedral, Southwest Transept to Nave.* 1899. Platinum print. George Eastman House, Rochester, N.Y.

whatever, except the spotting out of unavoidable mechanical defects, is not art, but a miserable confession of inability to treat photography as a true art. . . . I contend that by due attention to the exposure of the negative and again to the positive, any artistic effect desired can be faithfully done by pure photography without any retouching whatever."[25]

Evans followed this doctrine throughout his working life. His photographs of the great English and French cathedrals were remarkable interpretations of the light-filled interiors, immense in scale, rich in carved detail. He wrote that his photograph of Ely Cathedral, *A Memory of the Normans,* was taken

to suggest . . . contrasts in tone; rich, deep shadows, full of soft detail, and as interesting and valuable in themselves as the other parts of the picture, together with the fullest sense of soft, sunlit piers and arches seen through them in the distant nave; and these, not so much as opposing lights as harmonising brightnesses, the inviting future, the goal beyond, as full of its own charm as the dark arches of the shadowed present we stand in to gaze at the hopeful vista beyond.[26]

He was a prolific writer, and a most active member of the Linked Ring; for several years he was on the

selection committee of the Photographic Salon, and was responsible for installing the exhibitions.

Alfred Stieglitz of New York was one of the most prominent and respected participants at this salon and other European exhibitions. He was already the leader of the pictorial movement in America, and was to gain international fame not only as a photographer but as the founder of the Photo-Secession, the most dynamic society of art photographers in the world, and as publisher and editor of the handsome quarterly *Camera Work.*

Stieglitz took up photography in Germany, where he had gone in 1881 at the age of seventeen to study mechanical engineering. While a student at the Technische Hochschule in Berlin he bought a camera he saw in a shop window (it seemed, he later recollected, to have been waiting for him by predestination) and he enrolled in the course in photography at the Hochschule given by Hermann Wilhelm Vogel.

Largely because of the importance of his scientific contributions, notably in orthochromatic emulsions, Vogel's activity as a teacher and promoter of photography as an art form has been generally overlooked. Yet one-third of

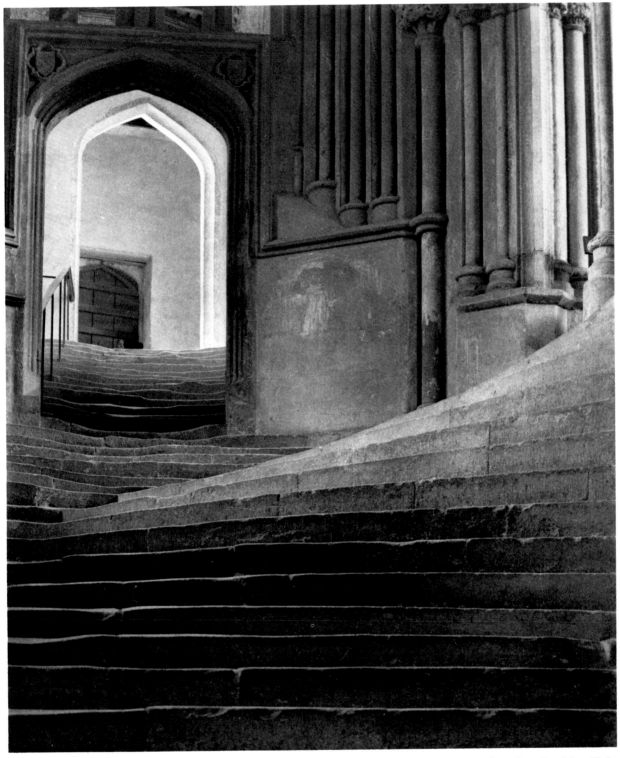

FREDERICK H. EVANS. *The Sea of Steps—Wells Cathedral.* 1903. Platinum print. The Museum of Modern Art, New York.

"By use of a 19 in. Zeiss anastigmat on a 10 by 8 in. plate, I succeeded in getting a negative that has contented me more than I thought possible . . . The beautiful curve of the steps on the right is for all the world like the surge of a great wave that will presently break and subside into smaller ones like those at the top of the picture. It is one of the most imaginative lines it has been my good fortune to try and depict, this superb mounting of the steps. . . ."—Frederick H. Evans, *Photography,* July 18, 1903.

ALFRED STIEGLITZ. *Leone.* 1889.
Collotype in *Der Amateur Photo-
graph,* 1890.

his *Handbook of Photography* is devoted to photographic aesthetics.[27] In 1891 he expanded that section and published it separately, with the title *Photographische Kunstlehre; oder, Die künstlerischen Grundsätze der Lichtbildnerei* ("Photographic Art Teaching; or, The Artistic Principles of Photographic Picture Making") — the first textbook on the subject written by a German.[28] From Vogel Stieglitz acquired not only a brilliant technique, but also an introduction to pictorial photography, especially as practiced by H. P. Robinson, upon whose theories Vogel heavily depended.

As a student Stieglitz was constantly making experiments, and often reporting on them in the photographic press: techniques for intensifying underexposed plates, for reducing those overexposed, tips on printing with platinum paper. He even invented a way to tone aristo paper with platinum salts, and was delighted when Professor Vogel mistook them for platinotypes. And he sent prints to exhibitions. He found little interest in pictorial photography in Germany. His work was first accepted in England by the Photographic Society in 1887, and he won his first prize—two guineas and a silver medal—in a contest held by the British weekly *The Amateur Photographer.* The sole judge was Peter Henry Emerson; the picture was of a group of Italian children clustered around the village well, each one laughing heartily. *A*

Good Joke lacked intensity, perhaps, but it had been taken directly and honestly, without straining for effect; it was not forced into an obvious compositional pattern. Emerson wrote Stieglitz that he found it the only truly spontaneous photograph that had been submitted.

Stieglitz's best student work was on this Italian trip of 1887. He used twenty-five dozen 18 x 24 cm (7⅛ x 9½ inch) Vogel-Obernetter Silver-Rosin Dry Plates. These were among the first orthochromatic plates to be commercially manufactured. The orthochromatic character of these plates, when used with a yellow filter over the lens to absorb some of the intense blue of the sky, enabled Stieglitz to take Alpine landscapes, often with massive and spectacular clouds.

In the picture alternately titled *Paula* and *Sun Rays, Berlin,* Stieglitz records a new, personal vision: in a room filled with sunlight broken into bands of brilliance and shadow by the partly closed shutters of a venetian blind, his young friend is writing at a table. It was a technical problem to retain detail in the extremes of light and dark. On the wall Paula pinned up two prints of *The Approaching Storm,* which Stieglitz made of Lake Como in 1887. Years later, in 1934, Stieglitz came across a group of his long-forgotten student negatives. He reprinted some of them, including *Paula,* and was amazed to see how, in spirit and realization, they foreshadowed the direct portraits and cloud pictures he called "Equivalents" he was then making, and proudly included them in his one-man exhibition at An American Place, his gallery in New York.

In 1890 Stieglitz was in Vienna, planning to continue his studies at the newly founded state printing and photography school, the Graphische Lehr-und Versuchsanstalt, headed by Josef Maria Eder. He became a member of the Club der Amateur-Photographen, and was helping them to organize their forthcoming Photographic Salon, when he was called back to America by the death of his sister.

On his return to New York Stieglitz found that while there were many camera clubs and photographic societies, none of them seemed to have the passionate belief in the art of photography that was rapidly spreading throughout Europe. He was elected a director of the Society of Amateur Photographers of New York, became editor of *The American Amateur Photographer,* and through his photographs and writings, through his publication of others' work, through lectures and demonstrations, he showed Americans aesthetic potentials of photography which they had not yet realized.

He now began to push technique beyond the accepted limits. The hand camera had been regarded by most pictorial photographers as unworthy of the "serious worker." Stieglitz saw it as a challenge. Borrowing from a friend a 4 x 5-inch detective camera, he waited three hours on Fifth Avenue in a fierce snowstorm on February 22, 1893, to photograph a coach drawn by a team of four horses.[29] He wrote that success in hand work depends upon patience: waiting and watching for "the moment in which everything is in balance; that is, satisfies your eye."[30] He also stated that he made his negatives expressly for enlargement, and rarely "used more than part of the original shot."[31] The selection of the final image was thus a twofold process, done partly at the moment of pressing the shutter, and partly in the darkroom, by cropping. For *Winter on Fifth Avenue* Stieglitz used less than half of the negative image.

In 1894 Stieglitz traveled again through Europe; it was a highly productive trip. In Paris he made a bold street picture, *A Wet Day on the Boulevard,* half of which was the bare glistening wet pavement. In the Dutch fishing village of Katwijk he made a series of the fisherfolk in their traditional peasant costumes. They have an air of the past about them in their picturesqueness of subject; in composition they are reminiscent of the paintings of the German Impressionist painters who frequented the village. Indeed *The Net Mender,* his most widely exhibited and be-medalled print of that year, was compared to a painting of the same motif by Max Liebermann. Of the pictures he took in Italy, *A Venetian Gamin* in its simplicity and directness foreshadows his later work. He continued experimenting. A photograph such as the 1896 *Reflections—Night,* a view of the Plaza Hotel, New York, on a rainy night with the wet pavement brilliantly reflecting light streaming from street lamps and windows, is a technical triumph. He tried making gum prints. With his friend Joseph T. Keiley he devised a method of controlling the tones of platinotypes by brushing glycerine over parts of the print, thus slowing the development and producing lighter tones in selected areas. The friends also worked out a way to tone platinotypes with mercury and uranium salts to produce remarkable flesh tones.

By 1897 Stieglitz had an international reputation. The editor of an English annual, reviewing his pictures at the London Photographic Salon, wrote:

Mr. Stieglitz is so astoundingly clever that it leaves a critic with nothing to say. He pushes the limits of his craft a shade farther every year, yet always in orthdox ways, and gains his sensation by legitimate effects. One wishes he were a Briton, to add to the list of brilliant workers home-born.[32]

But Stieglitz was an American, and he wanted to see American pictorial photographers equal the British, who

153

ALFRED STIEGLITZ. *Winter on Fifth Avenue.* 1893. Gelatin-silver print from entire negative. George Eastman House, Rochester, N.Y.

ALFRED STIEGLITZ. *Winter on Fifth Avenue, New York.* 1893. Photogravure. The Museum of Modern Art, New York.

ALFRED STIEGLITZ. *The Net Mender*. 1894. Carbon print. The Art Institute of Chicago, Chicago.

" 'Mending Nets' was the result of much study. It expresses the life of a young Dutch woman; every stitch in the mending of the fishing net, the very rudiment of her existence, brings forth a torrent of poetic thoughts in those who watch her sit there in vast and seemingly endless dunes, toiling with that seriousness and peacefulness which is so characteristic of these sturdy people. All her hopes are concentrated in this occupation—it is her life.

"The picture was taken in 1894 in Katwyk [Holland]. Taken on an 18 x 24 centimeter plate, with a Zeiss lens. The exhibition prints used are enlargement carbons, as the subject needs size fully to express it."—Alfred Stieglitz, "My favorite Picture," *Photographic Life*, vol. 1 (1899) pp. 11-12.

were winning prizes right and left. He was determined that America should hold international exhibitions of pictorial photography equaling those held annually in Europe. He pleaded with his countrymen:

And we here in the United States! What have we done? We continue upon the same old lines, shrug our shoulders with a self-satisfied air and remark: "That may be all right abroad, but we can never have an exhibition run on such lines here." Let me tell you I do not agree with you. . . .

We Americans cannot afford to stand still; we have the best of material among us, hidden in many cases; let us bring it out . . . let's start afresh with an *Annual Photographic Salon* to be run upon the strictest lines. . . . There is no better instructor than public exhibitions. . . . The writer will, with much pleasure, sacrifice time and money to bring about a revolution in photographic exhibitions in the United States.[33]

In 1896 Stieglitz was instrumental in the merging of the Society of Amateur Photographers and the New York Camera Club into a new society, The Camera Club of New York, with spacious quarters. He was elected the club's vice president and became its dynamic leader— some said dictator. Theodore Dreiser, in an article on the club, wrote that Stieglitz had three goals: "First, to elevate the standards of pictorial photography in this country; second, to give an annual national exhibition . . .; and third, to establish a national academy of photography."[34] As chairman of the publications committee, Stieglitz transformed the Club's journal into a handsome international quarterly, *Camera Notes*, containing superb reproductions of photographs by members and nonmembers, articles, and critical reviews of exhibitions.

Stieglitz organized many small exhibitions at the Club,

GERTRUDE KASEBIER. *"Blessed Art Thou Among Women."* ca. 1900. Platinum print. The Museum of Modern Art, New York.

CLARENCE H. WHITE. *The Orchard.* 1902. Platinum print. The Museum of Modern Art, New York.

CLARENCE H. WHITE. *Letitia Felix.* 1897. Photogravure in *Camera Work*, no. 3 (1903).

but the nearest approach to his ideal American Salon was held in 1898 by the Philadelphia Photographic Society in the Pennsylvania Academy of Art. He was one of the judges, together with the eminent painter William Merritt Chase. The Philadelphia Salon became a yearly fixture and brought to light new talent. Critics had high praise for the simple, informal portraits of women and children by Gertrude Käsebier. She had taken up photography at middle age, while an art student in Paris, and had opened a professional portrait studio in New York in 1896.

Clarence H. White of Newark, Ohio, sent portraits distinguished for their sense of light; his platinotypes of genre groups of young ladies, dressed in costumes he had designed and carefully posed in the soft light of early morning or late twilight, often had a lyric quality.

Eduard J. Steichen* of Milwaukee first became known for the pictures he sent to the 1899 Philadelphia Salon when he was only twenty years old; his impressionist, soft-focus landscapes such as *A Frost-Covered Pool* were at once controversial.

The most curious of the photographers identified with the new pictorial movement in America was Fred Holland Day, of Boston. He outraged critics by reenacting for the camera, on a hill outside Boston in the summer of 1898, the Passion of Our Lord, with himself as Jesus Christ. He is remembered for introducing to Europe "The New School of American Photography" in a large exhibition he organized that was shown in London at the Royal Photographic Society in 1900 and in Paris at the Photo-Club in the following year. Except for Stieglitz, who refused to participate, the exhibition included most of the more progressive of the American pictorial photographers: Day; Käsebier; White; Steichen; Frank Eugene, a painter who drew with an etching needle upon the negative; and a newcomer, Alvin Langdon Coburn, a relative of Day's, who helped him hang the show. High controversy broke out on opening day: the Impressionist style, with its lack of definition, the replacement of texture by its suggestion, the asymmetry of placement of broad areas, extremes of lights and darks, brought mixed criticism:

The Photographic News: We have here merely the excrescences of a diseased imagination, which has been fostered by the ravings of a few lunatics. . . . They are mere endeavors to be unacademic, unconventional, and eccentric. . . .

The Amateur Photographer: We do not propose to at present particularly criticise the American pictures, but merely to introduce them, and strongly urge everyone who

*He later changed the spelling of his first name to Edward, and dropped the middle initial.

EDUARD J. STEICHEN. *Rodin and "The Thinker."* 1902. Gum-bichromate print. The Museum of Modern Art, New York.

EDUARD J. STEICHEN. *Solitude (F. Holland Day).* 1901.
Gum-bichromate print, as reproduced in *Photographische
Rundschau,* July 1902. Later prints are laterally reversed.

can to see them. Most of them are indefinite and elusive
in character; the mere suggestion of forms and textures
leaves a great deal for imagination, yet the delicacy of
treatment, the selection, the composition, in most cases
denote intense feeling; but if the spectator lacks imagi-
nation and power of feeling, their effect upon him must
be nil. . . .

Photography: We do not exaggerate, but quite the re-
verse, when we point out that the collection . . . is not
equalled by anything since the publication of 'Natural-
istic Photography.' In organising it the Royal Photo-
graphic Society has done more in the interests of pictorial
photography than if it got up a hundred Salons, or made
a chain of linked rings from the earth to the moon."[35]

Steichen, now settled in Paris with a studio on the Left
Bank, was dividing his time between painting and pho-
tography. His rise to international fame was swift; he had
his first one-man exhibition in 1901 in Paris, mastered
the gum-bichromate process, and excelled in multiple
printing in several colors. He was at his best photograph-
ing leaders in the art world. He became a friend of
Auguste Rodin and made many portraits of him; a com-
bination gum print from two negatives of the sculptor
silhouetted in front of his bust of Victor Hugo and fac-
ing *The Thinker* was widely exhibited. He also made a
series of nudes that, in their strong contrast of brilliantly
lighted flesh against deep-shadowed, almost black back-
grounds, aroused the scorn of critics, including George
Bernard Shaw.

A portfolio of twelve full-page reproductions of
Steichen's photographs was published in the leading
German photographic magazine, *Die Photographische
Rundschau* for July 1902, with a laudatory article by
Ernst Juhl, the art editor.[36] So strong was the reaction of
the readers that Juhl was forced to resign. But Steichen's
work won recognition in Belgium; his *The Black Vase,*
which Juhl had reproduced, was purchased by the gov-
ernment for the National Gallery in Brussels. And in
October the jury of the prestigious Salon des Beaux-Arts

held in the Champs de Mars, Paris, accepted ten of
Steichen's photographs to be shown along with one of
his paintings and six drawings. It seemed that at long
last official recognition had been won for photography,
and Stieglitz proudly announced the jury's acceptance of
photography in *Camera Notes.* But, at the last minute,
the hanging committee refused to show the photographs.
It was a bitter blow. Steichen heard the news in New
York, where he had established a portrait studio at 291
Fifth Avenue. He renewed his friendship with Stieglitz
and there began a working collaboration that was to rev-
olutionize not only pictorial photography, but the other
arts as well.

Alvin Langdon Coburn, the youngest of the American
photographers whom Day introduced to London and
Paris in 1900, was born in Boston, and took up pho-
tography as a boy. He first exhibited when he was fifteen.
His early photographs were mainly landscapes, vague in
definition but containing those shimmering lights that
became a marked characteristic of his mature style. His
first success came with his portraits of writers and art-
ists. He began in 1904 with George Bernard Shaw, who
was an enthusiastic amateur photographer. Shaw received
him warmly, introduced him to fellow writers, and wrote
an extravagant preface to the catalog of his exhibition at
the Royal Photographic Society in London. Coburn also
photographed cities—Edinburgh, London, and New York
—with a keen sense of place and atmosphere. Henry
James commissioned him to make photographs to be
used as frontispieces of each of the twenty-four volumes
of a new edition of his novels.[37] It was a collaborative
effort between the writer and the photographer: Coburn
did not attempt to illustrate what James had written, but
to set the locale and the mood of the environments in
which the characters lived and acted. Coburn learned how
to make photogravures at a London trade school and set
up a press in his studio, etching the copper plates and
printing them himself. He published several books with
these hand-pulled gravures, notably *London* (1909),
with a preface by Hilaire Belloc;[38] *New York* (1910),
with a preface by H. G. Wells;[39] and *Men of Mark*
(1913), thirty-three portraits.[40]

On February 17, 1902, Stieglitz formed a new society
in New York to further the artistic recognition of pic-
torial photography.[41] He named the society the Photo-
Secession, choosing the name "Secession" because of its
use by societies of avant-garde artists in Germany and
Austria to denote their independence of the academic
establishment. The founders were Stieglitz—who was
director of the Council—John G. Bullock, William B.
Dyer, Frank Eugene, Dallet Fuguet, Gertrude Käsebier,

160

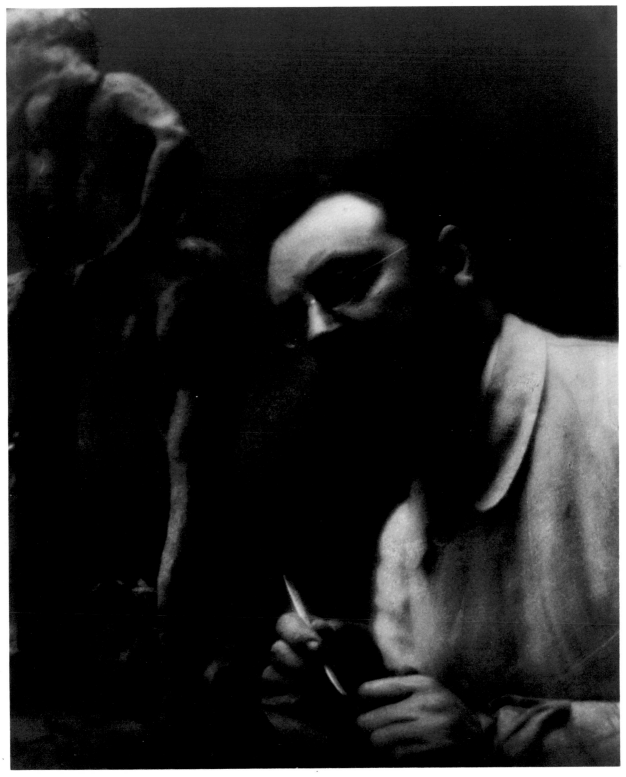

EDUARD J. STEICHEN. *Henri Matisse and "The Serpentine."* ca. 1909. Platinum print. The Museum of Modern Art, New York.

Joseph T. Keiley, Robert S. Redfield, Eva Watson-Schütze, Eduard J. Steichen, Edmund Stirling, John Francis Strauss, and Clarence H. White. Its stated aim was threefold:

To advance photography as applied to pictorial expression;

To draw together those Americans practicing or otherwise interested in art;

To hold from time to time, at varying places, exhibitions not necessarily limited to the productions of the Photo-Secession or to American work.[42]

Just after the founding of the society, Stieglitz was personally invited by the National Arts Club to organize an exhibition of American pictorial photography in their New York building. "I enlisted the aid of the then newly organized and limited 'Photo-Secession,' " he wrote in *Photograms of the Year 1902,* "and it was determined to hold the forthcoming exhibition under the auspices of that group."[43]

It was a carefully selected show, presented with taste and a sense of intimacy unusual in photographic exhibitions. A hundred and sixty-three framed photographs were hung, taken by thirty-two photographers, eighteen of whom were members of the society. Art critics were positive about it: some found it a revealing demonstration of hitherto unsuspected aesthetic possibilities of the camera, others condemned it as a pretentious display of imitation paintings and wondered if the aim of the photographers was "to hold as 'twere a smoked glass up to nature."[44]

Stieglitz reprinted the reviews in the July 1902, issue of *Camera Notes.* It was the last issue of the magazine to be edited by him. His determination to win recognition of pictorial photography had not been shared by all of the members of The Camera Club. They felt that Stieglitz was autocratic in his selection of illustrations; many members were hurt that their photographs were not recognized; some even challenged his honesty in accounting for the expenditure of the Club's funds. Stieglitz felt compelled to resign as editor, and at once founded a new quarterly, *Camera Work,* the editorship and publication of which he personally assumed.

Fifty issues of *Camera Work* appeared between 1903 and 1917. The cover designs and the typography were by Steichen. The plates were, for the most part, photogravures on thin Japan paper hand-mounted on the pages, often on submounts of brown or gray. The first number was devoted to Käsebier, the second to Steichen, and succeeding issues were virtually monographs of the work of other members of the Photo-Secession as well as of leading photographers in Europe: Evans, Coburn, Demachy, Kühn, Henneberg, Watzek, and others. Nor was photography of the past overlooked: one issue contained calo-

types by Hill and Adamson, another portraits by Julia Margaret Cameron—photographers then virtually forgotten. Essays by art critics and members of the Photo-Secession were printed, and the activities of the society were noted. *Camera Work* is thus a meticulous documentation of the pictorial movement as well as a beautiful presentation of its accomplishments. So impressive was the quarterly that the British press reviewed each issue along with recent books. The editor of *Photography* wrote: ". . . the conduct and success of the journal is a personal one, and a personal one only, and until we can find a British Stieglitz, *Camera Work* must remain unique."[45]

In addition to publishing, Stieglitz organized loan exhibitions of the work of the Photo-Secessionists and other photographers. He undertook full curatorial responsibility: selection, cataloguing, framing, packing, and shipping to organizations at home and abroad. Of the United States showings, the most important were held, by invitation, at the Corcoran Art Gallery, Washington, D.C., and at the Carnegie Institute, Pittsburgh, in 1904. Handsome catalogs with tipped-in photogravures from *Camera Work* were published. The extent to which the work of the Photo-Secessionists was exhibited in Europe can be measured by the Director's report in the members' bulletin, *The Photo Secession,* dated May 1904:

It is a remarkable comment upon the status of the photographic societies of the United States, that the Photo-Secession has been singled out by all the important European photographic and art-exhibitions as the only one worthy to be invited, and invited *hors concours* at that. At the time this is written the Secession has collections at the art-exhibitions at Dresden, Germany; Bradford, England; and at the photographic exhibitions in The Hague, Holland; Paris, France; Vienna, Austria. The size of these collections varies from 33 to 144 frames, the number now in Europe at all these exhibitions aggregating about 400.[46]

But the roster of cities where Photo-Secession work was exhibited did not include New York, for the society had no headquarters there. All its business was transacted at Stieglitz's home. In 1905 Steichen suggested that the members rent the studio at 291 Fifth Avenue, which he had just vacated. The proposal was accepted, and on November 5 "The Little Galleries of the Photo-Secession" opened to the public, with a show of photographs by the members. This inaugural show was followed by a series of exhibitions presenting work by leading pictorial photographers of Europe and America.

The Photo-Secession dominated the 1908 Photographic Salon of the Linked Ring in London. Three of the Selecting Committee—Steichen, Coburn, and Eugene—were Photo-Secessionists. On opening day photographers were shocked that more than one half of the photographs

BARON ADOLF DE MEYER. *Still Life.* 1907. Photogravure in *Camera Work*, no. 24 (1908).

on the walls were by Americans. So upset were those whose work had been rejected that the magazine *The Amateur Photographer* organized a "Salon des Refusés" in its editorial office. In protest Stieglitz, Clarence H. White, Coburn, and Eugene resigned from the Linked Ring, together with Heinrich Kühn and Baron Adolf de Meyer. The Photographic Salon at once lost the effective-

ness it had built up over the past fifteen years. Its last exhibition was held in 1909. Some of the more conservative members of the now-defunct Linked Ring organized The London Salon of Photography to replace it.

The revolt was not so much political as the reflection of an abrupt change in aesthetic sensibility. The work of three of the selecting committee of the 1908 Salon—

Baron Adolf de Meyer, Steichen, and Coburn—pointed in directions opposed to the quiet passivity of the now accepted impressionistic pictorial style.

De Meyer, who had begun exhibiting in 1894, was now producing portraits and large-scale still life arrangements taken with a soft-focus lens. This type of lens gave the pictorial photographer an optical control that could not be gained simply by throwing the image out of focus. With a true soft-focus lens, no part of the image is ever sharp because in their manufacture no correction is made for spherical aberration. In other types, designed specifically for portraiture, the degree of diffusion can be controlled. A characteristic of the images formed by these lenses is that highlights appear increased in brilliance, as if they projected rather than reflected the incident light. De Meyer placed still life arrangements—fruit, flowers in glass containers—on a glass tabletop. The transparency of vase and tabletop, the reflections, and the diffusion of focus eliminated the sense of depth or placement in space. In counterpoint to the delicacy of highlights are sturdy blacks, particularly of flower stems thrust in water-filled glass containers. One critic complained of "the effort needed to pierce the 'atmosphere' of the table top on which rests a black melon."[47] These photographs were far removed from conventional, easy to grasp still-life studies.

Steichen exhibited two prints, *Steeplechase Day*, and *Grand Prix*, that showed, not the racecourse nor the racehorses, but elegantly dressed spectators caught in brilliant bursts of sunshine. They were snapshots, taken with a newspaperman's hand camera—a Goerz-Anschütz—that he had borrowed. Coburn's *Flip-Flap* was made at an amusement park: two pivoted steel girders, each carrying a car for passengers, form a strident V against a stark sky. To Frederick H. Evans, these were distasteful, and he complained to Stieglitz that his photograph of Joan of Arc's house in Rouen had been rejected. Evans's picture was the opposite in spirit from Steichen's and Coburn's. Theirs showed the contemporary world, while Evans eliminated any sign of the present in his photograph. To avoid showing pedestrians, whose dress would date the picture, he worked early in the morning, with a neutral density filter over his lens to permit a very long exposure. Should a person or vehicle appear, he simply capped the lens and waited patiently until the streets were again empty. With superb craftsmanship he sought to record the beauty of the world; the ugliness of *Flip-Flap* was so distasteful he could not appreciate the stark geometric mechanical forms that led Coburn to make the photograph. Nor could he understand Steichen's pictures: "Their double tones are abhorrent; no modeling, no planes, no gradation, no lighting of any truth, in short no *photography* of any worth in 'em."[48]

Two years later, in a review of a salon show in Liverpool, Dixon Scott, the highly perceptive art critic of the Liverpool *Courier*, wrote: "Scenes and groupings torn out of the impetuous life of the hour are suddenly made momentous, given a new glamour and significance. And that, one likes to believe, is, after all, the special function of this newborn art of ours."[49] Evans replied in an article, "The New Criticism": "The rarity of the opportunity or power of making such vivid things, and the rarity of the event that, when seen by the capable artist, he is able and ready to catch them; the fact that such vividnesses are so accidental in their happenings, are so unsought, will always make them the exception and not the rule."[50]

In 1910 the Photo-Secession was invited to arrange an international exhibition of pictorial photography at the Albright Art Gallery in Buffalo. Complete control of the presentation was demanded and secured: Stieglitz, with the aid of his friends Paul Haviland, Clarence H. White, and the painter Max Weber, transformed the museum. They covered the exhibition walls with olive and blue cloth, and hung 600 photographs. Each photographer invited was represented by enough prints to enable his artistic development to be traced over the years.

It was gratifying to the Photo-Secessionists to be able to show photographs with such dignity in an art museum; it was even more gratifying that the museum purchased fifteen prints from the exhibition for its collection and planned to set aside a room for their permanent display, for it was a vindication of their belief that photography had the right to recognition as a fine art.[51] Critics almost unanimously praised the exhibition as the most impressive presentation of photography they had seen. It was a summing up of the pictorial movement in America and Europe. As if to emphasize its retrospective character, the dates of both the making of the negative and of the print were meticulously set down in the catalog, along with historical notes, presumably by Stieglitz. One critic even asked if the exhibition was the *nunc dimittis* of the Photo-Secession. The most prolific, and at times the most sensitive photographic critic of the day, Sadakichi Hartmann, noted that "the pictorial army is divided in two camps," one favoring "painter-like subjects and treatment" and the other, in which Stieglitz was numbered, made up of those "who flock around the standards of true *photographic themes and textures*." He went on to observe that "the camp of the former . . . becomes more and more deserted, the old flag hangs limp and the fires burn low. . . ."[52] But just what were the "*photographic themes and textures*" Hartmann emphasized with italics?

ALVIN LANGDON COBURN. *Flip-Flap*. 1908. Gelatin-silver print. Collection Beaumont Newhall, Santa Fe.

ANSEL ADAMS. *Courthouse, Bridgeport, California.* 1933. Gelatin-silver print. Courtesy of the photographer.

10 • STRAIGHT PHOTOGRAPHY

At the beginning of the twentieth century, progressive artists were groping for a new aesthetic based upon the unique properties and characteristics of their chosen medium. "Form follows function" became their slogan. Architects were designing skyscrapers that expressed the nature of the steel skeleton rather than imitating in design and ornamentation classical masonry structures. Sculptors were now respecting the texture of chiseled marble for its own sake; no longer were they working it over to simulate the soft smoothness of flesh or the very weave of textiles. Progressive painters found photography a liberation. They now felt free of the need to produce representational pictures: Cubism and abstract art were born.

This functional aesthetic also influenced photography. Critics began to praise "photographs that look like photographs," those devoid of the manipulation so prevalent in the work of pictorialists who strove to force photography to emulate the surface textures of pictures made by other media. Articles began to appear in the photographic press in praise of "pure photography." Art critic Sadakichi Hartmann, in an otherwise highly laudatory review of the Photo-Secession exhibition at the Carnegie Institute in 1904, condemned gum printing, the glycerine process, and handwork on negatives and prints. He called upon pictorialists "to work straight:"

"And what do I call straight photography," they may ask, "can you define it?" Well, that's easy enough. Rely on your camera, on your eye, on your good taste and your knowledge of composition, consider every fluctuation of color, light and shade, study lines and values and space division, patiently wait until the scene or object of your pictured vision reveals itself in its supremest moment of beauty, in short, compose the picture which you intend to take so well that the negative will be absolutely perfect and in need of no or but slight manipulation. I do not object to retouching, dodging or accentuation as long as they do not interfere with the natural qualities of photographic technique. Brush marks and lines, on the other hand, are not natural to photography, and I object and always will object to the use of the brush, to finger daubs, to scrawling, scratching and scribbling on the plate, and to the gum and glycerine process, if they are used for nothing else but to produce blurred effects.

Do not mistake my words. I do not want the photographic worker to cling to prescribed methods and aca-

demic standards. I do not want him to be less artistic than he is to-day, on the contrary I want him to be *more artistic*, but only in legitimate ways. . . . I want pictorial photography to be recognized as a fine art. It is an ideal that I cherish, . . . and I have fought for it for years, but I am equally convinced that it can only be accomplished by straight photography.[1]

Straight photography, of course, has a tradition as old as the medium. The daguerreotype image was so fragile that retouching was impractical and, while the densities of calotype negatives were frequently reinforced by applying opaque pigments to the back of the paper, the camera image was seldom radically altered. Retouching portraits became common practice in the collodion era, but for purposes more cosmetic than aesthetic: to please the customer by removing facial blemishes and softening the marks of time. What was new in the opening years of the twentieth century was the acceptance of the straight photograph as a "legitimate" art medium. In a later article Hartmann noted that

The composition of the Old Masters, used for centuries, has passed through its first decadence and by constant application has degraded into conventionalism. It grew more and more stereotyped, until impressionist composition—which explores obscure corners of modern life, which delights in strangeness of observation and novel view points (strongly influenced by Japanese art and snapshot photography)—gave it a new stimulant.

In photography, pictorial expression has become infinitely vast and varied, popular, vulgar, common and yet unforeseen; it is crowded with lawlessness, imperfection and failure, but at the same time offers a singular richness in startling individual observation and sentiments of many kinds. . . . The painter composes by an effort of imagination. The photographer interprets by spontaneity of judgment. He practices *composition by the eye*.[2]

Although Alfred Stieglitz championed many photographers who manipulated negative and prints, and experimented with gum printing and the glycerine process, in his mature years he preferred to stick closely to the basic properties of camera, lens, and emulsion. Charles H. Caffin said in 1901 that Stieglitz was

by conviction and instinct an exponent of the "straight photograph," working chiefly in the open air, with rapid

exposures, leaving his models to pose themselves, and relying for results upon means strictly photographic. He is to be counted among the Impressionists; fully conceiving his picture before he attempts to take it, seeking for effects of vivid actuality and reducing the final record to its simplest form of expression.[3]

In 1907 Stieglitz photographed *The Steerage*, a picture that in later life he considered his finest. He recollected that while he was promenading the first-class deck of the luxury liner *Kaiser Wilhelm II* on an eastbound voyage to Europe, he saw

A round straw hat, the funnel leaning left, the stairway leaning right, the white drawbridge with its railings made of circular chains—white suspenders crossing on the back of a man in the steerage below, round shapes of iron machinery, a mast cutting into the sky, making a triangular shape. . . . I saw a picture of shapes and underlying that the feeling I had about life.[4]

Hurriedly he rushed to his cabin for his Graflex camera, hoping that the figures would not move in the meantime. He returned to find all as he had left it and quickly released the shutter. The picture was the result of instant recognition of subject and form—"spontaneity of judgment" and "composition by the eye," as his friend Hartmann put it. No longer, as in his *Winter on Fifth Avenue,* did he find an environment and patiently wait until "everything was in balance." Now he instantly, without hesitation or even conscious thought, put a frame around the subject. Furthermore, he printed the full negative, without cropping.

Stieglitz was elated that Pablo Picasso liked *The Steerage.* The father of Cubism was at that time painting his *Les Demoiselles d'Avignon,* the canvas that was to mark a turning point in the style of the century.

It was also at this time that Stieglitz, at the instigation of Steichen and with his enthusiastic help, began to champion the most progressive painting and sculpture, as well as photography. The original announcement of the Little Galleries of the Photo-Secession at 291 Fifth Avenue, New York, proclaimed that future exhibitions were to be arranged, not only of photographs, but also of "such other art productions as the Council will from time to time secure." Stieglitz began in 1907 with an exhibition of drawings by Pamela Coleman Smith, in a style reminiscent of the late nineteenth-century German Romantic painters he so appreciated.

The Little Galleries of the Photo-Secession consisted of only three rooms. The largest was 15 by 17 feet, the second was 15 feet square, and the third was only 15 by 8 feet. Yet in this confined space Stieglitz, with the enthusiastic aid of Steichen, introduced the most avant-garde painting and sculpture that America had seen: drawings by Auguste Rodin, watercolors and lithographs

by Paul Cézanne, drawings and sculpture by Henri Matisse and Constantin Brancusi, Cubist paintings by Pablo Picasso, Georges Braque, and Francis Picabia. Soon paintings by Americans were shown as well as those of European origin, including work by John Marin, Marsden Hartley, Max Weber, Arthur Dove, and later, Georgia O'Keeffe. Photographers were bewildered, often angry, that the Photo-Secession should place such emphasis on nonphotographic works of art. *Camera Work* explained editorially that "291," as the Little Galleries came to be familiarly called, was " a laboratory, an experimental station, and must not be looked upon as an Art Gallery, in the ordinary sense of that term."[5]

When the Association of American Painters and Sculptors decided to hold a great international exhibition of contemporary painting and sculpture in the Armory of the 69th Regiment in New York in 1913, the organizing committee consulted Stieglitz. He did not actively participate, but wrote a challenging preview article in the Sunday New York *American* titled "The First Great Clinic to Revitalize Art,"[6] exhorting the public to see the show. And he put on the walls of "291" the first one-man exhibition of his own photographs in fourteen years. To him this was a demonstration of what photography is and painting is not; and the "Armory Show" was a demonstration of what painting is and photography is not.

Stieglitz's exhibition included recent work done in New York: the railroad yards, the skyscrapers, the harbor, with buildings rising sheer from the waterfront, ferry boats, ocean liners. He was now making many portraits, which formed a pictorial record of the artists and friends who participated in the activities of "291." The painter Konrad Cramer has described sitting for him in 1912:

His equipment was extremely simple, almost primitive. He used an 8 x 10 view camera, its sagging bellows held up by pieces of string and adhesive tape. The lens was a Steinheil, no shutter. The portraits were made in the smaller of the two rooms at "291" beneath a small skylight. He used Hammer plates with about three-second exposures.
During the exposure, Stieglitz manipulated a large white reflector to balance the overhead light. He made about nine such exposures and we then retired to the washroom which doubled as a darkroom. The plates were developed singly in a tray. From the two best negatives he made four platinum contact prints, exposing the frame on the fire escape. He would tend his prints with more care than a cook does her biscuits. The finished print finally received a coat of wax for added gloss and brilliance.[7]

Note that Stieglitz waxed the print "for added gloss and brilliance." A glossy surface had been considered "inartistic" only a few years earlier. So too were tintypes— yet in 1913 Stieglitz could write, "A smudge in 'gum' has

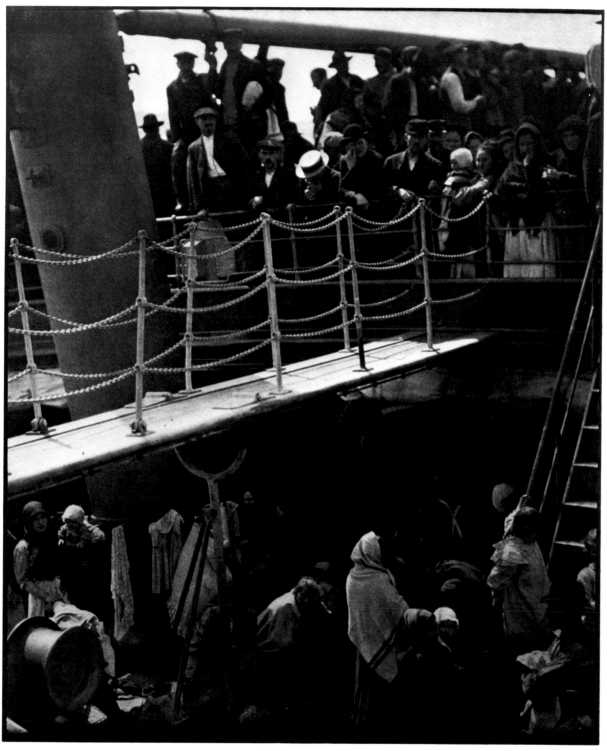

ALFRED STIEGLITZ. *The Steerage.* 1907. Photogravure in *291*, no. 7-8 (1915). The Museum of Modern Art, New York.

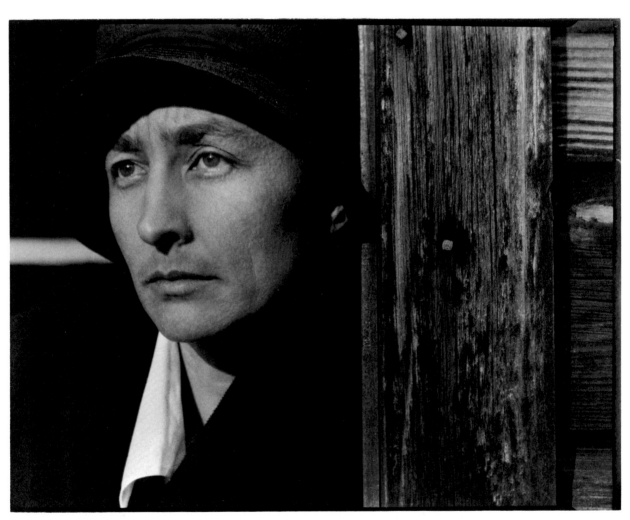

ALFRED STIEGLITZ. *Portrait of Georgia O'Keeffe*. 1922. Palladium print. George Eastman House, Rochester, N.Y.

less value from an aesthetic point of view than an ordinary tintype."[8]

In 1917 the Photo-Secession and "291" came to an end, when the building was torn down. Many of the members had already drifted away. Steichen joined the United States Army. Clarence H. White opened a highly influential School of Photography, and with Gertrude Käsebier and Alvin Langdon Coburn founded in 1916 a new organization, The Pictorial Photographers of America.

During the immediate postwar years Stieglitz brought his photography to a new intensity.[9] In 1921 he arranged an exhibition of both old and new work at the Anderson Galleries in New York. Every one of the photographs was startlingly direct, and the effect upon the public was electric. John A. Tennant, editor and publisher of *The Photo-Miniature*, reviewed the exhibition:

Never was there such a hubbub about a one-man show. What sort of photographs were these prints, which caused so much commotion? Just plain, straightforward photographs. But such photographs! Different from the photographs usually seen at the exhibitions? Yes. How different? There's the rub. If you could see them for yourself, you would at once appreciate their difference. One might venture the comparison that in the average exhibition print we have beauty, design, or tonal scheme deliberately set forth, with the subject as motive or material merely, the subject as the photographer saw it or felt it, an interpretation, a phase; whereas, in the Stieglitz prints, you have the subject itself in its own substance or personality, as revealed by the natural play of light and shade about it, without disguise or attempt at interpretation, simply set forth with perfect technique—and so on, multiplying words. There were portraits, some of them of men whom I knew fairly well. Sometimes it was a single print, at other times several prints side by side, giving different aspects of the subject but grouped as "one Portrait." Well, they were just portraits of those men, compellingly intimate, betrayals (if I may so use the word) of personality, satisfying in likeness, convincing in characterization, instinct with the illusion of life. They gave one the impression of being in the presence of the men whom they portrayed. They offered no hint of the photographer or his mannerisms, showed no effort at interpretation or artificiality of effect; there were no tricks of lens or lighting. I cannot describe them better or more completely than as plain straightforward photographs. . . . They made me want to forget all the photographs I had seen before, and I have been impatient in the face of all photographs I have seen since, so perfect were these prints in their technique, so satisfying in those subtler qualities which constitute what we commonly call "works of art."[10]

In the catalog Stieglitz wrote that the exhibition was "the sharp focusing of an idea. . . . My teachers have been life—work—continuous experiment. . . . Every print I make, even from one negative, is a new experience, a new problem. . . . Photography is my passion. The search for Truth my obsession."

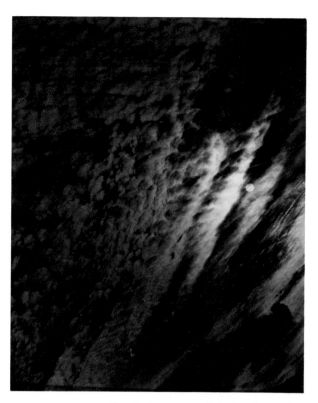

ALFRED STIEGLITZ. *Equivalent.* 1927. Gelatin-silver print. The Museum of Modern Art, New York.

Those who knew Stieglitz knew the force of his personality, and they attributed his success in portraiture to a kind of hypnotic power over his sitters. To show that this was not so, Stieglitz chose subject matter over which he could not possibly have any control: the sky and clouds.

I wanted to photograph clouds to find out what I had learned in forty years about photography. Through clouds to put down my philosophy of life—to show that my photographs were not due to subject matter—nor to special privileges, clouds were there for everyone—no tax on them yet—free.[11]

He produced hundreds of these pictures of sun and clouds, mostly made with a 4 x 5-inch Graflex camera. He processed them by means within the reach of any amateur, printing by contact on gelatin-silver paper. He called these pictures "equivalents," and he put them in series with other pictures of expressive, often evocative, content and handling—a meadow glistening with raindrops, a woman's hands pressed palm to palm between her knees. He found them to be equivalents to his thoughts, to his hopes and aspirations, to his despairs and fears. Viewed objectively, many of these rich prints with deep blacks and shimmering grays and incandescent whites delight us for their sheer beauty of form. They are photographic abstractions, for in them form is abstracted from its illustrative significance. Yet paradoxically the

171

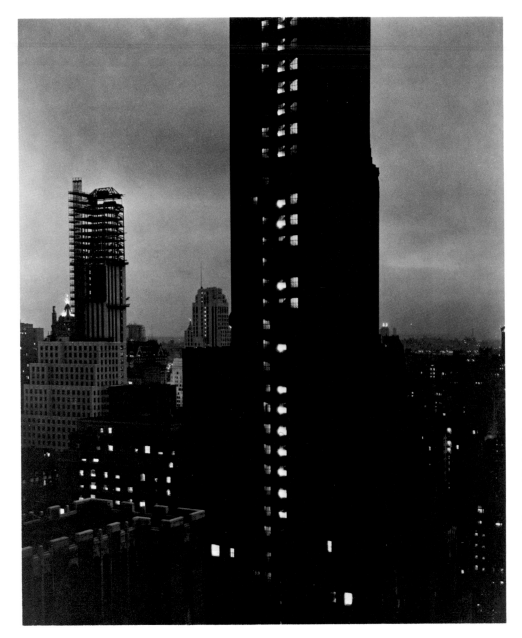

Left: ALFRED STIEG-
LITZ. *New York—
Night.* 1931. The Mu-
seum of Modern Art,
New York.

Right: PAUL STRAND.
*Portrait—Washington
Square, New York.*
1916. Photogravure in
Camera Work, no. 49-
50 (1917). The Mu-
seum of Modern Art,
New York.

spectator is not for an instant left unaware of what has been photographed. With the shock of recognition one realizes almost at once that the form that delights the eye is significant, and one marvels that such beauty can be discovered in what is commonplace. For this is the power of the camera: it can seize upon the familiar and endow it with new meanings, with special significance, with the imprint of a personality.

Among the last photographs Stieglitz made (poor health forced him to abandon using the camera around 1937) were pictures of New York taken from high windows, and the meadows and trees around the old family house at Lake George, where he spent his summers. He continued all the while to champion modern art: at An

American Place, his New York gallery, he continued the series of painting exhibitions, along with occasional photographic shows, up until his death in 1946. Stieglitz was always there, and from him many a young person found counsel and direction.

In the last two issues of *Camera Work,* dated 1916 and 1917, Stieglitz reproduced photographs by a newcomer, Paul Strand. They included a forceful series of portraits taken unawares in the streets with a Graflex camera, and pictures in which form and design were emphasized—a semiabstraction of bowls, a view looking down from a viaduct, an architectural scene dominated by the vertical accents of a white picket fence. As Stieglitz wrote, the work was "brutally direct, pure and devoid of trickery." It

PAUL STRAND. *The White Fence, Port Kent, New York.* 1916. Photogravure in *Camera Work,* no. 49-50 (1917). The Museum of Modern Art, New York.

was in striking contrast to much of the work produced by members of the Photo-Secession. It was prophetic of the reorientation in photographic aesthetics and of the return to the traditions of straight photography, which was to gain strength in the years after the war. Strand wrote in 1917:

The photographer's problem is to see clearly the limitations and at the same time the potential qualities of his medium, for it is precisely here that honesty no less than intensity of vision is the prequisite of a living expression. This means a real respect for the thing in front of him expressed in terms of chiaroscuro . . . through a range of almost infinite tonal values which lie beyond the skill of human hand. The fullest realization of this is accomplished without tricks of process or manipulation through the use of straight photographic methods.[12]

Strand was among the first to discover the photographic beauty of precision machines. He made a series of extreme close-ups of his Akeley motion picture camera (he was earning his living making films) and of power lathes. On a trip to Maine he discovered the beauty of large-scale details of driftwood, cobwebs, plants, and other natural objects. In 1923, lecturing to the students of the Clarence H. White School of Photography, he made a strong plea for the revival of craftsmanship and told them of the need to free photography from the domination of painting, and to recognize that the camera had its own aesthetic.

Strand's negatives were seen with intensity and sureness; his work has a quality rarely found in photography, a quality that can only be described as lyrical. He con-

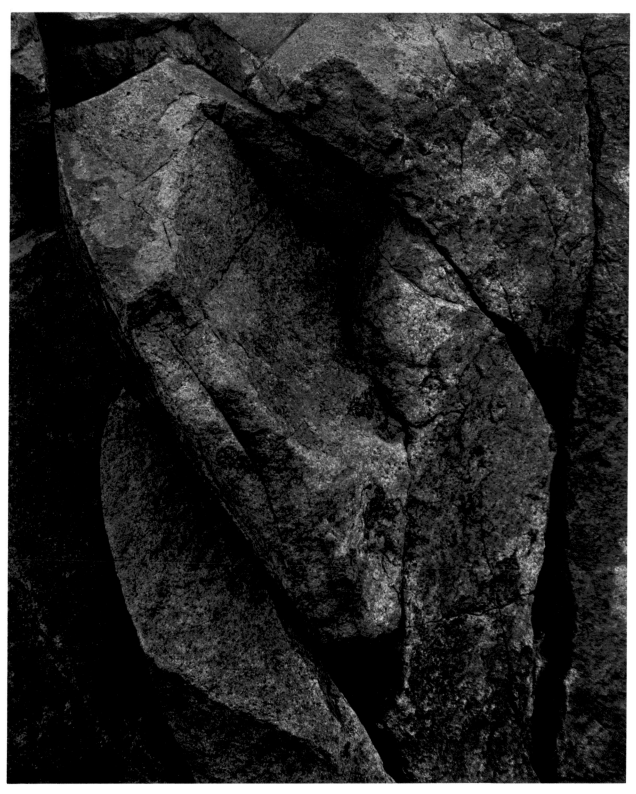

PAUL STRAND. *Rock, Porte Lorne, Nova Scotia.* 1919. Gelatin-silver print. The Museum of Modern Art, New York.

PAUL STRAND. *Double Akeley, New York.* 1922. Gelatin-silver print. The Museum of Modern Art, New York.

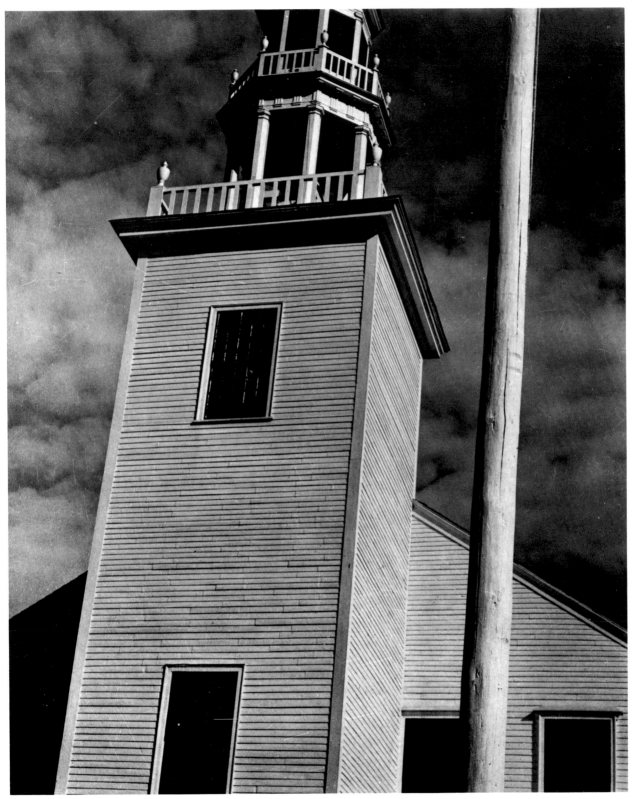

PAUL STRAND. *Town Hall, Vermont.* 1946. Gelatin-silver print. The Paul Strand Foundation, Millerton, N.Y.

CHARLES SHEELER. *Bucks County Barn*. 1916. Gelatin-silver print. Collection Beaumont Newhall, Santa Fe.

sistently photographed people and the landscape, seeking always the feeling of place, the land, and the inhabitants. He did a series of books beginning with *Time in New England* (1950), edited by Nancy Newhall, who selected New England writings from the seventeenth century to the present to accompany the photographs.[13] Words and pictures reinforce and illuminate one another with synergistic effect. For *La France de profil* (1952) Strand found a collaborator in Claude Roy, who used a somewhat similar editing technique.[14] The Italian scenarist and filmmaker Cesare Zavattini wrote the text for *Un Paese* (1955) to accompany photographs taken in his native village of Luzzara.[15] Strand's later books explore a wide range of countries, from the Hebrides to Egypt and Ghana. He died in the village of Orgeval, France, in 1976.

In 1914 Charles Sheeler began to discover with his camera the beauty of indigenous American architecture, photographing with honest directness the texture of white painted and weathered wood, and the beautifully proportioned rectangular forms of Pennsylvania barns. First and

foremost a painter, Sheeler had a keen appreciation of the photograph as a distinct medium. He told his biographer, Constance Rourke,

I have come to value photography more and more for those things which it alone can accomplish, rather than to discredit it for the things which can only be achieved through another medium. In painting I have had a continued interest in natural forms and have sought the best use of them for the enhancement of design. In photography I have strived to enhance my technical equipment for the best statement of the immediate facts.[16]

Charles Sheeler's contribution to photography has been his sensitive interpretation of the form and texture of man's work in precise, clean photographs of African Negro masks (1918), the industrial architecture of the Ford plant at River Rouge (1927), the Cathedral of Chartres, seen in a series of details (1929), and in the photographs of ancient sculpture that he did for The Metropolitan Museum of Art, New York (1942-45).

Edward Steichen, placed in charge of aerial photog-

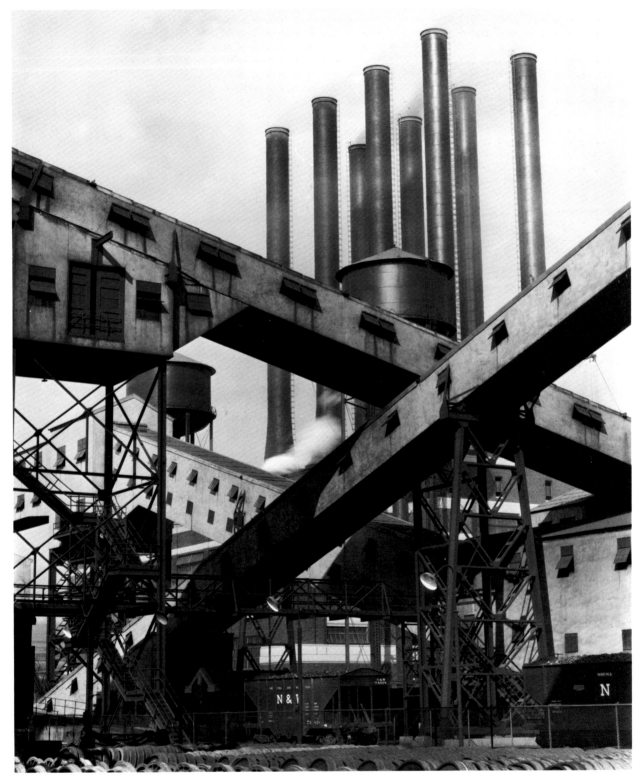

CHARLES SHEELER. *Ford Plant, Detroit.* 1927. Gelatin-silver print. The Museum of Modern Art, New York.

EDWARD STEICHEN. *Wheelbarrow with Flower Pots.* 1920. Gelatin-silver print. The Museum of Modern Art, New York.

EDWARD STEICHEN. *Backbone and Ribs of a Sunflower.* ca. 1920. Gelatin-silver print. The Museum of Modern Art, New York.

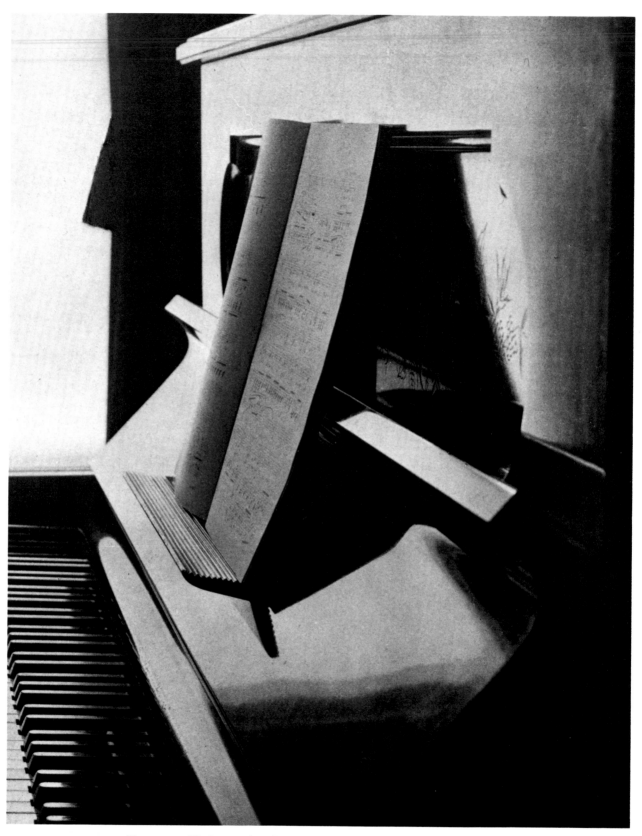

PAUL OUTERBRIDGE, JR. *Piano*. 1922. Platinum print. Courtesy of G. Ray Hawkins Gallery, Los Angeles.

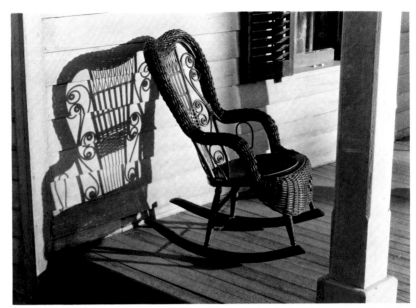

RALPH STEINER. *American Rural Baroque.* 1930. Gelatin-silver print. The Museum of Modern Art, New York.

WALKER EVANS. *Maine Pump.* 1933. Gelatin-silver print. The Museum of Modern Art, New York.

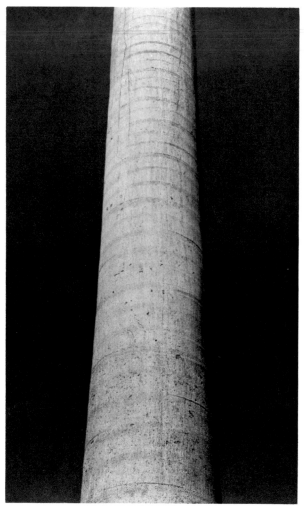

EDWARD WESTON. *Palma Cuernavaca II.* 1925. Platinum print. George Eastman House, Rochester, N.Y.

"The weather having favored me at last with printing days, I had ready to show a print of the new palm. Why should a few yards of white tree trunk, exactly centered, cutting across an empty sky, cause such real response? And why did I spend my hours doing it? One question is simply answered—I had to!"

—Edward Weston, *The Daybooks,* December 1925.

Opposite top: EDWARD WESTON. *Clouds—Mexico.* 1926. Platinum print. George Eastman House, Rochester, N.Y.

Opposite bottom: EDWARD WESTON. *Nude.* 1925. Platinum print. George Eastman House, Rochester, N.Y.

raphy of the American Air Service during the second Battle of the Marne, was faced with the problem of securing photographs with a maximum of detail, definition, and brilliance. He found such beauty in these straight photographs that in 1920 he repudiated his gum prints, abandoned painting, and set out to master pure photographic processes almost as if he were a beginner, setting himself such extreme problems as the rendition of the brilliant contrasts of a white teacup on black velvet. Armed with this mastery of technique, and with his brilliant sense of design and ability to grasp in an image the personality of a sitter, he began to raise magazine illustration to a creative level. (See Chapter 14.)

Younger photographers in New York, particularly Paul Outerbridge, Jr., Ralph Steiner, and Walker Evans, were quick to recognize in the early 1920s the new aesthetic of straight photography. Outerbridge's precise still-life studies and Steiner's photographs of the strident forms of skyscrapers and vernacular buildings won international recognition. Evans became preoccupied with the American scene: he photographed architecture, the folk art of signs and billboards, and people in the streets with a sensitivity that lifted the images above records. He is best known for later work with the Farm Security Administration and was instrumental in forming the documentary style of that government project. (See Chapter 13.)

In California, around 1920, Edward Weston, who had been honored by election to the London Salon of Photography (successor to The Linked Ring), began a critical reexamination of his work, which up to that time had been soft in focus, but always done with a sense of light and form. He experimented with semiabstractions: *R.S. —A Portrait* is a bold, unconventional placing of the upper half of the sitter's head at the very bottom of a composition of triangles and diagonals. A detail of a nude woman—circle of breast and diagonal of arm—was equally abstract. On a trip to New York in 1922 he met Alfred Stieglitz, who received him courteously, but without the affirmation he had hoped for. From 1923 to 1926 Weston lived in Mexico and became a friend of many of the artists of the Mexican Renaissance. It was for him a period of transition, of self-analysis and self-discipline, which he recorded with unusual frankness in his *Daybooks.*[17] He wrote that of the two directions he saw in his most recent work—abstraction and realism—the latter was the stronger and offered the greatest potential for creative expression, and commented:

The camera should be used for a recording of *life,* for rendering the very substance and quintessence of the *thing itself,* whether it be polished steel or palpitating flesh . . . I shall let no chance pass to record interesting

184

EDWARD WESTON. *Artichoke Halved.* 1930. Gelatin-silver print. The Museum of Modern Art, New York.

EDWARD WESTON. *White Dunes, Oceano, California.* 1936. Gelatin-silver print. The Museum of Modern Art, New York.

EDWARD WESTON. *Point Lobos, California.* 1946. Gelatin-silver print. The Museum of Modern Art, New York.

abstraction, but I feel definite in my belief that the approach to photography is through realism.[18]

His technique and aesthetic became one: "Unless I pull a technically fine negative, the emotional or intellectual value of the photograph is for me almost negated."[19] He simplified his working method, preferring contact prints to enlargements, gelatin-silver paper to the softer platinotype. He replaced his expensive soft-focus lens with an inexpensive, sharply cutting rapid rectilinear lens. "The shutter stops down to 256," he noted. "This should satisfy my craving for depth of focus."[20]

The most important part of Edward Weston's approach was his insistence that the photographer should previsualize the final result. As early as 1922 he wrote: "The real test of not only technical proficiency, but intelligent conception, is not in the use of some indifferent negative as a basis to work from, but in the ability to see one's finished print on the ground glass in all its desired qualities and values before exposure."[21]

Weston developed this approach to the point of virtuosity. He demanded clarity of form, he wanted every area of his picture clear-cut, with the substances and textures of things appreciable to the point of illusion. The fact that the camera can see more than the unaided eye he long regarded as one of the great miracles of photography. In a Weston landscape, everything is sharp from the immediate foreground to the extreme distance:

looking at the same scene in nature our eyes take in one detail after another. Constantly roving, jumping from spot to spot, they scan the panorama and send to the brain a series of reports from which a composite image is mentally created. In Weston's photographs the details are so compressed and reduced that the scanning process requires far less muscular effort on the part of the beholder, who unconsciously feels a physiological release. In 1909 Willi Warstat, in his *Allgemeine Ästhetik der photographischen Kunst,* a book that is perhaps the earliest systematic examination of photographic aesthetics from the standpoint of modern psychological and physiological theories of vision, succinctly analyzed this aspect of the mechanics of seeing.[22] He found that the compression of all-over detail was something to be avoided by the photographer in his "battle with realism." Weston had no quarrel with realism. His vision led him to a straight, often brutally direct approach that made use of the phenomenon with powerful effects. It must be noted, however, that the rendering of detail alone was not his criterion; it was governed by his taste, imagination, and feeling for form.

In 1937 Edward Weston was awarded a John Simon Guggenheim Memorial Foundation Fellowship—the first photographer to be so honored. His style expanded, the variety of subject matter increased, and a rich human quality pervaded his later work. His last photographs, intricately organized and of great force, were made in 1948 on his beloved Point Lobos on the California coast not far from his home in Carmel. Tragically, he was stricken with Parkinson's disease, and could no longer photograph. He died in Carmel, California, on New Year's Day, 1958.

Brett Weston began to photograph in 1925, when he was thirteen years old and living with his father in Mexico. Even his early photographs had an individual style, one marked by a strong appreciation of shadow forms and textures, as in his *Tin Roof* of 1926. It was Brett who discovered the richness of Point Lobos, the area that he and his father were to photograph so often. His more recent work is on a larger scale, with bolder compositions producing powerful abstraction, yet always with recognizable subjects.

In 1932 a number of younger photographers, greatly impressed by Edward Weston and his work, formed a society to which they gave the name "Group f/64."[23] They chose an optical term because they habitually set their lenses to that aperture to secure maximum image sharpness of both foreground and distance. The charter members—Ansel Adams, Imogen Cunningham, John Paul Edwards, Sonya Noskowiak, Henry Swift, Willard Van Dyke, and Edward Weston—formulated an aesthetic

BRETT WESTON. *Corrugated Iron Roof.* 1925. Gelatin-silver print. The Museum of Modern Art, New York.

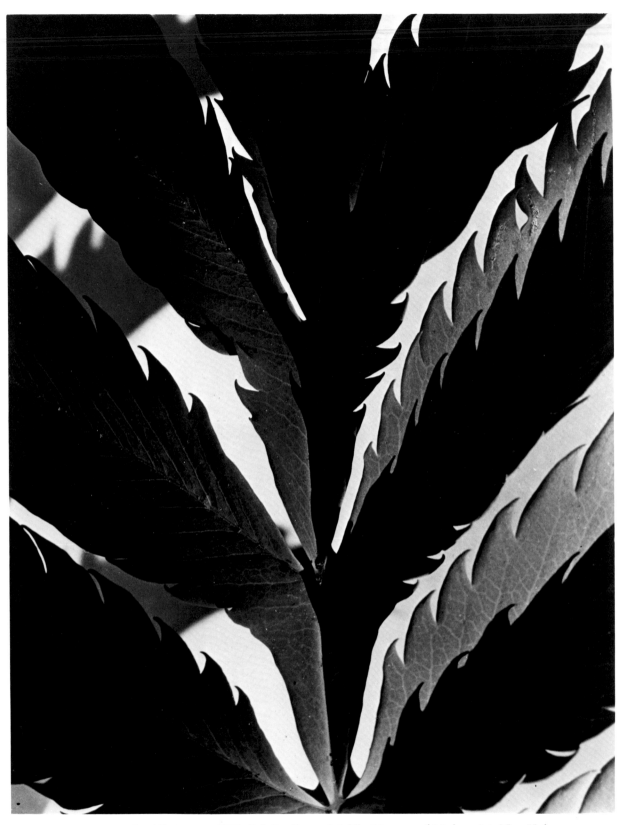

IMOGEN CUNNINGHAM. *Leaf Pattern,* ca. 1929. Gelatin-silver print. The Museum of Modern Art, New York.

ANSEL ADAMS. *Mount Williamson—Clearing Storm.* 1945. Gelatin-silver print. The Museum of Modern Art, New York.

that in retrospect now appears dogmatic in its strict specifications: any photograph not sharply focused in every detail, not printed by contact on glossy black-and-white paper, not mounted on a white card, and betraying any handwork or avoidance of reality in choice of subject was "impure." It was a violent reaction to the weak, sentimental style then popular with pictorial photographers in California, as seen particularly in the anecdotal, highly sentimental, mildly erotic hand-colored prints of William Mortensen. The M. H. de Young Memorial Museum in San Francisco presented the group's inaugural exhibition in 1932. For a few years the informal society was the most progressive in America. Even after they disbanded, their influence persisted; "*f*/64" came to be a convenient label for straight photography, and was applied to photographers who had nothing to do with the original group.

Ansel Adams, in his photography, his writing, and his teaching, has brilliantly demonstrated the capabilities of straight photography as a medium of expression.[24] Trained as a musician, he began to photograph as an avocation under the strong influence of pictorialism. In 1930 he met Paul Strand, whose negatives so impressed him that he realized the validity of the straight approach and began to devote all of his time to photography. His new work received international recognition in 1935 when the London Studio published his *Making a Photograph,* an instruction manual distinguished for its illustrations, which are such faithful reproductions that they have more than once been mistaken for actual photographic prints. When the book appeared it seemed as if the substance of weathered stone, glass, and flesh had never been so brilliantly rendered. His work was shown by Stieglitz at An American Place in 1936; it had a sensitivity and direct, honest integrity that were rare. Conservationist, mountaineer, lover of the wilderness, he specialized in the interpretation of the natural scene. His spectacular photographs have appeared in many books produced under his direct supervision. Like Strand, and in the tradition of Emerson, Stieglitz, and Coburn, he learned the complexities of photomechanical reproduction. He produces prints specifically for the platemaker's camera and checks proofs on the printing press itself, so that the results will be as close to his original concept as possible. *This Is the American Earth* (1960) is a magnificent poem by Nancy Newhall of the land and man's relation to it, with photographs by Adams and others.[25]

Adams uses all types of cameras and constantly experiments with new techniques. With his "zone system" he has worked out a highly ingenious and practical rationale for determining exposure and development, based upon sensitometric principles, which gives the photographer precise control over his materials. Adams first teaches the photographer to master the characteristic of the photographic emulsion by determining—not by laboratory test, but with the photographer's own working equipment—the interrelation of the four principal variables:

sensitivity of the negative material
amount of exposure
subject luminances (i.e. brightness)
development

From this data he can obtain in his negative any one tone and will know exactly the tones that other subject luminances will produce. The infinite gradation of light and shade found in nature Adams divides into ten zones. Zone O is black, Zone IX is white. Between these extremes are eight tones of gray, Zone V being the "middle" tone—not by objective measurement, but by subjective judgment—and next to it, marked VI, the value that conveys to the photographer the feeling of the tone of average, well-lighted skin. Using a photoelectric exposure meter Adams measures the luminances of the various parts of the scene he is photographing. These measurements are correlated with exposure and development procedures, so that the photographer can visualize the entire gamut of values that will appear in the final print. The control is comparable to that which a musician has over his instrument. Guesswork is eliminated, and the photographer can concentrate upon aesthetic problems, secure in the knowledge that his results will not only be of technical excellence, but will embody his subjective interpretation of the scene. With this mastery of technique, coupled with his lifelong deep spiritual resonance with the wilderness areas of the earth, Adams has produced magnificent landscapes of the American West and Alaska. *Mount Williamson—Clearing Storm* is epic, primeval, and truly cosmogonic.

In Europe a somewhat similar respect for straight photography is found in the work of the German photographer Albert Renger-Patzsch. His book, *Die Welt ist schön* ("The World is Beautiful"), published in 1928, was hailed as the photographic counterpart of the *New Objectivity* (Neue Sachlichkeit) movement in painting.[26] The pictures were strong and direct: extreme close-ups of plants and animals, lonely city streets, bold forms of industrial buildings, details of machinery, and still-life studies of their products. The freshness of Renger-Patzsch's vision was impressive. Thomas Mann found his photographs "exact statements drawn from the whole—and that's the way it usually is with this man who is, in his way, impassioned. The detail, the objective, is removed from the world of appearances, isolated, sharpened, made meaningful, animated. What more, I would like to ask, has art or the artist done?"[27] Renger-Patzsch

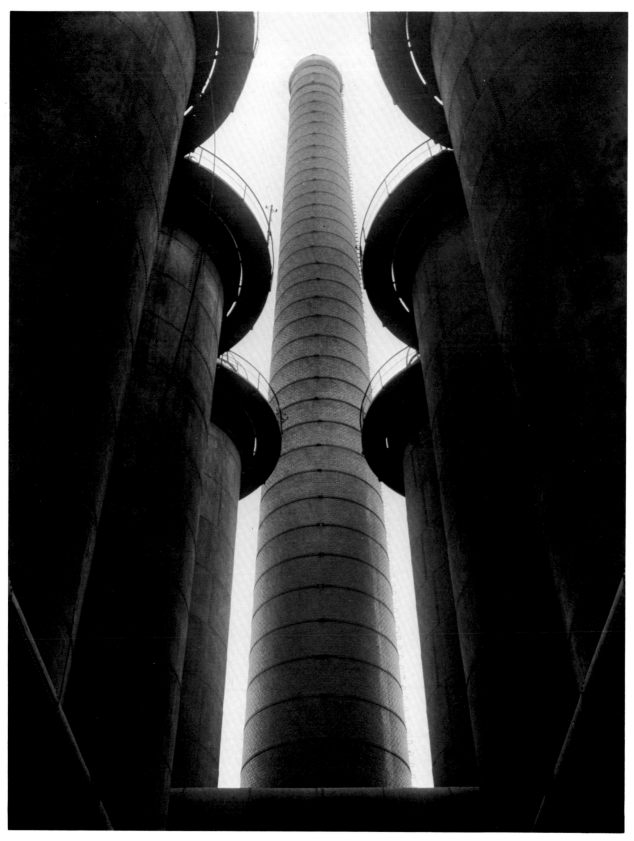

ALBERT RENGER-PATZSCH. *Blast Furnaces, Herrenwick, near Lübeck, Germany.* 1927. Gelatin-silver print. Galerie Wilde, Cologne.

EUGENE ATGET. *Hotel Fleselle, rue de Sévigné 52, Paris.* 1898 Aristotype print. The Museum of Modern Art, New York.

himself said, quite simply, "Let us leave art to the artist, and let us try—with photographic means—to create photographs which can stand alone because of their very *photographic* character—without borrowing from art."[28]

The growing appreciation of straight photography brought about the recognition in the late 1920s of photographers of the older generation whose work had been overlooked by the pictorialists. Jean Eugène Auguste Atget was virtually unknown when he died in 1927. He never showed in a salon. Not a single one of the thousands of photographs he had taken since 1898 of his beloved Paris had been reproduced in a photographic magazine. Painters had found his street scenes helpful documents, and the Surrealist artists, ever sensitive to the melancholy that a good photograph can so powerfully evoke, reproduced a few of his pictures in 1926 in their magazine *La Revolution surréaliste.* He was born near Bordeaux in 1857, lost his parents when very young, was reared by an uncle, and sent to sea as a cabin boy. He then became an actor in the provinces, but not a particularly successful one, and around 1898 he decided, after trying his hand at painting, to become a photographer. "For some time he had had the ambition to create a collection of all that which both in Paris and its surroundings was artistic and picturesque," wrote his friend André Calmettes.[29] *Photographe d'art*, photographer of works of art, he called himself, and he hand lettered the sign "Documents pour artistes" for the door of his fifth-floor apartment-darkroom at 31 rue Campagne Première. A great deal of his work was photographing the historic buildings of Paris in detail. He made a series of photographs of iron grill work, another of the fountains of Paris. He photographed the statues in the park at Versailles, and statues on the medieval churches in Paris. These he sold to the Parisian museums. But he did not limit himself to works of art and historic monuments: he photographed the face of Paris in all its aspects: shop fronts and carriages of all sorts, the little people who earn their living peddling umbrellas or lampshades, delivering bread or wheeling pushcarts. He photographed inside palaces, bourgeois homes, and ragpickers' hovels. He photographed trees and flowers and fallen autumn leaves. Each of these categories is a series comprising hundreds of photographs. For Atget was in truth, as Calmettes wrote, a collector. He was, too, a picture maker, *un imagier,* in the words of his friend.

His technique was of the simplest: a view camera—always used on a tripod—for plates 18 x 24 centimeters (7⅛ x 9⅜ inches) in size. His lens was a rapid rectilinear, used well stopped down. Its focal length is not known—it was discarded after his death—but it must have been fairly short, for so many of his pictures show

EUGENE ATGET. *Ragpicker, Paris.* 1899-1900. Aristotype print. The Museum of Modern Art, New York.

steep perspective and the tops of many of the negatives show bare glass where the image fell off. He printed the glass plates by daylight on aristotype printing-out paper, toning the prints with gold chloride. Atget's technical approach was, therefore, that of the nineteenth century and, looking at his prints, it is often hard to believe that he did most of his work after 1900. He seldom made an exposure that could be called a snapshot: moving objects are often blurred, and when he photographed people it is obvious that he asked them to pose. In an Atget photograph every detail stands forth with a clarity that is remarkable.

Among the thousands of photographs Atget took, there are those that reach beyond the record and approach the lyric, for he had a remarkable vision. He could find a human quality where no human being appears. His interiors lead one to feel that the people whose home he is photographing have just stepped behind the camera while he focuses and makes his exposure and will return the moment the lens is closed. Out-of-doors he worked early in the morning to avoid being disturbed by the curious, and his pictures have the atmosphere of early light. His work has no references to any graphic medium other than photography.

There is a curious parallel between Atget's photographs of Paris and the Berlin scenes taken by his contemporary,

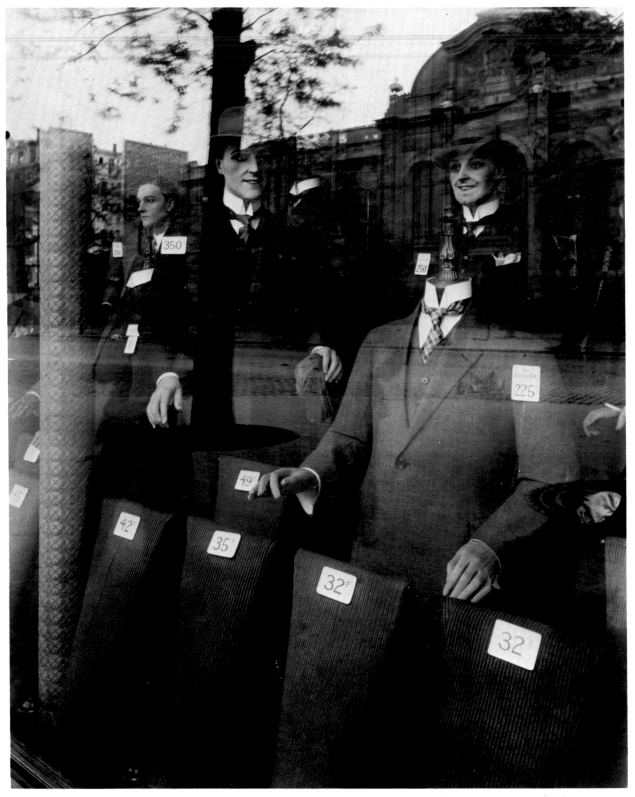

EUGENE ATGET. *Avenue des Gobelins, Paris.* ca. 1910. Aristotype print. The Museum of Modern Art, New York.

HEINRICH ZILLE. *Pelts and Fur Pieces, Berlin.* ca. 1910. Gelatin-silver print. Courtesy Schirmer/Mosel, Munich.

Heinrich Zille. Both chose the same type of subjects—the streets, shops fronts, peddlers, street fairs, of the poorer quarters of each city. Zille's photographs, for all their feeling for the urban environment and sympathy toward the working class, are slices of life, taken mostly with a hand camera for a specific purpose: to provide documentation for his drawings, which appeared as illustrations in popular magazines. The very immobility of Atget's tripod camera, and the long exposures that his slow plates and slow lens required, seem to have fairly forced deliberation upon him. But the process was, of course, Atget's choice; it was his preferred way of working. He was no primitive. His approach to technique was far from naive. It was deliberate.

Julien Levy, proprietor of an avant-garde art gallery in New York and a friend of the Surrealists, recollected that Man Ray offered to lend Atget a small hand camera. But Atget would have none of it: he complained that "le snapshot went faster than he could think. . . . *'Trop vite, enfin!* Too fast."[30]

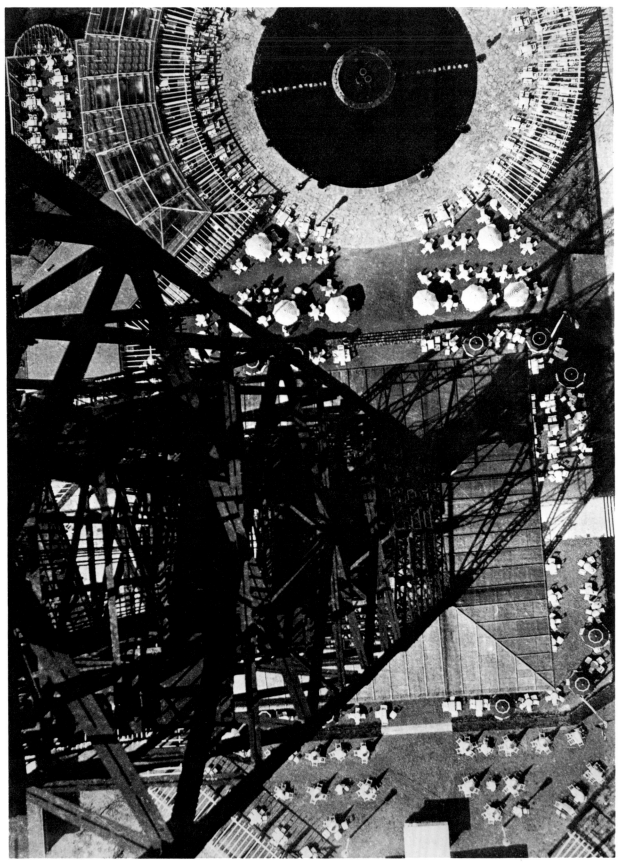

LASZLO MOHOLY-NAGY. *From the Radio Tower, Berlin.* ca. 1928. Gelatin-silver print. Art Institute of Chicago, Chicago.

"The receding and advancing values of the black and white, grays and textures, are here reminiscent of the photogram." —Moholy-Nagy.

11 · IN QUEST OF FORM

In 1913 Alvin Langdon Coburn, a member of the Photo-Secession, included in his one-man show at the Goupil Gallery, London, a series of five photographs under the title *New York from its Pinnacles*. They were views looking down, and the distorted perspective emphasized the abstract pattern of streets and squares and buildings. In the catalog he pointed out that one of them, *The Thousand Windows*, was

almost as fantastic in its perspective as a Cubist fantasy; but why should not the camera artist break away from the worn-out conventions, that even in its comparatively short existence have begun to cramp and restrict his medium, and claim the freedom of expression which any art must have to be alive?

In this photograph the camera axis is oblique; our sense of equilibrium is challenged, and the facades seem trapeziform planes arranged as in an abstract painting. An extremely wide angle of view adds to the effect: to achieve this Coburn used a pinhole in place of a lens "because it can be the widest angle of any wide angle 'lens'!"[1]

A few years later Coburn produced completely abstract photographs by devising an optical device based on the kaleidoscope. He clamped three mirrors together facing one another to form a hollow triangular prism through which he photographed bits of crystal and wood on a glass tabletop. His friend Ezra Pound, poet and spokesman for the Vorticist group of English abstract painters, called the instrument a *vortoscope* and the results *vortographs*. Coburn held an exhibition of them together with some of his recent paintings in 1917. The paintings were representational; Pound, in his speech at the opening, dismissed them as "Post-Impressionist," but for the vortographs he had high praise. Coburn's venture into abstract art, however, was brief and he laid the vortoscope away and made no more exposures with it.

Christian Schad, a member of the Zurich Dada group of modern artists, produced in 1918 abstractions made photographically without a camera. Using the technique dating back to H. Fox Talbot's first experiments, Schad laid cutout paper and flat objects on light-sensitive paper which, upon exposure to light, recorded designs closely resembling those Cubist collages made of newspaper clippings and bric-a-brac stuck onto canvas with glue.

Around 1921 Man Ray (an American painting in Paris) and László Moholy-Nagy (a Hungarian painter working in Berlin) began to make their somewhat similar *rayographs* and *photograms*. They went further than Schad, for they put three-dimensional objects on the sensitive paper; thus not only contours were recorded, but, cast shadows, and in the case of translucent objects, textures as well. The apparent automatism of the process appealed to the Dada-Surrealist sensibility: both Man Ray and Moholy-Nagy chose gear wheels and small machine parts for their early compositions, which bear a striking resemblance to the designs Francis Picabia made in a similar "automatic" way by dipping springs, toothed wheels, and pinions of an alarm clock in ink and then pressing them to paper. Moholy-Nagy's later photograms are exercises in light and form, architectonic in composition: to him the objects placed on the sensitive paper were "light modulators" and no longer identifiable objects.

Man Ray, on the other hand, chose objects for their evocative value: the twelve rayograms he published in 1922 as *Les Champs délicieux* ("Delectable Fields") contain such objects as a key tagged with a hotel room number, a pistol, a fan, a spinning gyroscope, a strip of motion picture film. His friend Tristan Tzara wrote in an introductory essay to the portfolio:

The photographer turned on the thousand candle power of his lamp and little by little the sensitive paper soaked up the black silhouetted by everyday objects. He had discovered the power of a tender, fresh lightning flash which goes beyond all constellations intended for visual pleasure. The precise, unique and exact mechanical alteration of form is fixed—as sleek as hair filtered through a comb of light.[2]

Everybody knows that when a camera is not held level, buildings seem to be falling down or about to topple over. Academic perspective is based on vanishing points situated on the horizon, which is always placed at eye level. That this is a convention anyone can prove by glancing up the side of a tall building or looking down upon one. The parallelogram of the facade becomes trapezoidal. As

199

ALVIN LANGDON COBURN. *The House of a Thousand Windows, New York,* 1912. Gelatin-silver print. George Eastman House, Rochester, N.Y.

early as 1840, Arthur Parsey in his book *The Science of Vision; or, Natural Perspective. . . . Containing the New Optical Laws of the Camera Obscura or Daguerreotype,* demonstrated that converging perpendiculars of the camera image were indeed mathematically correct and concluded: "Art has always represented objects geometrically, or as *they cannot be seen* in the *perpendicular* and visually, or as *they can be seen* in the *horizontal* direction."[3] But his findings were ignored. Indeed, amateurs were warned in manuals and instruction books never to tip the camera. Many hand cameras were even equipped with levels to assure the viewer that he was holding the camera horizontally.

But now, in the 1920s, photographers found the "new perspective" rich in compositional possibilities. The architect Erich Mendelsohn, pioneer of the International Style, made photographs of the skyscrapers of New York and the grain elevators of the Middle West by pointing the camera now upward, now downward. They were published as *Amerika: Bilderbuch eines Architekten* ("America: Picture Book of an Architect") in 1926.[4] Some of the photographs were so extreme that they became virtual abstractions, and Mendelsohn felt the need to state in the captions that they were *Schrägaufnahmen* ("oblique shots"). The Russian Constructivist artist El Lissitzky wrote that the book

is incomparably more interesting than the photographs and postcards of America that we have known up to now. Leafing through the pages for the first time grips us like a dramatic film. Completely strange pictures unwind before our eyes. You have to hold the book over your head and twist it around to understand some of the photographs. The architect shows us America, not from the distance, but from the inside; he leads us through the canyons of its streets.[5]

El Lissitzky's fellow countryman Alexander Rodchenko, who abandoned Constructivist painting to become a professional photographer, disdained photographs taken with the camera held level at the waist. "Bellybutton shots" he called them in 1928:

In photography there is the old point of view, the angle of vision of a man who stands on the ground and looks straight ahead or, as I call it, makes "bellybutton" shots. . . .
I fight this point of view, and will fight it, along with my colleagues in the new photography.
The most interesting angle shots today are those "down from above" and "up from below," and their diagonals.[6]

The influence of avant-garde filmmakers is obvious in the still camera work of "the new photography," not only in angle shots, but also in extreme close-ups. The abstract painter Fernand Léger, who was fascinated by the motion picture medium and directed *Le Ballet mécanique* (1924) wrote:

ALVIN LANGDON COBURN. *Vortograph.* 1917. Gelatin-silver print. George Eastman House, Rochester, N.Y.

When asked which was the top of this image, Coburn replied, "It does not really matter 'which way up' a good 'Vortograph' is presented, but you have this one right." (Letter to Beaumont Newhall, January 15, 1963.)

CHRISTIAN SCHAD. *Schadograph.* 1918. Photogram on aristotype paper. The Museum of Modern Art, New York.

MAN RAY. *Still Life of his Painting "Dancer/Danger" with Banjo.* 1920. Gelatin-silver print. Collection Arturo Schwarz, Milan.

Man Ray painted *Dancer/Danger* by putting gear wheels on the glass and spraying them with an airbrush.

MAN RAY. *Rayograph.* 1924. Gelatin-silver print. Private collection.

FRANCIS BRUGUIERE. *Cut-paper Abstraction.* ca. 1927. Gelatin-silver print. George Eastman House, Rochester, N.Y.

LASZLO MOHOLY-NAGY. *Photogram.* ca. 1925. Gelatin-silver print. George Eastman House, Rochester, N.Y.

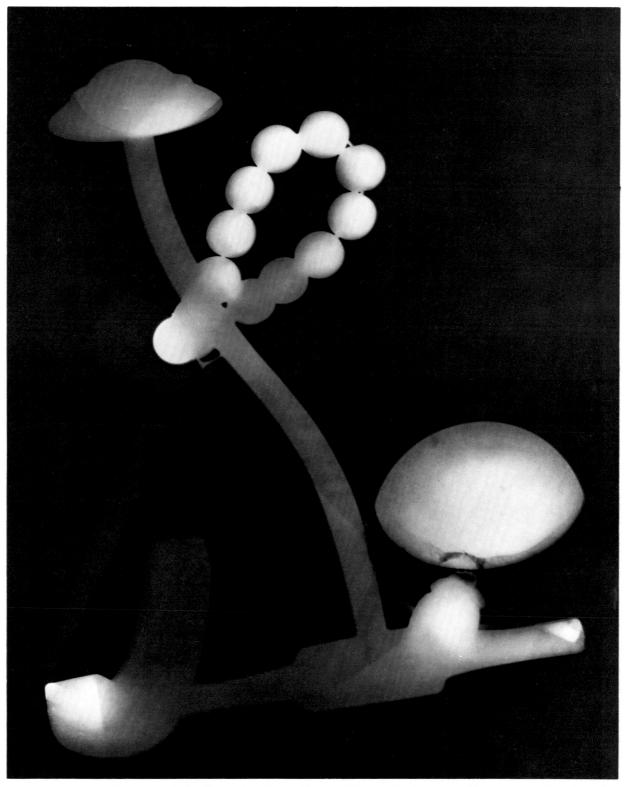

MAN RAY. *Rayograph.* 1922. Gelatin-silver print. From *Champs délicieux* (Paris: 1922). The Museum of Modern Art, New York.

ERICH MENDELSOHN. *Equitable Trust Building, New York*. ca. 1924. From *Amerika, Bilderbuch eines Architekten* (Berlin: 1926).

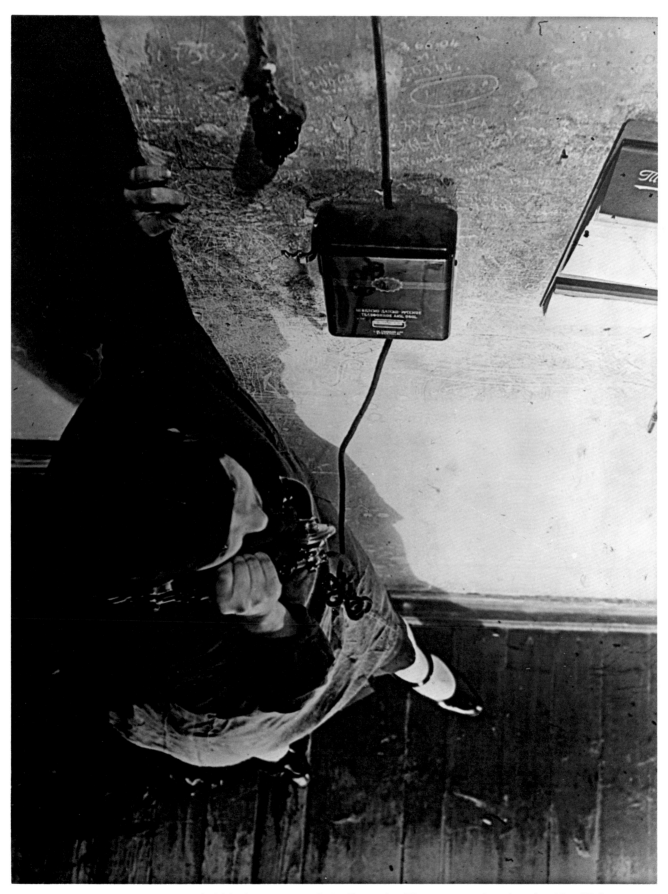

ALEXANDER RODCHENKO. *Woman at the Telephone.* 1928. Gelatin-silver print. The Museum of Modern Art, New York.

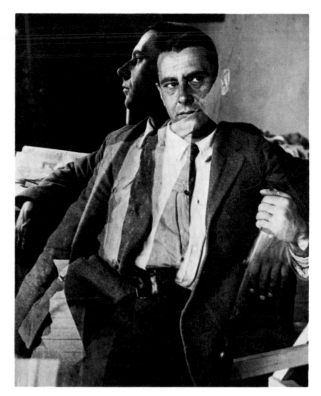

MAN RAY. *Faces.* 1932. Solarized gelatin-silver print. Menil Foundation Collection, Houston.

ALEXANDER RODCHENKO. *Portrait of Alexander Schewts-chenko, Russian Painter.* 1924. Gelatin-silver print. George Eastman House, Rochester, N.Y.

"What does that represent?" has no meaning: for example: with a brutal lighting of the fingernail of a woman—a modern fingernail, well manicured, very brilliant, shining—I make a movie on a very large scale. I project it enlarged a hundredfold, and I call it "Fragment of a Planet, Photographed in January, 1934." Everybody admires my planet. Or I call it "abstract form." Everybody either admires or criticizes it. Finally I tell the truth—that what you have seen is the nail of the little finger of the woman sitting next to you.

Naturally, the audience leaves, vexed and dissatisfied, because of having been fooled, but I am sure that hereafter those people won't ask any more of me and won't repeat that ridiculous question: "What does that represent?"[7]

The artist-photographers of the 1920s also explored double-exposures. One of the most successful is Rodchenko's portrait of Alexander Schewtschenko (1924) showing the painter in profile as well as full face.

The negative image was appreciated for its own sake. As Moholy-Nagy wrote, "The transposition of tones transposes the relationship, too."[8] The unreality of the negative throws emphasis upon shapes and contours not usually seen.

The phenomenon of edge reversal, known to scientists as the *Sabattier effect,* was used as a plastic control, particularly by Man Ray. When a sensitive emulsion that has been developed, but not fixed, is exposed to naked

206

light and developed again, the image shows a reversal of tones wherever there is a sharp edge. A print from such a negative has its contours rimmed with black lines. The process is generally known in artistic circles as *solarization,* although that term is reserved by scientists for a somewhat similar phenomenon of edge reversal caused by gross overexposure, particularly noticeable in daguerreotypes and platinum prints.

Man Ray also made negative prints, processed both normally and with edge reversal. He diffused the image by deliberately increasing the size of the silver grains. These controls are adaptations of the photographic process. Other physical methods of distorting the camera's image have been devised. Texture is introduced into the gelatin emulsion of the negative by subjecting it to rapid temperature changes, producing reticulation, a netlike structure in the normally transparent film. Or the gelatin is melted so that the image it bears droops and sags. A pseudo bas-relief appears when a negative and transparent positive are printed together slightly out of register. These methods have all been used singly or in combination by photographers who are impatient with the limitations imposed upon the medium by those who consider its function to produce conventional, readily understood images.

To Moholy-Nagy the camera was a tool for extending

vision. Once, looking at a photograph he had taken years previously from a bridge tower at Marseilles, his attention was held as if it were a new thing and the work of another. "What a wonderful form!" he said, pointing to a coiled-up rope. "I never saw it before!" It did not matter to him who had taken the photograph, or why. His quest for form led him to appreciate photographs taken for scientific and other utilitarian purposes.[9] In them he found a "new vision" of the world. His 1925 *Malerei, Photographie, Film* ("Painting, Photography, Film"), in the Bauhaus series of books, contains not only a selection of photograms and photographs made by himself and other artists deliberately as works of art, but an equal number of astronomical photographs, photomicrographs, x-ray exposures, aerial views, and news pictures.

Many other avant-garde artists were greatly influenced by scientific photographs. Marcel Duchamp stated that when he was painting his famous *Nude Descending a Staircase* in 1912, art circles in Paris were stimulated by the multiple-exposure, high-speed photographs taken by Etienne Jules Marey for his physiological studies. The Futurist painters were also greatly influenced by this type of photography. Giacomo Balla's 1912 painting *Dynamism of a Dog on a Leash* is truly stroboscopic: the dog appears to have a multitude of feet and tails. The Italian photographer and filmmaker Anton Giulio Bragaglia took issue with Marey and Balla. He felt that intermittent exposures did not reveal the continuum of motion, and compared Marey's photographs with a clock so built that the hands jumped at five-minute intervals. To produce a dynamic record of the trajectory of action, Bragaglia made time exposures of people in action. He called his work "photodynamism," and published a number of them in his book *Fotodinamismo futurista* (1913).[10]

The architect Le Corbusier chose an aerial photograph of the Eiffel Tower in Paris for the cover of his book *Decorative Art of Today* (1925); from the same photograph Robert Delaunay made a painting. Le Corbusier pointed out that the illustrations in popular scientific magazines

take the cosmic phenomenon to pieces under our eyes; amazing, revealing and shocking photos, or moving diagrams, graphs, and figures. We are attacking the mystery of nature scientifically. . . . It has become our folklore.[11]

There was also a great interest in what was described as "phototypography," a word coined to describe photomontage, photocollage, and the mixture of type and photographic image.

ALEXANDER RODCHENKO. *Chauffeur.* 1933. Gelatin-silver print. The Museum of Modern Art, New York.

ANTONIO GIULIO BRAGAGLIA. *Greetings!* 1911. From *Fotodiamismo futurista* (Rome: 1913). Courtesy Centro Studi Bragaglia, Rome.

ANTONIO GIULIO BRAGAGLIA. *The Futurist Painter Giacomo Balla.* 1912. From *Fotodinamismo futurista* (Rome: 1913). Courtesy Centro Studi Bragaglia, Rome.

Photographer unknown. *The Eiffel Tower, Paris, from a Balloon.* From André Schecher and S. Omer-Decusgis, *Paris vu en ballon* (Paris: ca. 1909).

HERBERT BAYER. *Sundeck.* 1930. Gelatin-silver print. The Museum of Modern Art, New York.

HANNAH HOCH. *The Millionaire, or High Finance.* 1923. Photomontage, from L. Moholy-Nagy, *Malerei, Photographie, Film* (Munich: 1925).

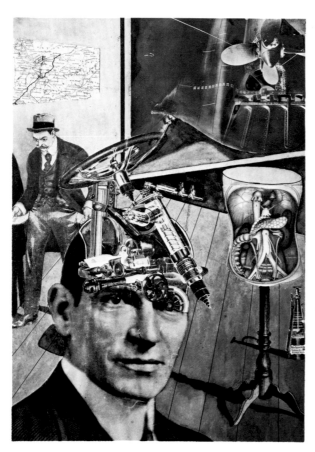

RAOUL HAUSMANN. *Tatlin at Home.* 1920. Pasted photoengravings, gouache, and pen and ink. Moderna Museet, Stockholm.

The pasting together or otherwise combining of separate and disparate pictures to form a new visual entity was one of the most striking contributions of the artists of the 1920s. Their work, though not technically dissimilar to the "combination prints" by H. P. Robinson, Rejlander, and other nineteenth-century photographers, was utterly different in intent and result. While the Victorians carefully fitted photographs together, as in a jigsaw puzzle, to produce a cohesive image resembling an academic painting, the men and women of the 1920s assembled pictures that widely varied in subject, perspective, scale, and tonal value. Each individual image reacted with its neighbor in sympathetic reinforcement or in violent opposition. The process was no doubt inspired by the introduction into abstract paintings of printed matter—usually newspaper clippings—and small objects that were glued to the canvas. Hence these works were referred to as *collages*, from the French verb *coller*, meaning "to glue."

The beginning of photomontage as an artistic medium may be traced to the Dada group of modern painters. Wieland Herzfelde, the brother of the brilliant *photomonteur* John Heartfield,* described the process in the catalog of the first Berlin Dada exhibition in 1920:

Painting once had the express purpose of recording the appearance of things—landscapes, animals, buildings, etc.—which people could not get to know with their own eyes. Today this task has been taken over by photography and film, and is accomplished incomparably better, more perfectly than ever was done by painting.

Yet painting did not die with this loss of purpose, but sought new goals. All artistic efforts since then—however great their differences—share this trend of emancipation from reality.

Dadaism is the reaction to every attempt to deny the factual, which has been the motive force behind the Impressionists, the Expressionists, the Cubists and—since they have not wished to surrender to film—the Futurists....

Dadaists say: while in the past vast quantities of love, time and effort were put into painting a person, a flower, a hat, a cast shadow, etc., we just take a pair of scissors and cut out all the things we need from paintings or photographs. If we need small-sized things, we do not represent them, but take the object itself, for example a pocket knife, an ash tray, books, etc.; simple things that in the museums of old art are beautifully painted. But, even so, only painted.[12]

Popular imagery, especially in the form of fantastic postcards, greatly influenced the pioneers. George Grosz and John Heartfield traced the origin of their montages to anonymous messages they sent to friends in combat in World War I. They pasted on postcards "a mischmasch

*He anglicized his name as a protest to German nationalism in World War I.

of advertisements for hernia belts, student song-books and dog food, labels from schnaps and wine-bottles, and photographs from picture papers, cut up at will in such a way as to say, in pictures, what would have been banned by the censors if we had said it in words."[13] Hannah Höch recollected that she and Raoul Hausmann, with whom she often collaborated, saw in a hotel room at a summer resort a chromolithograph of a uniformed soldier standing against a background of the regimental barracks and surrounded by military symbols. The face of the soldier, however, was cut out of a photograph and pasted on the lithograph in the blank space reserved for it.

Hannah Höch's photomontages are complex, powerful, and often menacing. In *The Millionaire* (1923) two industrial magnates hold machine parts. Between their fragmented heads is a gigantic rifle, broken at the breech for loading. In the background aerial views of cities are patched together with a vast factory complex, and an enormous tire, on the treads of which drives a truck and trailer. Raoul Hausmann has described the process of making his photomontage *Tatlin at Home* (1920):

To have the idea for an image and to find the photos that can express it are two different things. . . . One day, I was aimlessly leafing through an American periodical. Suddenly I was struck by the face of an unknown man, and for some reason I made an automatic association between him and the Russian Tatlin, the creator of machine art.

But I preferred to portray a man who had nothing in his head but machines, automobile cylinders, brakes, and steering wheels. . . .

Yes, but that was not enough. This man ought also to think in terms of large machinery. I searched among my photos, found the stern of a ship with a large screw propellor, and set it upright against the wall in the background.

Wouldn't this man also want to travel? There is the map of Pomerania, on the wall at the left.

Tatlin certainly wasn't rich, so I clipped out of a French paper a man with furrowed brows, walking along and turning his empty pants pockets inside out. How can he pay his taxes?

Fine. But now, I needed something at the right. I drew a tailor's dummy in my picture. It still wasn't enough. I cut out of an anatomy book the internal organs of the human body and placed them in the dummy's torso. At the feet, a fire extinguisher.

I looked once more.

No, there was nothing to change.

It was all right, it was done![14]

During the German Third Reich, Heartfield made the most biting of political comments in the photomontage medium. *The Spirit of Geneva,* a dove of peace impaled on a bayonet, appeared on the cover of *AIZ* (*Arbeiter Illustrierte Zeitung,* "Workers' Illustrated Newspaper")

MAX ERNST. *LopLop Introduces Members of the Surrealist Group.* 1930. Collage of pasted photographs and pencil. The Museum of Modern Art, New York.

PAUL CITROEN. *Metropolis.* 1920. Photomontage. Print-room of the University of Leiden, The Netherlands.

EL LISSITZKY. *The Constructor—Self-Portrait.* 1924. Photomontage. Courtesy VEB Verlag der Kunst. Dresden.

for November 27, 1932. He continued many similar covers for that periodical.

Alexander Rodchenko produced many photomontages reminiscent of the style of the Dadaists, but with a dynamism wholly original: his photomontage illustrations to *Pro Eta* (1923), a book of poems by Vladimir Mayakovski, form a striking continuity, with repetition of the face and haunting eyes of the same woman, introduced in a wide variety of situations. El Lissitzky superimposed his own photographs for his self portrait, titled *The Constructor* (1927). It is, like few other photomontages, completely photographic in its double exposure of face and hand.

Of the Bauhaus group, Paul Citroen piled building upon building to produce a 30 x 40-inch photomontage that Moholy-Nagy called "a gigantic sea of masonry." Moholy-Nagy's own photomontages are highly imaginative, often to the point of fantastic satire. In *Jealousy* (1927) the artist steps out of a negative, leaving a void filled by a squatting woman with a rifle at the ready. In *Leda and the Swan* (1925) the photographic elements are balanced in a delicate linear web.

In 1929 a mammoth international exhibition of "The New Photography" was held in Stuttgart by the Deutsche Werkbund, the German organization so instrumental in the promotion of modern architecture and industrial design. The "Film und Foto" exhibition featured photographs by the artists we have discussed in this chapter, and also a strong group of American photographs se-

lected by Edward Weston—who also wrote a foreword to the catalog—and Edward Steichen. The American work was highly praised. Indeed, the art historian Carl Georg Heise considered Weston's portrait *The Sharpshooter—Manuel Hernandez Galván* the high point of the entire exhibition.

A traveling version of this highly successful and influential exhibition was shown in Berlin, Munich, Vienna, Zagreb, Basel, and Zurich.[15] In addition to exhaustive reviews in the daily press and both art and photographic periodicals, two books were published about the exhibition. *Foto-auge/oeil et photo/photo-eye,* edited by Franz Roh and the typographer Jan Tschichold, with trilingual text and seventy-six illustrations, is a record of the show.[16] A lively manual, Werner Graeff's *Es kommt der neue Fotograf!* ("Here Comes the New Photographer!"), bold in its layout and selection of illustrations, forms a catalog of the plastic possibilities of photography.[17]

A film festival was held during the exhibition. Among the classics that were screened were *The Passion of Joan of Arc* (Carl Dreyer, 1929), *L'Etoile de Mer* (Man Ray, 1928), *Potemkin* (Sergei Eisenstein, 1925), *Variety* (E. A. Dupont, 1925), and *Man With a Movie Camera* (Dziga Vertov, 1928). These films were all made by directors and cameramen sympathetic to "The New Photography." And, conversely, the photographers learned from the filmmakers. Not before, and not since, have the two media so closely blended.

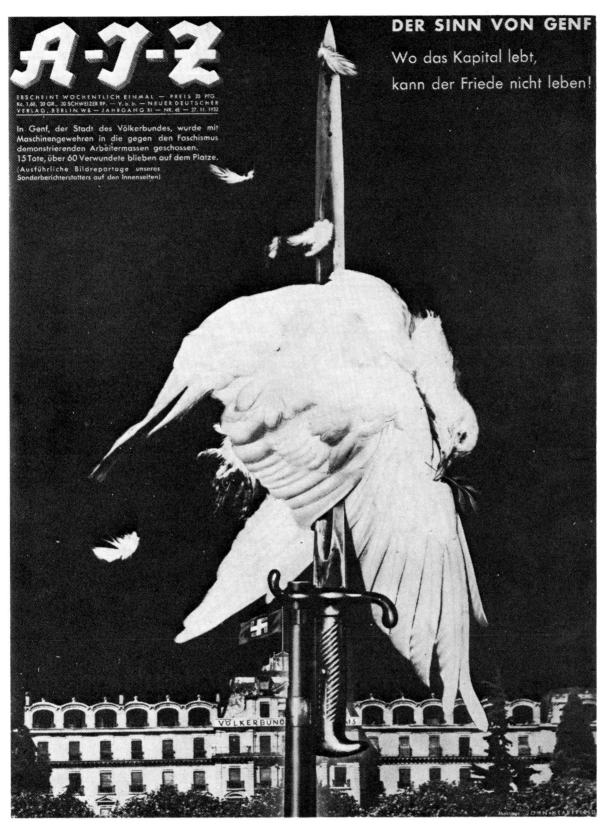

A·J·Z

ERSCHEINT WOCHENTLICH EINMAL — PREIS 20 PFG.
Kc. 1,60, 30 GR., 30 SCHWEIZER RP. — V.b.b. — NEUER DEUTSCHER
VERLAG, BERLIN W8 — JAHRGANG XI — NR. 48 — 27. 11. 1932

In Genf, der Stadt des Völkerbundes, wurde mit
Maschinengewehren in die gegen den Faschismus
demonstrierenden Arbeitermassen geschossen.
15 Tote, über 60 Verwundete blieben auf dem Platze.
(Ausführliche Bildreportage unseres
Sonderberichterstatters auf den Innenseiten)

DER SINN VON GENF

Wo das Kapital lebt,

kann der Friede nicht leben!

JOHN HEARTFIELD. *The Meaning of Geneva/Where Capital Lives/Peace Cannot Survive.* Cover of *Arbeiter Illustrierte Zeitung,* November 27, 1932.

"In Geneva, site of the League of Nations, workers demonstrating against fascism were machine gunned down: 15 dead and more than 60 wounded lying on the plaza. . . . The dove of peace is transfixed by the fascist bayonet before the League of Nations building. On the flag the white cross has been replaced by a swastika."—*Photomontages of the Nazi Period: John Heartfield* (New York: 1967).

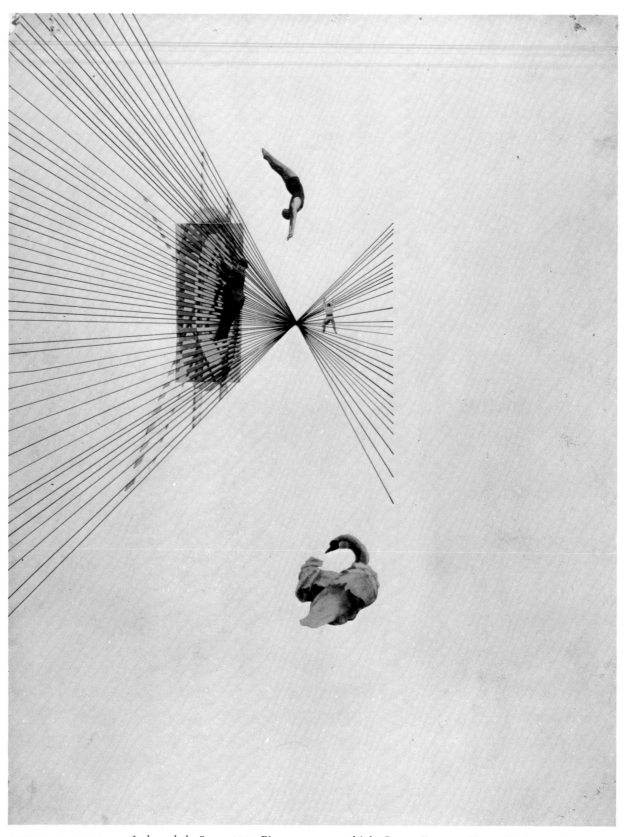

LASZLO MOHOLY-NAGY. *Leda and the Swan.* 1925. Photomontage and ink. George Eastman House, Rochester, N.Y.

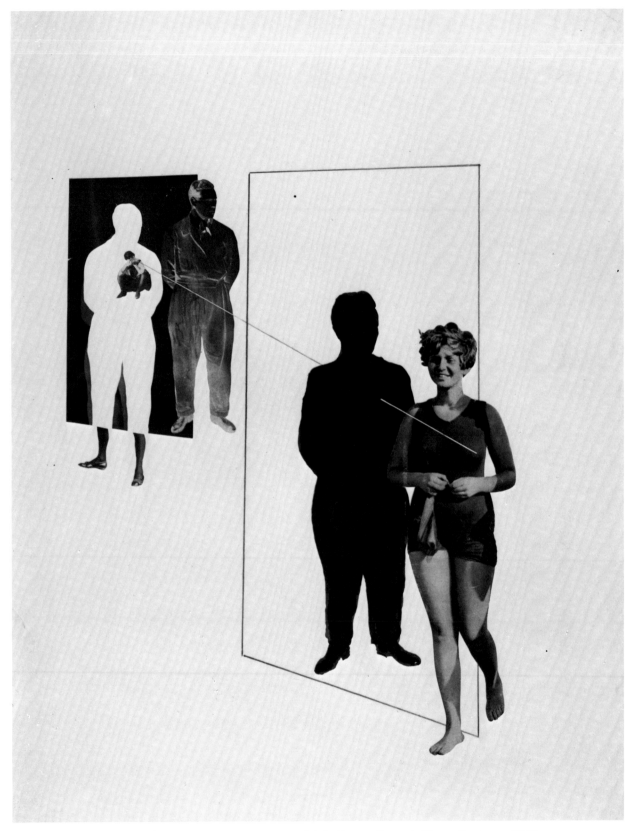

LASZLO MOHOLY-NAGY. *Jealousy*. 1927. Photomontage and ink. George Eastman House, Rochester, N.Y.

JACQUES-HENRI LARTIGUE. *Grand Prix of the Automobile Club of France.* 1912. Gelatin-silver print. The Museum of Modern Art, New York.

The effect of speed in this photograph is heightened by the imaging of the wheel as eliptical, rather than circular, and the apparent leaning of the spectators as if blown off balance by the air surge of the rushing automobile. The wheel is eliptical because Lartigue's camera was fitted with a focal plane shutter. This resembled a spring-operated roller window shade. A strip of opaque cloth, with a horizontal slit, passes swiftly from one roller to another when the shutter is released. The image is thus scanned horizontally. Since the image is inverted, the bottom is exposed before the top. Lartigue panned the camera to keep the car in focus. This motion caused the people's feet to be exposed before their heads.

12 · INSTANT VISION

The use of small cameras to produce big pictures was first suggested as a convenience. In 1840 John W. Draper reported that he was making enlarged copies of daguerreotypes

with a view of ascertaining the possibility of diminishing the bulk of the traveler's Daguerreotype apparatus, on the principle of copying views on very minute plates, with a very minute camera, and then magnifying them subsequently to any required size, by means of a stationary apparatus.[1]

With the perfection of the collodion process this system was put to use. Thomas Skaife devised a miniature camera with an $f/2.2$ lens in 1858 for plates one-inch square. They were enlarged by hand: the negative was projected to the desired size, and the image was traced. In 1859 Charles Piazzi Smyth, Astronomer Royal for Scotland, during a visit to Russia made stereoscopic negatives: a modern print from a street scene in Novgorod is astounding in its directness, sense of presence, and image quality. Six years later he undertook an expedition to Egypt to study the Great Pyramid and its astronomical orientation. He took along a miniature camera for one-inch-square wet collodion negatives. He stated that the reason for using such a small camera was that having been unsuccessful in securing government support for his survey he could not afford the expense of a large camera and the processing equipment. He exhibited enlargements from these negatives and lectured on his technique at the Edinburgh Photographic Society in 1869, comparing his "poor man's" photography with that "of the Ordnance Survey subsidized by London wealth at the same place four years afterwards." He called the attention of the members to a portrait of Alee Dobree, a dragoman, standing

in front of one of the tombs on the eastern side of the Great Pyramid hill; for although it is magnified up to 10 x 8 inches from one of the small or one-inch negatives, and although the Arab before the tomb door occupies only a subsidiary portion of the whole scene, yet the threads composing the cloth of his garment are discernible in those parts not affected by his breathing.[2]

Yet more remarkable than this technical achievement was Piazzi Smyth's editing process, which he contrasted with the more conventional contact printing of large plates produced by "London wealth."

Let us now suppose that all the negatives required have been obtained in the field. The rich man's servants have brought home his large glass plates in ponderous boxes; and then they busy themselves, according to his orders, in copying the negatives by the simple mechanical method of superposition, producing thereby positive copies in either silver or carbon, photolithography or photozincography—a dull and not very artistic or suggestive method, because it merely reproduces in positive just the scope and scene of view, which was taken in by the mere material sides of the camera at the place.

Not so, however, acts the poor man, with his little box of very little negatives brought home modestly in his waistcoat pocket. Therewith he sits him down at a table, having a compound achromatic microscope before him . . . and then . . . wanders at will, truly the monarch of all he surveys, over the various parts of each picture; recalls the circumstances under which it was taken; discovers characteristic detail which he never dreamed of before; and then—each picture you will remember having been taken *square*—he decides whether a positive copy should be shaped as a long, i.e. horizontal, rectangle, or as a tall, i.e. vertical, rectangle; whether it should include from side to side of the negative plate or stop short of its extreme parts, in order to secure a better balance of light and shade, or a more harmonious composition of light and angles; whether he should give preponderance to the sky or to the foreground; or whether some special scientific purpose may not be better served by extracting one little subject alone out of the whole scene, and making a very highly magnified picture of that one item by itself.

With all these notes taken at the microscope, the poor man then inserts his little negative into a copying and magnifying camera, and proceeds to realize all these various positive pictures, hitherto only sketched out in art or scientific idea, and makes them of any size that he can afford.[3]

With the advent of hand cameras and dry plates at the close of the century, and with the perfection of enlargers and rapid printing paper, Piazzi Smyth's system of choosing a portion of the negative for the final print became regular practice. Instruction manuals and camera magazines became full of a new kind of criticism; beginners were shown how their prints could be improved by cropping or trimming, and they were advised to try

CHARLES PIAZZI SMYTH. *Novgorod Street Scene.* 1859. Gelatin-silver print from original stereographic negative. Royal Society, Edinburgh.

CHARLES PIAZZI SMYTH. *Ibrahim the Cook.* 1865. Gelatin-silver print from original lantern slide made by Smyth from his one-inch-square negative. Royal Society, Edinburgh.

masking their proofs using two L-shaped cardboards. Except for isolated experiments like Piazzi Smyth's, the entire image formed by the camera had previously been so rigidly respected that daguerreotypes, tintypes, cartes-de-visite, and stereographs were all made in standard sizes.

The portable hand camera thus brought about a change in working methods. The photographers' output was increased, and oftentimes the recorded camera image was merely a starting point for the final composition. The hand camera also increased the scope of photography, for with it many subjects generally considered beyond the limits of photography were now brought within grasp.

At the turn of the century, technical innovations broadened the camera's field of operation still further. Lenses were designed that produced images far more brilliant than before; and small, compact precision cameras fitted with high-speed shutters were made, on which the powerful lenses could be used. The small negatives were intended for enlarging.

Jules Carpentier, who built the Cinématographe for the Lumières, had designed a precision camera in 1892 that he named the Photo-Jumelle because it looked like a pair of binoculars (*jumelle* in French). It had two identical lenses. One formed an image on the 4.5 x 6 cm dry plate; the other formed an image on a ground glass, which the photographer could see through a red filter when he held the little camera to his eye. The Photo-Jumelle was built to exacting specifications. Carpentier demanded a tolerance of 1/100 mm, a degree of precision unheard of in the camera industry of the day. The camera was loaded with twelve plates that were changed by pulling out and pushing in a brass rod. A sliding, spring-operated shutter worked at a speed of 1/60 of a second. The lens was set at fixed focus; Carpentier stated that photographers were incapable of focusing accurately enough to permit sharp enlargements to be made. A fixed-focus enlarger was sold as an accessory: he boasted that with it "the original negatives are easily increased to ½-plate size [6½ x 4¾ in.]—a matter of considerable moment to operators making views for practical purposes."[4]

The Photo-Jumelle was so popular that it was widely imitated, and became a classic camera type. The cameras were fitted with lenses of larger aperture than Carpentier's modest $f/11$ doublet. They were reduced in size and made collapsible, so that the Block-Notes camera made by the French camera manufacturer L. Gaumont & Cie. measured only 1¼ x 2⅓ x 3½ inches when folded, yet accepted 4.5 x 6 cm glass plates.

To Jacques Henri Lartigue the Block-Notes was a magic "image-trap." The French boy was six years old when he began to photograph with a view camera. He complained that he could not take action pictures with

it of the games he played with his big brother and their friends. "How could one record our bicycle races? Our jumping contests? Our model yacht races on the river?"[5] The next Christmas his father gave him a Block-Notes camera; with it he was able to photograph the remarkable activities and antics of the Lartigue family and their friends: flying man-lifting kites, racing automobiles and homemade motorcycles and wheeled bobsleds, navigating strange catamarans with propellors or paddle wheels powered by bicycle gearing. In 1908, when airplanes suddenly appeared in a bewildering variety of designs, both practical and impractical, "I haunted the airfield at Issy-les-Moulineaux," Lartigue has recollected, "where something called 'aviation' was gradually emerging from nothingness."[6] The photographs made when he was twelve years old of the first aircraft are the most vivid and accurate record in existence of the birth of flight. Photography to him was entirely personal, done for his own satisfaction and delight. His photographs were neither exhibited nor published until 1963, when they were hailed as prophetic of the vision of a Brassaï or a Cartier-Bresson.

Although by the use of specially sensitized panchromatic emulsions snapshots were occasionally taken using only stage light or street light as early as 1902, the potentials of what has come to be called "existing light"—or more popularly and less accurately, "available light"—photography first became apparent in 1924, when two German cameras were put on the market, the Ernox or, as it was later renamed, the Ermanox of the Ernemann-Werke A. G., and the Lunar of Hugo Meyer. Both were for 4.5 x 6 cm plates in individual metal holders, and were fitted with focal-plane shutters with speeds up to 1/1000 of a second, and extremely fast lenses, at first of aperture $f/2$, but soon increased to $f/1.5$. These apertures were at the time almost unknown in focal lengths as long as the 4-inch Ernostar lens of the Ermanox and the 3½-inch Kinoplasmat lens of the Lunar. Their great light-passing power enabled snapshots to be taken at low levels of illumination. The Ernemann-Werke boasted that

this extremely fast lens opens a new era in photography, and makes accessible hitherto unknown fields with instantaneous or brief time exposures without flashlight: night pictures, interiors by artificial light, theater pictures during performance, children's pictures, scientific records, etc.[7]

Learning of this seemingly miraculous camera, Erich Salomon of Berlin began in 1928 to use it to photograph famous people for the illustrated press. At first, when he asked permission to photograph at indoor functions, he was refused, for officials could not believe that a blinding

Advertisement in *Bulletin du Photo-Club de Paris.* 1901. "No Imitation will ever Dethrone the Photo-Jumelle. J. Carpentier."

Advertisement for the Ermanox Camera. From *Photo-Miniature,* May 1928.

JACQUES-HENRI LARTIGUE. *The Beach at Villerville*. 1908. Gelatin-silver print. The Museum of Modern Art, New York.

flash would not interrupt the formalities, leaving a dense pall of acrid smoke to hang over the dignitaries. Salomon convinced them by taking pictures unawares and showing them the results. Soon he gained the confidence of prominent statesmen and began to photograph in the very rooms where they forgathered. He took diplomats attentive and suave at eleven at night and then at one in the morning, slumped in their chairs, exhausted and haggard. Aristide Briand is reported to have said, "There are just three things necessary for a League of Nations conference: a few Foreign Secretaries, a table and Salomon."[8] When an English editor saw these pictures, so utterly different in revelation from the usual posed studio portraits, he called them "candid photographs," a phrase that the public took up. In 1933 Salomon fled from Nazi Germany to Holland. He was deported from that country and died at the Auschwitz concentration camp in 1944.

Felix H. Man, Salomon's contemporary, took a similar approach in picture stories that have appeared in leading illustrated magazines of Germany, England, and America since 1929. Among his most remarkable photographs are those in which he caught the peak of the ges-

tures of a speaker or the baton of the conductor of an orchestra. Like Salomon, he at first used the Ermanox with glass plates of relatively low sensitivity; the camera was invariably firmly fastened to a tripod and the shutter was set at "bulb." When Man sensed that the gesturing hand or conductor's baton was momentarily arrested at the peak of the action he would press the cable release to hold the shutter open until the action was resumed.

The Ermanox camera was soon replaced by the more flexible 35mm film camera, which had the advantage that it was smaller and enabled the photographer to take thirty-six negatives in rapid succession on a single loading of inexpensive standard motion-picture film. The first camera of this type to become popular with amateurs and professionals alike was the Leica, designed just before World War I by Oskar Barnack, a mechanic in the experimental workshop of the optical firm of E. Leitz in Wetzlar, Germany. In 1924 the company felt that the camera had sales possibilities, and that year the first Leica was put on the market. It was fitted with a lens of 50mm focal length with an aperture of $f/3.5$. The first improvement was to make the lens removable and to offer the

ERICH SALOMON. *Visit of German Statesmen to Rome, 1931: Benito Mussolini; Heinrich Brüning, German Chancellor; Julius Curtius, German Minister of Foreign Affairs; and Dino Grandi, Italian Minister of Foreign Affairs.* 1931. Gelatin-silver print. The Museum of Modern Art, New York.

photographer a choice of lenses of varying focal lengths and apertures that could be readily interchanged while shooting. In 1932 Zeiss Ikon brought out a similar camera, the Contax; it featured a built-in rangefinder coupled with the focusing mechanism so that by simply rotating the lens until a double image of the subject became single, the photographer was assured that the image would be in focus. Soon lenses with apertures as large as $f/1.5$ were offered for the Leica, the Contax, and a host of other 35mm rangefinder cameras. A further refinement was the provision of single-lens reflex viewing on a ground glass observed at eye level through a prism, as in the highly popular Nikon F, introduced shortly after World War II by Zeiss Ikon of Dresden as the Contax S.

Many photographers preferred cameras of larger format, such as the Rolleiflex, introduced by Franke & Heidecke in 1929. This was a revival of the twin-lens reflex design of the 1890s, but smaller and far more compact. Twelve negatives, each $2\frac{1}{4}$ inches square, could be taken on one roll of film. Later models were fitted with a mechanism that cocked the shutter and wound on fresh film at the turn of a crank. Single-lens reflex viewing was

offered for these larger cameras with the Swedish Hasselblad in 1948.

Photojournalists were the first to make wide use of the miniature camera. Both Erich Salomon and Felix H. Man came to prefer the Leica to the Ermanox. Alfred Eisenstadt covered the Ethiopian War; Peter Stackpole made pictures of the construction of the Golden Gate Bridge in San Francisco as the workmen saw it, from vantage points hardly accessible to the cameraman with standard equipment; Thomas McAvoy took the readers of *Time* magazine into President Franklin D. Roosevelt's office and showed them a statesman at work, not posing.

The miniature camera not only proved to be of great use to photojournalists, but it opened up new aesthetic possibilities. The ease with which the camera could be handled freed the photographer to seek unusual view points and to record segments of the flow of life.

André Kertész as early as 1915 was taking sensitive, unposed photographs of people amid their surroundings. In Paris, where he arrived from Hungary in 1926, his vision became more architectural, and he learned to capture the fleeting, never-to-be-repeated instant. From him

OSKAR BARNACK. *Portrait of Ernst Leitz.* 1917. Gelatin-silver print from 35mm film negative taken with the prototype Leica camera. E. Leitz, G.m.b. H. Wetzlar, West Germany.

ANDRE KERTESZ. *Montmarte, Paris.* 1927. Gelatin-silver print. The Museum of Modern Art, New York.

ANDRE KERTESZ. *Meudon.* 1928. Gelatin-silver print. The Museum of Modern Art, New York.

BILL BRANDT. *Parlormaid and Under-Parlormaid Ready to Serve Dinner.* ca. 1933. Gelatin-silver print. The Museum of Modern Art, New York.

BRASSAÏ. *"Bijou."* Paris. ca. 1933. Gelatin-silver print. The Museum of Modern Art, New York.

Brassaï learned the technique he used so eloquently in photographing Paris by night, by whatever light he could find. Brassaï pioneered in the discovery of form in the most unlikely aspects of the city: wall scrawls (graffiti), time-worn masonry, weathered boardings. He photographed people unobtrusively yet directly, with human warmth. His massive documentation of fellow artists at work—he is himself a sculptor and draftsman—is most impressive. In a spirit of fantasy, not without Surrealist overtones, Bill Brandt began to photograph the English at home; his book by that title (1936) and his *London by Night* (1938) are counterparts to Brassaï's *Paris de Nuit* (1933). With perception and imagination he photographed the homes of British authors and scenes evocative of their literary contributions; recently he has concentrated on a highly individual approach to the nude.

When miniature camera work by the French photographer Henri Cartier-Bresson was first shown at the Julien Levy Gallery in New York in 1933, it was called awkwardly enough, "antigraphic photography."[9] The impression arose that the photographs had been taken almost automatically and that they owed their strange and provocative beauty to chance; they were described as "equivocal, ambivalent, anti-plastic, accidental." For Cartier-Bresson showed the unreality of reality: the rhythm of children playing in ruins, a child lost to the world as trance-like he catches a ball; a bicyclist streaking by iron grill work. It was hard to believe they were deliberately composed. Yet that was precisely how he photographed.

Cartier-Bresson is able to seize the split second when the subject stands revealed in its most significant aspect and most evocative form. He finds the small camera ideal for he can bring it into action almost at once, as "an extension of the eye." Far from relying upon accident, he composes through the finder, invariably using the full negative area. In his earlier work—he bought his first Leica in 1932—there is an emphasis on form, and a delight in capturing aspects of the ordinary, unseen in time and space by the ordinary eye. His interest in people became stronger. Not infrequently he has produced studies amounting to caricatures as, for example, the pictures of the Coronation Parade of George VI in London in 1938, where he showed not the glittering pageantry, but the bystanders. He has the remarkable ability to capture those peak instants when the ever-moving image formed by his lens has attained a timeless harmony of form, expression, and content. He has made brilliant use of the 35mm camera's ability of allowing exposures to be made in rapid succession, and works with great intensity up to a climax.

The development of powerful yet portable light

BRASSAÏ. *The Park of Palazzo Orsini, Bomarzo, near Viterbo, Italy.* n.d. Gelatin-silver print. The Menil Foundation Collection, Houston.

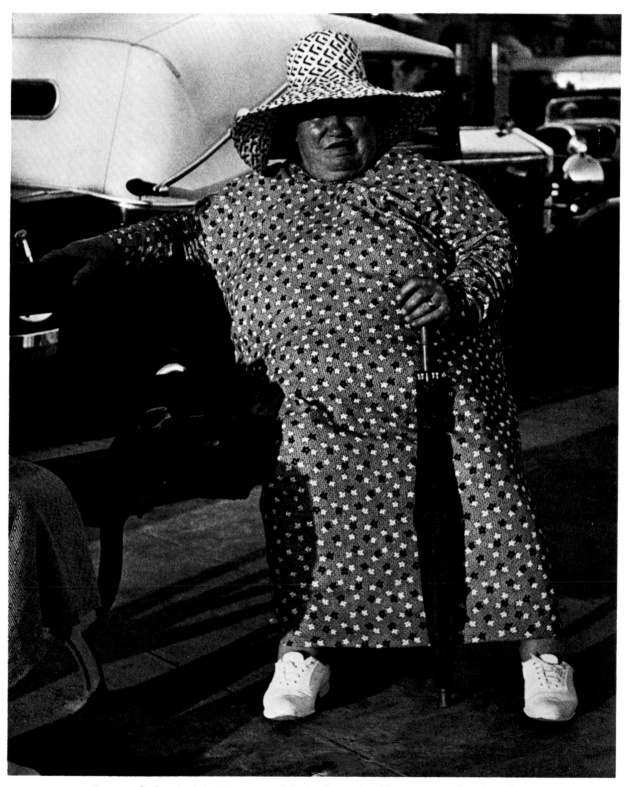

LISETTE MODEL. *Promenade des Anglais, Nice.* 1937. Gelatin-silver print. The Museum of Modern Art, New York.

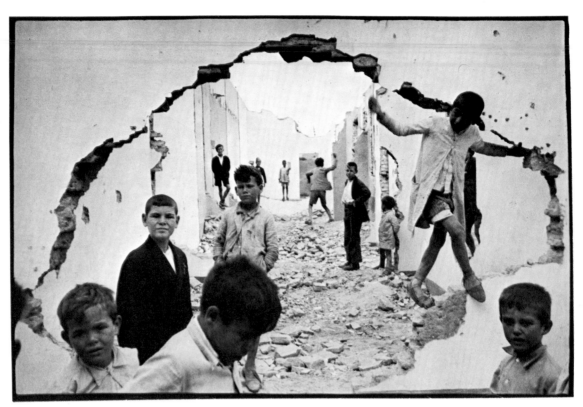

HENRI CARTIER-BRESSON. *Children Playing in Ruins, Spain*. 1934. Gelatin-silver print. The Museum of Modern Art, New York.

HENRI CARTIER-BRESSON. *Cardinal Pacelli (later Pope Pius XII) at Montmarte, Paris*. 1938. Gelatin-silver print. Courtesy of the photographer.

HENRI CARTIER-BRESSON. *Alfred Stieglitz at An American Place, New York*. 1946. Gelatin-silver print. The Museum of Modern Art, New York.

"I met and photographed Stieglitz for the first time a month before his death. I do not ordinarily photograph a person on such short acquaintance but I felt that I knew Stieglitz through his work, and could presume to make his portrait."

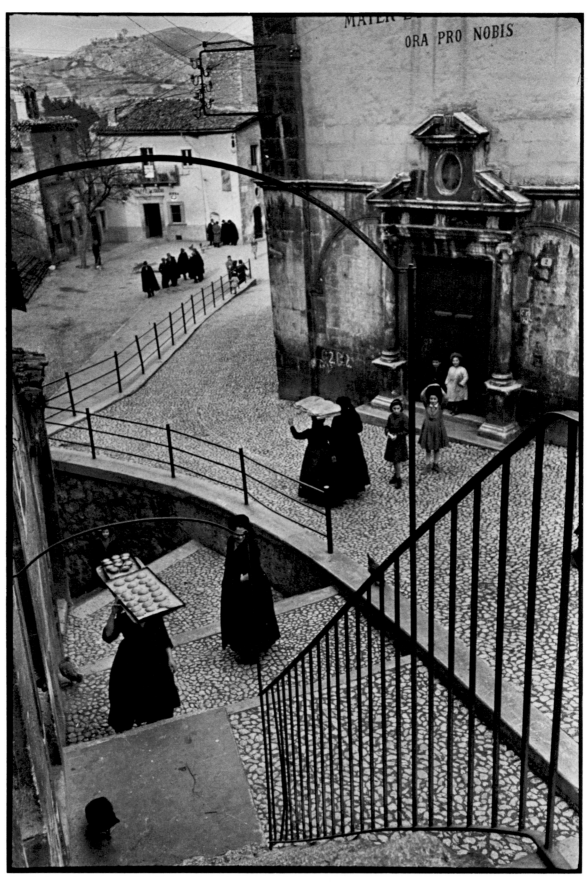

HENRI CARTIER-BRESSON. *Abruzzi, Italy*. 1953. Gelatin-silver print. Courtesy of the photographer.

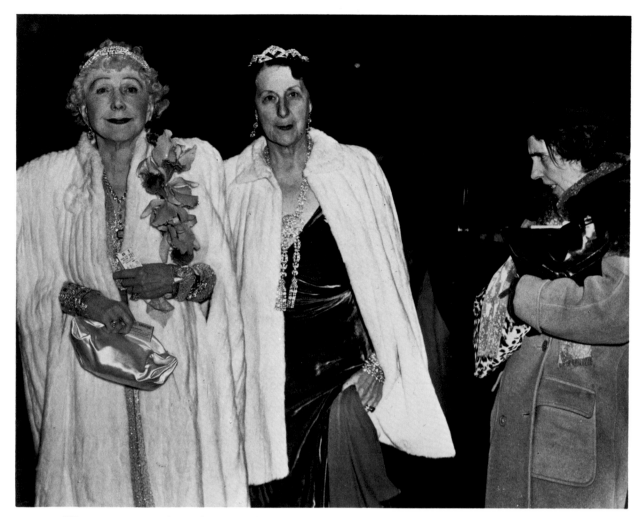

WEEGEE. *The Critic.* 1943. Gelatin-silver print. The Museum of Modern Art, New York.

sources has given the photographer the opportunity to create his own lighting effects anywhere and to record the most rapid action.

With flash powder the photographer had little control over the quality of the lighting; it was hardly more than a way of creating enough illumination to take snapshots in dark places. In 1925 Paul Vierkötter patented a radically new method of producing a flash: the inflammable mixture was put inside a glass bulb, from which the air had been evacuated. When weak electric current was passed through the mixture it ignited at once, giving forth, for the fraction of a second, brilliant light. J. Ostermeier perfected this flashbulb in 1929 by stuffing it with aluminum foil, and it was put on the market in Germany as Vacu-Blitz. It was introduced in England as Sashalite and in America as The Photoflash Lamp in 1930. The noiseless and smokeless flash bulb was immediately adopted by news photographers; its earliest use in America is said to have been photographing President Hoover signing the Unemployment Relief Bill. At first the "open flash" method was used: with the camera on a tripod, the

shutter was opened, the flash bulb set off, and the shutter was closed. Later the release of the shutter was mechanically synchronized with the discharge of electric current and the camera could be held in hand. For convenience the flash gun (battery case, flash bulb, and reflector) was fastened to the side of the camera.

With this equipment pictures could be taken anywhere. But the results were, for the most part, grotesque, because the harsh front light flattened faces, cast unpleasant shadows, and fell off so abruptly that backgrounds were unrelieved black. This unreal lighting of the flash from the camera can be used effectively; in many instances the New York news photographer Weegee made comments that reach into the field of social caricature. It is obvious, however, that photographs so lighted are far removed from naturalistic indoor pictures made with a wide-aperture lens on a miniature camera, in which we seem to be magically transported into the very presence of people and to be an onlooker of their activities along with the photographer. A further mechanical development made it possible to ignite several flash bulbs, placed

231

BARBARA MORGAN. *Martha Graham in "Letter to the World."* 1944. Gelatin-silver print. The Museum of Modern Art, New York.

at distant points from the camera and connected to it by extension wires. With this "multiple synchroflash" technique the lighting can be arranged either for dramatic effect, or to stimulate existing light sources; people can be photographed with it instantaneously, amid their normal surroundings, relaxed or in action. One of the first to make use of this technique was Margaret Bourke-White of *Life* magazine, who wrote in 1937:

I am deeply impressed with the possibilities of flash bulbs distributed through the room instead of using one attached to the camera in the usual way. I work mine with extension cords from a synchronizer attached directly to the shutter but always use two sources of light and sometimes three or four or even six distributed around the room. The flashlight gives a soft, very fine quality of light. The beauty of it, of course, is that you can watch your subjects until they show just the expressions or movements you wish and then release your flash. I feel, too, that it is very useful in dark places like night clubs and restaurants. Frequently I have set up a camera with remote control in the corner of a room, seated myself at a table some little distance, and released the flash, possibly an hour later, when everybody had forgotten about the camera.[10]

Brilliant use of artificial lighting, and particularly of the synchroflash technique, has been made by Barbara Morgan in her photographs of the dance. She has lit dancers specifically for the purpose of photographing them; they performed for her camera; instead of mere records of action, she has given us interpretations. Light is her medium:

I am grateful for man-made light and the creative freedom it gives.... With synchroflash and speedlamps I can illuminate *what I want and no more. At will* I can create zones of importance by dominant and subordinate lighting. I can impart sculptural volume or flat rendering to the same object. By controlling direction and intensity I can launch light as a dynamic partner of dance action, propelling, restraining, and qualifying. Light is the shape and play of my thought . . . my reason for being a photographer.[11]

Too often dance photographs are nothing more than technical accomplishments in which action is stopped and the performers are left awkwardly in space. In Bar-

232

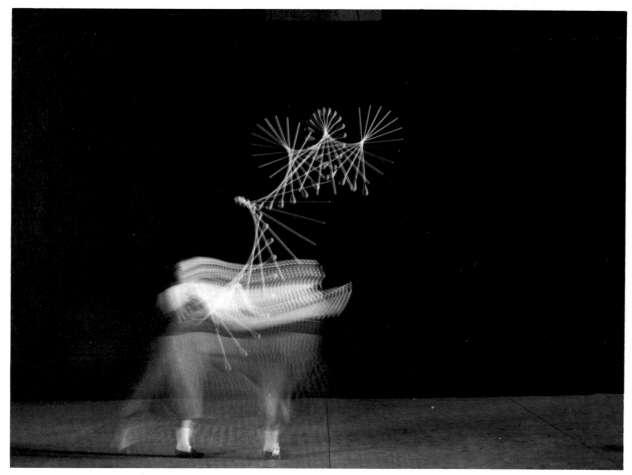

HAROLD E. EDGERTON. *A Drum Majorette at the Belmont, Massachusetts, High School Twirling a Baton.* 1948. Gelatin-silver print. Courtesy of the photographer. Exposed by a stroboscope flashing sixty times a second.

bara Morgan's photographs every shape has meaning. Sometimes "freezing" of action is demanded; at other times a slightly blurred image helps to convey the emotion. Often both renderings are needed simultaneously, to show part of the action arrested and part in flow. Experience has enabled her to visualize what the lens will record during the fraction of a second it is open. She sees the dance not as a spectator, nor as a performer, but as a photographer. She has brought her sense of light and form to many other fields besides the dance, always bringing out the human qualities with warmth and acute sympathy.

Flashbulbs are expendable: they can be used only once. They have been completely replaced by xenon-filled discharge tubes flashed from energy stored in electrical capacitors. These "speedlamps," as they were at first called, enable exposures to be made in one-millionth of a second, or even shorter. Small, less powerful electronic flash units are now widely used—either attached to the camera or connected to it by a wire and held at arm's length. Any number of supplementary units can be flashed simulta-

neously without extension wires, by a slave unit that picks up light from the main flash and instantaneously converts it to electricity to fire all units simultaneously.

The electronic flash has a further capability: it can emit flashes intermittently. Harold E. Edgerton of the Massachusetts Institute of Technology, who invented the gas-filled tube in 1938, first made use of it to examine rapidly moving machine parts by the long-familiar stroboscopic method: a light flashing at exactly the rate that a regularly moving object revolves or oscillates will illuminate the same phase of the motion at each flash, and the object—to the eye and camera alike—will appear to stand still.

Photographs taken by "strobe light" fix forever forms never detected by the unaided eye. With it Edgerton has produced highly imaginative staccato images of the flow of motion and the very trajectory of objects moving at a rate approaching the speed of light. Gjon Mili has used this multiexposure technique to picture the cycle of drumsticks, a *pas de ballet*. The camera has gone beyond seeing and brings us a world of form normally invisible.

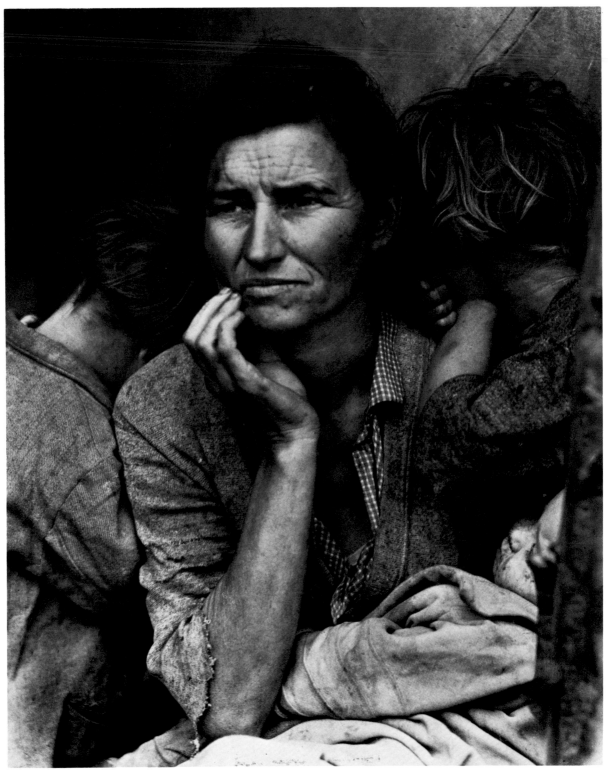

DOROTHEA LANGE. *Migrant Mother, Nipomo, California.* 1936. Gelatin-silver print. The Museum of Modern Art, New York.

13 · DOCUMENTARY PHOTOGRAPHY

The quality of authenticity implicit in a photograph may give it special value as evidence, or proof. Such a photograph can be called "documentary" by dictionary definition: "an original and official paper relied upon as basis, proof, or support of anything else;—in its most extended sense, including any writing, book, or other instrument conveying information."[1]

Thus *any* photograph can be considered a document if it is found to contain useful information about the specific subject under study. The word was not infrequently used in the nineteenth century in a photographic context: *The British Journal of Photography* in 1889 urged the formation of a vast archive of photographs "containing a record as complete as it can be made . . . of the present state of the world," and concluded that such photographs "will be most valuable *documents* a century hence."[2] In a quite different sense, the painter Henri Matisse stated in *Camera Work* in 1908: "Photography can provide the most precious documents existing, and no one can contest its value from that point of view. If it is practised by a man of taste, the photographs will have the appearance of art. . . . Photography should register and give us documents."[3]

At this time in America, Lewis W. Hine was making a series of remarkable photographs of immigrants arriving in New York. Trained as a sociologist at the Universities of Chicago, Columbia, and New York, he found the camera a powerful tool for research and for communicating his findings to others. He was greatly concerned with the welfare of the underprivileged. In the years before World War I Hine took his camera to Ellis Island to record the immigrants who were then arriving by the tens of thousands. He followed them into the unsavory tenements that became their homes, penetrated into the miserable sweatshops where they found work, and photographed their children playing among the ashcans and the human derelicts in the sprawling slums of New York City. Hine realized, as Riis had before him, that his photographs were subjective and, for that very reason, were powerful and readily grasped criticisms of the impact of an economic system on the lives of under-privileged and exploited classes. He described his work as "photo-interpretations." The photographs were published as "human documents." His training enabled him to comprehend instantly, and without effort, the background and its social implications. Unbothered by unnecessary details, his sympathies were concentrated on the individuals before him; throughout his pictures this harmony can be felt. When, with his 5 x 7-inch camera he photographed children working in factories, he showed them at the machines, introducing a sense of scale that enabled the viewer to see that the workers were indeed very young children. His photographs were widely published. The phrase "photo story" was used to describe his work, which was always of equal importance to the writer's and in no sense "illustrations" to it. His revelation of the exploitation of children led to the eventual passing of child labor laws.

Hine by no means limited his photography to negative criticism, but brought out positive human qualities wherever he found them. In 1918 he photographed American Red Cross relief in the Middle European countries; years later he concentrated on American workmen, and a collection of photographs of them was published in 1932 as *Men at Work*.[4]

Perhaps the best photographs in the book were chosen from the hundreds he took of the construction of the 102-story Empire State Building in New York, upon its completion in 1931 the tallest in the world. Day by day, floor by floor, he followed the steelwork upward. With the workmen he toasted sandwiches over the forges that heated the rivets; he walked the girders at dizzying heights, carrying over his shoulder his view camera complete with tripod or, more rarely, his 4 x 5-inch Graflex. When he and the workmen reached the pinnacle of the building, he had them swing him out over the city from a crane so that he might photograph in midair the moment they had all been striving for—the driving of the final rivet at the very top of the skyscraper. These spectacular pictures are not melodramatic; they were not taken for sensation; they are a straightforward record of a job that happened to be dangerous.

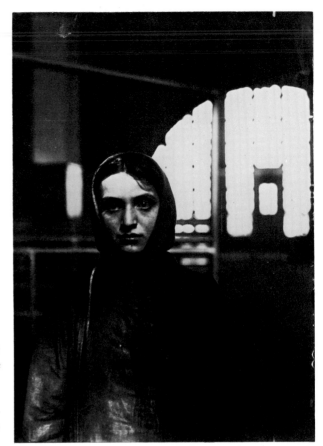

Right: LEWIS W. HINE. *Young Russian Jewess at Ellis Island.* 1905. Gelatin-silver print. George Eastman House, Rochester, N.Y.

Below: LEWIS W. HINE. *Carolina Cotton Mill.* 1908. Gelatin-silver print. The Museum of Modern Art, New York.

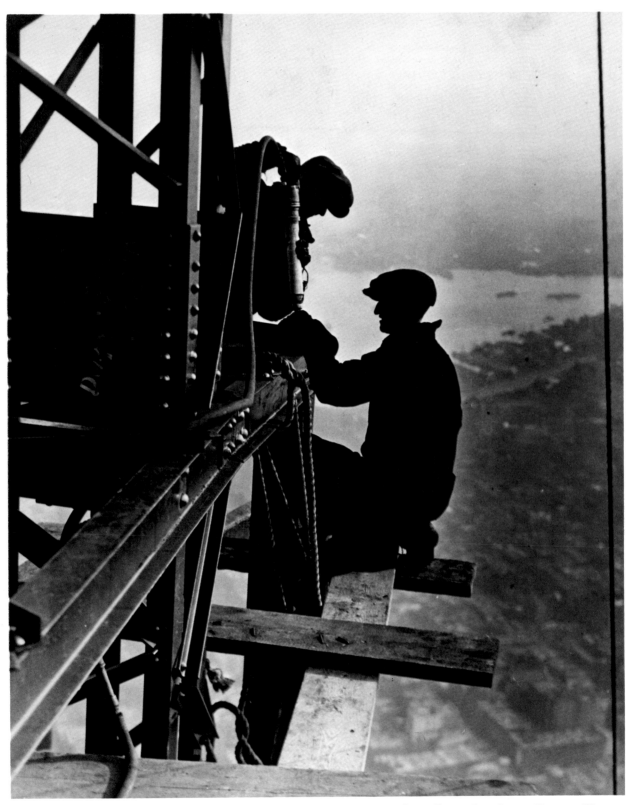

LEWIS W. HINE. *Steelworkers, Empire State Building, New York.* 1931. Gelatin-silver print. George Eastman House, Rochester, N.Y.

When the darkness of the Depression fell upon the world in the 1930s, many artists at once reacted to it. In the field of painting the return to realism became pronounced; following the lead of the Mexican muralists, painters began to instruct the public through their work. A group of independent filmmakers had already begun to make films that, in contrast to the usual entertainment productions, were rooted in real problems and real situations, with the participants themselves as the actors. John Grierson, spokesman for a British group, recollects that they felt this type of motion picture

in the recording and the interpretation of fact was a new instrument of public influence which might increase experience and bring the new world of our citizenship into the imagination. It promised us the power of making drama from our daily lives and poetry from our problems.[5]

They called this type of film *documentary*.

As social photographers they shied away from the word "artistic," and the voluminous literature of the movement is insistent that documentary film is *not* art. "Beauty is one of the greatest dangers to documentary," wrote the producer-director Paul Rotha in his *Documentary Film*.[6] He came to the astonishing conclusion that photography —the very life blood and essence of the motion picture— was of secondary importance and if too good might prove detrimental. Yet Grierson wrote that

documentary was from the beginning . . . an 'anti-aesthetic' movement . . . What confuses the history is that we had always the good sense to use the aesthetes. We did so because we liked them and because we needed them. It was, paradoxically, with the first-rate aesthetic help of people like Robert Flaherty and Alberto Cavalcanti . . . that we mastered the techniques necessary for our quite unaesthetic purpose.[7]

Documentary is, therefore, an approach that makes use of the artistic faculties to give "vivification to fact"— to use Walt Whitman's definition of the place of poetry in the modern world.

At the same time that filmmakers began to talk about "documentary," here and there photographers were using their cameras in a similar way. In 1935 the United States government turned to these photographers for help in fighting the Depression. Among the many agencies that President Franklin D. Roosevelt brought into being by executive order was the Resettlement Administration, charged with the problem of bringing financial aid to the thousands of rural workers driven from their farmlands by the sterility of the "dust bowl" of the central states or by competition with mechanized agricultural practices. The new agency was headed by Rexford G. Tugwell, Undersecretary of Agriculture and former professor of economics at Columbia University. Tugwell

appointed his former student and colleague, Roy E. Stryker, as Chief of the Historical Section with the assignment to direct a vast photographic project, documenting not only the agency's activities, but American rural life in depth. In 1937 the agency became a part of the Department of Agriculture, under the title of the Farm Security Administration (FSA).

Walker Evans was one of the first photographers to be hired. He continued his dual interest in the American form and the American people. He traveled to the South and documented the condition of the land, the plight of tenant farmers, their houses, their belongings, the way they worked, their crops, their schools and churches and stores. He photographed with an 8 x 10-inch camera crossroads stores, streets of small towns, billboards, and the automobile. Much of what Evans photographed was squalid, but his interpretation was always dignified. Glenway Westcott pointed out that

others have photographed squalid scenes wonderfully; but it has been a wonder dispersed, hit-or-miss in a thousand rotogravure sections, etc. Here is a lot of it, all hanging together: fantastic martyred furniture, lampshades and pictures, rags, hats. Usually Mr. Evans has dismissed the dweller from his dwelling, but we can deduce him. Then one sometimes sees, in wild grass, the indentations where a rabbit has been lying, hungering, quaking. Countrymen of ours like rabbits. . . . For me this is better propaganda than it would be if it were not aesthetically enjoyable. It is because I enjoy looking that I go on looking until the pity and the shame are impressed upon me, unforgettably. And on the superb, absurd old houses . . . there has fallen—along with the neglect and decay—an illumination of pearl, shadows of sable, accentuations as orderly as in music. Look at them. I find that I do not tire of them. Look at the old mansion upon which the rottenness of the wood appears like the marks of a sort of kiss.[8]

Dorothea Lange, who joined the Resettlement Administration photographic team in 1935, had a portrait studio in San Francisco. During the Depression she was dismayed to see breadlines of the homeless and unemployed and was determined to photograph them so that others might feel the compassion she so deeply felt. Her prints were exhibited by Willard Van Dyke of Group $f/64$ in his Oakland gallery. There they were seen by Paul S. Taylor, professor of economics at the University of California, who was so impressed that he used her photographs to illustrate the report of a survey he was making on agricultural labor problems in the state. The report was seen by Tugwell and Stryker, who invited her to join their project. Her photographs of migratory workers with overladen jalopies on the highways, living in tents pitched in fields or the town dump, in transient camps, working in the fields, are at once an accurate record and a moving comment, for she had a deep feeling of compassion and respect for them.

WALKER EVANS. *Garage, Atlanta, Georgia.* 1936. Gelatin-silver print. The Library of Congress, Washington, D.C.

WALKER EVANS. *Allie Mae Burroughs, Wife of a Cotton Sharecropper, Hale County, Alabama.* 1936. Gelatin-silver print. The Museum of Modern Art, New York.

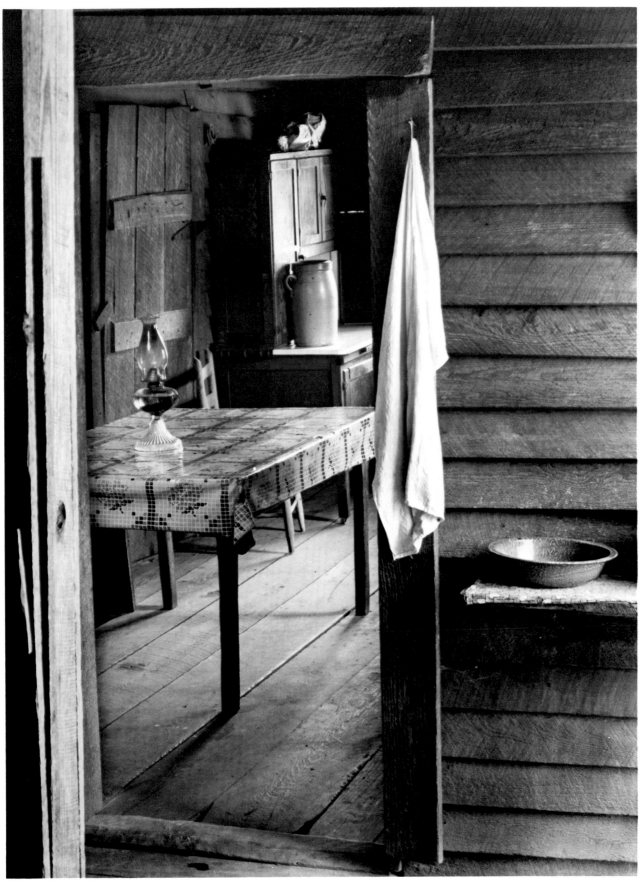

WALKER EVANS. *Washroom and Dining Area of Floyd Burroughs' Home, Hale County, Alabama.* 1936. Gelatin-silver print. The Museum of Modern Art, New York.

DOROTHEA LANGE. *Tractored Out, Childress County, Texas.* 1938. Gelatin-silver print. The Museum of Modern Art, New York.

BEN SHAHN. *Rehabilitation Client, Boone County, Arkansas*. 1935. Gelatin-silver print. Fogg Art Museum, Cambridge, Mass.

Lange could make a deserted farmhouse, abandoned in acres of machine-plowed land, an eloquent definition of the phrase "tractored-out," which was on the lips of hundreds of dispossessed farmers. Her photograph of a migrant mother surrounded by her children, huddled in a tent, became the most widely reproduced of all the FSA pictures. She wrote:

My own approach is based upon three considerations. First—hands off! Whatever I photograph, I do not molest or tamper with or arrange. Second—a sense of place. Whatever I photograph, I try to picture as part of its surroundings, as having roots. Third—a sense of time. Whatever I photograph, I try to show as having its position in the past or in the present.[9]

Ben Shahn, the painter, made hundreds of photographs for Stryker with a 35mm camera fitted with a right-angle viewfinder, so that he could photograph people without their knowledge. These informal portraits superficially appear to be snapshots; they are transient images, and yet many are massive, even sculptural, bearing a close affinity to the work of Henri Cartier-Bresson, whom Shahn greatly admired.

The scope of the FSA project included all phases of rural America. The small town is such an integral part of our agricultural fabric that it could not be overlooked. Sherwood Anderson found enough material in the thousands of FSA photographs to make a picture book, *Home Town*,[10] showing the positive side of typical American community life.

For seven years, until its entire resources were turned over to the Office of War Information during World War II, the FSA project employed Arthur Rothstein, Russell Lee, John Vachon, Theodor Jung, Paul Carter, Marion Post Wolcott, Jack Delano, Carl Mydans, and John Collier, Jr., in addition to Evans, Lange, and Shahn. The work, which is now in the collection of the Library of Congress in Washington, is remarkably cohesive and yet individual. Each photographer contributed to the project; working together, sharing common problems, they helped one another. The scope of the documentation and its general aim were controlled and guided by Stryker, who briefed the photographers on the sociological and economic backgrounds of their assignments, stimulated their imagination, and encouraged their curiosity. Not a photographer himself, Stryker wisely left all questions of equipment, technique, and style of visualization

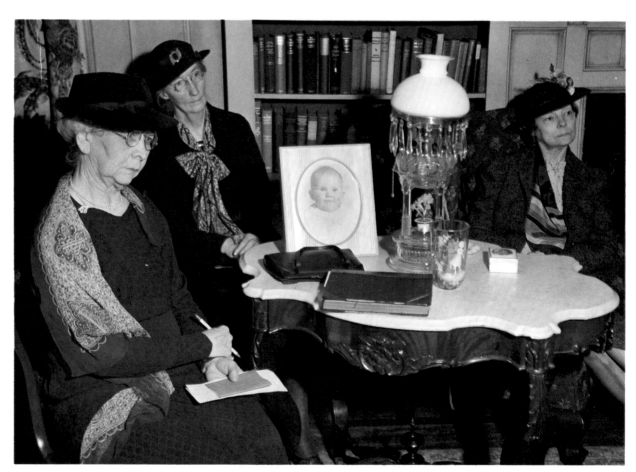

MARGARET BOURKE-WHITE. *Conversation Club.* From the photo essay "Muncie, Indiana" in *Life*, May 10, 1937. *Life* Magazine, © Time Inc.

to the individual photographers. He pointed out:

Documentary is an approach, not a technique; an affirmation, not a negation. . . . The documentary attitude is not a denial of the plastic elements which must remain essential criteria in any work. It merely gives these elements limitation and direction. Thus composition becomes emphasis, and line sharpness, focus, filtering, mood—all those components included in the dreary vagueness "quality" are made to serve an end: to speak, as eloquently as possible, of the things to be said in the language of pictures.[11]

The documentary approach was eagerly pursued elsewhere. Margaret Bourke-White, who had made an enviable reputation as a photographer of industry for *Fortune* and *Life* magazines, produced with the writer Erskine Caldwell a photographic survey of the South in *You Have Seen Their Faces* (1937).[12] Eleven pages of *Life* for May 10, 1937, were devoted to her photographs of Muncie, Indiana, the city that had been selected by Robert and Helen Lynd for their sociological study *Middletown*, published in 1929. Bourke-White's photographic essay was presented as "an important American document"; it showed the aspect of the city from the ground and from the air, the homes of the rich and the poor; it was an unusually graphic cross section of an American community.

New York City found its interpreter in Berenice Abbott, who in 1929 decided to give up her Paris studio, where she had produced many striking portraits of artists and writers, and return to America. Impressed by the complex and ever-varied life of New York, she began the task of photographing not only the outward aspect of the metropolis, but its very spirit. At first she worked alone, then under the auspices of the Art Project of the Work Progress Administration (WPA). The negatives and a set of master prints from them are now in the Museum of the City of New York; they are historical source material, for many of the landmarks she photographed no longer exist. A selection of her work was published in book form with the title *Changing New York*[13] in 1939. She wrote:

To make the portrait of a city is a life work and no one portrait suffices, because the city is always changing. Everything in the city is properly part of its story—its physical body of brick, stone, steel, glass, wood, its lifeblood of living, breathing men and women. Streets, vistas, panoramas, bird's eye views and worm's eye views, the noble and the shameful, high life and low life, tragedy, comedy, squalor, wealth, the mighty towers of skyscrapers, the ignoble façades of slums, people at work, people at home, people at play. . . .[14]

In her instruction manual *A Guide to Better Photography*, Abbot advises the photographer to use as large a camera as possible, so that the records will be fully detailed and rich in information. Such photographs can be

BERENICE ABBOTT. *Wall Street, New York.* 1933. Gelatin-silver print. The Museum of Modern Art, New York.

read; they are not illustrations but actual source material.

Fox Talbot observed in *The Pencil of Nature* that

it frequently happens, moreover—and this is one of the charms of photography—that the operator himself discovers on examination, perhaps long afterwards, that he had depicted many things he had no notion of at the time. Sometimes inscriptions and dates are found upon the buildings, or printed placards most irrelevant, are discovered upon their walls. . . .[15]

It is significant that, time after time, the documentary photographer includes in his image printed words and wall scrawls. More than one photographer in the bitterness of the thirties chose to contrast billboard slogans with the contrary evidence of the camera. A sign, photographed as an object, carries more impact than the literal transcription of the words it bears.

However revealing or beautiful a documentary photograph may be, it cannot stand on its image alone. Paradoxically, before a photograph can be accepted as a document, it must itself be documented—placed in time and space. This may be effectively done by context, by including the familiar with the unfamiliar, either in one image or in paired images. A series of photographs, presented in succession on exhibition walls or on the pages of a book, may be greater than the sum of the parts. Thus in *American Photographs*, published by The Museum of Modern Art in 1938 at the time of his exhibition, Walker Evans arranged his photographs in two separate series and relied upon the sequence of images to show in the first part "the physiognomy of a nation" and in the second part "the continuous fact of an indigenous American expression." Each photograph was numbered and factual titles were supplied at the end of each section. In a collaborative work with the writer James Agee, *Let Us Now Praise Famous Men* (1941), Evans grouped his photographs in the front of the book, in front of the title page itself.[16] They were presented without a single word of explanation. They were, Agee wrote, ". . . not illustrative. They, and the text, are coequal, mutually independent, and fully collaborative."

In contrast to the austerity of this book design, Dorothea Lange and Paul S. Taylor in *An American Exodus* (1939) presented a close relation between the image and the word by printing with the photographs excerpts from conversation heard or overheard at the time of photographing—an approach in itself wholly documentary in spirit.[17] Yet another device was used in *Land of the Free* (1938), a collection of documentary photographs, mostly from the FSA files, to which Archibald MacLeish supplied a "sound track" in the form of a poem.[18] He explained that,

The original purpose had been to write some sort of text to which these photographs might serve a commentary. But so great was the power and stubborn inward livingness of these vivid American documents that the result was a reversal of that plan.

In all of these, and in many other publications of similar nature, the chief characteristic is that the photographs assert their independence. They are not illustrations. They carry the message together with the text.

In Germany in 1910 August Sander, a professional portrait photographer, began an ambitious program: the production of a vast atlas of German types from all classes of the social structure. He sought, not the individual personality, but the representative of various professions, trades, and businesses, as well as members of social and political groups. He called his project "Man in the Twentieth Century." In 1929 the first of a proposed series of twenty volumes of Sander's photographs was published under the title *Antlitz der Zeit* ("Face of Our Time").[19] No further volumes appeared, for the political implications displeased the Nazi regime. The publisher's inventory of books was confiscated, and the printing plates destroyed.

"Documentary," in the sense in which we have described it, has been accepted as the definition of a style. Since World War II the movement has lost impetus in the organizational sense. Its tenets have been absorbed and have become essential to the fabric of photojournalism and, especially, to the style of factual reporting developed by television. Substitutes have been suggested for the word "documentary": "historical," "factual," "realistic." While each of these qualities is contained within "documentary," none conveys the deep respect for fact coupled with the desire to create the basically subjective interpretation of the world in which we live that marks documentary photography at its best.

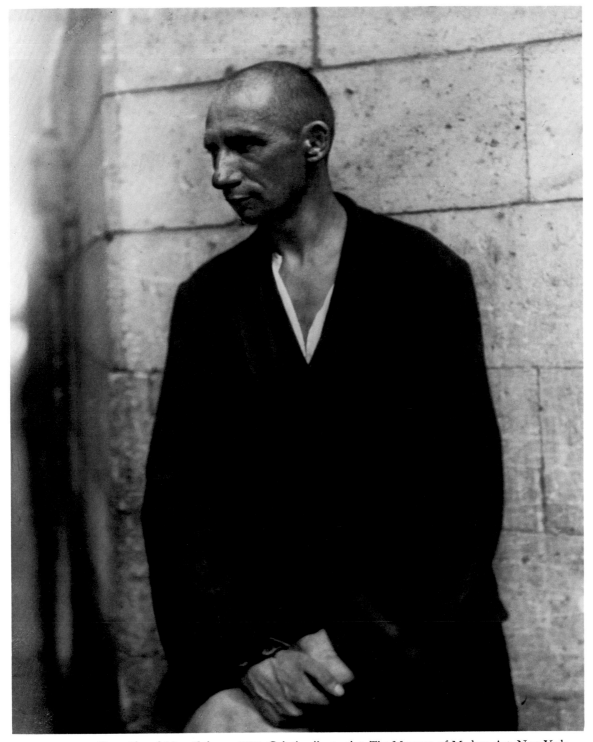

AUGUST SANDER. *Unemployed Man, Cologne.* 1928. Gelatin-silver print. The Museum of Modern Art, New York.

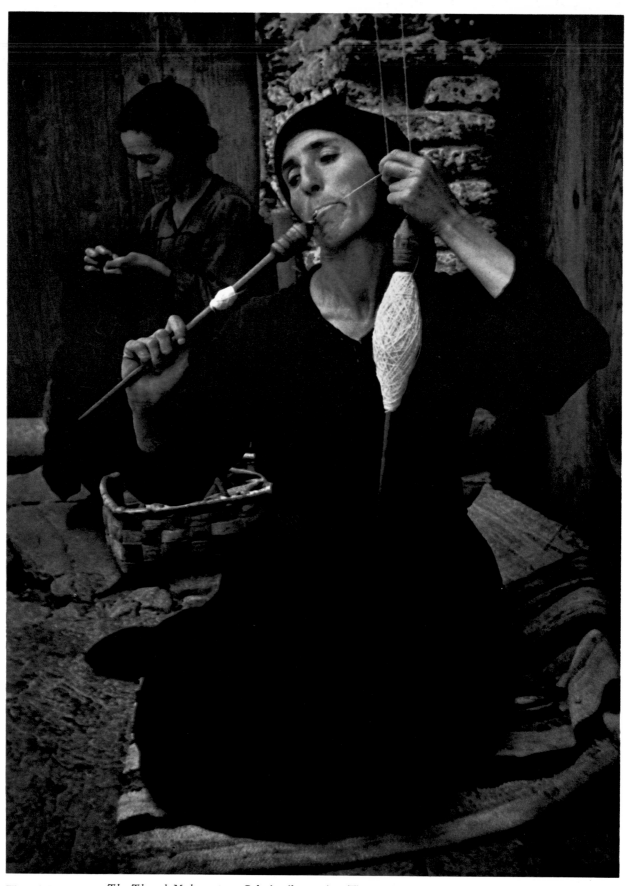

W. EUGENE SMITH. *The Thread Maker.* 1951. Gelatin-silver print. The Museum of Modern Art, New York. From the photo-essay "Spanish Village" in *Life*, April 9, 1951. *Life* Magazine, © 1951 Time Inc.

14 · PHOTOJOURNALISM

Almost contemporary with the invention of photography was the birth and phenomenal growth of the pictorial press. The first weekly magazine to give preference to pictures over text was *The Illustrated London News*, founded in 1842. It was quickly followed by *L'Illustration* (Paris), the *Illustrirte Zeitung* (Leipzig), *L'Illustrazione Italiana* (Milan), *Gleason's Pictorial Drawing-Room Companion* (Boston), *Harper's Weekly* (New York), *Frank Leslie's Illustrated Newspaper* (New York), *Revista Universal* (Mexico), *A Illustração* (Rio de Janeiro), *Illustrated Australian News* (Melbourne), and a host of others. Indeed, practically every country had its lavishly illustrated magazines: printed on high-speed rotary web presses, their circulations reaching at times well over 100,000 per issue. The illustrations were invariably wood engravings cut from sketches made in the field or from drawings or paintings or, very occasionally, from photographs. The engravers were not artists but skilled technicians who followed with their burins the lines a draftsman had drawn on the block, cutting away the wood beside each line. So faithfully did the engravers follow the drawing that, to save time, the block was sometimes divided into pieces and engraved by as many different hands, and then reassembled. As long as a drawing had to be made for each cut, there was no advantage in using photographs. The few wood engravings from photographs that appear in magazines of the mid-nineteenth century usually lack photographic quality, as can be seen by comparing the photograph of General U. S. Grant at his headquarters in City Point, Virginia, with its reproduction on the cover of *Harper's Weekly* for July 16, 1864. Only the credit line "Photograph by Brady" reveals its photographic origin.

The reason that photography had such little impact on the pictorial press was largely technological, but also stylistic. The reading public had become used to wood engravings, and the editors saw no reason to change a group journalistic system that was successful. The letterpress was set in type in a traditional way, and the wood engravings, which were in relief and on blocks exactly type high, were locked in forms with the type. Until the

1880s there was no photomechanical process to provide relief blocks that could be printed with the type on high-speed magazine presses, even though from the very birth of photography many experiments were made to reproduce the photographic image in ink.

In his 1826 experiments Niépce was very concerned with working out a photomechanical reproduction technique as a means of recording the camera image on a pewter plate that could be printed like a copperplate engraving. Soon after the daguerreotype process had been published, the silvered copper plates were themselves converted into intaglio plates from which impressions could be printed on paper. A satirical lithograph of 1839 by Théodore Maurisset, captioned *Daguerréotypomanie,* shows Alfred Donné at work with camera, aqua fortis bottle, and etcher's press. Donné made the plates printable by etching out the clear silver areas so that they could hold ink, and then printing them like an etching or engraving. He showed examples to the Academy of Sciences in Paris on September 3, 1839, but refused to divulge his process. Quite independently Josef Berres of Vienna worked out a similar process. In his privately published booklet, *Phototyp,* containing five plates and a short text and dated August 3, 1840, he called specific attention to a view of the cathedral of St. Stephan's in Vienna as his most successful plate from which he pulled "many hundred" impressions.

The technique was improved by the Frenchman Hippolyte Louis Fizeau, who introduced two innovations: he built up the highlights of the etched daguerreotype plate by the newly discovered electrotype process, and he borrowed from the aquatint engraver the technique of granulating the plate so the etched areas would hold ink in proportion to the halftone densities. He dusted the plate with powdered resin, heated it so that the grains would adhere to the surface, and then etched it. For the second series of Lerebours' *Excursions daguerriennes* (1843) Fitzeau etched three daguerreotype plates. However, no widespread use was made of his process.

More successful photomechanical reproduction techniques came with the adaptation of the negative-positive

Photographer unknown. *General U. S. Grant.* 1864. Gelatin-silver print from original negative. National Archives, Washington, D.C. *Right*: Wood engraving in *Harper's Weekly*, July 16, 1864.

The Virgin's Funeral, Relief on Notre Dame Cathedral, Paris. ca. 1841. Print from a daguerreotype converted to an intaglio plate by the Fizeau process. From N. M. P. Lerebours, *Excursions daguerriennes* (Paris: 1843). The Metropolitan Museum of Art, New York.

process. Fox Talbot himself, discouraged by the impermanence of his calotypes, followed up the work of Donné, Berres, and Fizeau. In 1852 he patented a method of etching steel plates from which prints could be made with permanent ink. He first coated the plates with gelatin to which had been added potassium bichromate. On these sensitized plates he put an object—a blade of grass or a stalk of wheat—and exposed it to light. All the areas except those shaded by the object were made insoluble by light action. Talbot then washed the plate, and the image was revealed in the bare metal, which he then etched. Large objects produced a problem: the etched areas were too large to hold ink. So he broke up these areas into dots by double-exposing the plate through a folded piece of gauze with mesh so fine that at reading distance it appeared of uniform tint. In his patent he suggested that a substitute for the gauze could be a sheet of glass covered with fine opaque crossed lines. In 1858 Talbot improved his process by powdering the bichromated gelatin coating with resin—thus following in principle the technique of Fizeau. This technique, which Talbot named *photoglyphic engraving,* became the basic principle of *photogravure,* the graphic arts process so favored by P. H. Emerson and the pictorial photographers of the turn of the century as a medium for the direct presentation of their work.

A third process, *photolithography,* was perfected by Alphonse Louis Poitevin in 1855. He discovered that bichromated colloids, in addition to becoming relatively insoluble upon exposure to light, also accepted greasy printer's ink in the unexposed areas only and rejected water in those exposed. He coated a grained lithographic stone with bichromated albumen, exposed it beneath a negative, washed away the unhardened albumen and printed it from the stone on a conventional lithograph press. He sold the process to the Parisian lithographer Rose Joseph Lemercier, who produced superb reproductions of works of art, particularly of architecture and sculpture, by its means. A variation, *collotype,* gave prints of exquisite tonal quality and exceedingly fine grain. As perfected in 1868 by Josef Albert of Munich, it depended on bichromated gelatin: a delicate grain was produced by baking the coated plate, which caused the gelatin surface to reticulate. As the *albertype* it became internationally popular, especially for the reproduction of paintings.

Yet another process for reproducing the photographic image in facsimile was the *woodburytype,* invented in 1866 by the English photographer Walter Bentley Woodbury. He printed negatives on gelatin sensitized with potassium bichromate. The exposed gelatin, when "developed" in hot water, became a record of shadows and highlights in relief. A mold of these contours was made by forcing a lead block against the gelatin relief in a powerful hydraulic press. The resulting lead intaglio plate was filled with a jellylike ink, paper was then pressed against it, and a perfect facsimile of the photograph was obtained, with variations of tone reproduced by proportionate variations in the thickness of the deposit. No finer process for the facsimile reproduction of photographs in ink has ever been devised. Yet the woodburytype became obsolete because it was difficult to manipulate and each impression had to be hand trimmed to plate size, for the excess gelatin ink oozed out around the edges during printing.

All of these processes—photogravure, photolithography, collotype, woodburytype, and dozens of variants of them—had a common disadvantage: they could not be printed on a press together with type. Although these processes made possible the reproduction of photographs in quantity, the printed sheets had to be bound separately in books or magazines, or the sheets had to be passed through two presses, once for the text and again for the pictures. For this reason none of these processes could be adapted for the use of newspaper and magazine publishing, which required the rapid printing in a rotary press of thousands of impressions an hour.

The invention of the *halftone* plate in the 1880s made this possible, and revolutionized the pictorial magazines. Type is in relief. As in a rubber stamp the ink is applied to the raised portions. To print photographs in the same press as type, a method was needed by which the highlights would be depressed and the darker portions would remain on the same level as the type. The principle discovered by Talbot of double-exposing a finely ruled screen with a photographic image was now used for the production of relief blocks by a number of experimenters, notably Frederick Eugene Ives, Stephen Henry Horgan, and Max Levy in America, and George Meisenbach in Germany. Basically the process converts a photograph or other kind of picture or diagram to a series of dots formed by the interstices of the crossed lines ruled upon the screen. The dots appear in varying size, depending on the tones of the original photographs. A negative copy of the picture is first made with a camera, inside of which is fitted the halftone screen. This negative is then printed on a metal coated with bichromated gelatin. The dots on the negative allow light to penetrate and render the glue insoluble, so that when the plate is etched with acid each single dot remains on the surface of the plate, which is then mounted at type height on a wooden block. In the final print the minute clusters of dots cannot be distinguished, but appear as tones of gray.

This important invention was perfected at precisely the same time that the greatest technical revolution in

WILLIAM HENRY FOX TALBOT. *Stalks of Wheat.* ca. 1852. Photogravure made by placing wheat stalks on a photosensitive metal plate, then etching it. The Museum of Modern Art, New York.

photography since 1839 was taking place. Dry plates, flexible film, emulsions sensitive to all colors, anastigmat lenses, and hand cameras now made it possible to produce photographs more quickly, more easily, and of a greater variety of subjects than ever before. The halftone process enabled these photographs to be reproduced economically and in limitless quantities in books, magazines, and newspapers. The entire economy of news photography was changed with the introduction of the halftone process.

The Leipzig *Illustrirte Zeitung* ("Illustrated Newspaper") published two instantaneous photographs taken by Ottomar Anschütz of German army war maneuvers in its March 15, 1884 edition, printed from plates engraved in halftone by George Meisenbach. The editor noted:

For the first time we see two instantaneous photographs printed at the same time as the letterpress....Photography has opened new paths. Its motto is now 'speed' in every respect, both in picture taking and reproduction. The old techniques are surpassed as much by today's as the stagecoach by the railroad.

The adoption of the halftone was slow, however, due more to stylistic than technical reasons. Readers preferred the wood engravings as more "artistic." Interviewed in

1893 on the subject, the editor of *The Illustrated London News* stated: "I think the public will in time become tired of mere reproductions of photographs. . . . It is my intention to introduce into the pages of the *Illustrated London News* more wood-engravings than have appeared in the past."[1]

But when the feeling of presence and authenticity was needed, the "mere reproduction of a photograph" could carry a conviction unattainable by the wood engraving. On the occasion of the one-hundredth birthday of the French scientist Michel-Eugène Chevreul in 1886, Nadar's son Paul took a series of twenty-one exposures of him in conversation with his secretary and with Nadar père, which were published as a "photo-interview" in *Le Journal illustré* for September 5, 1886. A stenographer noted the very words that Chevreul spoke at each exposure, and these were printed as captions. A second photo-interview was made two years later of General Georges Boulanger; some of the pictures were circular. They had been taken with one of the first Kodak cameras. The use of so many pictures would hardly have been feasible without the hand camera and the facility of reproduction offered by the halftone process. As many as thirty-three halftones from sequence photographs by

OTTOMAR ANSCHUTZ. *Army Maneuvers near Hamburg.* Half-tone photomechanical reproductions by the Meisenbach Relief Printing Process in the Leipzig *Illustrirte Zeitung,* March 15, 1884.

5. « — Je n'ai jamais bu que de l'eau et pourtant, je suis président de la Société des vins d'Anjou, — mais président honoraire seulement ! »

6. « — C'est là l'inconvénient de cette philosophie du jour, de cette philosophie de rhéteurs, de grands diseurs de riens. On se contente de mots et de paroles creuses... »

7. « — Remarquez que je suis loin de blâmer ce que je ne puis expliquer ; mais je vous dirai qu'il faut qu'on me prouve, *qu'il faut que je voie.* »

8. « — Alors, puisqu'ils nous affirment qu'ils dirigent, à leur volonté, leur ballon, qu'ils viennent me prendre ici, à cette fenêtre, tous les jours de séance à l'Institut et qu'ils me ramènent ! Cela m'évitera de descendre et de monter mes deux étages d'escaliers. »

PAUL NADAR. *The Art of Living a Hundred Years; Three Interviews with M. Chevreul . . . On the Eve of his 101st Year.* From *Le Journal Illustré,* September 5, 1886.

ALEXANDER BLACK. *Three Scenes from the Picture-Play "Miss Jerry."* From *Scribners*, vol. 18 (1895), p. 357.

"Primarily my purpose was to illustrate art with life. . . . After outlining a combination of fiction and photography, each devised with regard for the demands and limitations of the other, it began to be quite clear that the pictures must do more than illustrate. In the first place the pictures would be primary, the text secondary. Again the pictures would not be art at all in the illustrator's sense, but simply the art of the *tableau vivant* plus the science of photography. If it is the function of art to translate nature, it is the privilege of photography to transmit nature. But in this case the *tableaux vivants* must be progressive, that the effect of reality may arise not from the suspended action of isolated pictures, but from the blending of many."— Alexander Black.

WILLIAM WARNECKE. *Shooting of Mayor William J. Gaynor of New York.* 1910. Gelatin-silver print. The Museum of Modern Art, New York.

SAM SHERE. *Explosion of the "Hindenburg," Lakehurst, N.J.* 1937. Courtesy of the International News Service.

Alexander Black, arranged as if frames of a motion picture, illustrated his short story "Miss Jerry" in *Scribner's Magazine* in 1895.

The first picture magazine deliberately planned to use photographs exclusively appears to be the *Illustrated American.* In its first issue, dated February 22, 1890, the publisher stated that "its special aim will be to develop the possibilities, as yet almost unexplored, of the camera and the various processes that reproduce the work of the camera." The issue carried six photographs of the U.S. Navy, twenty-one of the Westminster Kennel Club Bench Show, eight of the Chicago Post Office, fifteen of a production of *As You Like It,* six of historical sites in Bordentown, New Jersey, fourteen to illustrate "A Trip to Brazil," and five showing the latest millinery. Of a layout of twelve photographs of the Chicago Public Library in a subsequent issue the editors pointed out: "These are no fancy sketches; they are the actual life of the place reproduced upon paper, and they tell more than words could of the immense usefulness of the institution."

But the *Illustrated American* found that it could not rely upon photographs alone. Month by month more and more words appeared in its pages, until it had lost its original character.

Daily newspapers lagged behind the illustrated magazines in their use of photographs. Obviously all news is not photogenic. Diplomats seated around a table may be reshaping the world, but it is the rare photographer who can make the reader feel the tensions underlying such a conference. The immediate drama of accidents, the exaggerated emotions brought out on faces in the presence of disaster or crime, the violent split-second action of sports can be imparted vividly by the camera. The photographer needs not so much artifice, subtlety of light and shade, and sense of composition as boldness, strong nerves, and a mastery of his camera so complete that handling it is an automatic reflex.

Although the technique of the new photographer does not differ from that of any other cameraman, the special demands made on his skill, daring, and ingenuity in getting unusual pictures, and the need of turning out a print with all possible speed, make his work a special branch.

Sensing the exact instant to release the shutter becomes instinctive. A second's hesitation, and a picture scoop may

257

FELIX H. MAN. *Mussolini.* Photo essay in *Münchner Illustrierte Presse,* March 1, 1931.

be missed. When William Warnecke of the New York *World* went on a routine assignment to photograph Mayor William J. Gaynor of New York as he was about to sail to Europe on a vacation in 1910, he arrived late, after the other cameramen had left. Hurriedly he asked the Mayor for a last minute pose. Just then an assassin fired two shots from a revolver at the Mayor. Warnecke, in the midst of the confusion, remained cool, and photographed that sickening moment when the victim—who, fortunately, was not mortally wounded—staggered into the arms of his companion.

Chance often gives news photographers their opportunity, yet great news photographs are not accidentally made. Twenty-two photographers, representing New York and Philadelphia newspapers, were gathering at Lakehurst, N.J., on May 6, 1937, for a routine assignment: the dirigible *Hindenburg* was due, and although it was the airship's eleventh transatlantic crossing, the event was still considered newsworthy. At dusk the great silver giant sailed majestically in from the Atlantic, and the cameramen were preparing to compose "art shots" for the feature editors, when suddenly flames shot out from the hull. In forty-seven seconds the great dirigible lay on the ground, a mass of twisted, flaming wreckage.

In those forty-seven seconds, every one of those photographers produced pictures that are still memorable. Jack Snyder of the Philadelphia *Record* said,

I've been carrying my camera around for sixteen years, but I never got an opportunity for really good pictures before. I waited for hours for the Hindenburg in a pouring driving rain, as I wanted to get a close-up. I thought, "I'll get close to the mooring mast to see her tied up." Then I heard a crackling over my head, a sort of roaring crackle, and then W-H-A-M. There was a terrible flame and the heat singed my hair.[2]

He rushed for shelter, but not before he had clicked his shutter. Another photographer worked so fast that he threw the film holders on the ground at his feet after exposing only one of the two films that each contained, for fear that in his excitement he might make a double exposure. A messenger collected the holders; they were flown to New York. The metropolitan newspapers, all of them, told the story of the tragedy not in words but in pictures, which were often enlarged half a page in size. The New York *World-Telegram* carried twenty-one photographs; the New York *Post* had seven pages of pictures, the *Daily Mirror,* nine. Never had a disaster been so thoroughly covered by photography.

But if the daily papers used photographs in a some-

MUSSOLINI BEI DER ARBEIT

what sporadic way, the Sunday newspapers began to feature photographs in supplements, printed in brown ink by *rotogravure,* a variation of photogravure. As perfected by Edward Mertens in Germany in 1904, the intaglio plate bearing the illustrations was wrapped around a cylinder. A second cylinder carried the type. With this tandem press the *Freiburger Zeitung* printed ten thousand impressions per hour for its Easter 1910 issue. Later the printed matter was photomechanically reproduced on the same plate as the illustrations, and the second cylinder was eliminated.

In the late 1920s there were more illustrated magazines in Germany than anywhere else in the world. By 1930 their combined circulation was five million copies per week, and, it is estimated, reached at least twenty million readers. But of more importance than the popularity of these magazines was the way that photographs and text were integrated into a new form of communication, which came to be called *photojournalism.*

The leaders in this new movement were the established *Berliner Illustrirte Zeitung* ("Berlin Illustrated Newspaper"), founded in 1890; the *Münchner Illustrierte Presse* ("Munich Illustrated Press"), founded in 1923; and *AIZ,* or *Arbeiter Illustrierte Zeitung* ("Work-

ers' Illustrated Newspaper"), founded in 1921. The new style was an active collaboration between the editors and the photographers. The new picture-taking possibilities opened by the introduction of miniature cameras fitted with high-speed lenses and loaded with fast film were taken advantage of to bring, as it were, the reader to the scene, rather than providing a visual report. Erich Salomon's striking "candid" photographs of diplomats were featured. Felix H. Man contributed a series of photographs of "A Day with Mussolini." Tim N. Gidal and his brother George took performance photographs at the premiere of the satirical musical play *Die Dreigroschen Oper* by Bertolt Brecht. André Kertész visited a Trappist monastery. Alfred Eisenstaedt covered the Ethiopian war. Of the picture editors, Stefan Lorant of the *Münchner Illustrierte Presse* appears to be the most effective, along with Karl Korff and Kurt Safranski of the *Berliner Illustrirte.* There was a friendly relation between photographer and editor. An idea would be presented by one of them and discussed in a general way. The photographer not only felt free to cover the situation as he thought appropriate, he was expected to do so. Upon delivery of the prints the editor took over. From his selection of the photographs he built a well-structured,

organic layout, with a large general view as an "establishment shot"—to use the language of the motion-picture editor—through details to a finale. Great care was taken with the captions, or cut lines: the words were chosen to explain or illuminate the photographs, not to repeat their content.

This great early period of European photojournalism utterly collapsed in 1933, when Hitler came to power. *AIZ,* avowedly Communist, published its last Berlin-datelined issue on February 19 and moved to Czechoslovakia. Both Safranski and Korff of the *Berliner Illustrirte* found refuge in America, where many of the photojournalists also sought asylum. Although the *Münchner Illlustrierte* was nonpolitical, Stefan Lorant was imprisoned. A Hungarian national, he was released and returned to Budapest. In 1934 he went to London, where he founded *Lilliput,* was editor of the *Weekly Illustrated,* and then in 1938 founded *Picture Post.* Although his tenure as editor of that weekly was short—he emigrated to the United States in 1940—his successors continued the lively style of picture reporting that had been developed in Germany, plus a more positive and aggressive left-wing political editorial policy. At the time when it was hoped that Neville Chamberlain had brought peace to the world, *Picture Post* recorded the horrifying extent of Hitler's atrocities. Its photographers —notably Kurt Hutton (Kurt Hübschmann), Felix H. Man, and Tim Gidal from Germany, Bert Hardy and Leonard McCombe—went anywhere: in the king's castle, to political meetings, to pubs, railroad stations, operating rooms, to bring back vivid pictures—all made with Leica cameras by available light, mostly unposed. Although the prints—and the reproductions of them—often lacked clarity and definition, they had great impact. Unfortunately the magazine met with financial reverses and in 1957 discontinued publication.

America soon adopted a photojournalistic style based on the German illustrated press and on the lively French picture magazine *Vu* ("Seen," founded in 1928), brilliantly edited by Lucien Vogel. Erich Salomon came to America in 1929: his visit was seminal, and many of his photographs appeared in Henry Luce's magazines, *Time* and *Fortune.* In 1934 Luce envisaged a new magazine to be the "Show Book of the World." Its purpose was stated in a prospectus:

To see life, to see the world, to eyewitness great events; to watch the faces of the poor and the gestures of the proud; to see strange things—machines, armies, multitudes, shadows in the jungle and on the moon; to see man's work—his paintings, towers, and discoveries; to see things a thousand miles away, things hidden behind walls and within rooms, things dangerous to come to; the women that men love and many children; to see and

take pleasure in seeing; to see and be amazed; to see and be instructed.

To accomplish this ideal, the editors proposed to replace the "haphazard" taking and publishing of pictures with the "mind-guided camera," and to "harness the main stream of optical consciousness of our time." The first issue of the new magazine, which was called *Life,* appeared on November 23, 1936. The cover was an industrial photograph by Margaret Bourke-White of the construction of a great dam near Fort Peck, Montana, in the style for which, as a photographer for *Fortune,* she was noted. The opening picture story, however, focused not on the construction, but on the life of the builders of the dam and their families in temporary cities in the desert. It was not what the editors had assigned, and they wrote, by way of introduction:

What the Editors expected—for use in some later issue— were construction pictures as only Bourke-White can take them. What the Editors got was a human document of frontier life which, to them at least, was a revelation.

Three other photographers were on the original staff: Alfred Eisenstaedt, from Germany; Peter Stackpole, a former member of Group $f/64$; and Thomas D. McAvoy. *Life* published two types of pictures: spot news photographs, supplied for the most part by news agencies, and feature stories, written and photographed on assignment by staff members.

Independently, and at the same time, the somewhat similar picture magazine *Look* was founded by Gardner Cowles and his brother John Cowles. The first issue was datelined January 1937. It relied more upon feature stories than on news coverage.

What distinguished *Life* and *Look* from earlier picture magazines was not so much the number of photographs they published but the theory of the "mind-guided camera." The typical picture essay is the cooperative work of editors and staff photographers. A story is decided upon, background research done, and a shooting script prepared to give the photographer as complete an understanding as possible of the type of pictures needed, their mood, and their purpose. Many more photographs are taken than will be used, for it is hardly possible to previsualize what the photographer will find. From the stack of prints delivered by the laboratory, the editors— usually without consulting the photographer—choose those they consider will best tell the story. A layout is planned, with blocks to be filled with words by writers.

This approach lends itself to forceful statements and to clear exposition. Unfortunately it also tends to over-emphasize the caption. John R. Whiting, in his *Photography is a Language,* made an illuminating experiment: he reprinted, in sequence and without the accompanying

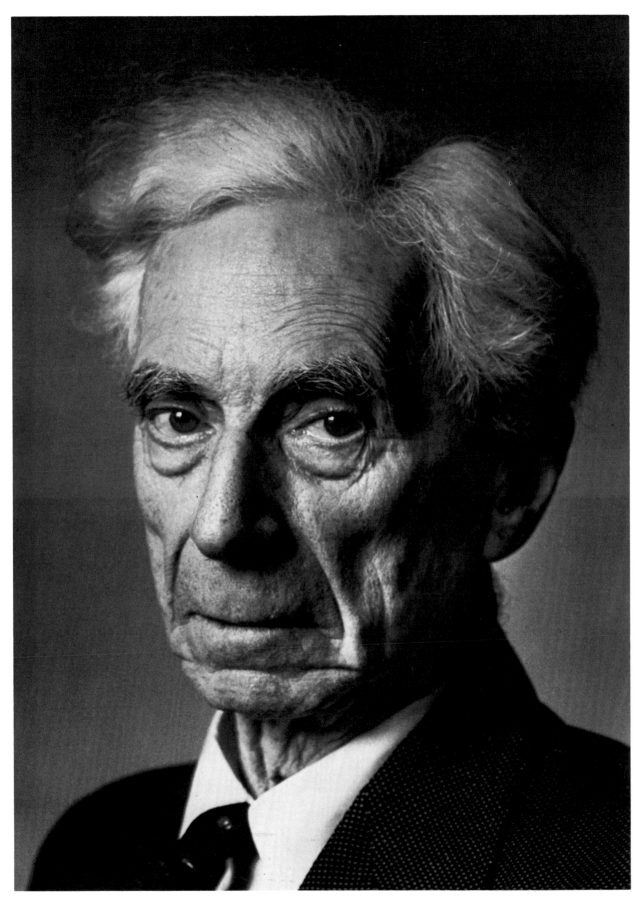

ALFRED EISENSTAEDT. *Bertrand Russell*. From *Life*, January 14, 1952. *Life* Magazine. © 1952 Time Inc.

BARON ADOLPHE DE MEYER. *A Wedding Dress, Modeled by Helen Lee Worthing.* 1920. Gelatin-silver print. Courtesy Condé-Nast, New York.

photographs, the captions of a typical *Life* picture essay. The result was a somewhat telegraphic, but completely coherent and readily grasped personality story to which the photographs were embellishments. Indeed, as Whiting states, "It is very often the caption you remember when you think you are telling someone about a picture in a magazine."[3]

Remarkable photographs have been made on magazine assignments. W. Eugene Smith, while a *Life* photographer, produced a series of photographs of life in a Spanish village that will be remembered long after the picture essay is forgotten. Seventeen pictures were published in the issue of April 9, 1951. *Life's* editors regretted that so few had been selected, and put out, for promotional purposes, a portfolio of full-page reproductions of eight of the pictures not used. They were presented without text, for their own sake and not as elements of a pictorial essay. Smith photographed the very atmosphere of the village and the very personality of its people. Yet the photographs, however particular, are universal, for he photographed the culture of the Mediterranean. It has been said that *The Thread Maker* is "at once a village woman at work and an image haunting and eternal as a drawing by Michelangelo of one of the Three Fates."[4]

Alfred Eisenstaedt produced a series of fine portraits of English notables that *Life* published in its January 14, 1952, issue. Unlike studio photographers, Eisenstaedt did not set up a battery of floodlights and spotlights and a bulky 8 x 10-inch tripod camera with an impressive focusing cloth. He did not apply makeup to models to mask Nature's deficiencies. Describing his experiences, he wrote, "My approach was not that of a photographer with a lot of equipment doing a job, but of a casual visitor, who incidentally brought a Leica, three lenses and a little tripod along.... The longest time I spent with each was 28 minutes."[5]

The most telling and dramatic photographs of World War II were made by magazine photographers or under their influence. *Life* ran a school for army photographers and sent its own photographers to the front: Eliot Elisofon was in North Africa; William Vandivert was in London during the Blitz and in India; Margaret Bourke-White was in Italy and Russia; Eugene Smith was in the Pacific where, at the cost of serious injury, he produced some of the finest war photographs; Robert Capa—who was to die in combat in Indo-China—covered the invasion and landed with paratroopers. Captain Edward Steichen, U.S.N.R., served as Director of Navy Combat Photography; under his command were many photographers who had received their training on magazine assignments.

The bitter and disastrous Korean War was photographed by David Douglas Duncan. He concentrated on the troops, with close-ups of biting intensity that revealed the battle against not only the enemy but the cold. These photographs he published in 1951 in *This is War!*, a picture book with a short introduction but no captions. He later joined *Life's* staff.

The Vietnam War was brought closer to civilians than any other conflict by courageous photographers and television cameramen. The horrors of war—the wounded, the dying, and the dead—had never been more graphically and more compassionately pictured, particularly in the color photographs taken by Larry Burrows, who spent nine years in the combat area, and lost his life when the airplane in which he was traveling was shot down over Laos in 1971.

For financial reasons *Look* ceased publication in 1972; the reason given was competition with television. *Life*, too, met with reverses and—except for occasional special issues—suspended publication in the same year. In 1978 publication was resumed on a monthly basis.

Fashion magazines were among the earliest to make regular editorial use of photographs. *Vogue* in 1913 began to publish photographs taken for them by Baron A. de Meyer; he founded a style in which the elegance of fashions is displayed with photographic feeling for textures. In 1923 Edward Steichen—who had taken fashion photographs both in black and white and color for *Art et Décoration* as early as 1911—joined the staff of Condé Nast. In addition to photographing fashions he produced a great quantity of portraits of celebrities, which appeared regularly in *Vogue* and in *Vanity Fair*. These photographs are brilliant and forceful; they form a pictorial biography of the men of letters, actors, artists, statesmen of the 1920s and 1930s, doing for that generation what Nadar did for the mid-nineteenth century intellectual world of Paris. Steichen's work is straightforward photography that relies for its effectiveness on the ability to grasp at once the moment when a face shows character, on the dramatic use of artificial lighting, and on a solid sense of design. He succeeded best with people of the theater. In *U.S. Camera Magazine* he showed how he photographed Paul Robeson as "Emperor Jones" by reproducing twenty-eight of the exposures made during one sitting. His account is revealing:

I have almost invariably found that the sitter acted as a mirror to my own point of view, so that the first step was to get up full steam on my own interest and working energy.... If everything moves swiftly and with enthusiasm, the model gains courage in the belief that he or she is doing well, and things begin to happen. The model and the photographer click together.... In photo-

EDWARD STEICHEN. *Lillian Gish as Ophelia.* 1936. Gelatin-silver print. The Museum of Modern Art, New York.

EDWARD STEICHEN. *Greta Garbo*. 1928. Gelatin-silver print. The Museum of Modern Art, New York.

EDWARD STEICHEN. *Paul Robeson in the Title Role of the Play "Emperor Jones."* 1933. Gelatin-silver print. The Museum of Modern Art, New York.

graphing an artist, such as Paul Robeson, the photographer is given exceptional material to work with. In other words, he can count on getting a great deal for nothing, but that does not go very far unless the photographer is alert, ready and able to take full advantage of such an opportunity.[6]

The most challenging portraiture of the past decades has been done on assignment, for magazines rather than for the sitter himself, his family, and his friends. The studio photographer, with his set lighting and standard backgrounds and props, depending for income solely on the sale of photographs printed by the dozen from heavily retouched negatives and enclosed in deckle-edged folders, is fast becoming obsolete.

Yousuf Karsh, trained in the Boston studio of John H. Garo, travels the world over to photograph great leaders and personalities. He carries a battery of studio lights with him, along with an 8 x 10-inch camera. He thus can convert any available room into a studio, where he can light his subjects in the classical way that is so distinctive of his style.

Another approach was taken by Sir Cecil Beaton, in which there is an emphasis upon the setting, often of an elaborate nature, specially built for the occasion. Beaton, who was a painter as well as a photographer, produced stage sets for theatrical productions, and this interest is reflected in his camera work. His friend the late photographer George Platt Lynes showed striking ingenuity in working out poses and new uses of materials to express the character of the sitter. Arnold Newman follows in this tradition: his portraits are distinguished by the way he has introduced into them objects symbolical of the profession or interest of the sitter. Philippe Halsman, Irving Penn, and Richard Avedon are concerned not only with interpreting the personality of the sitter, but in exploring those visual possibilities that will give the photograph that arresting and appealing quality so essential to the reproduction on the printed page.

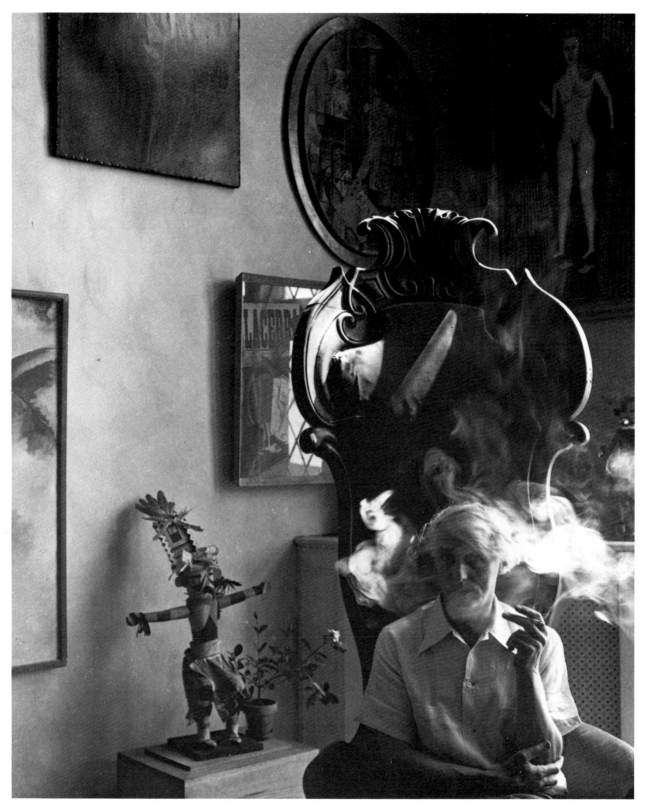

ARNOLD NEWMAN. *Max Ernst.* 1942. Gelatin-silver print. Courtesy of the photographer.

LOUIS DUCOS DU HAURON. *Angoulême, France.* 1877. Three-color carbon print. George Eastman House, Rochester, N.Y.

15 · IN COLOR

When Niépce described his photographic researches to his brother Claude, he said, "But I must succeed in fixing the colors," and when he visited Daguerre in 1827 he was especially interested in the latter's researches into this problem. He wrote enthusiastically to his son:

M. Daguerre has arrived at the point of registering on his chemical substance some of the colored rays of the prism; he has already reunited four and he is working on combining the other three in order to have the seven primary colors. But the difficulties which he encounters grow in proportion to the modification which this same substance must undergo in order to retain several colors at the same time.... After what he told me, he has little hope of succeeding and his researches can hardly have any other object than that of pure curiosity. My process seemed to him much preferable and more satisfactory, because of the results which I have obtained. He felt that it would be very interesting to him to procure views with the aid of a similar simple process which would also be easy and expeditious. He desired me to make some experiments with colored glasses in order to ascertain whether the impression produced on my substance would be the same as on his.[1]

Apparently Niépce had no better results than Daguerre, but the immediate acceptance of daguerreotypes in monochrome outweighed the fact that the colors were not recorded. It was not long, however, before the lack was sensed, and daguerreotypists began to color their plates by hand. This was accomplished by carefully dusting on the surface dry powdered pigment. The use of moist watercolors was not advised, for fear of obscuring image detail—except with gold or silver, so essential for adding realism to jewelry. With the advent of paper prints, a far bolder approach was taken: many a photographic image disappeared beneath the thick impasto laid over it by ambitious artists. Indeed, few were the studios that could not boast a resident artist. For the public demanded color. John Towler wrote in *Humphrey's Journal of Photography* of the value and the problems of satisfying this need:

As soon as the operation of drying is finished, the picture is ready to pass into the hands of an artist, in order to receive the touch of his magic pencil.... Parts before gray and indefinite in character, assume shades distinct and agreeable; besides this, he works in a slight shade on the cheeks which communicate a lifelike brilliancy to the picture which before it did not possess; in fact, it gives a roundness to the features which before were flat and death-like.... Good taste, however, eschews much color; a vulgar taste seeks gratification of strong contrasts, and hence of colors; for such a taste you will have to *gild* buttons, ear-rings, breast pins and watch-charms; for such you will have to *paste* on color to obscure every other shade beneath; for such, unfortunately, the artistic photographer has frequently to cast his pearls before swine; his bread, however, is the gain; and it is the part of a *business man* at least to sacrifice all preconceived notions to the desires of his customers.[2]

In the later decades of the nineteenth century enlargements of portrait negatives were frequently made on photosensitized canvas specifically for the use of the artist. One supplier boasted that the emulsions on their prepared canvases were "so thin that they in no way interfere with the very threads of the canvas, nor in the least take away from the beautiful receiving properties of the prepared oil-ground."[3] Thus the origin of the painted portrait was completely disguised.

The first attempts to produce color automatically, by photographic means, was a search for a substance which, chameleonlike, would assume whatever color was shining upon it.

In 1850 Levi L. Hill, a Baptist minister and professional daguerreotypist of Westkill, New York, announced in the public press that he had succeeded in fixing the colors of nature on daguerreotype plates. He showed examples of his work to leading American daguerreotypists. The editor of the *Daguerreian Journal* was so impressed that he said "Could Raphael have looked upon a *Hillotype* just before completing his Transfiguration, the palette and brush would have fallen from his hand, and his picture would have remained *unfinished*."[4]

The profession demanded to know the technique. They were prepared to pay roundly for the secret, but Hill fended them off by saying that "$100,000 would not purchase my discovery," and declaring that he would publish his results "when I think proper." Months went by, and not a word from Hill. In a pamphlet dated 1852

Photographer unknown. *Girl on Chair*. ca. 1850. Hand-colored albumen copy print of a daguerreotype. Collection Beaumont Newhall, Santa Fe.

WARREN THOMPSON. *The Painter.* ca. 1850. Stereoscopic daguerreotype, hand tinted. George Eastman House, Rochester, N.Y.

LOUIS DUCOS DU HAURON. *Leaves.* 1869. Three-color carbon print. Société Française de Photographie, Paris.

and addressed "To the Daguerreotypists of the United States and the Public at Large," Hill stated that the invention was all that he had claimed for it, but that he was faced with difficulties beyond his control in perfecting it, by "the invisible goblins of a new photogenic process." The profession became impatient, for their business had been hurt by Hill's premature announcement. They denounced him in the press as a humbug and as an impostor. He finally published in 1856 his *Treatise on Heliochromy,*[5] a confused and complicated piece of writing, which contained, in place of specific workable directions, an autobiography and an account of endless experiments.

That Hill achieved some kind of result cannot be doubted; the evidence of daguerreotypists, and particularly of so notable an artist and scientist as Samuel F. B. Morse, is too convincing to be dismissed. More than once daguerreotypists had, by accident, found colors upon their plates; Niépce de Saint-Victor, nephew of the inventor, in 1851 secured colored daguerreotypes by sensitizing silver plates with chlorides. They received acclaim in their day, but unfortunately, could not be made permanent. Only a few examples, carefully kept in darkness over the years, exist. Hill had perhaps stumbled upon the same path which these other experimenters had struck out on, but we can form no more definite conclusion about his work than what was written about him after his death in 1865: "He always affirmed that he *did* take pictures in their natural colors, but it was done by an *accidental* combination of chemicals which he could not, for the life of him, again produce!"[6]

The search for a direct color-sensitive medium continued. In 1891 Gabriel Lippmann, professor of physics at the Sorbonne, perfected his interference process, which relied upon the phenomenon that a thin film, such as oil upon water, will produce all the colors of the rainbow. The results were startling. Steichen in 1908 wrote Stieglitz:

Professor Lippmann has shown me slides of still-life subjects by projection, that were as perfect in color as in an ordinary glass-positive in the rendering of the image in monochrome. The rendering of white tones was astonishing, and a slide made by one of the Lumière brothers, at a time when they were trying to make the process commercially possible, a slide of a girl in a plaid dress on a brilliant sunlit lawn, was simply dazzling, and one would have to go to a good Renoir to find its equal in color luminosity.[7]

Unfortunately the Lippmann process was not a practical technique, and is now obsolete.

The practical solution of photography in color was found in an indirect approach. The British physicist James Clerk Maxwell performed a dramatic experiment at the Royal Institution of London in 1861. To prove that any color can be recreated by mixing red, green, and blue light in varying proportions, he projected three lantern slides of a tartan ribbon upon a screen. In front of each projector was a glass cell filled with colored solution: one was red, a second, blue and a third, green. Each slide had been made from a negative that Thomas Sutton had taken through the identical glass cells or filters; each was theoretically a record of the red, blue, and green rays reflected by the ribbon. The result was a color photograph—crude, but prophetic of the future.

Because Clerk Maxwell *added* red, green, and blue light together, this technique is called *additive.* An equal addition of the three colors forms white; red and green add to form yellow; red and blue, magenta; green and blue, the blue-green known by photographers as cyan. It is important to bear in mind that this theory holds true only for colored *light;* the mixture of pigments is another matter.

The iodized collodion emulsion Sutton used was not sensitive to red rays, and it long puzzled scientists how he got any result. On the occasion of the centenary of Clerk Maxwell's classic experiment, Ralph Evans, a Kodak research scientist, proposed an ingenious explanation, which he proved by recreating the experiment. The red dyes used by ribbon-makers of the day not only reflected red rays but also fluoresced, and it was this fluorescence that Sutton obtained as his "red" record. When panchromatic emulsion was perfected, Clerk Maxwell's system was put to practice with success. It is inconvenient to set up three magic lanterns whenever a color photograph is to be looked at. A portable apparatus, the *Kromskop,* was devised in 1892 by Frederic E. Ives of Philadelphia, which optically reunited three stereoscopic transparencies so they could be viewed in register. Each transparency was illuminated through a filter of the appropriate primary color: red, green, blue. The result was a brilliant color photograph in three dimensions, of startling realism.

But looking through the eyepiece of an instrument, or at a screen in a darkened room, was not like looking at a hand-held photograph. The first practical method of making by the additive process a single picture to be viewed without any apparatus was invented in 1893 by John Joly of Dublin. Instead of taking three separate pictures through three colored filters, he took one negative through a screen checkered with microscopic areas of red, green, and blue. The screen was the exact size of the photographic plate and was placed in contact with it in the camera. After the plate had been developed, a transparency was made from it and bound permanently to the color screen. The black, gray, and white areas of the

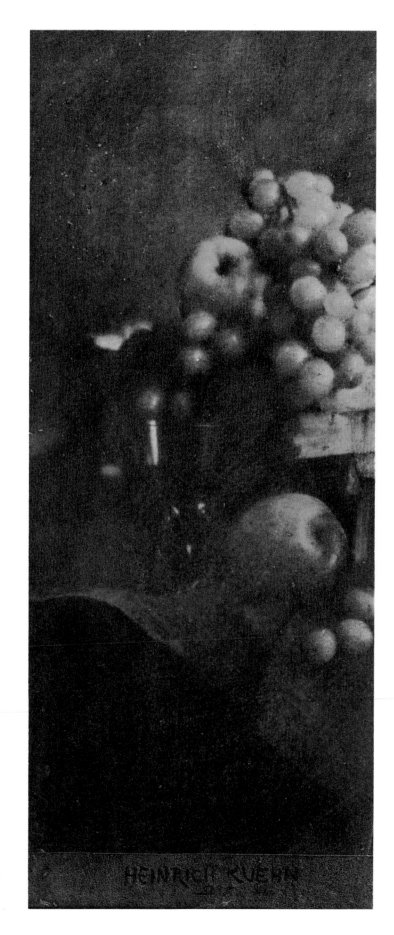

HEINRICH KÜHN. *Still Life.* 1904. Three-color
gum-bichromate print. Preus Fotomuseum,
Horten, Norway.

EDUARD J. STEICHEN. *Alfred Stieglitz.* 1907. Autochrome. The Museum of Modern Art, New York.

EDUARD J. STEICHEN. *Gertrude Käsebier.* 1907. Autochrome. The Museum of Modern Art, New York.

picture allowed more or less light to shine through the filters; viewed from a normal reading distance the primary colors so modulated blended to form combinations reproducing the colors of the original scene. In 1903 the same principle was used by the brothers Lumière in their *autochromes,* which were put on the market in 1907. The photographic plate itself was covered with minute grains of starch that had been dyed. One third were orange, one third green, and one third violet, and they were mixed together so that the three primary colors were evenly distributed over the surface of the plate, which was then coated with emulsion. Exposure was made through the back of the plate. After development the negative was turned into a positive by the reversal process, and a transparency resulted that reproduced the original colors. Steichen was privileged to obtain a supply of the new Lumière color plates before they were put on the market. As a result the first public exhibition in the United States of autochromes by Steichen, Frank Eugene, and Steiglitz, was held at the Little Galleries of the Photo-Secession in New York during November 1907. Manufacture of the plates was discontinued in 1932. *Dufaycolor, Agfacolor,* and the Lumières' *Filmcolor* and *Alticolor* combined these two techniques: film base was ruled to form a multiple filter somewhat similar to the Joly screen, and the image was reserved as in the autochrome process.

These methods have given way to techniques based on the *subtractive* theory. A black object absorbs, or subtracts, all of the light falling upon it; nothing is reflected to the eye, and hence it looks black. A white object reflects all of the light rays falling upon it. If white light shines upon it, white light is reflected; if red alone shines upon it, red is reflected. A colored object, however, absorbs, or subtracts, some of the rays and reflects others. When white light falls upon a red object, the red rays are reflected, while the blue and green are subtracted. But when red light falls upon a cyan object there are no blue or green rays to be reflected and the red rays are entirely subtracted. No light reaches the eye, and the object appears black.

Transparencies printed from negatives taken through red, blue, and green filters will, if tinted in the respective complementary colors (cyan, yellow, and magenta), superimposed in register, and held against light, reproduce all the natural colors in the scene that was in front of the photographer's camera.

By one of the strangest coincidences in the history of photography, this subtractive technique was announced simultaneously in 1869 by two Frenchmen, Louis Ducos du Hauron and Charles Cros. Neither knew the other; both sent communications to the Société Française de Photographie at the same time; the secretary described their almost identical techniques at the meeting of May 7, 1869, and showed examples submitted by Ducos du Hauron. What is even more extraordinary, the two inventors, instead of disputing priority, became friends. Cros, who was a friend of the Impressionists and more interested in the theory of color than in working out a practical photographic technique, did not pursue his invention, but Ducos du Hauron began extensive research. As soon as Vogel had shown how photographic emulsions could be sensitized to all colors he perfected his technique, and was able to make quite acceptable prints by the carbon process in 1877.

Many variations of this basic principle have been devised. Separate black-and-white prints can be made from each of the three color-separation negatives, as they are called, and the developed emulsions converted to images formed of cyan, magenta, and yellow pigments respectively. Heinrich Kühn, the Austrian master of the gumbichromate process, produced memorable still lifes by multiple printing in the 1890s. An alternate technique is the *carbro* process: black-and-white prints are made conventionally from each separation negative. After development, the gelatin emulsion is stripped from each print, dyed cyan, magenta, and yellow, and superimposed on a fresh paper support.

Another method of superimposing the three images is by *dye transfer.* In this process a gelatin matrix is prepared that will absorb dye in proportion to the lights and shadows, and that will yield up this colored image when pressed in contact with paper.

These techniques require three separate negatives. Where the subject is stationary, the exposures can easily be made in succession, but in photographing moving objects they must be made simultaneously. "One-shot" cameras have been devised, fitted with half-silvered mirrors, which will allow this to be done. But this apparatus is cumbersome and inefficient.

The greatest improvement in the history of color photography came with the perfection of film coated with three layers of emulsion that could be used in any camera, and required merely a single exposure for each picture. Available in 1935 for 16mm motion picture cameras and in 1937 for 35mm still cameras, this *Kodachrome* film was the invention of Leopold Mannes and Leopold Godowsky, working in collaboration with research scientists at the Eastman Kodak Company. The process is based on the 1912 invention of dye-coupling development by Rudolf Fischer of Berlin.

The top emulsion of Kodachrome film is sensitive to blue light only. Beneath it is a layer of yellow dye that absorbs the recorded blue rays, but allows the red and

PAUL OUTERBRIDGE. *Avocados.* 1936. Carbro print. The Museum of Modern Art, New York.

green rays to penetrate to the two emulsions beneath it, one of which is sensitive to green rays only, and the other to red. Thus, upon exposure a simultaneous record, in latent image form, is obtained of the three primary colors in the scene. The film is first developed to a negative and then, by reversal processing, to a positive. During the second development dyes of the complementary colors of yellow, cyan, and magenta are formed in the appropriate areas, and the silver is bleached away. At first the processing required complex machinery and precise control and, consequently, was done exclusively by the manufacturer. To answer the demand for a film the photographer could process himself, Ansco brought out in 1942 its *Ansco-Color* film, which was followed by Kodak's *Ektachrome* film; in both of these dye-couplers were incorporated into the separate emulsions.

These techniques have the same limitation as the daguerreotype and the tintype: each color photograph is unique. The negative-positive principle was utilized in *Kodacolor* film (1941), which is similar in general principle to Kodachrome film, except that the image is not reversed to a positive. Dye-coupling development directly converts each emulsion to an image complementary to the color it records. Thus a color negative shows not only reversal of the lights and shades, but also of color. A blond will appear with blue hair and green lips. From this negative any number of prints can be made by repeating the process with identical triple emulsion coated on a white base.

Using *Ektacolor* film, announced by the Eastman Kodak Company in 1947, the photographer can process his own color negatives. An important feature of this color process is the incorporation into the film of a mask that automatically compensates for inaccuracies in color rendition. Theoretically it should be possible to choose dyes that will completely absorb each of the primary colors. In practice this cannot be done. To correct these errors, the dye couplers added to the emulsion are themselves colored, absorbing the very rays that are incorrectly absorbed by the dyes. From the Ektacolor negative three gelatin matrices can be made directly for printing by dye transfer; or prints can be made on color-positive material.

For reproduction on the printed page, transparencies are rephotographed by normal means and through the primary filters: from each negative a printing plate is made, usually by the halftone process. The paper is run through the press four times, with cyan, yellow, magenta, and black inks—as printers say, "in four colors."

The greatest users of color film are amateurs: today

EDWARD WESTON. *Waterfront.* 1946. Kodachrome transparency. George Eastman House, Rochester, N.Y.

almost all snapshots are in color. To the commercial photographer color has long been indispensable in meeting the requirements of advertisers. Magazines are using more and more color editorially. Newspapers are overcoming the great technical difficulties of printing color on newsprint in high speed presses. And today an increasing number of creative photographers have chosen color as a means of personal expression, favored above other media.

In the tradition of straight photography, Eliot Porter, whose sensitive black-and-white photographs were shown by Stieglitz at An American Place in 1938—has brilliantly photographed the natural scene. Porter makes his own prints from color transparencies, and can thus control his final image. Ernst Haas has chosen to depart from the naturalistic. By deliberately double-exposing the film, by moving the camera while the lens is open, by choosing abnormal exposures, he produces images that are often of great intrinsic value. Eliot Elisofon, the *Life* photographer, experimented with the use of colored filters over the lens or light source. He was consultant to Hollywood in the distortion of color for emotional effect, as in the motion picture *Moulin Rouge.*

The color photographer is faced with many aesthetic problems. The dye does not see color the way the camera does. Should he choose the naturalistic approach and, as P. H. Emerson did in black and white, limit himself to producing what the eye sees? Or should he follow the camera's lead, exploiting its potentials and respecting its limits? There seem to be colors that exist only in photographs: Kodachrome film, for example, gives blue of a richness and depth that can validly be used for its own sake with no attempt at realism. Work has been done in every field with color; practically every photographer has worked with the new techniques; and although the complexity of processing and the expense of materials has been a deterrent to free experimentation, the aesthetic capabilities are being explored.

The temptation is to choose subjects that are themselves a blaze of color, and to ignore the fact that color is everywhere and that it is not the colorful subject itself but the photographer's handling of it, that is creative. The most satisfying results appear to be of subjects that are basically of subdued colors, with here and there a brilliant, telling accent.

The line between the photographer and the painter is no more clearly drawn than in color photography. Imitation is fatal. By the nature of his medium, the photographer's vision must be rooted in reality; if he attempts to create his own world of color he faces a double dilemma: his results no longer have that unique quality we can only define as "photographic," and he quickly discovers that with only three primary colors, modulated in intensity by three emulsions obeying sensitometric laws, he cannot hope to rival the painter with the range of pigments he can place on his canvas at will. On the other hand the painter cannot hope to rival the accuracy, detail, and above all the authenticity of the photograph. The aesthetic problem is to define that which is essentially *photographic* in color photography, to learn what is unique about the process, and to use it to produce pictures that cannot otherwise be obtained. Edward Weston clearly stated the problem, writing about the work he did in 1947:

So many photographs—and paintings, too, for that matter—are just tinted black-and-whites. The prejudice many photographers have against color photography comes from not thinking of *color as form.*[8]

Weston came to color late in his career, and produced a relatively small body of work. His photograph *Waterfront,* 1946, embodies his aesthetic theory of color as form. In viewing the picture we are not concerned with the information that it displays, but our eye delights in the play and contrast of the brilliant color fields of red, blue, and yellow. Note, too, that the customary depth of field so present in Weston's black-and-white work has given way to an emphasis on a flat plane. Highly criticized as blatant when first published, the picture points to current styles in color photography.

JERRY UELSMANN. *Symbolic Mutation.* 1961. Combination print. The Museum of Modern Art, New York.

16 · NEW DIRECTIONS

Since 1945 great technical advances have been made in photographic technology. The sensitivity of film has been increased; exposure problems have been simplified by the introduction of photoelectric meters that not only measure the light, but when built into cameras can automatically set shutter times or lens apertures. The most innovative contribution was the invention by Edwin H. Land in 1947 of the Polaroid-Land process that uses a specially-designed camera to produce a finished print (or, if desired, a negative) in a matter of seconds.[1] These technological improvements are based on the now century-old gelatin-silver halide system.

Although there has been little change in the working methods of the creative photographer, there have been significant changes in attitudes toward photography as an art form. To some the camera is a means of self-expression, and the burden of interpreting the intended yet hidden inner meaning of the photograph is placed on the viewer. To others the tenets of straight photography, which are based on the technical limitations of the process, are restrictive and intolerable. The concept of pre-visualization precludes the possibility of altering the camera image after exposure. Concern with subject matter is paramount in much recent work that stresses the banal, the commonplace, and even the abnormal. The creation of situations and environments specifically for the camera to record has become popular. Painters as well as photographers are exploring the mix of the media. Many photographers feel that both the negative and the print are but a means to an end; not considering them sacrosant, they do not hesitate to alter them with hand work. The so-called "control" processes of printing that were rendered obsolete during the reign of the purist aesthetic have now been revived: gum-bichromate, brom-oil, cyanotype.

As in all the visual arts, the past three decades have seen a succession of styles: vigorous experimentation, veneration of certain traditions of the past mingled with iconoclasm, and a search for meaning in a new vision of the world.

The tradition of straight photography is clearly seen in the meticulous work of Minor White. His photographic style was formed during his long association with Stieglitz, Weston, and Adams. A master technician, he made photographs that possess great beauty. Highly influenced by frequent, long conversations with Stieglitz, White explored that master's theory of the equivalent as a medium for expressing or translating into visual form the supersensual. He defined the photograph as a mirage and the camera as a metamorphosing machine:

To get from the tangible to the intangible (which mature artists in any medium claim as part of their task) a paradox of some kind has frequently been helpful. For the photographer to free himself of the tyranny of the visual facts upon which he is utterly dependent, a paradox is the only possible tool. And the talisman paradox for unique photography is to work "the mirror with a memory" as if it were a mirage, and the camera a metamorphosing machine, and the photograph as if it were a metaphor. . . . Once freed of the tyranny of surfaces and textures, substance and form [the photographer] can use the same to pursue poetic truth.[2]

By this definition, then, White's goal was to make photographs that extend beyond the subject. Surface appearance, although of secondary importance, is essential, but the image must be transformed into a new event, to be discovered by the *viewer*. Finding the inner meaning intended by the photographer is not easy. Of the photograph *The Three Thirds* White wrote:

Identification of subject can be so offhand that a title is required to suggest that further experience of the picture is worth the effort. The photograph *The Three Thirds* needs such a title because the picture is not informative; it is meaningful only if the subject is treated as a kind of peg upon which to hang, in this case, self-contained symbols: reading left to right, clouds in window—youth, plaster under clapboards—middle years, broken glass —old age. What caprice of chance brought the photographer to this point exactly at the time when the continuity of birth, living and death were uppermost in his mind and when he secretly hoped to materialize his feelings that each of the three was a third of experience? Was it his need that caused the metamorphosis?[3]

MINOR WHITE. *Pacific.* 1948. Gelatin-silver print. The Museum of Modern Art, New York. Courtesy of The Minor White Archives, Princeton University, Princeton, N.J.

White cultivated the acceptance of the accidental: his essay "Found Photography" is a profound description not only of his approach, but of his spiritual process.[4]

The photograph as metaphor can be found throughout photography. In the early days of the motion picture the visual photographic metaphor was common: D. W. Griffith's *Intolerance* (1916), in which the theme is unfolded by four disparate sequences of images that are suddenly intermingled in a wholly realistic yet utterly nonliteral way, is an example. Erich von Stroheim's *Greed* (1924) carries symbolism almost to an excess; the camera lingers on everything gold (actually tinted in gold on the release print); a caged canary, freed at the hero's death, symbolizes his soul. The Russians, especially Sergei Eisenstein and Vsevolod I. Pudovkin, not only showed again and again the power of the visual metaphor in their films, but also wrote extensively about it.

Photographs have been combined with the printed word, not as literal illustrations, but to reinforce one another so that new meanings can be read in each. Thus in the book *Time in New England*, an anthology of New England writings with Paul Strand's photographs, Nancy Newhall put a photograph of a blasted tree with an account of witchcraft, a stern detail of rock with eyewitness accounts of the Boston Massacre, the spire of a meeting house with a statement on abolition, an infinite seascape with the chronicle of the loss of a ship at sea. In the 1955 exhibition *The Family of Man* at The Museum of Modern Art, and in the book made from it, Edward Steichen not only juxtaposed photographs of family life the world over, but also used photographs as metaphors: the great *Mount Williamson* of Ansel Adams expressed the creation of earth; a photograph by Wynn Bullock of a child asleep in a forest glade, the creation of man.

To Aaron Siskind the challenge of straight photography lies in the transformation of everyday subject matter into autonomous abstract compositions. He expresses the beauty of the outward, indeed obvious, surface of things, which he isolates for our contemplation. As he

MINOR WHITE. *The Three Thirds.* 1957. Gelatin-silver print. Collection Beaumont Newhall, Santa Fe. Courtesy of The Minor White Archives, Princeton, N.J.

has stated, his concern is with

a concentration of the world within the frame of the picture. For my material I have gone to the "commonplace," the "neglected," the "insignificant"—the walls, the pavements, the iron work of New York City, the endless items once used and now discarded by people, the concrete walls of Chicago and the deep subways of New York on which water and weather have left their mark—the detritus of our world which I am combing for meaning. In this work fidelity to the object and to my instrument, the clearseeing lens, is unrelenting; transformation into an esthetic object is achieved in the act of seeing, and not by manipulation.[5]

The result is a distinctive style. Siskind emphasizes the linear. Edges are sharp, contrasts are great. Everything seems on a single plane, with little depth. Often the image is ambiguous, creating in the beholder a tension between what is obvious and what is a fresh, visual discovery. When The Museum of Modern Art showed his work in 1946 one reviewer wrote: "The relation of photography to abstract art is close and challenging. . . .

Siskind's isolation and organization within a rectangle of such apparently ungrateful subjects as a shingle or marked-up tar paper is a close one. Siskind's remark, 'I regard the picture as a new object to be contemplated for its own meaning and its own beauty,' is a point of view seldom expressed by photographers. . . ."[6]

Harry Callahan's work is of great lyric beauty and reveals an acceptance of the world around us. His vision is precise: he can make a blade of grass or a single electric power line fill the frame. He has experimented with double exposure. Of particular power are his photographs of pedestrians on sidewalks in strong raking light.

Frederick Sommer, after a period as a landscape architect and city planner, met Alfred Stieglitz and became absorbed by photography as a medium of expression. In 1935 he met Edward Weston, "whose decisive use of the tonal scale had given his photographs a new impact to art," Sommer wrote.[7] He soon began to work with the 8 x 10-inch camera, making portraits, fragmentations, animal carcasses and skeletons, vast landscapes of the Ari-

AARON SISKIND. *Symbols in Landscape.* 1944. Gelatin-silver print. Courtesy of the photographer.

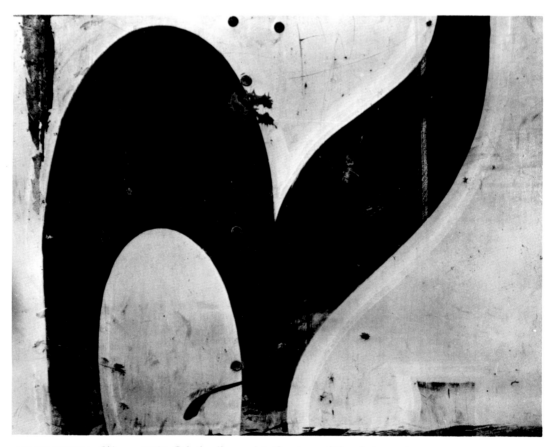

AARON SISKIND. *Chicago.* 1949. Gelatin-silver print. Courtesy of the photographer.

HARRY CALLAHAN. *Multiple Exposure, Chicago.* 1956. Gelatin-silver print. The Museum of Modern Art, New York.

FREDERICK SOMMER. *Max Ernst.* 1946. Gelatin-silver print. The Museum of Modern Art, New York.

"Max Ernst, a great artist, whose vision has that angelic restlessness of Solomon, frightening to the facile partisans of thought or of instinct." —Frederick Sommer, *Aperture*, vol. 10, no. 4 (1964)

PAUL CAPONIGRO. *Ardava Dolmen, Donegal, Ireland.* 1967. Gelatin-silver print. The Museum of Modern Art, New York.

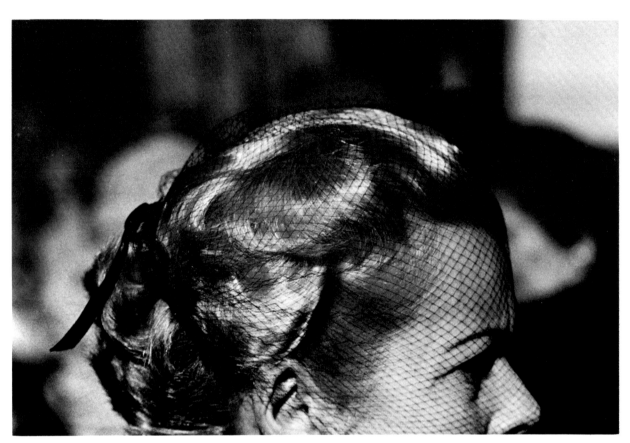

HARRY CALLAHAN. *Chicago*. 1950. Gelatin-silver print. The Museum of Modern Art, New York.

ROBERT FRANK. *Parade, Hoboken, New Jersey.* 1955. Gelatin-silver print. The Museum of Modern Art, New York.

zona desert, and compelling double exposures and montages. He has long had a great interest in Surrealism, particularly as expressed in the art of his friend Max Ernst.

Paul Caponigro, who was highly influenced at the start of his photographic career by Minor White, has found his subjects in landscape and, in recent years, the megalithic monuments of northern Europe. These immense stones were erected for religious purposes in the distant, unrecorded past; Caponigro's photographs of their awesome forms capture their spiritual significance.

While the work of these photographers is basically within the tenets of the straight photography aesthetic, others have reacted to this classical convention that rejects any aftertreatment of the negative or positive image as seen at the moment of exposure. Making combination prints from several negatives is the special interest of Jerry Uelsmann, who has refined this technique to the point of virtuosity. Unlike the nineteenth-century pioneers in this technique, Uelsmann combines disparate images to produce strange, often disquieting and ambivalent compositions, such as the face/fist in *Symbolic Mutations*. Significantly, he calls his approach to photography "post-visualization."

From a background of highly successful photojournalism, Swiss-born Robert Frank, frustrated by the pressure of magazine assignments, applied successfully for a John Simon Guggenheim Memorial Fellowship, and in 1955 made a photographic tour of the United States. Using a 35mm camera, he photographed the American scene in its most popular aspects: outings, parades, automobiles, filling stations, billboards, roadside bars, the lonely desert highway. A leitmotif in his work is the presence of the American flag—decorating the reviewing stand of a civic parade, draped on buildings, hanging in broad splendor over a Fourth of July picnic ground. His images are restless; in their loose structural organization they often represent moments snatched in a seemingly casual fashion. They are in contrast to the balanced and elegant photographs of Cartier-Bresson, of whom he is reported to have said, "You never felt he was moved by something that was happening other than the beauty of it, or just the composition."[8] For Frank had no interest in beauty, but rather in stark realism, however unpleasant or common. Walker Evans wrote of Frank's work:

That Frank has responded to America with many tears, some hope, and his own brand of fascination, you can see in looking over . . . his pictures of people, of roadside landscapes and urban cauldrons and of semi-living, i.e. semi-satanic children. He shows a high irony towards a nation that generally speaking has it not. . . .[9]

Frank's photographs were published in Paris as *Les*

288

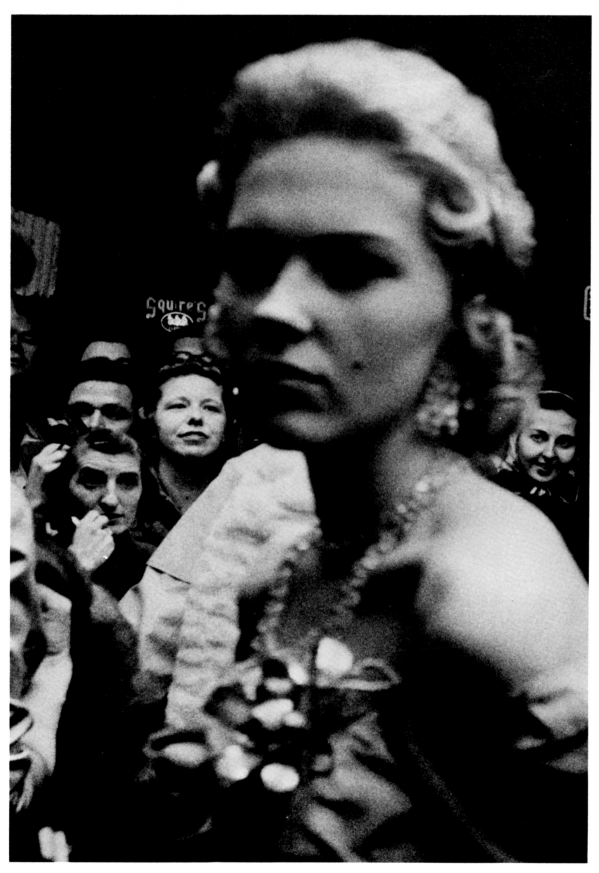

ROBERT FRANK. *Movie Premiere, Hollywood.* ca. 1955. Gelatin-silver print. The Museum of Modern Art, New York.

DIANE ARBUS. *Identical Twins, Roselle, N.J.* 1966. Gelatin-silver print. The Museum of Modern Art, New York.

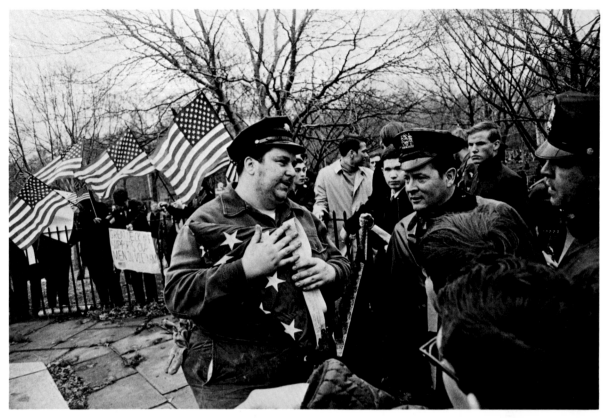

GARRY WINOGRAND. *Peace Demonstration, Central Park, New York.* 1970. Gelatin-silver print. The Museum of Modern Art, New York.

LEE FRIEDLANDER. *New York City.* 1964. Gelatin-silver print. The Museum of Modern Art, New York.

DUANE MICHALS. *Death Comes to the Old Lady.* 1969. Gelatin-silver prints. The Museum of Modern Art, New York.

Américains (1958).[10] On the appearance of the American edition in the following year, critics were almost unanimously negative: it seemed to them that Frank had deliberately chosen the sordid, the neglected, and the forlorn to represent this country. But to a younger generation the pictures spoke strongly. Lee Friedlander's photographs of city scenes and civic monuments and Garry Winogrand's seemingly haphazard street scenes and flash photographs of public functions demonstrate a use of the camera in which the image seems boundless, not contained within the rectangle of the frame, but stretching beyond it. Winogrand is reluctant to talk about his work, but his oft-quoted remark, "I photograph to see what the photograph will look like,"[11] though seemingly simplistic, is an expression of disregard, perhaps distrust, of the concept of previsualization. To him—and to many other contemporary photographers—the magic of photography is its all-seeing eye, capable of capturing more than the human eye can possibly observe in that mere fraction of a second when the shutter is open and allows the film to absorb the fleeting image. In this sense the camera is more than an instrument to record an image already seen in all its details: it is a tool for sharpening our vision.

Concern for subject matter led Diane Arbus to photograph with alarming frankness people on the fringes of "normal" society: giants and dwarfs, transvestites, nudists. She showed, with compassion, the normality of the seemingly abnormal, using her camera with direct simplicity.

Much recent work is basically illustration, related more to the dramatic arts than to the inherent qualities of the photographic medium, which serves merely as the recorder. Thus Duane Michals, in the spirit of the motion picture, produced such narrative sequences as *Death Comes to the Old Lady.*

In the past few decades there has been considerable experimentation in combining the photographic process with other media, especially painting and drawing. In contrast to the master photographs taken by such recognized painters as Man Ray, Moholy-Nagy, and Charles Sheeler, who kept work done by the camera and that done by the brush strictly separate, today's practitioners of mixed media so intertwine the media that the results seem to me to have little to do with photography, and lie outside the scope of this survey.

Color photography as a creative medium, after long neglect by all but a few master photographers, now enjoys increased popularity. Working in the tradition of Eliot Porter and Edward Weston, such contemporaries as William Eggleston, Stephen Shore, and Joel Meyerowitz delight in the brilliant hues that can be rendered by present-

RICHARD AVEDON. *Ezra Pound.* 1958. Gelatin-silver print. The Museum of Modern Art, New York.

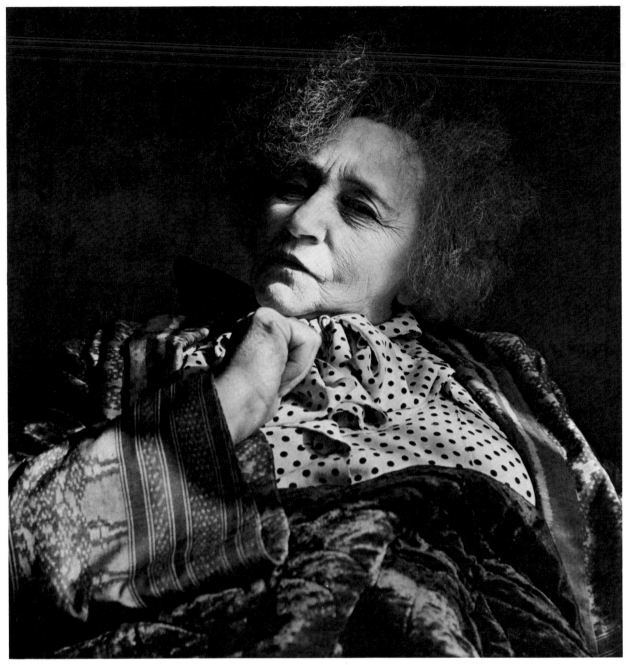

IRVING PENN. *Colette.* 1951. Gelatin-silver print. The Museum of Modern Art, New York.

day color materials, bringing us a world transformed.

Everywhere progress is being made in the acceptance of photography as a valid and needful art form. The formation of a Department of Photography at The Museum of Modern Art in 1940; the founding of the International Museum of Photography at the George Eastman House in Rochester in 1949; the scheduling of major photographic exhibitions by leading art museums in Europe and America; the growing interest in photography on the part of individuals as well as institutions; the inclusion of courses in the photographic arts by universities and art schools are all steps toward the ultimate unquestioned acceptance of the potentials of the camera.

More and more people are turning to photography as a medium of expression as well as of communication. The leavening of aesthetic approaches that we have noted continues. While it is too soon to define the characteristics of the photographic style of today, one common denominator, rooted in tradition, seems in the ascendancy: the direct use of the camera for what it can do best, and that is the revelation, interpretation, and discovery of the world of man and nature. The present challenge to the photographer is to express inner significance through outward form.

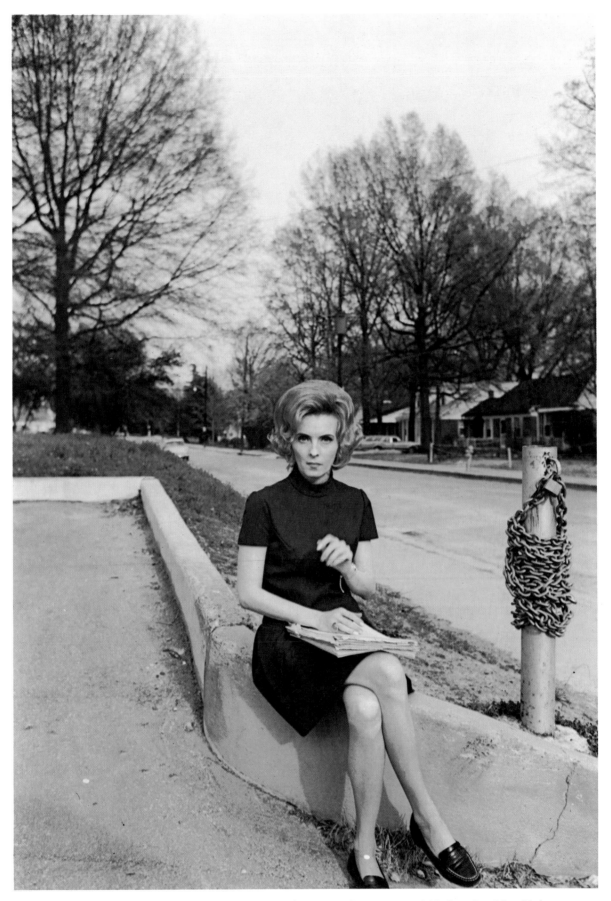

WILLIAM EGGLESTON. *Memphis.* ca. 1969-70. Dye transfer print. The Museum of Modern Art, New York.

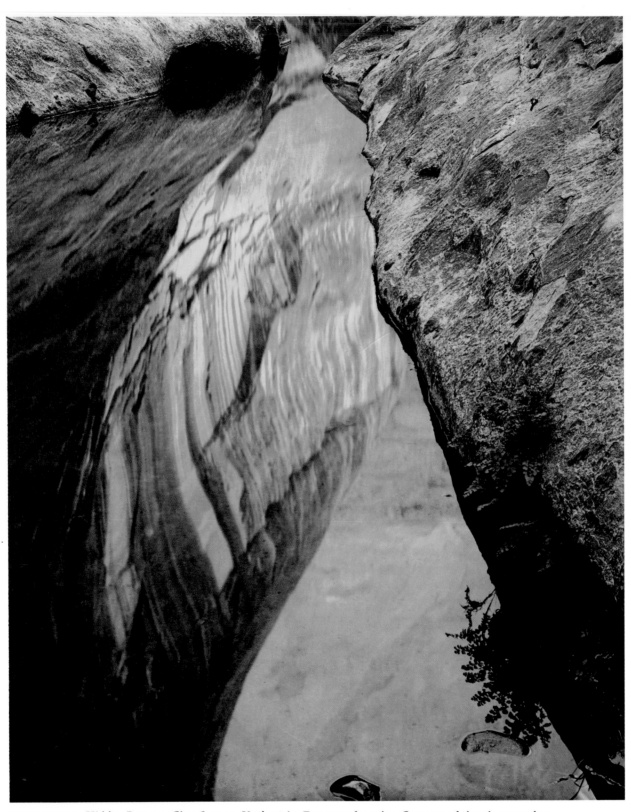

ELIOT PORTER. *Hidden Passage, Glen Canyon, Utah.* 1961. Dye transfer print. Courtesy of the photographer.

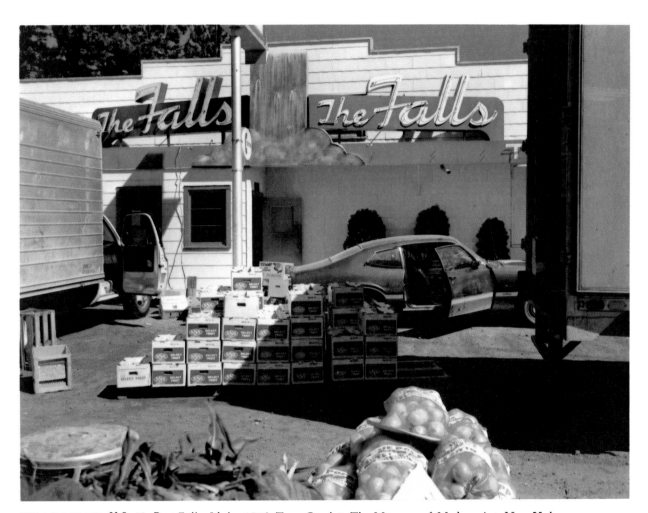

STEPHEN SHORE. *U.S. 10, Post Falls, Idaho.* 1974. Type C print. The Museum of Modern Art, New York.

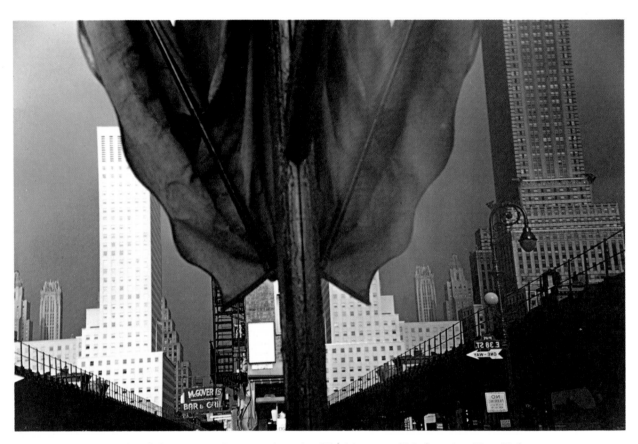

ERNST HAAS. *Corner of 38th Street*. 1952. Dye transfer print. The Museum of Modern Art, New York.

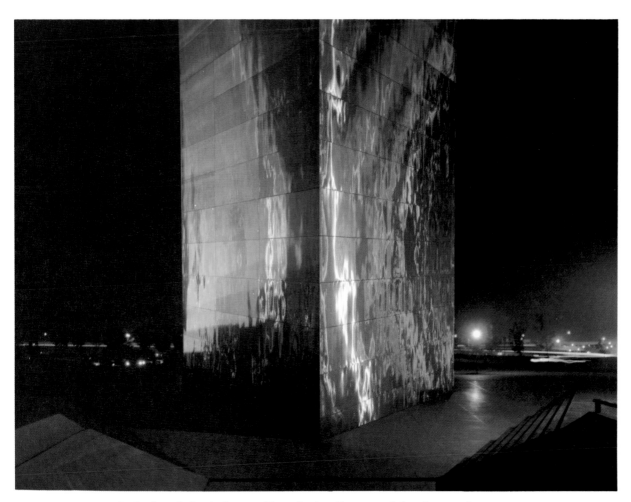

JOEL MEYEROWITZ. *St. Louis and the Arch.* 1977. Type C print. Courtesy of the photographer.

NOTES

An asterisk (*) following a note indicates that the cited article is reprinted in full in Beaumont Newhall, ed. *Photography: Essays & Images* (New York: The Museum of Modern Art, 1980), a companion volume to this book.

CHAPTER 1: THE ELUSIVE IMAGE

1. Leon Battista Alberti, *On Painting and on Sculpture,* ed. and translated by Cecil Grayson (London: Phaidon Press, Ltd., 1972), p. 55.
2. Albrecht Dürer, *Underweysung der Messung* (Nürnberg, 1525), Book IV.
3. Giovanni Battista della Porta, *Magiae naturalis; sive, de miraculis rerum naturalium* (Naples: Apvd. M. Cancer, 1553).
4. Daniello Barbaro, *La pratica della perspettiva* (Venezia: appresso Camillo & Rutillo Borgominieri frateli, al segno di S. Georgio, 1568); translated A. Hyatt Mayor in *Bulletin of The Metropolitan Museum of Art,* Summer, 1946, p. 18.
5. Count Francesco Algarotti, *Essay on Painting* (London: L. Davis and C. Reymers, 1764), pp. 64–65.
6. A translation of this report is in R. B. Litchfield, *Tom Wedgwood, the First Photographer* (London: Duckworth & Co., 1903), pp. 218–24: The original texts, in Latin and German, are reprinted in Josef Marie Eder, *Quellenschriften zu den frühsten Anfängen der Photographie bis zum XVIII. Jahrhundert* (Halle: Knapp, 1913).

CHAPTER 2. INVENTION

1. Sir Humphry Davy, "An Account of a Method of ... Making Profiles by the Agency of Light," *Journals of the Royal Institution,* vol. 1 (1802), pp. 170–74.*
2. Victor Fouque, *La Vérité sur l'invention de la photographie: Nicéphore Niépce, sa vie, ses essais, ses travaux* (Paris: Librarie des Auteurs et de l'Académie des Bibliophiles, 1867), p. 61.
3. Ibid., p. 62.
4. Ibid., p. 64–65.
5. Ibid., p. 23.
6. Ibid., pp. 140–42.
7. *Nicéphore Niépce, Correspondances 1825-1829* (Rouen: Pavillon de la Photographie, 1974), p. 134.
8. Fouque, *La Vérité,* pp. 157–58.
9. *Journal des Artistes,* September 27, 1835, pp. 203–05.
10. *Journal des Artistes,* September 11, 1836, p. 166.
11. Fouque, *La Vérité,* p. 222.
12. Reprinted in full in Newhall, *Photography: Essays & Images,* pp. 17–18.
13. *Literary Gazette,* no. 1160 (April 12, 1839), p. 235.
14. William Henry Fox Talbot, *The Pencil of Nature* (London: Longman Brown, Green, & Longmans, 1844–46).

15. H. J. P. Arnold, *William Henry Fox Talbot* (London: Hutchinson Benham, 1977), p. 108.
16. William Henry Fox Talbot, *Some Account of the Art of Photogenic Drawing* (London: R. and J. E. Taylor, 1839).*
17. Ibid.
18. Ibid.
19. *Literary Gazette,* no. 1150 (February 2, 1839), p. 74.
20. *Compte-rendu des Séances de l'Académie des Sciences,* vol. 8 (1839), p. 171.
21. Quoted from the original by the courtesy of the Science Museum, London.
22. For an explanation of why the name of the compound $Na_2 S_2 O_3 \cdot 5 H_2O$ was changed in 1861 from sodium hyposulphite to thiosulphate, see Beaumont Newhall, *Latent Image* (Garden City, N.Y.: Doubleday & Company, Inc., 1967), p. 58.
23. *Compte-rendu,* p. 17.
24. *The Magazine of Science,* vol. 1 (1839), pp. 25, 33.
25. Mungo Ponton, "Notice of a Cheap and Simple Method of Preparing Paper for Photographic Drawing," *Edinburgh New Philosophical Journal,* vol. 27 (1839), pp. 169–71.
26. *L'Artiste,* series 2, 3 (1839), p. 444.
27. Sir John F. W. Herschel to William Henry Fox Talbot, May 9, 1839; quoted by D. B. Thomas, *The First Negatives* (London: Her Majesty's Stationery Office, 1964), p. 6.
28. For the complete text, and an account in the *London Globe,* August 23, 1839, see Newhall, *Photography: Essays & Images,* pp. 18–22.
29. I am indebted to Pierre Harmant, whose patient search in the political press gives the exact time for this legislation, which was incorrectly stated by Daguerre himself! See Harmant in *La Photographie,* December 20, 1962, pp. 627–28, and *France-photographie,* no. 40 (1975), pp. 4–5.
30. Marc Antoine Gaudin, *Traité pratique de la photographie* (Paris: J. J. Dubochet et Cie., 1844), pp. 6–7.
31. "Bibliography of Daguerre's Instruction Manuals," compiled by Beaumont Newhall, in Helmut and Alison Gernsheim, *L. J. M. Daguerre* (New York: Dover Publications, Inc., 1968), pp. 198–205.
32. British Association for the Advancement of Science, *Report of the Ninth Meeting at Birmingham* (London, 1839), p. 4.
33. Lo Duca, *Bayard* (Paris: Prisma, 1943), pp. 22–23.

CHAPTER 3. DAGUERREOTYPE: THE MIRROR WITH A MEMORY

1. *Excursions daguerriennes: vues et monuments les plus remarquables du globe* (Paris: Noel Marie Paymal Lerebours, 1840–43).
2. Horace Vernet to Monsieur Fabreguettes, French consul at

Malta, November 23, 1839, author's collection.

3. *Edinburgh Review*, vol. 76 (1843), p. 332.

4. John Baptiste Soleil, *Guide de l'amateur de photographie* (Paris: L'Auteur, 1840), pp. 70–71.

5. Samuel F. B. Morse to Marcus Aurelius Root, February 20, 1855; quoted in Marcus Aurelius Root, *The Camera and the Pencil* (Philadelphia: M. A. Root, 1864), pp. 346–47.

6. Julius F. Sachse, "Philadelphia's Share in the Development of Photography," *Journal of the Franklin Institute*, vol. 135 (April 1893), pp. 271–87.

7. Letter signed "G" describing his visit on February 2, 1840 to the house of A. S. Wolcott, Second St., New York City, where he had fitted up a room for taking daguerreotype portraits, *American Journal of Photography*, new series vol. 4 (1861), p. 41.

8. The Chevalier lenses fitted to the camera sold by Daguerre were of the aperture $f/17$. The Petzval lenses worked at $f/3.6$. The brightness ratio is the square of the quotient of the f numbers, or $(17 \div 3.6)^2 = 22$.

9. In a letter published in the *Literary Gazette*, vol. 23 (1840), p. 803.

10. George W. Prosch to Albert Sands Southworth, March 30, 1841; quoted in Beaumont Newhall, *The Daguerreotype in America* (New York: Dover Publications, Inc., 1976), p. 122.

11. Memoir read March 25, 1840, to the French Academy of Sciences. Reprinted in Noel Marie Paymal Lerebours, *A Treatise on Photography* (London: Longman, 1843), pp. 52–55.

12. Commonwealth of Massachusetts, *Statistical Information Relating to Certain Branches of Industry in Massachusetts for the Year Ending June 1, 1855* (Boston, 1856), p. 591. According to the national census of 1850, the population of Massachusetts was 994,514; by 1860 it had grown to 1,231,066.

13. Oliver Wendell Holmes, "Sun-Painting and Sun Sculpture," *Atlantic Monthly*, vol. 8 (1861), pp. 13–29.

14. Louis Jacques Mandé Daguerre to Edward Anthony and J. R. Clark, February 15, 1847, Kodak-Pathé Collection, Vincennes, France.

15. Horace Greely, *Glances at Europe* (New York: Dewitt & Davenport, 1851), p. 26.

16. Charles Lester Edwards, ed., *The Gallery of Illustrious Americans ... From Daguerreotypes by Mathew Brady*, engraved by D'Avignon (New York: M. B. Brady, F. D'Avignon, C. Edwards Lester, 1850).

17. Albert Sands Southworth, "The Early History of Photography in the United States," *British Journal of Photography*, vol. 18 (1871), pp. 530–32.*

18. Advertisement in *The Massachusetts Register: A State Record* (Boston, 1852), pp. 327–28.

19. Invoice, Southworth & Hawes to Mr. Burnet, January 1, 1850, author's collection.

20. *Humphrey's Journal of Photography*, vol. 7 (1856), p. 389.

CHAPTER 4. CALOTYPE: THE PENCIL OF NATURE

1. William Henry Fox Talbot, *The Process of Calotype Photogenic Drawing* (London: J. L. Cox & Sons, 1841).*

2. Lady Elizabeth Talbot to William Henry Fox Talbot, July 12, 1842; quoted in *Photographic Journal*, vol. 108 (1968), p. 366.

3. William Henry Fox Talbot, *The Pencil of Nature* (London: Longman, Brown, Green, & Longmans, 1844–46), unpaged introduction.

4. William Henry Fox Talbot to Sir Charles Fellows, April 26, 1843, Albert Boni Collection, University of California at Los Angeles.

5. David Octavius Hill to Mr. Bicknell, January 17, 1848, George Eastman House, Rochester, New York.

6. Translated in *The Chemist*, new series vol. 1 (1851), pp. 502–03.

7. Gustave Le Gray in J. H. Croucher, *Plain Directions for Obtaining Photographic Pictures* (Philadelphia: A. Hart, 1853), p. 103.

8. *Photographic Notes*, vol. 2 (1857), pp. 103–04.

9. Maxime Du Camp, *Recollections of a Literary Life* (London: Remington & Co., Ltd., 1893), vol. 1, pp. 296–97.

10. R. Derek Wood, *The Calotype Patent Lawsuit of Talbot v. Laroche* (Bromley, Kent, England: Author, 1975).

11. *Art Journal*, vol. 1 (1855), p. 51.

12. William Henry Fox Talbot to Constance Talbot, December 21, 1854; quoted in *Photographic Journal*, vol. 108 (1968), p. 371.

CHAPTER 5. PORTRAITS FOR THE MILLION

1. Frederick Scott Archer, "The Use of Collodion in Photography," *The Chemist*, new series vol. 2 (1851), pp. 257–58.*

2. For a lively account of working the collodion process, see Oliver Wendell Holmes, "Doings of the Sunbeam," *Atlantic Monthly*, vol. 12 (1863), pp. 1–15.*

3. Nathan G. Burgess, *The Photographic Manual* (New York: D. Appleton & Co., 1863), p. 42.

4. Quoted from the *Bulletin de la Société française de la Photographie* in Josef Marie Eder, *History of Photography*, translated by E. Epstean (New York: Dover Publications, Inc., 1978) pp. 355–56.

5. Marcus Aurelius Root, *The Camera and the Pencil* (Philadelphia: M. A. Root, 1864), p. 295.

6. D. Van Monckhoven, *Traité générale de photographie*, 5th ed. (Paris: Victor Masson et Fils, 1865), p. 543.

7. Frederick Scott Archer, *The Collodion Process on Glass*, 2d ed. (London: Printed for the Author, 1854).

8. J. H. Croucher, *Plain Directions for Obtaining Photographic Pictures* (Philadelphia: A. Hart, 1853).

9. *American Journal of Photography*, new series vol. 6 (1863), p. 144.

10. Edward M. Estabrooke, *The Ferrotype and How to Make It* (Cincinnati, Ohio: Gatchell & Hyatt, 1872), p. 53.

11. Paul Eduard Liesgang, quoted in Josef Maria Eder, *The History of Photography* (New York: Dover Publications, 1978) p. 352.

12. "He took the 'cardomania' at the height of the flood." Obituary of a Mr. Clarkington in *Photographic News*, vol. 5 (1861), p. 538.

13. *Anthony's Photographic Bulletin*, vol. 15 (1884), p. 65.

14. Philippe Burty, "Nadar's Portraits at the Exhibition of the French Society of Photography," *Gazette des Beaux-Arts*, vol. 2 (1859), pp. 215–16.*

15. Nadar's testimony in a lawsuit. Translated from Jean Prinet and Antoinette Dilasser, *Nadar* (Paris: Armand Colin, 1966), pp. 115–16.

16. Hermann Wilhelm Vogel, "Paris Correspondence," *Philadelphia Photographer*, vol. 4 (1867), pp. 152–53.

17. Alphonse de Lamartine, quoted in Gisele Freund, *Photography & Society* (Boston: David R. Godine, Publisher, 1980), p. 77.

18. *Wilson's Photographic Magazine*, vol. 30 (1893), p. 11.

19. Ibid., vol. 34 (1897), pp. 65–75.

20. Ibid., vol. 30 (1893), p. 11.

CHAPTER 6. ART PHOTOGRAPHY

1. C. Jabez Hughes, "On Art Photography," *American Journal of Photography*, new series vol. 3 (1861), pp. 260–63, 273–77.
2. Reprinted in *Photographic Art Journal*, vol. 6 (1853), p. 195.
3. Sir William Newton, "Upon Photography in an Artistic View," *Journal of the Photographic Society*, vol. 1 (1853), pp. 6–7.*
4. Noel Marie Paymal Lerebours, *A Treatise on Photography* (London: Longman, 1843), p. 5.
5. Henry Peach Robinson, "Oscar Gustave Rejlander," *Anthony's Photographic Bulletin*, vol. 21 (1890), pp. 107–110.*
6. *Humphrey's Journal of Photography*, vol. 9 (1857), pp. 92–93.
7. Ibid., p. 93.
8. *Photographic Journal*, vol. 4 (1858), p. 193.
9. Henry Peach Robinson, *The Elements of Pictorial Photography* (Bradford, England: Percy Lund & Co., Ltd., 1896), p. 102.
10. Quoted in *The Practical Photographer*, vol. 6 (1895), pp. 68, 69.
11. Ibid., p. 70.
12. Henry Peach Robinson, *Pictorial Effect in Photography* (London: Piper & Carter, 1869).
13. Ibid., pp. 9–10.
14. Ibid., p. 78.
15. Ibid., p. 109.
16. Ibid., p. 51.
17. *American Journal of Photography*, new series vol. 3 (1861), pp. 273–74.
18. Julia Margaret Cameron, *The Annals of My Glass House*, manuscript, The Royal Photographic Society of Great Britain, Bath.*
19. Julia Margaret Cameron to Sir John F. W. Herschel, December 31, 1864; reprinted in Colin Ford, *The Cameron Collection* (Wokingham, England and New York: Van Nostrand Reinhold Company, Limited, 1975), pp. 140–41.
20. Julia Margaret Cameron to William Michael Rosetti; quoted in Helmut Gernsheim, *Julia Margaret Cameron*, 2d ed. (Millerton, N.Y.: Aperture, Inc., 1975), p. 60.
21. Raymond Escholier, *Delacroix* (Paris: H. Floury, 1929), vol. 3, p. 201.
22. Beaumont Newhall, *The Daguerreotype in America* (New York: Dover Publications, Inc., 1976), p. 83.
23. *The Studio* (London), vol. 1 (1893), p. 6.
24. *Photographic Notes*, vol. 8 (1863), p. 16.
25. Charles Baudelaire, *The Mirror of Art* (London: Phaidon Press Limited, 1955), pp. 228–31.*

CHAPTER 7.
"A NEW FORM OF COMMUNICATION"

1. Lady Elizabeth Eastlake, "Photography," *Quarterly Review* (London), vol. 101 (1857), pp. 442–68.*
2. Quoted in Helmut and Alison Gernsheim, *Roger Fenton* (London: Secker & Warburg, 1954), p. 65.
3. Quoted in H. Milhollen, "Roger Fenton, Photographer of the Crimean War," *Library of Congress Quarterly Journal of Current Acquisitions*, vol. 3 (1946), p. 11.
4. Quoted in Lena R. Fenton, "The First Photographer at the Crimea in 1855," *Illustrated London News*, vol. 92 (1941), p. 590.

5. *American Journal of Photography*, new series vol. 5 (1862), p. 145.
6. Ibid., vol. 3 (1861), p. 320.
7. Quoted in *Catalogue of Card Photographs Published by E. & H. T. Anthony* (New York: E. & H. T. Anthony, 1862), p. 2.
8. Josephine Cobb, in "Photographers of the Civil War," *Military Affairs* (Fall 1962), pp. 127–35, reports that she searched the U. S. War Department files and found the names of 300 photographers who were issued passes by the Army of the Potomac; seven stated that their employer was Mathew B. Brady.
9. Alexander Gardner, *Gardner's Photographic Sketch Book of the War*, 2 vols. (Washington, D.C.: Philip & Solomons, 1865–66).
10. Yet on the witness stand in a lawsuit involving authorship, Gardner testified that "Photograph by A. Gardner" on a mount "should not be taken to mean that he himself had made the picture." Cobb, "Photographers of the Civil War," p. 136.
11. George N. Barnard, *Photographic Views of Sherman's Campaign* (New York: G. N. Barnard, 1866).
12. Oliver Wendell Holmes, "The Stereoscope and the Stereograph," *Atlantic Monthly*, vol. 3 (1859), pp. 738–48.*
13. Frederick S. Dellenbaugh, *A Canyon Voyage* (New York: G. P. Putnam's Sons, 1908), p. 58.
14. Ibid., p. 179.
15. "Photographs from the High Rockies," an anonymous account of Clarence King's exploration, *Harper's New Monthly Magazine*, vol. 39 (1869), pp. 465–75.*
16. George M. Wheeler, *Progress Report . . . Explorations and Surveys Principally in Nevada and Arizona* (Washington, D.C.: U.S. Government Printing Office, 1874) p. 18.
17. William Henry Jackson, *Time Exposure* (New York: Cooper Union Publishers, Inc., 1970), p. 205.
18. "Interesting American Scenery," *The Philadelphia Photographer*, vol. 12 (1876), pp. 120–22.
19. Francis Frith, "The Art of Photography," *The Art Journal*, vol. 5 (1859), pp. 71–72.*
20. John Thomson, *Illustrations of China and Its People* (London: Sampson Low, Marston, Low and Searle, 1873).
21. John Thomson and Adolphe Smith, *Street Life in London* (London: Sampson Low Marston, Searle and Rivington, 1877).
22. "A Visit to Messrs. Valentine & Sons' Printing Works," *British Journal of Photography*, vol. 33 (1886), pp. 162–63. For a description of G. W. Wilson's printing establishment by his son, Charles A. Wilson, see Helmut and Alison Gernsheim, *The History of Photography* (New York: McGraw-Hill Book Company, 1969), p. 402.
23. C. Jabez Hughes, "On Art Photography," *American Journal of Photography*, new series vol. 3 (1861), p. 261.
24. Charles Wheatstone, "On Some Remarkable, and Hitherto Unobserved, Phenomena of Binocular Vision," *Philosophical Transactions of the Royal Society of London*, vol. 11 (1838), pp. 373–74.
25. Ibid., p. 376.
26. Charles Wheatstone, "On Some Remarkable . . . Phenomena of Binocular Vision (cont.)," *Philosophical Transactions of the Royal Society of London*, vol. 14 (1852), p. 7.
27. Sir David Brewster, *The Stereoscope, Its History, Theory and Construction* (London: John Murray, 1856).
28. See note 12, above.
29. *The Amateur Photographer*, vol. 15 (1892), p. 328.

CHAPTER 8. THE CONQUEST OF ACTION

1. *Foreign Quarterly Review*, 1839, pp. 213–18.
2. Lake Price, *A Manual of Photographic Manipulation*, 2d ed. (London: John Churchill & Sons, 1858), p. 174.
3. *Photographic Notes*, vol. 4 (October 1, 1859), pp. 239–40.
4. Ibid.
5. Ibid., vol. 5 (1860), 12–13.
6. *Photographic News*, vol. 5 (May 24, 1861), p. 242.
7. Oliver Wendell Holmes, "The Human Wheel, Its Spokes and Felloes," *Atlantic Monthly*, vol. 11 (May 1863), pp. 567–80.
8. Ibid.
9. Reprinted in *Photographic News*, vol. 21 (September 21, 1877), p. 456.
10. Caption to his published photograph of Sallie Gardner, copyright 1878.
11. "Muybridge's Motion Pictures," news accounts, 1860.*
12. *British Journal of Photography*, vol. 38 (1891), p. 677.
13. *International Annual of Anthony's Photographic Bulletin*, vol. 2, (1889), pp. 285–87.
14. Peter Henry Emerson, *Naturalistic Photography* (London: Sampson Low, Marston, Searle and Rivington, 1889), p. 161.
15. Richard Leach Maddox, "An Experiment with Gelatino Bromide," *British Journal of Photography*, vol. 18 (1871), pp. 422–23.
16. From the rhyme "Gelatine" signed "Marc Oute" in *British Journal Photographic Almanac* (1881), p. 213.
17. *The Philadelphia Photographer*, vol. 20 (1883), pp. 305–06.
18. Quoted in W. B. Ferguson, *Photographic Researches of Ferdinand Hurter and Vero C. Driffield* (London: The Royal Photographic Society of Great Britain, 1920), p. 6.
19. Ibid., p. 76.
20. *The Philadelphia Photographer*, vol. 11 (1874), pp. 27–29.
21. "Photographic Printing by Machinery," *British Journal of Photography*, vol. 42 (1895), pp. 551–52.
22. Illustrations of several of these cameras are reproduced in Beaumont Newhall, ed., *Photography: Essays & Images* (New York: The Museum of Modern Art, 1980), pp. 146–47.
23. Henry Peach Robinson, "The Hand Camera Taken Seriously," *Amateur Photographer*, vol. 23 (March 27, 1895), p. 270.
24. George Eastman to John M. Manley, December 15, 1906; quoted in C. W. Ackerman, *George Eastman* (Boston: Houghton Mifflin, 1930), p. 76.
25. *Harper's Magazine Advertiser*, June 1891, p. 20.
26. Alexander Black, "The Amateur Photographer," *The Century Magazine*, vol. 34 (1887) pp. 722–29.*
27. George Eastman, "The Kodak Manual," manuscript, George Eastman House, Rochester, New York.
28. Advertisement reproduced in Eaton S. Lothrop, Jr., *A Century of Cameras* (Dobbs Ferry, N.Y.: Morgan & Morgan, Inc., 1973), p. 62.
29. *Photographic News*, vol. 4 (1860), p. 13.
30. Ibid.
31. "Flashes from the Slums," The New York *Sun*, February 12, 1888.*
32. Ibid.
33. Jacob A. Riis, *How the Other Half Lives; Studies Among the Tenements of New York* (New York: Charles Scribner's Sons, 1890).
34. Jacob A. Riis, *Children of the Poor* (New York: Charles Scribner's Sons, 1892), pp. 77–82.
35. Quoted by Jean Adhemar, "Emile Zola, Photographer," in Van Deren Coke, ed., *One Hundred Years of Photographic History* (Albuquerque: University of New Mexico Press, 1975), p. 4.
36. *Photo-Miniature*, no. 21 (December 1900), p. 396.
37. Edward S. Curtis, *The North American Indian*, 20 vols. plus 20 portfolios (New York: Published by the author, 1907–30).

CHAPTER 9. PICTORIAL PHOTOGRAPHY

1. Peter Henry Emerson, "Photography, A Pictorial Art," *The Amateur Photographer*, vol. 3 (1886), pp. 138–39.*
2. Peter Henry Emerson, *Life and Landscape on the Norfolk Broads* (London: Sampson Low, Marston, Searle and Rivington, 1886).
3. Peter Henry Emerson, *Naturalistic Photography for Students of the Arts* (London: Sampson Low, Marston, Searle and Rivington, 1889).
4. Peter Henry Emerson, *Pictures of East Anglian Life* (London: Sampson Low, Marston, Searle and Rivington, 1888).
5. R. Child Bayley, *The Complete Photographer* (New York: McClure and Phillips, 1906), p. 357.
6. Emerson, *Naturalistic Photography*, p. 193.
7. Ibid., p. 150.
8. Quoted by Nancy Newhall, "Emerson's Bombshell," *Photography*, vol. 1 (Winter 1947) p. 114.
9. *The British Journal of Photography*, vol. 36 (September 13, 1889), p. 611.
10. Henry Peach Robinson, *Picture-Making by Photography*, 2d ed. (London: Hazell, Watson & Viney, Ltd., 1889), p. 135.
11. *The Amateur Photographer*, vol. 9 (April 26, 1889), p. 270.
12. Peter Henry Emerson, *The Death of Naturalistic Photography* (privately published, 1890).
13. Peter Henry Emerson, *Marsh Leaves* (London: D. Nutt, 1895).
14. Ernst Juhl, "Die Jubiläumsausstellung des Wiener Kamera-Klub," *Photographische Rundschau*, vol. 12 (1898), pp. 108–13.
15. Herman Wilhelm Vogel, "Letter from Germany," *Anthony's Photographic Bulletin*, vol. 22 (July 25, 1891), p. 420.
16. Joseph T. Keiley, "The Linked Ring," *Camera Notes*, vol. 5 (October 1901), p. 113.
17. The *Studio* (London), vol. 1 (November 1893), p. 68.
18. Reprinted in *The Amateur Photographer*, vol. 18 (October 27, 1893), p. 271.
19. *Bulletin du Photo-Club de Paris*, vol. 3 (February 1894), pp. 33–34.
20. Alfred Litchwark, in Fritz Matthies-Masuren, *Künstlerische Photographie* (Berlin: Marquardt & Co., 1907), p. 2–3.
21. Ibid., p. 11.
22. A. Rouillé Ladévèze, *Sépia-photo et Sanguine-photo* (Paris: Gauthier Villars et Fils, 1894).
23. Robert Demachy in *The Practical Photographer* (Library Series), no. 18 (1905), pp. 11–13.
24. *Photography*, vol. 15 (1903), p. 438.
25. *British Journal of Photography*, vol. 33 (1886), pp. 20–21.
26. "Frederick H. Evans on Pure Photography," *Photographic Journal*, vol. 59 (1900), pp. 236–41.*
27. Hermann Wilhelm Vogel, *Handbook of the Practice and the Art of Photography*, 2d ed. (Philadelphia: Bennerman, 1875).

28. Hermann Wilhelm Vogel, *Photographische Kunstlehre; oder, Die künstlereischen Grundsätze der Lichtbildnerei* (Berlin: Velag von Robert Oppenheim, 1891).

29. The date was given by Alfred Stieglitz in *The American Annual of Photography for 1897*. He later stated that the picture was taken on February 22, 1892. On this date no snow fell in New York City. A fall of four inches, however, was recorded by the Weather Bureau on February 22, 1893.

30. Alfred Stieglitz, "The Hand Camera—Its Present Importance," *American Annual of Photography for 1897*, pp. 19–26.

31. Ibid.

32. *Photograms of 1897*, p. 70.

33. *American Annual Photography for 1895*, p. 27.

34. Theodore Dreiser, "The Camera Club of New York," *Ainslee's Magazine*, vol. 4 (1899), pp. 324–35.

35. The quotations from *Photographic News*, *The Amateur Photographer* and *Photography* are from A. Horsley Hinton, "Some Further Consideration of the New American School and Its Critics," *The Amateur Photographer*, vol. 32 (1900), pp. 383–85.

36. Ernst Juhl, "Eduard J. Steichen," *Die Photographische Rundschau*, vol. 16 (July 1902), pp. 127–29.*

37. *The Novels and Tales of Henry James*, definitive ed., 24 vols. (London: Macmillan and Co., 1907).

38. Alvin Langdon Coburn, *London*, with an introduction by Hilaire Belloc (London: Duckworth and Co., 1909).

39. Alvin Langdon Coburn, *New York*, with a foreword by H. G. Wells (London: Duckworth and Co., 1910).

40. Alvin Langdon Coburn, *Men of Mark* (London: Duckworth and Co., 1913).

41. Alfred Stieglitz, "The Photo-Secession," *The Bausch & Lomb Lens Souvenir* (Rochester, N.Y.: Bausch & Lomb Optical Company, 1903).*

42. *The Photo-Secession*, no. 1 (1902), p. 1.

43. Alfred Stieglitz, "The Photo-Secession at the National Arts Club, New York," *Photograms of the Year*, pp. 17–20.

44. New York *Evening Sun;* reprinted in *Camera Notes*, vol. 6 (1902), p. 39.

45. *Photography*, vol. 7 (1904), p. 243.

46. *The Photo-Secession*, no. 5 (1904), p. 2.

47. *Photography News*, vol. 53 (1908), p. 268.

48. Frederick H. Evans to Alfred Stieglitz, December 6, 1908, Stieglitz Archives, The Beinecke Rare Book and Manuscript Library, Yale University, New Haven, Connecticut.

49. Dixon Scott, "Welding the Links: The Salon Show at Liverpool," *The Amateur Photographer*, vol. 50 (1909), pp. 48–49.

50. Frederick H. Evans, "The New Criticism," *The Amateur Photographer*, vol. 50 (1909), pp. 89–90.

51. "The Photo-Secession at Buffalo," a portfolio of photographs purchased by the Albright Gallery in 1910.*

52. Sadakichi Hartmann, "What Remains," *Camera Work*, no. 33 (1911), pp. 30–32.

CHAPTER 10. STRAIGHT PHOTOGRAPHY

1. Sadakichi Hartmann, "A Plea for Straight Photography," *American Amateur Photographer*, vol. 16 (1904), pp. 101–09.*

2. Sadakichi Hartmann, "On the Possibility of New Laws of Composition," *Camera Work*, no. 30 (1910), pp. 23–26.

3. Charles H. Caffin, *Photography as a Fine Art* (New York: Doubleday, Page & Company, 1901), p. 39.

4. Alfred Stieglitz in conversation with Dorothy Norman, *Twice-A Year*, no. 8–9 (1942), p. 128.

5. *Camera Work*, no. 30 (1910), p. 47.

6. January 26, 1913. See Beaumont Newhall, "Stieglitz and 291," in the special "Armory Show" issue of *Art in America*, no. 51 (1963), pp. 48–51.

7. *PSA [Photographic Society of America] Journal*, vol. 13 (November 1947), p. 721.

8. Catalog of photographic exhibition at the John Wanamaker department store, Philadelphia, March 1913. Quoted from *The Photo-Miniature*, no. 124 (1913), pp. 220–21.

9. Paul Rosenfeld, "Stieglitz," *The Dial*, vol. 70 (1921), pp. 397–409.*

10. *The Photo-Miniature*, no. 183 (1921), pp. 138–39.

11. Alfred Stieglitz, "How I Came to Photograph Clouds," *The Amateur Photographer*, vol. 56 (1923), p. 255.

12. Paul Strand, "Photography," *Seven Arts*, vol. 2 (1917), pp. 524–25.*

13. Paul Strand and Nancy Newhall, *Time in New England*, 2d ed. (Millerton, N.Y.: Aperture, Inc., 1980.) For extracts from correspondence between Paul Strand and Nancy Newhall, see "The Making of 'Time in New England,'" in Beaumont Newhall, ed. *Photography: Essays & Images* (New York: The Museum of Modern Art, 1980), pp. 297–303.

14. Claude Roy and Paul Strand, *La France de profil* (Lausanne: La Guilde du Livre, 1952).

15. Cesare Zavattini and Paul Strand, *Un Paese* (Turin: Giulio Einaudi, 1955).

16. Quoted by Constance Rourke, *Charles Sheeler* (New York: Harcourt, Brace and Company, 1938), p. 120.

17. *The Daybooks of Edward Weston: Vol. 1, Mexico*, edited by Nancy Newhall (Millerton, N.Y.: Aperture, Inc., 1973).

18. Ibid., p. 55.

19. Ibid., p. 102.

20. Ibid., p. 80. The lens was given to the International Museum of Photography, Rochester, New York, by Brett Weston. The diaphragm is calibrated in the now-obsolete "Uniform System:" the smallest stop, U.S. 256, is the equivalent to $f/64$.

21. Edward Weston to Frank Roy Fraprie, June 7, 1922, The Center for Creative Photography, University of Arizona, Tucson.

22. Willi Warstat, *Allgemeine Ästhetik der photographischen Kunst auf psychologischer Grundlage* (Halle: Wilhelm Knapp, 1909).

23. John Paul Edwards, "Group f.64," *Camera Craft*, vol. 42 (1935), pp. 107–08, 110, 112–13.*

24. Ansel Adams, "A Personal Credo," *American Annual of Photography for 1944*, vol. 58 (1943), pp. 7–16.*

25. Nancy Newhall and Ansel Adams, *This is the American Earth* (San Francisco: Sierra Club, 1960).

26. Albert Renger-Patzsch, *Die Welt ist schön; einhundert photographischen Aufnahmen* (Munich: Kurt Wolff Verlag, 1928).

27. Thomas Mann, "Die Welt ist schön," *Berliner Illustrirte Zeitung*, no. 52 (1928), pp. 2262–63.

28. Albert Renger-Patzsch, "Ziele," *Das deutsche Lichtbild, 1927*, p. XVIII.

29. André Calmettes, French actor and motion picture director, was a close friend of Eugène Atget. Upon the photographer's death he represented the entire estate, and sold the negatives and prints left by Atget to Berenice Abbott. At her request, Calmettes wrote down what he knew of Atget's life in the form of an undated letter, which is now in The Museum of Modern Art, New York. A translation of this letter appears in Berenice Abbott, *The World of Atget* (New York: G. P. Putnam's Sons, 1979).

30. Julien Levy, *Memoir of an Art Gallery* (New York: G. P. Putnam's Sons, 1977), p. 91.

CHAPTER II. IN QUEST OF FORM

1. Alvin Langdon Coburn to Beaumont Newhall, September 8, 1963, George Eastman House, Rochester, N.Y.
2. Man Ray, *Champs délicieux* (Paris: Société Générale d'Imprimerie et d'Editions, 1922), unpaged introduction.
3. Arthur Parsey, *The Science of Vision; or, Natural Perspective . . . Containing the New Laws of the Camera Obscura or Daguerreotype,* 2d ed. (London: Longman and Co., 1840), p. vii.
4. Erich Mendelsohn, *Amerika: Bilderbuch eines Architekten* (Berlin: Rudolf Mosse Buchverlag, 1926).
5. El Lissitzky, *Proun und Wolkenbugel* (Dresden: 1977), p. 65.
6. Quoted in Evelyn Weiss, ed., *Alexander Rodtschenko: Fotografien 1920–1938* (Cologne: Wienand Verlag, 1978), pp. 50–57.
7. Quoted in Robert John Goldwater & M. Theves, eds., *Artists on Art* (New York: Pantheon Books, 1958), p. 422.
8. László Moholy-Nagy, *Painting, Photography, Film,* translated by Janet Seligman (Cambridge, Mass.: The MIT Press, 1969), p. 98.
9. Ibid.
10. Anton Giulio Bragaglia, *Fotodinamismo futurista,* 3d edition (Rome) (Malato Editore, [1913]). Reprint ed., Turin: Giulio Einaudi editore, 1970. No copy of the first edition (1911) has been located.
11. Le Corbusier [pseud.], *L'Art decoratif d'aujourd'hui* (Paris: C. Cres et Cie., [1925]), p. 127.
12. *Erste Internationale Dada Messe,* exhibition catalog (Berlin: Kunsthandlung Otto Burchard, 1920), unpaged.
13. Quoted in Hans Richter, *Dada: Art and Anti-art* (New York: McGraw-Hill Book Company, [1965]), p. 117.
14. Quoted in K. G. Pontus Hulten, *The Machine as Seen at the End of the Mechanical Age* (New York: The Museum of Modern Art, 1968), p. 111.
15. "The International Exhibition 'Film und Foto,' Stuttgart, 1929," a portfolio of illustrations from the catalog.*
16. Franz Roh and Jan Tschichold, *foto-auge; 76 fotos der zeit / oeil et photo; 76 photographies de notre temps; photo eye; 76 photos of the period* (Stuttgart: Akademischer Verlag Dr. Fritz Wedekind & co., 1929).
17. Werner Graeff, *Es kommt der neue Fotograf!* (Berlin: Verlag Hermann Reckendorf, 1929).

CHAPTER 12. INSTANT VISION

1. *American Repertory of Arts, Sciences and Manufacturers* (1890), pp. 401–02.
2. Charles Piazzi Smyth, *A Poor Man's Photography at the Great Pyramid in the Year 1865* (London: Henry Greenwood, 1870), p. 14.
3. Ibid.
4. *British Journal Photographic Almanac* (1894), p. 1008.
5. Unpublished statement by Jacques-Henri Lartigue prepared for The Museum of Modern Art, New York.
6. *Boyhood Photos of J.-H. Lartigue* (Lausanne: Ami Guichard, 1966), p. 84.
7. Ernemann Werke, *Katalog* (Dresden n.d. [1925?]), p. 6.
8. Quoted in *Letters* (Time, Inc.), March 18, 1935, pp. 1–2.
9. By Julien Levy, under the psedonym of Peter Lloyd, in the announcement of the Cartier-Bresson exhibition in his

New York Gallery, 1933.
10. Margaret Bourke-White to Beaumont Newhall, June 28, 1937, author's collection.
11. Barbara Morgan, "Photographing the Dance," in *Graphic Graflex Photography,* edited by Willard D. Morgan and Henry M. Lester, 7th ed. (New York: Morgan & Lester, 1940), pp. 216–25.

CHAPTER 13. DOCUMENTARY

1. *Webster's New Collegiate Dictionary* (Springfield, Mass.: C. C. Merriam Co., 1956), p. 244.
2. *British Journal of Photography,* vol. 36 (1889), p. 688.
3. *Camera Work,* no. 24 (1908), p. 22.
4. Lewis W. Hine, *Men at Work* (New York: The Macmillan Company, 1932).
5. John Grierson, introduction to Paul Rotha, *Documentary Film* (London: Faber & Faber, 1936), p. 5.
6. Ibid., p. 189.
7. *Grierson on Documentary,* edited by Forsyth Hardy (London: Collins, 1946), p. 179.
8. *U.S. Camera Magazine,* vol. 1, no. 1 (1938), pp. 37, 67.
9. Quoted in Daniel Dixon, "Dorothea Lange," *Modern Photography,* vol. 16 (December 1952), pp. 68–77, 138–41.
10. Sherwood Anderson, *Home Town: Photographs by the Farm Security Photographers* (New York: Alliance Book Corporation, 1940).
11. Roy E. Stryker, "Documentary Photography," *Encyclopedia of Photography* (New York: Greystone Press, 1963), vol. 7, p. 1180.
12. Erskine Caldwell and Margaret Bourke-White, *You Have Seen Their Faces* (New York: The Viking Press, 1937).
13. Berenice Abbott, *Changing New York* (New York: E. P. Dutton & Company, Inc., 1939).
14. Berenice Abbott, "Documenting the City," *Encyclopedia of Photography,* vol. 4, p. 1392.
15. William Henry Fox Talbot, *The Pencil of Nature* (London: Longman, Brown, Green, & Longmans, 1844–46), unpaged text opposite plate XIII.
16. In the first edition (Boston: Houghton Mifflin Company, 1941), thirty-one photographs were reproduced. In the second, revised edition of 1960, sixty are reproduced, with a foreword "James Agee in 1936," by Walker Evans.
17. Dorothea Lange and Paul Schuster Taylor, *An American Exodus: A Record of Human Erosion* (New York: Reynal & Hitchcock, 1939).
18. Archibald McLeish, *Land of the Free* (New York: Harcourt, Brace, 1938).
19. August Sander, *Antlitz der Zeit; sechszig Aufnahmen deutscher Menschen des 20. Jahrhunderts* (Munich: Transmare Verlag, 1929).

CHAPTER 14. PHOTOJOURNALISM

1. Quoted in the *British Journal of Photography,* vol. 42 (1895), p. 387.
2. *The New York Post,* May 7, 1937.
3. John R. Whiting, *Photography is a Language* (Chicago: Ziff Davis Publishing Company, 1946), p. 98.
4. Nancy Newhall, "The Caption," *Aperture,* vol. 1 (1952), p. 22.
5. Alfred Eisenstaedt to Beaumont Newhall, January 28, 1952, author's collection.
6. *U.S. Camera* Magazine (October 1938), pp. 15–16.

CHAPTER 15. IN COLOR

1. Victor Fouque, *La Vérité sur l'invention de la photographie: Nicéphore Niépce, sa vie, ses essais, ses travaux* (Paris: Libraire des Auteurs et de l'Académie des Bibliophiles, 1867), pp. 140–42.
2. *Humphrey's Journal of Photography,* vol. 14 (1862), p. 146.
3. Joseph Wake, "The Art of Painting Upon the Photographic Image," *British Journal of Photography,* vol. 24 (1877), p. 522.
4. *Daguerreian Journal,* vol. 2 (1851), p. 17.
5. Levi L. Hill, *A Treatise on Heliochromy; or, The Production of Pictures of Light, in Natural Colors* (New York: Robinson & Caswell, 1856).
6. *Humphrey's Journal of Photography,* vol. 16 (1865), pp. 315–16.
7. *Camera Work,* no. 22 (1908), p. 14.
8. *Modern Photography,* December 1953, p. 54.

CHAPTER 16. NEW DIRECTIONS

1. Edwin H. Land, "One-Step Photography," *Photographic Journal,* vol. 99A (January 1950), pp. 7–15.
2. *Art in America,* vol. 46, no. 1 (1958), pp. 52–55.
3. Ibid.
4. In Beaumont Newhall, ed., *Photography: Essays & Images* (New York: The Museum of Modern Art, 1980), pp. 307–09.
5. Aaron Siskind to Beaumont Newhall, 1954.
6. Beaumont Newhall, "Dual Focus," *Art News,* vol. 45, no. 4 (1946), pp. 36–39.
7. Frederick Sommer, autobiographical note, *Aperture,* vol. 10, no. 4 (1964), unpaged.
8. Tod Papageorge, *Walker Evans and Robert Frank: An Essay on Influence* (New Haven, Conn.: Yale University Art Gallery, 1981), p. 3.
9. *U.S. Camera 1958,* edited by Tom Maloney (New York: U.S. Camera Publishing Company, 1958), p. 90.
10. *Les Americaines,* photographs by Robert Frank, text edited by Alain Bosquet (Paris: Robert Delpire Editeur, 1958). American edition: *The Americans,* introduction by Jack Kerouac (New York: Grove Press, 1959. Revised ed., Millerton, N.Y.: Aperture, Inc., 1978).
11. *Image,* vol. 15, no. 2 (1972), p. 4.

BIBLIOGRAPHY

The books listed below have been chosen as an introduction to the vast literature on the history of photography. I have limited my selection as far as practical to books in English and, for the most part, those that are either in print or available in facsimile reprint editions. Many of the titles contain extensive bibliographies listing periodical articles as well as earlier books on their special fields. These are indicated by "Bibl." All of the books are helpful for reference, most of them are well researched and written, a few of them are inspirational.—B.N.

GENERAL

After Daguerre: Masterworks of French Photography (1848-1900) from the Bibliothèque Nationale. New York: The Metropolitan Museum of Art in association with Berger-Levrault, Paris, 1980.

Beaton, Cecil and Buckland, Gail. *The Magic Image: The Genius of Photography from 1839 to the Present Day.* Boston: Littlt Brown & Company, 1975.

Bernard, Bruce. *Photodiscovery: Masterworks of Photography 1840-1940.* With notes on the photographic processes by Valerie Lloyd. New York: Harry N. Abrams, 1980.

Buckland, Gail. *Reality Recorded: Early Documentary Photography.* Greenwich, Conn.: New York Graphic Society, 1974. Bibl.

Bunnell, Peter, ed. *A Photographic Vision: Pictorial Photography, 1889-1923.* Salt Lake City, Utah: Peregrine Smith, 1980.

Caffin, Charles H. *Photography as a Fine Art: the Achievement and Possibilities of Photographic Art in America.* 1901. Reprint, with introduction by Thomas F. Barrow. Dobbs Ferry, N.Y.: Morgan & Morgan, Inc., 1971.

Camera Notes: Official Organ of the Camera Club of New York. 6 vols. 1897-1903. Reprint, with index by Kate Davis. New York: Da Capo Press, 1978.

Camera Work. A Photographic Quarterly. Edited and published by Alfred Stieglitz. 50 issues. 1903-1917. Reprint. New York: Kraus Reprints, 1969.

Cassell's Cyclopaedia of Photography. Edited by Bernard E. Jones, 1911. Reprint. New York: Arno Press, 1973.

Coke, Van Deren. *The Painter and the Photograph from Delacroix to Warhol.* Revised edition. Albuquerque: University of New Mexico Press, 1972.

Coke, Van Deren; Eskildsen, Ute; Lohse, Bernd, eds. *Avant-garde Photography in Germany, 1919-1930.* San Francisco: San Francisco Museum of Modern Art, 1960.

Crawford, William. *The Keepers of Light: A History & Working Guide to Early Photographic Processes.* Dobbs Ferry, N.Y.: Morgan & Morgan, 1979. Bibl.

Darrah, William C. *The World of Stereography.* Gettysburg, Penn.: William C. Darrah, 1977.

Doty, Robert. *Photo-Secession: Stieglitz and the Fine Art Movement in Photography.* New York: Dover Publications, 1978. Bibl.

Eder, Josef Maria. *The History of Photography.* Translated by Edward Epstean. New York: Dover Publications, 1978.

The Focal Encyclopedia of Photography. Desk edition. London and New York: Focal Press, 1965.

Freund, Giselle. *Photography & Society.* Boston: David R. Godine, 1980.

Galassi, Peter. *Before Photography: Painting and the Invention of Photography.* New York: The Museum of Modern Art, 1981. Bibl.

Gernsheim, Helmut and Gernsheim, Alison. *The History of Photography from the Camera Obscura to the Beginning of The Modern Era.* New York: McGraw-Hill Book Co., 1969.

Gernsheim, Helmut. *The Origins of Photography.* New York: Thames and Hudson, 1982. Bibl. (The first of 3 vols., comprising the 3rd ed. of Gernsheim's *History of Photography*.)

Gidal, Tim N. *Modern Photojournalism: Origins and Evolution 1910-1933.* New York: Macmillan Publishing Co., 1973.

Goldberg, Vickie, ed. *Photography in Print.* New York: Simon & Schuster, 1981.

Great Photographic Essays from Life. Commentary by Maitland Edey. Pictures edited by Constance Sullivan. Boston: New York Graphic Society, 1978.

Harker, Margaret. *The Linked Ring: The Secession Movement in Photography in Britain, 1892-1910.* London: Heineman, 1979.

Hicks, Wilson. *Words and Pictures: An Introduction to Photojournalism.* 1952. Reprint. New York: Arno Press, 1973. Bibl.

Haworth-Booth, Mark, ed. *The Golden Age of British Photography, 1839-1900.* Millerton, N.Y.: Aperture, Inc., 1984. Bibl.

Hurley, F. Jack. *Portrait of a Decade: Roy Stryker and the Development of Documentary Photography in the Thirties.* Baton Rouge: Louisiana State University Press, 1972. Bibl.

Jammes, André, and Janis, Eugenia Parry. *The Art of French Calotype.* Princeton, N.J.: Princeton University Press, 1983.

Jussim, Estelle. *Visual Communication and the Graphic Arts: Photographic Technologies in the Nineteenth Century.* New York: R. R. Bowker Company, 1974. Bibl.

Kempe, Fritz. *Daguerreotypie in Deutschland.* Seebruck am Chiemsee: Heering-Verlag, 1979. Bibl.

Lécuyer, Raymond. *Histoire de la photographie.* 1945. Reprint. New York: Arno Press, 1979. Bibl.

Life Library of Photography. 17 vols. New York: Time-Life Books, 1970-72.

Lothrop, Eaton S., Jr. *A Century of Cameras from the Collection of the International Museum of Photography at George Eastman House.* Dobbs Ferry, N.Y.: Morgan & Morgan, 1973.

Lyons, Nathan, ed. *Photographers on Photography: A Critical Anthology.* Englewood Cliffs, N.J.: Prentice-Hall, 1966.

Mellor, David, ed. *Germany: The New Photography, 1927-33.* London: Arts Council of Great Britain, 1978.

Naef, Weston J. *The Collection of Alfred Stieglitz: Fifty Pioneers of Modern Photography.* New York: The Metropolitan Museum of Art/Viking Press, 1979. Bibl.

Naef, Weston J. and Wood, James N. *Era of Exploration: The Rise of Landscape Photography in the American West, 1860-1885.* Buffalo, N.Y.: Albright-Knox Art Gallery; New York: The Metropolitan Museum of Art, 1975. Bibl.

Newhall, Beaumont. *The Daguerreotype in America.* 3rd revised edition. New York: Dover Publications, 1976. Bibl.

Newhall, Beaumont. *Latent Image: The Discovery of Photography.* Albuquerque: University of New Mexico Press, 1983.

Newhall, Beaumont, ed. *Photography: Essays & Images.* New York: The Museum of Modern Art, 1980.

Petruck, Peninah R., ed. *The Camera Viewed: Writings on Twentieth-Century Photography.* 2 vols. New York: E. P. Dutton, 1979.

Potonniée, Georges. *History of the Discovery of Photography.* 1936. Reprint. New York: Arno Press, 1973.

Rinhart, Floyd and Rinhart, Marion. *The American Daguerreotype.* Athens: University of Georgia Press, 1981.

Rosenblum, Naomi. *A World History of Photography.* New York: Abbeville Press, 1984. Bibl.

Rudisill, Richard. *Mirror Image: The Influence of the Daguerreotype on American Society.* Albuquerque: University of New Mexico Press, 1971. Bibl.

Scharf, Aaron. *Art and Photography.* Baltimore: Penguin Books, 1974.

Sobieszek, Robert A. *Masterpieces of Photography from the George Eastman House Collection.* New York: Abbeville Publishers, 1985. Bibl.

Stryker, Roy and Wood, Nancy. *In This Proud Land: America 1935-1943 as Seen in the FSA Photographs.* Greenwich, Conn.: New York Graphic Society, 1973. Bibl.

Szarkowski, John. *Looking at Photographs.* New York: The Museum of Modern Art, 1973.

Szarkowski, John. *The Photographer's Eye.* New York: The Museum of Modern Art, 1980.

Taft, Robert. *Photography and the American Scene: A Social History 1839-1889.* New York: Dover Publications, 1964.

Trachtenberg, Alan, ed. *Classic Essays on Photography.* New Haven, Conn.: Leete's Island Books, 1980.

Welling, William. *Photography in America: The Formative Years, 1839-1900.* New York: Thomas Y. Crowell Company, 1978. Bibl.

Whiting, John R. *Photography is a Language.* 1946. Reprint. New York: Arno Press, 1979.

Witkin, Lee D. and London, Barbara. *The Photograph Collector's Guide.* Boston: New York Graphic Society, 1979. Bibl.

MONOGRAPHS

BERENICE ABBOTT

Abbott, Berenice. *Changing New York.* Text by Elisabeth Mc-Causland, 1939. Reprint, with title *New York in the Thirties.* New York: Dover Publications, 1973.

Berenice Abbott Photographs. Foreword by Muriel Rukeyser. Introduction by David Vestal. New York: Horizon Press, 1970.

ANSEL ADAMS

Adams, Ansel. *Autobiography.* Boston: Little, Brown and Co., 1985.

Adams, Ansel. *Examples: The Making of 40 Photographs.* Boston: Little, Brown and Company, 1983.

Ansel Adams: Images 1923-1974. Foreword by Wallace Stegner. Boston: New York Graphic Society, 1974.

Adams, Ansel. *Yosemite and the Range of Light.* Boston: New York Graphic Society, 1979.

DeCock, Liliane. *Ansel Adams.* Hastings-on-Hudson, N.Y.: Morgan & Morgan, 1972. Bibl.

Newhall, Nancy. *Ansel Adams: The Eloquent Light.* Millerton, N.Y.: Aperture, 1980.

THOMAS ANNAN

Annan, Thomas. *Photographs of the Old Closes and Streets of Glasgow 1868/1877.* Introduction by Anita Venthra Mozley. New York: Dover Publications, 1977.

EDWARD ANTHONY

Marder, William, and Marder, Estelle. *Anthony: The Man, the Company, the Cameras.* N.p.: Pine Ridge Publishing Co., 1982.

DIANE ARBUS

Diane Arbus. Millerton, N.Y.: Aperture, 1972.

Bosworth, Patricia. *Diane Arbus, a Biography.* New York: Knopf, 1984.

EUGENE ATGET

Szarkowski, John and Hambourg, Maria Morris. *The Work of Atget.* 4 vols. New York: The Museum of Modern Art, 1981-85. Bibl.

RICHARD AVEDON

Avedon, Richard. *Portraits.* Essay by Harold Rosenberg. New York: Farrar, Straus and Giroux, 1976.

GEORGE N. BARNARD

Barnard, George N. *Photographic Views of Sherman's Campaign.* 1866. Portfolio of 61 albumen prints. Reprinted by halftone, with introduction by Beaumont Newhall. New York: Dover Publications, 1977.

HIPPOLYTE BAYARD

Lo Duca [Joseph-Marie]. *Bayard.* 1943. Reprint. New York: Arno Press, 1979.

HERBERT BAYER

Herbert Bayer: Photographic Works. Introduction by Leland Rice. Essay by Beaumont Newhall. Los Angeles: Arco Center for Visual Art, 1977.

MARGARET BOURKE-WHITE

Bourke-White, Margaret. *Portrait of Myself.* New York: Simon and Schuster, 1963.

Callahan, Sean, ed. *The Photographs of Margaret Bourke-White.* Greenwich, Conn.: New York Graphic Society. 1972. Bibl.

SAMUEL BOURNE

Ollman, Arthur. *Samuel Bourne: Images of India.* Carmel, Calif.: Friends of Photography, 1983.

MATHEW B. BRADY

Horan, James D. *Mathew Brady, Historian with a Camera.* New York: Crown Publishers, 1955.

Meredith, Roy. *Mr. Lincoln's Camera Man: Mathew B. Brady.* 2d rev. ed. New York: Dover Publications, 1974.

ANTON GIULIO BRAGAGLIA

Bragaglia, Anton Giulio. *Fotodinamismo futurista.* 3d ed. 1913.

Reprint. Turin: Giulio Einaudi Editore S. P. A., 1970.

BILL BRANDT

Brandt, Bill. *The Shadow of Light: A Collection of Photographs from 1931 to the Present.* Introduction by Cyril Connolly and notes by Marjorie Beckett. London: Bodley Head, 1966.

BRASSAI

Brassaï. *The Secret Paris of the 30's.* New York: Pantheon Books, 1976.

Brassaï. Introductory essay by Lawrence Durrell. New York: The Museum of Modern Art, 1968. Bibl.

FRANCIS JOSEPH BRUGIERE

Enyeart. James. *Bruguière: His Photographs and His Life.* New York: Alfred A. Knopf, 1977. Bibl.

HARRY CALLAHAN

Harry Callahan: Photographs. Edited by Keith F. Davis. Biographical essay by Callahan. Kansas City, Mo.: Hallmark Cards Inc., 1981.

Bunnell, Peter C. *Harry Callahan.* New York: American Federation of Arts, 1978. Catalog of exhibition at 38th Venice Biennial. Bibl.

JULIA MARGARET CAMERON

Ford, Colin. *The Cameron Collection: An Album of Photographs by Julia Margaret Cameron Presented to Sir John Herschel.* Wokingham, England and New York: Van Nostrand Reinhold Company, Limited, in association with The National Portrait Gallery, London, 1975.

Weaver, Mike. *Julia Margaret Cameron, 1815-1870.* Boston: Little, Brown and Company, 1984.

PAUL CAPONIGRO

Caponigro, Paul. *Landscape.* New York: McGraw-Hill Book Company, 1975.

LEWIS CARROLL

Gernsheim, Helmut. *Lewis Carroll, Photographer.* Revised edition. New York: Dover Publications, Inc., 1979.

HENRI CARTIER-BRESSON

Cartier-Bresson, Henri. *The Decisive Moment.* New York: Simon and Schuster, 1952.

Henri Cartier-Bresson: Photographer. Boston: New York Graphic Society, 1979.

Cartier-Bresson, Henri. *Photoportraits.* New York: Thames and Hudson Inc., 1935.

DESIRE CHARNAY

Davis, Keith F. *Désiré Charnay: Expeditionary Photographer.* Albuquerque: The University of New Mexico, 1981. Bibl.

PAUL CITROEN

Retrospektive Fotografie: Paul Citroen. Bielefeld/Düsseldorf: Edition Marzona, 1978.

ALVIN LANGDON COBURN

Alvin Langdon Coburn: Photographer: An Autobiography. Edited by Helmut Gernsheim and Alison Gernsheim. New York: Dover Publications, 1978.

A Portfolio of Sixteen Photographs by Alvin Langdon Coburn. Introduction by Nancy Newhall. Rochester, N.Y.: George Eastman House, 1962. Bibl.

ROBERT CORNELIUS

Stapp, William F. *Robert Cornelius: Portraits from the Dawn of Photography.* Washington, D.C.: National Portrait Gallery, 1983. Bibl.

IMOGEN CUNNINGHAM

Dater, Judy. *Imogen Cunningham: A Portrait.* Boston: New York Graphic Society, 1979.

Imogen Cunningham: Photographs. Introduction by Margery Mann. Seattle: University of Washington Press, 1970. Bibl.

EDWARD S. CURTIS

Andrews, Ralph W. *Curtis' Western Indians.* New York: Bonanza Books, 1962.

LOUIS JACQUES MANDE DAGUERRE

Daguerre, Louis Jacques Mandé. *An Historical and Descriptive Account of the Various Processes of the Daguerreotype and the Diorama.* 1839. Reprint, with introduction by Beaumont Newhall. New York: Winter House, Ltd., 1971.

Gernsheim, Helmut and Gernsheim, Alison. *L. J. M. Daguerre: The History of the Diorama and the Daguerreotype.* New York: Dover Publications, 1968. Bibl.

F. HOLLAND DAY

Jussim, Estelle. *Slave to Beauty . . . Life and Career of F. Holland Day.* Boston: David R. Godine, 1981. Bibl.

ROBERT DEMACHY

Jay, Bill. *Robert Demachy 1859-1936: Photographs and Essays.* London: Academy Editions, 1974. Bibl.

BARON ADOLF DE MEYER

De Meyer. Edited by Robert Brandau. Biographical essay by Philippe Jullian. New York: Alfred A. Knopf, 1976.

DISDERI, ANDRE ADOLPHE EUGENE

McCauley, Elizabeth Anne. *A. A. E. Disdéri and the Carte de Visite Portrait Photograph.* New Haven: Yale University Press, 1985.

THOMAS EAKINS

Hendricks, Gordon. *The Photographs of Thomas Eakins.* New York: Grossman, 1972.

HAROLD E. EDGERTON

Edgerton, Harold E. and Killian, James R. Jr. *Moments of Vision: The Stroboscopic Revolution in Photography.* Cambridge, Mass.: The MIT Press, 1979. Bibl.

ALFRED EISENSTAEDT

The Eye of Eisenstaedt. By Alfred Eisenstaedt as told to Arthur Goldsmith. New York: The Viking Press, 1969.

PETER HENRY EMERSON

Emerson, Peter Henry. *Naturalistic Photography for Students of the Art.* London: Sampson Low, Marston, Searle and Rivington, 1889. Reprint: New York: Arno, 1975.

Newhall, Nancy. *P. H. Emerson: The Fight for Photography As a Fine Art.* Millerton, N.Y.: Aperture, Inc., 1975. Bibl.

FREDERICK H. EVANS

Newhall, Beaumont. *Frederick H. Evans: Photographer of the Majesty, Light and Space of the Medieval Cathedrals of England and France.* Millerton, N.Y.: Aperture, Inc., 1978. Bibl.

WALKER EVANS

Agee, James and Evans, Walker. *Let Us Now Praise Famous Men.* Boston: Houghton, Mifflin Company, 1969.

Walker Evans. Introduction by John Szarkowski. New York: The Museum of Modern Art, 1971. Bibl.

ROGER FENTON

Gernsheim, Helmut and Gernsheim, Alison. *Roger Fenton, Photographer of the Crimean War.* 1954. Reprint. New York: Arno Press, 1973.

Hannavy, John. *Roger Fenton of Crimble Hall.* Boston: David R. Godine, 1976.

ROBERT FRANK

The Americans. Photographs by Robert Frank. Introduction by Jack Kerouac. Millerton, N.Y.: Aperture, Inc., 1978.

LEE FRIEDLANDER

Lee Friedlander Photographs. New City, N.Y.: Haywire Press, 1978.

FRANCIS FRITH

Frith, Francis. *Egypt and the Holy Land in Historic Photo-*

graphs. New York: Dover Publications, 1980. Bibl.

ALEXANDER GARDNER
Gardner, Alexander. *Gardner's Photographic Sketch Book of the War*. 2 vols., each with 50 original albumen prints. 1866. Reprint, with halftone reproductions. New York: Dover Publication, 1959.

RAOUL HAUSMANN
Hausmann, Raoul. *"Je ne suis pas un photographe."* Textes et documents choisis et presenté par Michel Giroud. Paris: Editions du Chêne, 1975. Bibl.

LADY CLEMENTINA HAWARDEN
Ovenden, Graham, ed. *Clementina, Lady Hawarden*. London: Academy Editions. New York: St. Martin's Press, 1974

JOSIAH JOHNSON HAWES
See SOUTHWORTH & HAWES, below.

JOHN HEARTFIELD
Heartfield, John. *Photomontages of the Nazi Period*. New York: Universe Books, 1977.

DAVID OCTAVIUS HILL AND ROBERT ADAMSON
In Early Victorian Album: The Photographic Masterpieces of David Octavius Hill and Robert Adamson. Edited and introduced by Colin Ford, and with an interpretive essay by Roy Strong. New York: Alfred A. Knopf, 1976.
Schwarz, Heinrich. *David Octavius Hills Master of Photography*. Translated by Helen E. Fraenkel. London: George C. Harrap & Co., 1932. Bibl.

JOHN K. HILLERS
Hillers, John K. *"Photographed All the Best Scenery": Jack Hiller's Diary of the Powell Expeditions, 1871-1875*. Edited by Don D. Fowler. Salt Lake City: University of Utah Press, 1972.

LEWIS HINE
America & Lewis Hine: Photographs 1904-1940. Foreword by Walter Rosenblum, biographical notes by Naomi Rosenblum, essay by Alan Trachtenberg. Millerton, N.Y.: Aperture, 1977. Bibl.

HANNAH HOCH
Adriani, Gotz, ed. *Fotomotagen, Gemälde, Aquarelle: Hannah Höch*. Mit Textbeiträgen von Julia Dech, Peter Krieger, Heinz Ohff, Eberhard Roters, Karin Thomas. Cologne: DuMont Buchverlag, 1980. Bibl.

VICTOR HUGO
Gruyer, Paul. *Victor Hugo Photographe*. Paris: Charles Mendel, 1905.

WILLIAM HENRY JACKSON
Jackson, William Henry. *Time Exposure*. 1940. Reprint. New York: Cooper Square Publishers, 1970.
Newhall, Beaumont, and Edkins, Diana E. *William H. Jackson*. Dobbs Ferry, N.Y.: Morgan & Morgan, Inc., for the Amon Carter Museum of Western Art, 1974. Bibl.

GERTRUDE KASEBIER
Homer, William Inness. *A Pictorial Heritage: The Photographs of Gertrude Käsebier*. Wilmington, Del.: Delaware Art Museum, 1979. Bibl.

ANDRE KERTESZ
Phillips, Sandra; Travis, David; Naef, Weston J. *André Kertész of Paris and New York*. New York: Thames and Hudson, 1985. Bibl.

DOROTHEA LANGE
Metzker, Milton. *Dorothea Lange, A Photographer's Life*. New York: Farrar, Straus and Giroux, 1978. Bibl.
Coles, Robert. *Dorothea Lange: Photographs of a Lifetime*. Millerton, N.Y.: Aperture, Inc., 1982. Bibl.

JACQUES HENRY LARTIGUE
Boyhood Photos of J.-H. Lartigue: The Family Album of a Gilded Age. Lausanne: Ami Guichard, 1966.

AUGUSTE AND LOUIS LUMIERE
Génard. Paul and Barret, André. *Lumière: les premières photographies en couleurs*. Paris: André Barret, 1974.

ETIENNE JULES MAREY
Marey, Etienne Jules. *Movement*. London: William Heinemann, 1895.

JOEL MEYEROWITZ
Meyerowitz, Joel. *St. Louis & the Arch*. Preface by James N. Wood. Boston: New York Graphic Society in association with The St. Louis Art Museum, 1980.

LISETTE MODEL
Lisette Model. Preface by Berenice Abbott. Millerton, N.Y.: Aperture, Inc., 1979. Bibl.

LASZLO MOHOLY-NAGY
Haus, Andreas. *Moholy-Nagy: Photographs and Photograms*. New York: Pantheon Books, 1980. Bibl.
Moholy-Nagy, László. *Painting, Photography, Film*. Cambridge, Mass.: MIT Press, 1969. A translation of *Malerei, Photographie, Film*. Munich: Albert Langen Verlag, 1927.

BARBARA MORGAN
Barbara Morgan. Introduction by Peter Bunnell. Hastings-on-Hudson, N.Y.: Morgan & Morgan, Inc., 1972. Bibl.

EADWEARD MUYBRIDGE
Haas, Robert B. *Muybridge, Man in Motion*. Berkeley: University of California Press, 1976.
Hendricks, Gordon. *Eadweard Muybridge, The Father of Motion Pictures*. New York: Grossman Publishers, 1975. Bibl.
Muybridge, Eadweard. *Muybridge's Complete Human and Animal Locomotion*. Introduction by Anita Ventura Mozley. 3 vols. New York: Dover Publications, Inc., 1979.

NADAR (Gaspard Félix Tournachon)
Gosling, Nigel. *Nadar*. New York: Alfred A. Knopf, 1976.

CHARLES NEGRE
Borcoman, James. *Charles Nègre*. Ottawa: The National Gallery of Canada, 1976. Bibl.

ARNOLD NEWMAN
Newman, Arnold. *One Mind's Eye*. Introduction by Robert Sobieszek. Boston: David R. Godine. 1974. Bibl.

JOSEPH NICEPHORE NIEPCE
Fouque, Victor. *The Truth Concerning the Invention of Photography: Nicéphore Niépce: His Life, Letters and Works*. 1935. Reprint. New York: Arno Press, 1973.

TIMOTHY O'SULLIVAN
Horan, James D. *Timothy O'Sullivan: America's Forgotten Photographer*. Garden City, N.Y.: Doubleday & Company, Inc., 1966. Bibl.
Snyder, Joel. *American Frontiers: The Photographs of Timothy H. O'Sullivan, 1867-1874*. Millerton, N.Y.: Aperture, 1981. Bibl.

PAUL OUTERBRIDGE, JR.
Paul Outerbridge, Jr.: Photographs. Edited by Graham Howe and G. Ray Hawkins. Text by Graham Howe and Jacquelyn Markham. New York: Rizzoli International Publications, 1980. Bibl.

IRVING PENN
Szarkowski, John. *Irving Penn*. New York: The Museum of Modern Art, 1984.

ELIOT PORTER

Intimate Landscapes: Photographs by Eliot Porter. Afterword by Weston J. Naef. New York: The Metropolitan Museum of Art/E. P. Dutton, 1979. Bibl.

COUNT GIUSEPPE PRIMOLI

Vitali, Lamberto. *Un fotografo fin de siècle: Il conte Primoli.* Turin: Giulo Einaudi editore, 1968.

MAN RAY

Photographs by Man Ray: 1920 Paris 1934. 1935. Reprint. New York: Dover Publications, Inc., 1979.

Ray, Man. *Self Portrait.* Boston: Little, Brown and Company, 1963.

Schwarz, Arturo. *Man Ray: Biographical Notes, Bibliography and an Anthology of Texts.* Milan: Galleria Schwarz, 1971.

OSCAR G. REJLANDER

Jones, Edgar Yoxall. *Father of Art Photography: O. G. Rejlander, 1813-1875.* Newton Abbot: David & Charles, Devon, 1973.

ALBERT RENGER-PATZSCH

Albert Renger-Patzsch: 100 Photographs. Essays in English, German, and French by Fritz Kempe and Carl Georg Heise. Cologne: Galerie Schurmann & Kicken, 1979.

Renger-Patzsch, Albert. *Die Welt ist schön: Einhundert photographische Aufnahme.* Edited by Carl Georg Heise. Munich: Kurt Wolff Verlag, 1928.

JACOB A. RIIS

Alland, Alexander, Sr. *Jacob A. Riis, Photographer & Citizen.* Preface by Ansel Adams. Millerton, N.Y.: Aperture, 1974. Bibl.

HENRY PEACH ROBINSON

Robinson, Henry Peach. *Pictorial Effect in Photography.* 1869. Reprint, with an introduction by Robert A. Sobieszek. Pawlet, Vt.: Helios, 1971.

ALEXANDER RODCHENKO

Alexander Rodchenko 1891-1956. Edited by David Elliott. Oxford: Museum of Modern Art, 1979.

Weiss, Evelyn, ed. *Alexander Rodtschenko: Fotografien 1920-1938.* Cologne: Wienand Verlag, 1978. Bibl.

·ARTHUR ROTHSTEIN

The Depression Years as Photographed by Arthur Rothstein. New York: Dover Publications, Inc., 1978.

ERICH SALOMON

Hunter-Salomon, Peter. *Erich Salomon: Portrait of an Age.* New York: The Macmillan Company, 1867. Bibl.

AUGUST SANDER

August Sander: Photographs of an Epoch. 1904-1959 Preface by Beaumont Newhall. Historical commentary by Robert Kramer. Accompanied by excerpts from the writings of August Sander and his contemporaries. Millerton, N.Y.: Aperture, Inc., 1980. Bibl.

Sander, August. *Citizens of the Twentieth Century.* Edited by Gunther Sander. Text by Ulrich Keller. Cambridge, Mass.: The MIT Press. 1986. Bibl.

BEN SHAHN

Pratt, Davis, ed. *The Photographic Eye of Ben Shahn.* Cambridge, Mass.: Harvard University Press, 1975.

CHARLES SHEELER

Millard, Charles W., III. "Charles Sheeler, American Photographer." *Contemporary Photographer,* vol. 6, no. 1 (1967), entire issue. Bibl.

AARON SISKIND

Aaron Siskind Photographer. Edited with an introduction by Nathan Lyons, essays by Henry Holmes Smith and Thomas B. Hess, statement by Aaron Siskind. Rochester, N.Y.: George Eastman House, 1965. Bibl.

Places: Aaron Siskind Photographs. Introduction by Thomas B. Hess. New York: Light Gallery and Farrar, Straus and Giroux, 1976.

W. EUGENE SMITH

Johnson, William. "W. Eugene Smith, A Chronological Bibliography." *Center for Creative Photography, University of Arizona,* vol. 12 (July 1981), pp. 97-147; and Research Series, Supplement (July 1981), pp. 147-261.

Maddow, Ben. *Let Truth Be the Prejudice: The Life and Photographs of W. Eugene Smith.* Millerton, N.Y.: Aperture, Inc., 1985.

W. Eugene Smith: His Photographs and Notes. Afterword by Lincoln Kirstein. Millerton, N.Y.: Aperture, 1969.

FREDERICK SOMMER

Frederick Sommer at Seventy-Five: A Retrospective. Edited by Constance W. Glenn and Jane K. Bledsoe. Long Beach: The Art Museum and Galleries, California State University, 1980. Bibl.

ALBERT SANDS SOUTHWORTH &
JOSIAH JOHNSON HAWES

Sobieszek, Robert A., and Appel, Odette M. *The Daguerreotypes of Southworth & Hawes.* New York: Dover Publications, 1980. Bibl.

EDWARD STEICHEN

Longwell, Dennis. *Steichen: The Master Prints 1895-1914.* New York: The Museum of Modern Art, 1978. Bibl.

Steichen, Edward. *A Life in Photography.* Garden City, N.Y.: Doubleday & Company, 1981.

Steichen the Photographer. New York: The Museum of Modern Art, 1961. Bibl.

RALPH STEINER

Steiner, Ralph. *A Point of View.* Introduction by Willard Van Dyke. Middletown, Conn.: Wesleyan University Press, 1978.

ALFRED STIEGLITZ

Greenough, Sarah, and Hamilton, Juan. *Stieglitz: Photographs & Writings.* Washington, D.C.: National Gallery of Art; New York: Calloway Editions, 1983.

PAUL STRAND

Paul Strand: Sixty Years of Photographs. Profile by Calvin Tompkins. Excerpts from correspondence, interviews, and other documents. Millerton, N.Y.: Aperture, 1976. Bibl.

WILLIAM HENRY FOX TALBOT

Arnold, H. J. P. *William Henry Fox Talbot.* London: Hutchinson Benham, 1977. Bibl.

Buckland, Gail. *Fox Talbot and the Invention of Photography.* Boston: David R. Godine, Publishers, Inc., 1980. Bibl.

Talbot, William Henry Fox. *The Pencil of Nature.* London: Longmans, Brown, Green & Longmans, 1844-46. Reprint, with essay by Beaumont Newhall, New York: Da Capo Press, 1969.

JERRY UELSMANN

Uelsmann, Jerry N. *Silver Meditations.* Introduction by Peter C. Bunnell. Dobbs Ferry, N.Y.: Morgan & Morgan, Inc., 1975. Bibl.

ADAM CLARK VROMAN

Webb, William and Weinstein, Robert A. *Dwellers at the Source: Southwest Indian Photographs of A. C. Vroman, 1895-1904.* New York: Grossman Publishers, 1973. Bibl.

CARLETON E. WATKINS

Palmquist, Peter E. *Carleton E. Watkins, Photographer of the*

American West. Albuquerque: University of New Mexico Press, 1983.

Watkins, Carleton E. *Photographs of the Columbia River and Oregon.* Introductory essays by David Featherstone and Russ Anderson, edited by James Alinder. Carmel, Cal.: The Friends of Photography, Inc., 1979.

WEEGEE

Weegee [psued.] *Naked City.* 1945. Reprint. New York: Da Capo Press, 1975.

THOMAS WEDGWOOD

Litchfield, R. B. *Tom Wedgwood, the First Photographer.* 1903. Reprint. New York: Arno Press, 1973.

BRETT WESTON

Brett Weston: Voyage of the Eye. Afterword by Beaumont Newhall. Millerton, N.Y.: Aperture, 1975. Bibl.

EDWARD WESTON

The Daybooks of Edward Weston. Edited by Nancy Newhall. 2 vols. Millerton, N.Y.: Aperture, 1973.

Maddow, Ben. *Edward Weston, His Life and Photographs.* Revised edition. Afterword by Cole Weston. Millerton, N.Y.: Aperture, 1979. Bibl.

CLARENCE H. WHITE

Homer, William Innes. *Symbolism of Light: The Photographs of Clarence H. White.* Wilmington, Del.: Delaware Art Museum, 1977. Bibl.

MINOR WHITE

Minor White: Rites and Passages. His Photographs Accompanied by Excerpts from His Diaries and Letters. Biographical essay by James Baker Hall. Millerton, N.Y.: Aperture, 1978. Bibl.

White, Minor. *Mirrors, Messages, Manifestations.* Millerton, N.Y.: Aperture, 1969. Bibl.

HEINRICH ZILLE

Ranke, Winfried. *Heinrich Zille, Photographien Berlin 1890-1910.* Munich: Schirmer/Mosel, 1975. Bibl.

EMILE ZOLA

Zola, François-Emile and Massin, eds. *Emile Zola Photograph.* Munich: Schirmer/Mosel, 1979.

TECHNICAL

The books listed have been selected as representative of the technical state-of-the-art at the time of their original publication.

Abbott, Berenice. *A Guide to Better Photography.* New York: Crown Publishers, 1941.

Adams, Ansel. *Making a Photograph.* London: The Studio Limited; New York: The Studio Publications, 1935.

Adams, Ansel, and Baker, Robert. *The Camera.* Boston: New York Graphic Society, 1980.

Bayley, Roger Child. *The Complete Photographer.* New York: McClure and Phillips, 1906.

Henney, Keith, and Dudley, Beverly, eds. *Handbook of Photography.* New York: Whittlesey House, 1939.

Hunt, Robert. *A Manual of Photography.* 3rd ed. 1853. Reprint, New York: Arno Press, 1973.

Lerebours, Noel Marie Paymal. *A Treatise on Photography.* Translated by J. Egerton. 1843. Reprint. New York: Arno Press, 1973.

Morgan, Douglas O.: Vestal, David; and Broecker, William L., eds. *Leica Manual: The Complete Book of 35mm Photography.* 15th ed. Hastings-on-Hudson, N.Y.: Morgan & Morgan, 1973.

Morgan, Willard D., and Lester, Henry M. *Graphic Graflex Photography.* Chapters by Ansel Adams, Laura Gilpin, Berenice Abbott, Barbara Morgan, and others. 1940. Reprint, Hastings-on-Hudson, N.Y.: Morgan & Morgan, 1971.

Towler, John. *The Silver Sunbeam: A Practical & Theoretical Text-Book on Sun Drawing and Photographic Printing.* 1864. Reprint. Hastings-on-Hudson, N.Y.: Morgan & Morgan, 1969.

Upton, Barbara, and Upton, John. *Photography.* 3rd ed. Boston: Little, Brown and Company, 1985.

Wilson, Edward L. *Wilson's Photographics: A Series of Lessons ... on All Processes which Are Needful in the Art of Photography.* 1881. Reprint. New York: Arno Press, 1973.

INDEX

ACKNOWLEDGMENTS

The following photographs are covered by claims to copyright:

Edouard Vuillard: *The Artist's Sisters-in-law.* © 1981 SPADEM, Paris/VAGA, New York.

Paul Strand: *The White Fence, Port Kent, New York; Rock, Porte Lorne, Nova Scotia; and Double Akeley, New York.* © 1971, 1976 The Paul Strand Foundation, as published in *Paul Strand, Sixty Years of Photographs* (Aperture, 1976).

Paul Strand: *Town Hall, Vermont.*

© 1950, 1971, 1976, 1977 The Paul Strand Foundation, as published in *Paul Strand, Time in New England* (Aperture, 1980).

Paul Strand: *Portrait—Washington Square, New York.* © 1971 The Paul Strand Foundation, as published in *Paul Strand: A Retrospective Monograph, The Years 1915-1968* (Aperture, 1971).

Edward Weston: *Palma Cuernavaca II, Clouds—Mexico, Nude,* and *Waterfront,* © 1981, Center for Creative Photography, Arizona Board of Regents.